Facts On File

BIOGRAPHICAL

ENCYCLOPEDIA OF

ARTISTS

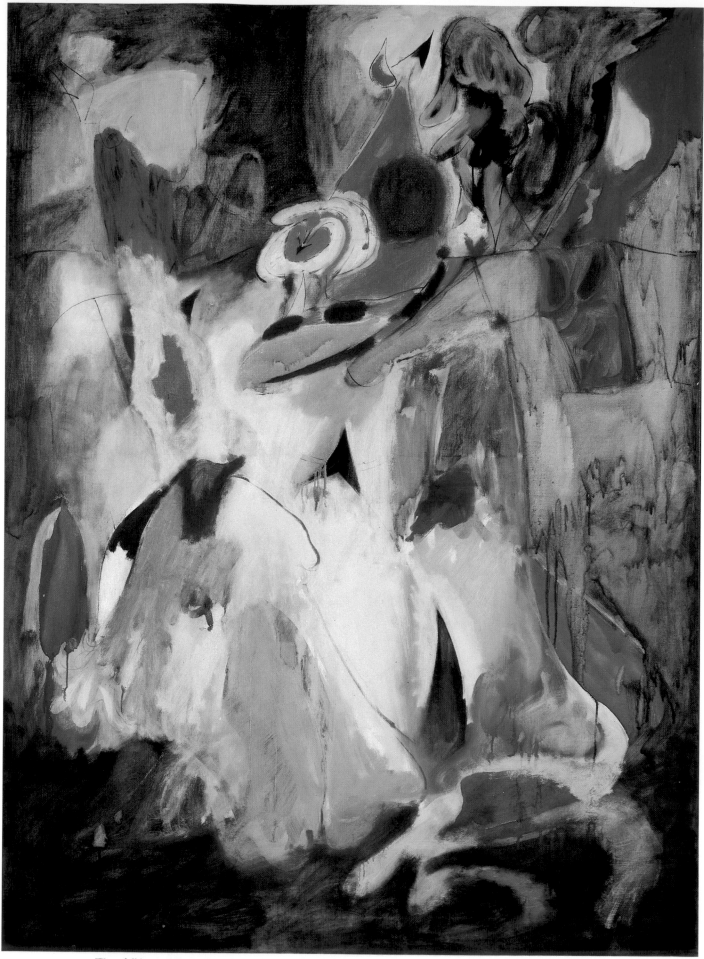

Waterfall by Arshile Gorky; oil on canvas; 155×114cm (61×45in); 1943. Tate Gallery, London (see page 271)

Facts On File

BIOGRAPHICAL

ENCYCLOPEDIA OF

ARTISTS

SIR LAWRENCE GOWING
GENERAL EDITOR

Facts On File, Inc.

Published in North America by:
Facts On File, Inc.
132 West 31st Street
New York, NY10001

The Brown Reference Group plc
(incorporating Andromeda Oxford Ltd)
8 Chapel Place
Rivington Street
London EC2A 3DQ

Library of Congress Cataloging-in-Publication Data

LC Control Number: 2005040500
 Type of Material: Text
 Main Title: Biographical encyclopedia of artists / edited by Lawrence Gowing.
Published/Created: New York: Facts On File, c2005.
Projected Pub. Date: 0504
 Related Names: Gowing, Lawrence.
 Description: p. cm.
 ISBN: 0816058032
 Contents: v. 1. Alvar Aalto–Paul Durand-Ruel -- v. 2. Albrecht Dürer–Jan
 Lievensz -- v. 3. Limburg Brothers–Francisco Ribalta -- v. 4.
 Jusepe de Ribera–Francisco de Zurbarán.
 Subjects: Artists--Biography.
 Artists--Encyclopedias.
 LC Classification: N40 .B535 2005
 Dewey Class No.: 709/.2/2 B 22

Volume 1 ISBN 0-8160-5804-0
Volume 2 ISBN 0-8160-5805-9
Volume 3 ISBN 0-8160-5806-7
Volume 4 ISBN 0-8160-5807-5
Set ISBN 0-8160-5803-2

Facts On File books are available at special
discounts when purchased in bulk quantities
for businesses, associations, institutions, or
sales promotions. Please call our Special Sales
Department in New York at (212) 967-8800
or (800) 322-8755.

You can find Facts On File on the World Wide
Web at http://www.factsonfile.com

Cover design by Cathy Rincon

Printed in China

10 9 8 7 6 5 4 3 2 1

Note

The chronological tables on pages x–xv show the life spans (or, in the case of most medieval artists, the active periods) of a selection of major figures.

Technical matter in the contributions and captions has been edited according to the following conventions. Titles of works are given in English, except where a title in another language is more familiar. Wherever possible, the locations of works are provided, by reference to the full name of an institution and to the town or city in which it stands. Names of institutions in English, French, German, and Italian are normally given in their original forms. Others have been translated, except where an original name is familiar or because an idiomatic translation is not possible. The names of some major institutions have been abbreviated. A statement of location does not necessarily imply a statement about ownership. The suggestions for "Further reading" usually specify the latest editions.

In the captions, dimensions are given in the order height × width (× depth in the case of sculpture). Measurements for most works are given to the nearest centimeter with, in parentheses, an imperial equivalent to the nearest inch. Where possible, the media of works are also given, but for many works, especially those from the period of European painting when tempera and oils were both in common use, media have not been specified because the binders and pigments of such works have not been analyzed.

The publisher wishes to thank the following individuals and institutions for their help in the preparation of this work:

INDIVIDUALS: Margaret Amosu, Professor Manolis Andronikos, Janet Backhouse, Claudia Bismarck, John Boardman, His Grace the Duke of Buccleugh, Richard Calvocoressi, Lord Clark, Curt and Maria Clay, James Collins, Bryan Cranstone, Mrs E.A. Cubitt, Mary Doherty, Judith Dronkhurst, Rosemary Eakins, Mark Evans, Claude Fessaguet, Joel Fisher, Jean-Jacques Gabas, Dr Oscar Ghez, Paul Goldman, G. St G.M. Gompertz, Zoë Goodwin, Toni Greatrex, A.V. Griffiths, Victor Harris, Barbara Harvey, Maurice Howard, A.D. Hyder, Jane Jakeman, Peg Katritzky, Moira Klingman, Andrew Lawson, Betty Yao Lin, Christopher Lloyd, Jean Lodge, Richard Long, Lorna McEchern, Eunice Martin, Shameem Melluish, Jennifer Montagu, Sir Henry Moore, Richard Morphet, Elspeth O'Neill, Alan Peebles, Professor Dr Chr. Pescheck, Pam Porter, Professor P.H. Pott, Alison Renney, Steve Richard, Andrew Sherratt, Richard Shone, Lawrence Smith, Don Sparling, Graham and Jennifer Speake, Annamaria Petrioli Tofani, Mary Tregear, Jim Tudge, Betty Tyers, Ivan Vomáčka, Tom Wesselmann.

INSTITUTIONS: Ashmolean Museum, Oxford; Bibliothèque Nationale, Paris; Bodleian Library, Oxford; British Library, London; British Museum, London; Courtauld Institute of Art, London; Gulbenkian Foundation, Lisbon; Louvre, Paris; Merseyside County Museums, Liverpool; Metropolitan Museum, New York; Museum of Modern Art, New York; Museum of Modern Art, Oxford; Oriental Institute, Oxford; Oxford City Library; Petit Palais, Geneva; Phaidon Press, Oxford; Pitt Rivers Museum, Oxford; Sainsbury Centre for the Visual Arts, Norwich; Sotheby Parke Bernet & Co., London; Tate Gallery, London; Victoria and Albert Museum, London; Warburg Institute, London.

The publisher wishes to thank the numerous individuals, agencies, museums, galleries, and other institutions who kindly supplied the illustrations for this book.

The publisher also wishes to acknowledge the important contributions of Judith Brundin, Ann Currah, Bernard Dod, Herman and Polly Friedhoff, Juliet Grindle, Jonathan Lamède, Giles Lewis, Andrew McNeillie, Penelope Marcus, and Louise Pengelley.

CONTENTS

BIOGRAPHICAL ENCYCLOPEDIA OF ARTISTS 1

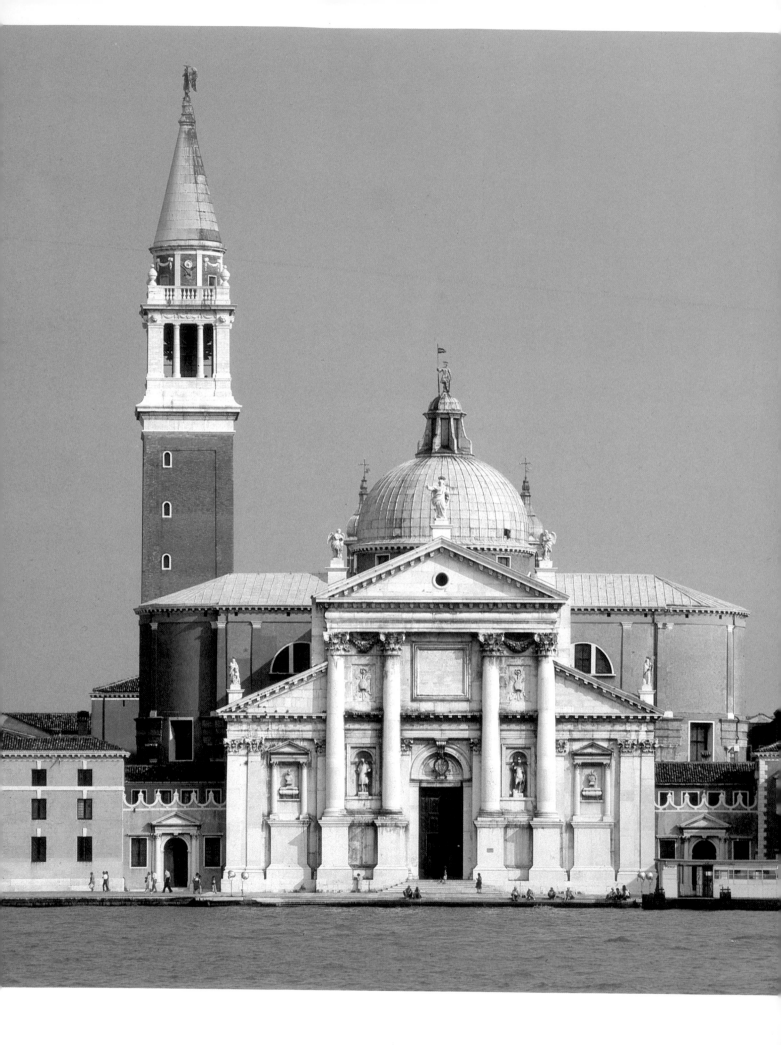

PREFACE

It was a bold man who first guessed that a collection of artists' biographies would be one of the most delightful books in the world. Not just incidentally interesting or entertaining, but germane to the essence of art, relevant to all its pleasures and meanings.

The fact is that the Western conception of art, which has flourished since Giorgio Vasari published his *Lives* four centuries ago, is a conception of artistic identity and personality. A meaningful work is the production of a more or less identifiable artist. His achievement is relative to an outlook which is in the strict sense no one's but his, the communicator of an individual purpose which could not have been expressed in any other way. The more works we know by an artist, the more each of them will signify.

The *Biographical Encyclopedia of Artists* is one of the prime imaginative achievements of our culture, and it is my pleasure to introduce as distinguished and useful an example of its kind as I know. The range is wide. This encyclopedia deals with more than three times the number of artists who figure in the only previous volumes of equal readability and convenience. No major Western artist is missing, and the relatively minor names, which we might be in doubt whether to seek here, are listed in summary form in the Index. The artists of other cultures of whom we have an impression personal enough to compare with those of our own are included too.

I dare promise that whenever you open these books you will both profit and gain enjoyment.

LAWRENCE GOWING
(1918–91)

DAVID FREKE
Director, Rescue Archaeology Unit, University of Liverpool

RICHARD FREMANTLE
Author of *Florentine Gothic Painters from Giotto to Masaccio*

JOHN FREW
Lecturer, Department of Fine Art, University of St Andrews

MARTIN GAUGHAN
Senior Lecturer in the History and Theory of Art, South Glamorgan Institute of Higher Education, Cardiff

JOHN GLAVES-SMITH
Lecturer in the History of Art, North Staffordshire Polytechnic, Stoke-on-Trent

BASIL GRAY
Former Keeper of Oriental Antiquities (Retired), British Museum, London

MICHAEL GREENHALGH
Senior Lecturer, History of Art, University of Leicester

ALASTAIR GRIEVE
Senior Lecturer, School of Fine Arts and Music, University of East Anglia

KEITH HARTLEY
Assistant Keeper, Scottish National Gallery of Modern Art, Edinburgh

ADELHEID HEIMANN
Former Assistant Curator of the Photographic Collection, Warburg Institute, London

JAMES HOLLOWAY
Assistant Keeper of Art, National Museum of Wales, Cardiff

CHARLES HOPE
Lecturer in Renaissance Studies, Warburg Institute, London

JOHN HOUSE
Lecturer in the History of Art, Courtauld Institute of Art, London

MAURICE HOWARD
Lecturer in the History of Art, University of Sussex

PETER HUMPHREY
Lecturer in the History of Art, University of St Andrews

OLIVER IMPEY
Assistant Keeper of Eastern Art, Ashmolean Museum, Oxford

CHRISTOPHER JOHNSTONE
Curator of Education and Information, National Gallery of Scotland, Edinburgh

MARTIN KEMP
Professor and Chairman of the Department of Fine Art, University of St Andrews

PETER KIDSON
Reader in the History of Art, Courtauld Institute of Art, London

HELEN LANGDON
Author of *The Mitchell Beazley Pocket Art Gallery Guide*, and *Everyday Life Painting*

PETER LASKO
Director, Courtauld Institute of Art, London

CHRISTINA LODDER
Lecturer, Department of Fine Arts, University of St Andrews

SHEILA MADDISON
Tutor, Open University, West Yorkshire Region

JODY MAXMIN
Associate Professor, Department of Art, Stanford University

HUGH MELLER
Historic Buildings Representative, The National Trust, Devon

HAMISH MILES
Director, Barber Institute of Fine Arts, Birmingham

JOHN MILNER
Senior Lecturer, Department of Fine Art, University of Newcastle-upon-Tyne

PARTHA MITTER
Lecturer in South Asian History, University of Sussex

JENNIFER MONTAGU
Curator of the Photographic Collection, Warburg Institute, London

KATHLEEN MORAND
Professor and Head of Department of Art, Queen's University, Kingston, Ont.

JOHN M. NASH
Senior Lecturer, Department of Art, University of Essex

PATRICK NOON
Assistant Curator, Yale Center for British Art, New Haven, Conn.

OLGA PALAGIA
Lecturer in Archaeology, University of Athens

RONALD PARKINSON
Head of the Department of Education, Victoria and Albert Museum, London

RONALD PICKVANCE
Richmond Professor of History of Fine Arts, University of Glasgow

GRISELDA POLLOCK
Lecturer in the History of Art, University of Leeds

ANTHONY RADCLIFFE
Keeper of Sculpture, Victoria and Albert Museum, London

BENEDICT READ
Deputy Witt Librarian, Courtauld Institute of Art, London

HON. JANE ROBERTS
Curator of the Print Room, Royal Library, Windsor Castle

†KEITH ROBERTS
Former Associate Editor, *Burlington Magazine*, and sometime Commissioning Editor for Phaidon Press, Oxford

GILES ROBERTSON
Professor Emeritus, Department of Fine Art, University of Edinburgh

RUTH RUBINSTEIN
Warburg Institute, London

ROBIN SIMON
Director, Institute of European Studies, London

LAWRENCE R.H. SMITH
Keeper of Oriental Antiquities, British Museum, London

ROBIN SPENCER
Lecturer, Department of Fine Arts, University of St Andrews

PAUL SPENCER-LONGHURST
Assistant to the Director, Barber Institute of Fine Arts, Birmingham

GERETH SPRIGGS
Freelance writer and authority on English medieval manuscript illumination

JOHN STEER
Head of Department of History of Art, Birkbeck College, London

MARY-ANNE STEVENS
Lecturer, History and Theory of Art, University of Kent at Canterbury

NEIL STRATFORD
Keeper of Medieval and Later Antiquities, British Museum, London

SARAH SYMMONS
Lecturer, Department of Art, University of Essex

ALAN TAIT
Reader in the History of Art, University of Glasgow

MARY TREGEAR
Keeper of Eastern Art, Ashmolean Museum, Oxford

NICHOLAS TURNER
Assistant Keeper, Department of Prints and Drawings, British Museum, London

WILLIAM VAUGHAN
Reader in the History of Art, University College, London

NICHOLAS WADLEY
Head of Department of Art History, Chelsea School of Art, London

CHRISTOPHER WAKELING
Lecturer in Fine Art, University of Keele

ERNST WANGERMANN
Reader in Modern History, University of Leeds

MALCOLM WARNER
Freelance writer; coauthor of *The Phaidon Companion to Art and Artists in the British Isles*

ANTHONY WHITE
Managing Director, Frederick Muller Ltd, London

ALAN G. WILKINSON
Curator of the Henry Moore Sculpture Centre, Art Gallery of Ontario, Toronto

D.J.R. WILLIAMS
Research Assistant, Department of Greek and Roman Antiquities, British Museum, London

CHRISTOPHER WRIGHT
Freelance writer; publications include *Rembrandt and His Art*, *Paintings in Dutch Museums*

ERIC YOUNG
Distinguished authority on Spanish painting; publications include *Francisco Goya*

GEORGE ZARNECKI
Professor of the History of Art, Courtauld Institute of Art, London

CHRONOLOGY OF ARTISTS: ROMANESQUE TO BAROQUE

	1100	1200	1300

ROMANESQUE

GOTHIC ITALY

ITALIAN RENAISSANC

ITALIAN

- 1 W. OF M.
- Benedetto ANTELAMI
- CIMABUE
- ORCAGNA
- Lorenzo MAITANI
- SIMONE MARTINI
- VITALE DA BOLOGNA
- Giovanni PISANO
- GUIDO DA SIENA
- N. PISANO
- Taddeo GADDI
- DUCCIO DI BUONINSEGNA
- Francesco TRAINI
- TOM. DA MODENA
- GIOTTO DI BONDONE
- Andrea PISANO
- N. PISANO

FRENCH

- RENIER DE HUY
- 5 V. DE H.
- HONORÉ
- André BEAUNEVE
- J. D
- 6
- SUGER OF ST-DENIS

SPANISH

- FERRER BASSA

FLEMISH

- 10 N. OF V.
- 11

DUTCH

GERMAN

- THEOPHILUS
- M. OF NAUMBERG

ENGLISH

- W. de BRAILES
- YEVEL
- Matthew PARIS

1 WILIGELMO OF MODENA 2 DESIDERIO DA SETTIGNANO 3 DOMENICO VENEZIANO 4 ANDREA DEL CASTAGNO
5 VILLARD DE HONNECOURT 6 GILABERTUS OF TOULOUSE 7 Jean de BEAUMETZ 8 BOUCICAUT MASTER 9 NUNO GONÇALVES
10 NICHOLAS OF VERDUN 11 Jean BONDOL 12 Melchior BROEDERLAM 13 Nikolaus GERHAERT VAN LEYDEN
14 GEERTGEN TOT SINT JANS 15 MASTER FRANCKE 16 Herman SCHEERRE

1400 | **1500**

MANNERISM

NORTHERN RENAISSANCE

BAROQUE

GOTHIC OUTSIDE ITALY

Cennino CENNINI
Donato BRAMANTE
Il TINTORETTO
T. DA FABRIANO
Giovanni BELLINI
Giovanni BOLOGNA
SASSETTA
LEONARDO DA VINCI
Paolo VERONESE
GIOVANNI DE PAOLO
Andrea PALLADIO
UCCELLO
SEBASTIANO DEL PIOMBO
PISANELLO
Filippino LIPPI
Francesco PRIMATICCIO
DONATELLO
Il SANSOVINO
Lorenzo GHIBERTI
Fra BARTOLOMMEO
Lodovico CARRACCI
o della QUERCIA
Antonio CORREGGIO
Agostino CARRACCI
Filippo BRUNELLESCHI
PERUGINO
Ludovico CIGOLI
Fra ANGELICO
PIERO DI COSIMO
Annibale CARRACCI
MASACCIO
Dom. GHIRLANDAIO
Jacopo PONTORMO
CARAVAGGIO
Leon Battista ALBERTI
MICHELANGELO
PIETRO DA CORTONA
Fra Filippo LIPPI
Vittore CARPACCIO
Alessandro ALGARDI
PIERO DELLA FRANCESCA
ROSSO FIORENTINO
Francesco BORROMINI
Agostino di DUCCIO
Lorenzo LOTTO
2 D. DA S.
GIORGIONE
Gentile BELLINI
NICCOLO ALUNO
Agnolo BRONZINO
Cosmè TURA
GIULIO ROMANO
ANT. DA MESSINA
PALMA VECCHIO
Andrea MANTEGNA
Giorgio VASARI
VERROCCHIO
TITIAN
3 D.V.
RAPHAEL
4 A. DEL C.
Benvenuto CELLINI
Alessandro BOTTICELLI

Jean FOUQUET
Philibert DELORME
Simon MARMION
8 B.M.
9 N.G.
Gil de SILOE

LIMBURG
Hugo van der GOES
Pieter BRUEGEL E.
12 M.B.
Gerard DAVID
Jan BRUEGEL
Jan van EYCK
Quentin MASSYS
Anthony van DYCK
Rogier van der WEYDEN
Jan GOSSAERT
Joachim PATENIER

MALOUEL
13 N.G. VAN L.
LUCAS VAN LEYDEN
Hendrick GOLTZIUS
Dieric BOUTS
Hieronymus BOSCH
14 G.T.S.J.

Stefan LOCHNER
H. HOLBEIN THE ELDER
A. ELSHEIMER
Hans MULTSCHER
Matthias GRÜNEWALD
15 M.F.
Michael PACHER
MASTER OF LIESBORN
Martin SCHONGAUER
Hans HOLBEIN Y.
Michael WOLGEMUT
Bernt NÖTKE
Veit STOSS
Albrecht DÜRER
Lucas CRANACH THE ELDER
Albrecht ALTDORFER

16 H.S.
Nicholas HILLIARD
Inigo JONES
n SIFERWAS

CHRONOLOGY OF ARTISTS: BAROQUE TO REALISM

	1500	1600	1700

BAROQUE

FRENCH

- Georges de LA TOUR
- Nicolas POUSSIN
- Francesco DUQUESNOY
- Jules-Hardouin MANSART
- François MANSART
- Claude LORRAIN
- Philippe de CHAMPAIGNE
- Charles LEBRUN
- Pierre PUGET
- L-S ADAM
- Salomon de BROSSE
- Antoine COYSEVOX
- Jacques SARRAZIN
- Giullaume COUST
- Louis LEVAU
- J-A WATTEA
- Nicolas COUSTOU

ENGLISH

- Inigo JONES
- Christopher WREN
- Samuel COOPER
- William HOGARTH
- Peter LELY
- Nicholas HAWKSMOOR
- John VANBRUGH
- James GIBBS
- William ADAM

FLEMISH

- Peter Paul RUBENS
- Jacob JORDAENS
- Anthony van DYCK

DUTCH

- Frans HALS
- REMBRANDT VAN RIJN
- Jan STEEN
- Jacob van RUISDAEL
- Pieter de HOOCH
- Jan VERMEER
- Meyndert HOBBEMA

GERMAN/AUSTRIAN

- Johann Lucas von HILDEBRAN
- Balthasar NEUMANN
- J.M. FISCHER
- Egid Quirin ASAM

ITALIAN

- Guido RENI
- PIAZZETTA
- PIETRO DA CORTONA
- TIEPOLO
- Alessandro ALGARDI
- Gian Lorenzo BERNINI
- Francesco BORROMINI
- Filippo JUVARRA
- Carlo MADERNO
- Ferdinando BIBIENA

SPANISH

- Jusepe de RIBERA
- José Benito CHURRIGUERA
- Francisco de ZURBARAN
- Diego VELAZQUEZ
- Alonso CANO
- Bartolomé MURILLO
- Francisco HERRERA the Younger

AMERICAN

1800
1900

NEOCLASSICISM/ROMANTICISM

ROCOCO
REALISM

Jean-Baptiste CHARDIN
J-B-C COROT
François BOUCHER
GERICAULT
Eugène DELACROIX
J-B GREUZE
Gustave COURBET
C-M CLODION
J-A HOUDON
J-L DAVID
J-A-D INGRES
Eugène DAUMIER
P E T ROUSSEAU
Charles GARNIER
P-P PRUD'HON
Henri FANTIN-LATOUR

Joshua REYNOLDS
Samuel PALMER
Thomas GAINSBOROUGH
A.W.N. PUGIN
Thomas LAWRENCE
William MORRIS
Robert ADAM
John RUSKIN
John FLAXMAN
Edward BURNE-JONES
J.M.W. TURNER
John CONSTABLE
John CROME
Ford Madox BROWN
Thomas GIRTIN
John MILLAIS
John NASH
George STUBBS
John TENNIEL

Jozef ISRAELS

Caspar David FRIEDRICH
Wilhelm LEIBL
Philipp Otto RUNGE
Johann Friedrich OVERBECK
Anton MENGS
Gottfried SEMPER

CANALETTO
Pietro LONGHI
Antonio CANOVA
Francisco GOYA

John Singleton COPLEY
Winslow HOMER
Benjamin WEST
Thomas EAKINS
Gilbert STUART
John Singer SARGENT
Louis Henry SULLIVAN

CHRONOLOGY OF ARTISTS: SINCE IMPRESSIONISM

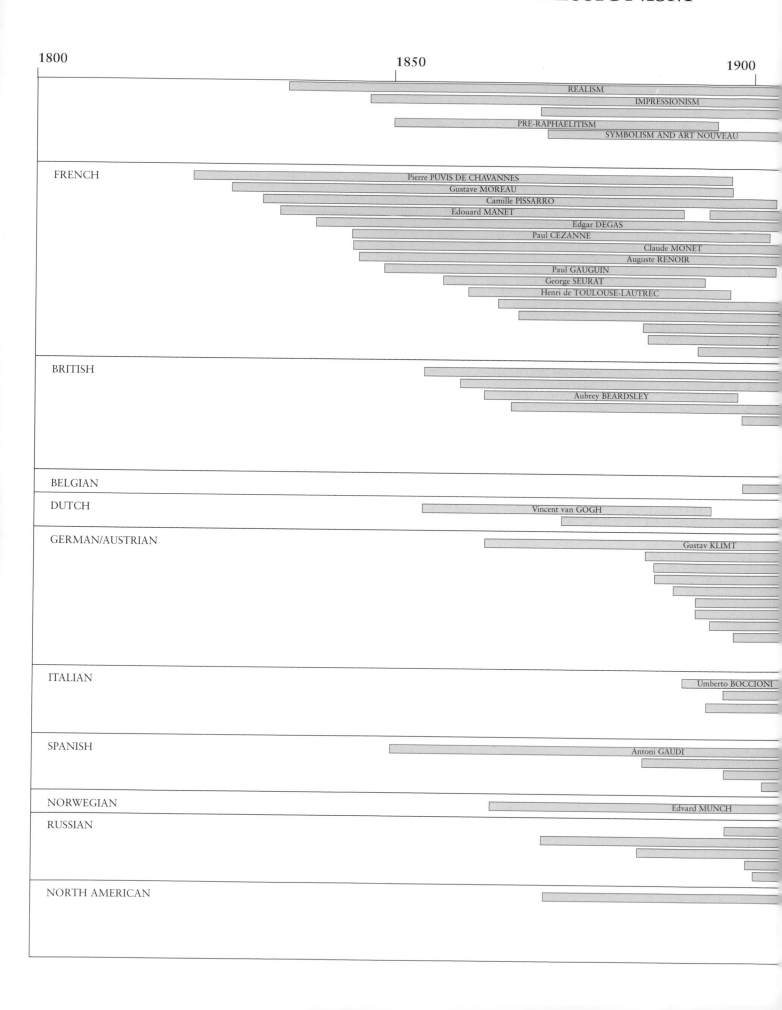

1800 1850 1900

REALISM

IMPRESSIONISM

PRE-RAPHAELITISM

SYMBOLISM AND ART NOUVEAU

FRENCH

Pierre PUVIS DE CHAVANNES

Gustave MOREAU

Camille PISSARRO

Edouard MANET

Edgar DEGAS

Paul CEZANNE

Claude MONET

Auguste RENOIR

Paul GAUGUIN

George SEURAT

Henri de TOULOUSE-LAUTREC

BRITISH

Aubrey BEARDSLEY

BELGIAN

DUTCH

Vincent van GOGH

GERMAN/AUSTRIAN

Gustav KLIMT

ITALIAN

Umberto BOCCIONI

SPANISH

Antoni GAUDI

NORWEGIAN

Edvard MUNCH

RUSSIAN

NORTH AMERICAN

1950 2000

POP/OP ART
MINIMALISM AND CONCEPTUALISM
POST-IMPRESSIONISM
INTERNATIONAL STYLE
NEO-EXPRESSIONISM
FAUVISM AND EXPRESSIONISM
POST-MODERNISM
ABSTRACTION
CUBISM AND FUTURISM
DADA AND SURREALISM

Marcel DUCHAMP

ORLAN

Sophie CALLE

Pierre BONNARD
Henri MATISSE
Fernand LEGER
George BRAQUE
Jean ARP

Walter SICKERT
Antony GORMLEY
Roger FRY
Tracy EMIN
Barbara HEPWORTH
Damien HIRST
Jacob EPSTEIN
Henry MOORE
David HOCKNEY
Norman FOSTER
Sarah LUCAS
Jake and Dinos CHAPMAN

René MAGRITTE

Rem KOOLHASS

Piet MONDRIAN

Georg BASELITZ

Paul KLEE
Anselm KIEFER
Ernst Ludwig KIRCHNER
Rebecca HORN
Franz MARC
Walter GROPIUS
Oscar KOKOSCHKA
Ludwig MIES VAN DER ROHE
Sigmar POLKE
Kurt SCHWITTERS
Max ERNST
Hans HAACKE
Gerhard RICHTER

Sandro CHIA
Giorgio de CHIRICO
SALVO
Amedo MODIGLIANI
Mimmo PALADINO
Maurizio CATTELAN

Pablo PICASSO
Juan GRIS
Ricardo BOFILL
Joan MIRÓ

Santiago CALATRAVA

Marc CHAGALL
Wassily KANDINSKY
Kasimir MALEVICH
Naum GABO
Jakoff LIPCHITZ

Frank Lloyd WRIGHT
Jackson POLLOCK
Matthew BARNEY
Andy WARHOL
Judy CHICAGO
Julian SCHNABEL
Jeff KOONS

PICTURE ACKNOWLEDGMENTS

Aberdeen Art Gallery: 197, 203. © ADAGP, Paris and DACS, London 2005 83, 171, 191, 204t, 406. AKG, London: 133, © ADAGP, Paris and DACS, London 2005 344, 503. Albright-Knox Art Gallery, Buffalo: 23. Alinari, Florence: 7, 31, 91, 140, 157, 181, 225, 240, 366, 380, 391, 408, 414, 445, 450 (photo: Anderson), 485, 504, 527, 541, 547, 552 (photo: Anderson), 589, 592, 612 (photo: Anderson), 614, 615, 616bl and tr, 650, 660, 677, 679, 681. Alte Pinakothek, Munich: 212, 289, 502. Archivo Fotografico d'Arte A. Villania Figli, Bologna: 710l. © ARS, NY and DACS, London 2005: 654. Art Gallery of New South Wales: 373. Art Institute of Chicago: © DACS 354, 411b, 732tr. Ashmolean Museum, Oxford: 14. Bergen Art Gallery; Munch Museum/ Munch-Ellingsen Group, BONO, Oslo, DACS, London 2005 480. Bibliothèque Nationale, Paris: 242. Bildarchiv Foto Marburg: 353b, 433, 499, © DACS 622br. Mr D.Bliken, New York: © William Turnball 2005. All rights reserved, DACS 685. O. Bohm, Venice: 711b. Boymans van Beunigen Museum, Rotterdam: 339b. J. Brennan, Oxford: © FLC/© ADAGP, Paris and DACS, London 2005 370. Bridgeman Art Library, London: 40, 45, 76, 95cr, 238b, 307, 358, 402, © Succession H Matisse/DACS 2005 438, 473bl, 477. British Library, London: 429. British Museum, London: 36, 58, 100, 318, 531. Brooks Memorial Art Gallery, Memphis, Tenn.: 74. Bulloz, Paris: 37, 38, 161, 261, 340, 443, 501. Busch-Reisinger Museum, Cambridge, Mass.: 349, © DACS 458. Butler Institute of American Art, Youngstown, Ohio: 321b. Caisse Nationale des Monuments Historiques et des Sites, Paris: 533, 643. City of Birmingham Museums and Art gallery: 105t, 111b, 293, 327, 539. Cleveland Museum of Art, Ohio: 241l. Corpus Christi College, Cambridge: 509r. Collection of John Cravens, Paris: © ADAGP, Paris and DACS, London 2005 732.© DACS 469 ,663, 678. Dallas Museum of Fine Art: 462 (Munger Fund). Detroit Institute of Arts; © ADAGP, Paris and DACS, London 2005 186, 223b, 579tl, 727. Collection of H.M. Queen Elizabeth II: 598, 739. Equinox Archive, Oxford: 731b. Estate of Francis Bacon 2005, All rights reserved, DACS, 28. William Hayes Fogg Art Museum, Cambridge, Mass.: 214t (gift of Dr G. Stevens Jones), 613 (Louise E. Betters Fund). Freer Gallery of Art, Washington D.C.: 121t, 581br. Frick Collection, New York: 712. Gabinetto Fotografico Nazionale, Rome: 9, 459. Gemaldegalerie Alte Meister, Dresden: 673b. Giraudon, Paris: 3b, 26, 39, 41, 48, 74l and r, 85, 87, 97, 110, 122, 147, 148t, 149, 149l, 160, 169, 212, 219, 241, 252, 260, 272, 404, 410, 481, 530. Adolph and Esther Gottlieb Foundation/VAGA, New York/DACS, London 2005: 273. Solomon R. Guggenheim Museum, New York: © ARS, NY and DACS, London 2005 353t. Frans Hals Museum, Haarlem: 52tl. Robert Harding Associates, London: 231tl, 436. Joseph Hirschhorn Museum, Washington D.C.: 488. Michael Holford, Loughton, Essex: 250, 338, 517b, 733. Holle Verlag, Baden-Baden: 134. Imperial War Museum, London: 382t. Sidney Janis Gallery, New York: Dedalus Foundation, Inc/VAGA, New York/DACS, London 2005 476, 497t (Carol Janis Collection). Kenwood House, London: 658. A. F. Kersting, London: 2, 4, 33, 119, 156l, 176, 177t, 303, 738. Kunsthistorisches Museum, Vienna: 23. 264. Andrew Lawson, Oxford: 348. Lefevre Gallery, London: 95tl. Los Angeles County Museum of Art: 401t, © ADAGP, Paris and DACS, London 2005 708. Marlborough Gallery of Fine Art, London: © DACS 350.

Mansell Collection, London 427t (photo: Anderson). MAS, Barcelona: 127. Pierre Matisse Gallery, New York: © ADAGP, Paris and DACS, London 2005 172. Metropolitan Museum, New York: 27t, 70 (Brisbane Dick Fund) , 126, 199, 259, 392, © ARS, NY and DACS, London 2005 496 (Steiglitz Collection), Eduardo Paolozzi 2005. All rights reserved, DACS 508, 581tl, 592, 609r, 707, 741. Ministry of Public Buildings and Works, London: 667t. Minneapolis Institute of Artts: 554. Modern Museum, Stockholm; © ADAGP, Paris and DACS, London 2005 367. Montreal Museum of Fine Arts: © DACS 214b. Musée d'Art Moderne, Geneva: 666, Museo Nazionale, Florence: 15. Museum of Fine Arts, Antwerp: © DACS 202. Museum Ludwig, Cologne: © DACS 178, Art © Judd Foundation. Licensed byVAGA, New York/DACS, London 2005 341. Museum of Fine Arts, Boston: 47, 238t, 283, 657. Museum of Fine Arts, Houston: 190. Museum of Modern Arts, New York: 63 (Lillie P. Bliss Request), © ADAGP, Paris and DACS, London 2005 118, © Estate of Stuart Davis/VAGA, New York/DACS, London 2005 164, © ADAGP, Paris and DACS, London 2005 204b, © ARS, NY and DACS, London 2005 219b, © DACS 2005 288, © ARS, New York 7 DACS, London 2005 330, 345, 350t, © ADAGP, Paris and DACS, London 2005 360b (Inter American Fund), 382b, Escobar Marisol/VAGA, New York/DACS, London 2005 420, © ADAGP, Paris and DACS, London 2005 427, © ADAGP, Paris and DACS, London 2005 439, 509l (Blanchette Rockefeller Fund), © ADAGP, Paris and DACS, London 2005 670, 736. National Gallery, London: 21, 73, 86, 108, 117, 131, 179, 201, 221, 234b, 308, 313, 322, 355, 416, 419t, 425, 430, 440, 446, 470, 473, 487, 500, 510, 512t, 516, 518, 526, 533t, 542, 543tl, 545, 576l, 591t, 596, 611, 618, 620t, 647, 652, 665, 671br, 684, 696. 698, 699, 725, 730, 733. National Gallery of Art, Washington D.C.: 40, 110t (Chester Dale Collection), 209 (Melton Collection), 226, 388, 389 (Kress Collection), 395 (Windener Collection), 444 (Kress Collection), 455l, 471, 513br (Kress Collection), 584 (Kress Collection), 646 (Kress Collection). National Gallery of Ireland, Dublin: 276, 682. National Gallery of Scotland, Edinburgh; 17br, 885, 321t, 323, 541tl, 560, 561b, 570, 600t, 719. National Museum, Stockholm: © DACS 125. National Gallery of Victoria, Melbourne: 333b, 512. National Maritime Museum, Greenwich: 199r, 700. National Museum of Wales, Cardiff: 224t. National Palace Museum, Taipei: 26, 441r, 717, 736b. National Portrait Gallery, London: 245, 300, 337t, William Rockhill Nelson Gallery, Kansas City, Mo.: 634, 722. The National Trust, London: 205b. Offentliche Kunstsammlung, Kunstmuseum Basel: © DACS 178r, 315b: Osterreichische Galerie, Vienna: 441l. Pennsylvania Academy of Fine Arts, Philadelphia: 723. Maria Perotti, Milan: 457r. Phaidon Press Picture Archive, Oxford: 6b, 10, 11, 12, 13, 16, 19, 24t , © DACS 24b, 27b, 29, 30, 31r, 32t and b. 35, 42, 44, 50t and b, 51, 52br, © ADAGP, Paris and DACS, London 2005, 53, 59, © Peter Blake 2005. All Rghts Reserved, DACS 60, 64b, © ADAGP, Paris and DACS, London 2005 66t ,66b, 69, 72, 77, © ADAGP, Paris and DACS, London 2005 81, © ADAGP, Paris and DACS, London 2005 82, 88, 89, 94, 99, 101t, 103, 105, 106, © DACS 2005, 107, 112, 114, 116, 121b, 123r, 124, 125t, 129, 132, 134br, 136, 139, 141, 142, 144, 145b, 147t, 148bl, 150t and b, 151, 154, 155t, © Salvador Dali, Gala-Salvador Dali Foundation, DACS, London

2005 158, 159r, 163, 165, 167, 174t, 175, 178, 180t, 182, 188, 202b, 205t, 207, 211, 212, 213, 215, 216, 222, 227, 228, 231br, 232, 237, 239, 243, 247, 248, 249b, 253t and b, 254, 256, 261b, 263, 267, 269, 274, 275, 278, 281, 285, 286, 289, 294, 299, © Estate of Duane Hanson/VAGA, New York/DACS, London 2005 301t, Richard Hamilton 2005. All rights reserved, DACS 301b, 305, 310, 311br, 312, 315t and b, 317, 332, 334, 360t, 361t and b, 362, © ADAGP, Paris and DACS, London 2005 363, 364, 365, 369, 376t and b, 377, 383l and r, © DACS 384t , The Estate of Roy Lichtenstein 384b, 386, 390, 391l, 393, 394t and b, 396, 397b, 399, 403l, 405t and b, © ADAGP, Paris and DACS, London 2005 407, 412, 414b, 417t and b, 418, 422, 423, 431, 432t and b, 434, 435tr and br, © Sucession H Matisse 437, 442, 448, 449, 451, 452, Successio Miro, DACS, 2005 454, 457, 460, 468, 469b, 473tr, 478, 484l and r, © Angela Verren-Taunt 2005 All rights reserved, DACS 491, 498, 507br, 515, 521l and r, 528, 530tl, © ARS, NY and DACS, London 2005 543br, 548l and r, 549, 551, 553t, 555, 556, 557, 558, 561t, 562, 565b, 567, 568, 569, 571, 572, 573, 575, 576t, 577bl and tr, 579br, 582, 586, 588l and r, 593, 595, © ADAGP, Paris and DACS, London 2005 597, 599, 600b, 601, 602, 604, 605, 607 608, 610, 613tr, 619bl and tr, 620b, 621, 622tl, 623, © DACS 625, 626, 627, 629, 630, © ADAGP, Paris and DACS, London 2005 631, 632, 635b, © ADAGP, Paris and DACS, London 2005 637, 638, 641, 642, 644, 645, © ADAGP, Paris and DACS, London 2005 649, © ADAGP, Paris and DACS, London 2005 651, 667b, 669, 672, 673t, 676, 677tl, 680 685tr, 689, 690, 692, © ADAGP, Paris and DACS, London 2005 694, 695l and r, 701, 702, 705t and b, 706, 709, 710r, © ADAGP, Paris and DACS, London 2005 713t , 713b, © ADAGP, Paris and DACS, London 2005 715, 716, 721t and b, 724, 726, 730, 731t, 732bl, 735, © The Estate of Jack B. Yeats 2005. All rights reserved DACS 737, 740.. Philadelphia Museum of Art: © Succession Marcel Duchamp/ © ADAGP, Paris and DACS, London 2005 189, 233t, 309t, 333t, © ADAGP, Paris and DACS, London 2005 371, 421, 507tl, 514. Photodisc, UK: © ADAGP, Paris and DACS, London 2005 387t. Pollock House, Glasgow: 282. A. Raichle, Ulm: 54. Rijksmuseum, Amsterdam: 25, 339t. Rijksmuseum Vincent Van Gogh, Amsterdam: © ADAGP, Paris and DACS, London 2005 411tr. Royal Academy of Art, London: 138. Royal Albert Memorial Museum, Exeter: 304. Royal Library, Windsor: 320. Saint Louis Art Museum, Missouri: 609b. San Diego Museum of Art: 613bl. Scala, Florence: 5, 17t, 20, 53l. 57, 68, 79, 92, 98b, 101b, 109, 113, 130, 152, 153, 187, 192, 233b, 235tl, 246, 258, 262, 280, 292, 342, 343, 401b, 403r, 426, 443br, 490, 502, 505, 517t, 532, 535, 536, 537, 544, 546, 553b, 559, 674, 704. R.V. Schoder, Chicago: 482. Anton Schroll and Co., Vienna: 441. Scottish National Portrait Gallery, Edinburgh: 483. Seattle First National Bank: Jules Olitski/VAGA, New York/DACS, Lodnon 2005 497b. Service de Documentation Photographique de la Réunion des Musées Nationaux, Paris: 34b, 319, 428, 538. Olive Smith (photo: Edwin Smith)m Saffron Walden: 75b. Sotheby's Picture Library, London: 120. Staatliche Antikensammlung, Munich: 206 (photo: Moessener), 208. Staalliche Museen zu Berlin, East Berlin: 446t. Stadtische Kunsthalle, Mannheim: 46tl, 479. State Art Museum, Copenhagen: 3t. Stedelijk Museum, Amsterdam: 409. © Succession Picasso/DACS 2005: 524t.. Tate Gallery, London: © The

Josef and Anni Albers Foundation/VG Bild-Kunst, Bonn and DACS, London 2005 6t, 34t, 46br, 61, 64t, 95bl, 137, 157l, © Foundation P Delvaux -St Idesbald, Belgium/ DACS, London 2005 170, © Estate of Sam Francis/DACS DACS 225b, 230, 252t, 268, 270, © ADAGP, Paris and DACS, London 2005 271, 279, © DACS 296, 306, 309b, 314, 316, 325b, 335, Jasper Johns/VAGA, New York/DACS, London 2005 336, 337b, © ADAGP, Paris and DACS, London 2005 352, 362b, 374, 397t, 419b, 455r, 467, 475, 492, 493b, © Kenneth Noland/VAGA, New York/DACS, London 2005 494, Tom Philips 2005. All rights reserved, DACS 520, © Succession Picasso/ DACS 2005 523, © Succession Picasso/ DACS 2005 524bl, Robert Rauschenberg/VAGA, New York/DACS, London 2005 564, © Man Ray Trust/ ADAGP, Paris and DACS, London 2005 565t, Estate of Ceri Richards 2005. All rights reserved, DACS 578, 580, 585, 590, © James Rosenquist/VAGA, New Tork/DACS, London 2005 591b, 594, © 1998 Kate Rothko Prizel & Christopher Rothko/DACS 2005 596, 617, 635t, © Estate of Walter R. Sickert 2005. All rights reserved, DACS 636, © Estate of Stanley Spencer 2005. All rights reserved, DACS 650t, 653, 655, 659, 660, © ARS, NY and DACS, London 2005 661 © Fundacio Antoni Tapies/DACS, London, 2005 662, 664, 686, 687, l The Andy Warhol Foundation for the Visual Arts, Inc./ARS, NY and DACS, London 718, 728. E. Teitelman, Camden, N.J.: 96, 191t. Thorvalsden Museum, Copenhagen: 668. Toledo Museum of Art, Ohio: 540br. UNESCO, Paris: 89t, © ARS, NY and DACS, London 2005 98t 493t. Vautier Phototeque, Paris: 8. Victoria and Albert Museum, London: 43, 691. Virginia Museum of Fine Arts, Richmond Va.: 583. Wadsworth Atheneum, Hartford, Conn.: 328. Walker Art Center, Minneapolis: 235br. Walker Art Gallery, Liverpool: 729. Wallace Collection, London: 65, 220, 223, 290, 325t, 375, 398b. Wallraf-Richartz Museum, Cologne: © ARS, NY and DACS, London 2005 489. Walters Art Gallery, Baltimore: 161b, 711t, Whitney Museum of American Art, New York: 347b, © Willem de Kooning Revocable Trust/ ARS, Ny and DACS, London 2005 356. Wilhelm-Lehmbruck Museum, Duisburg: 387b. Yale University Art Gallery, New Haven: 683. York City Art gallery: 180b. Zefa, London: 145t, 173, 184, 200, 218, 234t, 295.

Private Collections: 71 (c Fernando Botero/DACS London/VAGA New York 1995), 83 (c ADAGP Paris and DACS London 1995), 168 (c ADAGP Paris and DACS London 1995), 171 (c DACS 1995), 191b (c DACS 1995), 204t (c SPADEM/ADAGP Paris and DACS Londn 1995), 311br (c Estate of Roger Hilton 1995 All rights reserved DACS 1995), 363t (ADAGP Paris and DACS London 1995), 406 (c ADAGP Paris and DACS London 1995), 411tl (c ADAGP Paris and DACS London 1995), 469t (c DACS 1995), 622b (c DACS 1995), 654 (c ARS New York and DACS London 1995), 678 (c ADAGP Paris and DACS London 1995), 706 (c ADAGP Paris and DACS London 1995)

Brown Reference Group has made every effort to trace copyright holders of the pictures used in this book. Anyone having claims to ownership not identified above is invited to contact Brown Reference Group.

Facts On File
BIOGRAPHICAL
ENCYCLOPEDIA OF ARTISTS

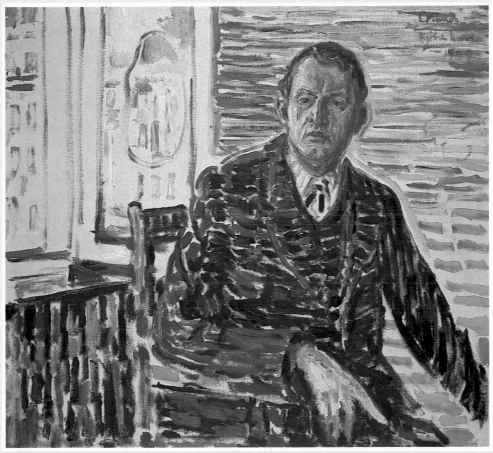

Edvard Munch: Self-portrait in Blue Suit; oil on canvas; 100×110cm (39×43in); 1909.
Bergen Art Gallery, Norway (see page 480)

VOLUME 1
Aalto, Alvar–Durand-Ruel, Paul

A

Aalto Alvar 1898–1976

Alvar Aalto was one of the most original and inventive architects of this century. Born at Kuortane in Finland, son of a forester, he studied architecture at the Helsinki Polytechnic, and in 1927 won a competition for a library at Viipuri. His second major work of the early "white" period was the Paimio Sanatorium (1929–33), a reinforced concrete building in the International style, for which he also designed the equipment (bent plywood furniture, used here for the first time).

Aalto's work was distinguished by a remarkable sensitivity to natural materials, especially to timber which featured prominently in his Finnish Pavilions at the Paris Exhibition (1937) and the New York World Fair (1939). He showed an almost instinctive approach to the creation of forms, which prevented his work from lapsing into any of the architectural clichés of his day. And he was able to integrate his architecture with landscape and with local building tradition.

After the Second World War, Aalto began building in red brick and timber. A fine example from this so-called "red" period is the Civic Center at Säynätsalo (1950–2). In the early 1950s, his work upon the redesigning of Helsinki began in earnest. Projects included the Otaniemi Polytechnic (begun 1955), and the Cultural Center (1955–8). The main building of the Institute of Technology in Otaniemi (executed 1961–4) and Finlandia house in Helsinki are among of his last major works.

Further reading. Quantrill, M. *Alvar Aalto: A Critical Study*, New York (1983).

Abbate Niccolò dell' 1509?–71

Born at Modena, west of Bologna, Niccolò dell'Abbate was a fresco painter, mainly of secular subjects. The details of his early career at Modena are obscure. He was probably familiar with Raphael's *bella maniera*, with the work of Pordenone and Correggio, and with that of Parmigianino with whose work some of his own has been confused. His affinity with the Dossi brothers is even stronger. His earliest decoration, on the facade of the Beccherie (1537; fragments are now in the Galleria Estense, Modena), introduced a characteristically piquant theme of Venetian origin, that of amorous genre, with the actors in romantic costumes. The theme reached the height of elegance in his work in the Palazzo Poggi (now the University) at Bologna, c1550–2. His second decorative commission, for the Rocco di Scandiano (c1540; now in the Galleria Estense, Modena), introduced delicately observed landscape which is developed into a sophisticated contrivance for delight. During his residence in Bologna from c1548 his already synthetic style was influenced by the refinements of contemporary Florentine figurative painting.

Niccolò's work in the Palazzo Poggi, which was to affect Bolognese painting later in the century, was left unfinished. In 1552, perhaps on the recommendation of Primaticcio, Niccolò was called to the court of Henry II of France. He was the last important Italian painter to establish himself at Fontainebleau, but most of his work there has perished.

Niccolò's activity as a decorator was directed by Primaticcio. His own style, while sympathetic to Primaticcio's, was not altogether subservient to it. He embroidered it with engaging superfluities, anticipating in spirit some of the qualities of the French Rococo. The finest surviving works from the last decade of his life are two large panoramic landscapes on canvas, filled with topographical fantasies and magical artifices of light (Louvre, Paris, and National Gallery, London).

Abd Allah 16th century

Abd Allah was court painter in Bukhara (now in Uzbekistan) under Abd al-Aziz (1540–9) and Yar Muhammad (1550–7) and may have been active until c1575. Said to have been a pupil of Mahmud, Abd Allah developed the tendency towards flat, decorative painting, increasing the emphasis on the silhouette, first seen in a *Bustan* of Sa'di of 1542 on which he collaborated with Mahmud (Gulbenkian Foundation, Lisbon) and in the *Gulistan* of Sa'di dated 1543 (Bibliothèque Nationale, Paris). His separate figure drawings show the development even more clearly.

Alvar Aalto: a lecture theater at the Institute of Technology, Otaniemi, Finland; built 1964

Nicolai Abildgaard: The wounded Philoctetes;
oil on canvas; 123×174cm (48×69in); 1774–5.
State Art Museum, Copenhagen

Abildgaard Nicolai 1743–1809

The Danish history painter and decorative
artist Nicolai Abraham Abildgaard studied
at the Royal Academy, Copenhagen
(1764–7) and then in Italy (1772–7).
Through meeting the Swedish sculptor
Johan Sergel in Rome, he was influenced
by Henry Fuseli's subject matter. In the
1780s, he carried out the decorations of
the Palace of Charlottenburg in Denmark,
where he is best known for his Neo-
classical figures and his contribution to the
applied arts, including furniture, medals,
and sculpture. Abildgaard's later paintings
were often based on the writings of
Apuleius and Terence, and, in their relaxed
elegance, they contrast with the darker,
more dramatic compositions of his earlier
years.

Abul Hasan 1589–1616

Born 1589 in the Mughal Imperial house-
hold, India, Abul Hasan was the son of the
Persian painter Aqa Riza. He started work
in the Akbar period, but attained eminence
in Jahangir's reign (1605–27). Jahangir
gave him the title Nadir-al-Zaman
("Wonder of the Age") and wrote in his
autobiography that his work was "perfect,
and his picture is one of the *chefs d'oeuvre*
of the age. At the present time he has no
rival". Specializing in allegorical portraits,
he copied and in turn was influenced by
European art, particularly in the treatment
of light and color. Natural history was
another subject area in which he excelled;
his painting *Squirrels in a Chennar Tree*
(India Office Library, London) is a marvel
of observation and sensitivity, and sur-
passes even the best works of Mansur.
Among his known works are *Portrait of
Jahangir Holding Picture of Akbar* (Musée
Guimet, Paris), *Jahangir Standing on a
Globe* (Chester Beatty Library, Dublin),
Durbar of Jahangir (c1620; Boston
Museum of Fine Arts), and several in the St
Petersburg Album (Hermitage, St Peters-
burg).

Adam Lambert Sigisbert 1700–59

Lambert Sigisbert Adam was both a sculp-
tor and the business head of a large family
workshop in Paris, together with his
brothers Nicolas Sébastien (1705–78) and
François Gérard (1710–61). Their father
was the provincial Nancy sculptor, Jacob
Sigisbert Adam (1670–1747). Lambert
Sigisbert provided the principal competi-
tion for J.B. Lemoyne the younger and
Edmé Bouchardon during the second quar-
ter of the 18th century.

After working under his father, and at
Metz, Adam arrived in Paris in 1719. He
won the *premier prix* at the Académie in
1723, then left for Rome with Bouchar-
don. Patronized there by Cardinal de
Polignac and Pope Clement XII, he was
joined by Nicolas Sébastien in 1726 and
later by François Gérard. Adam won the
competition for designing the Fontana di
Trevi, but failed to gain the commission.

In 1733, Adam returned to Paris where
his *Neptune Calming the Waves* (Louvre,
Paris) was completed in 1737. The statue's
debt to Bernini was self-evident, but its
dramatic flamboyance and vitality com-
pensate for its lack of originality. This
immensely decorative treatment also
proved ideal for the central group of
Neptune and Amphitrite, executed in lead
by the family workshop for the Basin de
Neptune at Versailles. Completed in 1740,
this exuberant group was a great success,
but the same principles as applied to the
bust of *Louis XV as Apollo* (before 1741;
terracotta; Victoria and Albert Museum,
London) result in empty grandiloquence.
Nicolas Sébastien's *Monument to Queen
Catharina Opalinska* (set up 1749, Notre-
Dame de Bon Secours, Nancy) is a finer,
less ostentatious work.

Lambert Sigisbert Adam: Neptune and Amphitrite, part of the Neptune Fountain, Versailles; lead; completed in 1740

Robert Adam: the Tapestry Room at Nostell Priory, West Yorkshire; 1767. Tapestries were added in the early 19th century

Adam family 18th century

The Adam family were Scottish architects. William Adam (1689–1748), Master Mason to the Ordnance in North Britain, was the leading architect of his generation in Scotland. His robust style resembles that of Vanbrugh (1664–1726), and is well represented at Hopetoun House, Midlothian (1723–48). Of his four sons, Robert (1728–92) and James (1730–94) were architects; and it is with the former that the family name is chiefly associated.

Robert Adam was born in Kirkcaldy. He matriculated at Edinburgh University in 1743, and was already established as an independent architect before he set off on The Grand Tour in 1754. Arriving in Rome he befriended Piranesi, made an exhaustive study of antique, Renaissance, and post-Renaissance architecture, and undertook an archaeological expedition to Spalato (now Split, in Croatia), the fruits of which were published in 1764 as *The Ruins of the Palace of the Emperor Diocletian at Spalato in Dalmatia*.

He returned to Britain in 1758, established himself in London in partnership with his brother James, and immediately began to promote a self-acclaimed "revolution" in British domestic architecture.

The new style was characterized by an intricate, linear style of interior decoration, Pompeian in origin, but also inspired by the "antique" wall frescoes of Raphael and Peruzzi. The brothers achieved a free but elegant interpretation of the Classical orders, defended as being in "the spirit" rather than in "servile imitation" of Antiquity. Most important of all, the Adam style contributed "movement", defined by the brothers as "the rise and fall, the advance and recess with other diversity of form, in the different parts of a building, so as to add greatly to the picturesque of the composition". The principle had important implications for the exterior as well as the interior of the country house; it expressed itself most fully in an imaginative use of screen columns, and a preference for spatially contrasting apartments, frequently arranged in imitation of Roman Imperial baths.

Much of the "revolution" had been anticipated by Vanbrugh and Kent, but it proved sufficiently innovatory to excite a public bored by the repetitive formalism of late Palladianism. For almost 15 years (c1760–75) Robert Adam was the most fashionable architect in Britain. Of the many buildings with which he was associated during this period, those that best represent the Adam style include Kedleston Hall in Derbyshire (c1761), Osterley Park (1763–80) and Syon House (1762–9) in Middlesex, and Luton Hoo in Bedfordshire (1766–70).

But as early as 1772, the style had produced at least one serious imitator, James Wyatt, and when, in 1774, a speculative venture decimated the family fortune, Adam's attention returned again to Scotland where the expansion of Edinburgh provided him with an opportunity to display his talents in the sphere of civic architecture. Register House (1774–92), Edinburgh University (c1789–92), and Charlotte Square (designed 1791) introduce a monumentality almost entirely lacking in the elegant sophistication of his earlier work. His new style culminated in the romantic massing of his Scottish castles, of which Culzean, Ayrshire (1777–90) is the largest and most impressive.

Further reading. Beard, G. *The Work of Robert Adam*, London (1978). Bolton, A.T. *The Architecture of Robert and James Adam* (2 vols.), London (1922). Fleming, J. *Robert Adam and his Circle in Edinburgh and Rome*, London (1978). Oresko, R. (ed.) *The Works in Architecture of Robert and James Adam*, London (1975).

Adams Robert 1917–1984

An English sculptor born in Northampton, Robert Adams studied at the Northampton School of Art in evening classes from 1933 to 1942. Between 1949 and 1960 he taught industrial design at London's Central School of Art and Design.

Adam's first mature sculptures were carvings in wood and stone based on the figure, influenced by reproductions of the works of Henry Moore and Barbara Hepworth. In 1949 he began welding vertical, open, linear constructions in various metals inspired by the Spanish sculptor Julio Gonzalez (1876–1942), and continued in this manner until 1965. Contrasts of transparency and solidity are apparent in his wood carvings and bronzes of the early 1950s, which consist of rectilinear forms and planes. His *Large Screen Form No.2* (1962) is in the Tate Gallery, London. From 1963, his major output has been uncompromisingly Abstract, juxtaposing simple planes of bronzed steel which retain openings or perforations. Since 1970, his sculptures in marble and polished bronze have introduced curved surfaces.

Aertsen Pieter 1508–75

The Flemish painter Pieter Aertsen was probably born in Amsterdam, where he originally trained. In 1535 he was registered as a master in the Antwerp guild, though he returned to Amsterdam in his later years. Aertsen was famous in his day as a painter of altarpieces, but many of these were destroyed in the widespread image-breaking in Amsterdam during the 1560s. Among the few that survive are some panels in the Royal Museum of Fine Arts at Antwerp and an *Adoration of the Magi* of 1555–60 (Rijksmuseum, Amsterdam).

Aertsen's chief historical significance lies in his contribution to the development of small Netherlandish genre subjects, (popularized by the Bruegel workshop) into life-size, monumental paintings. His scenes of peasants in everyday domestic settings give weight to foreground detail, which is usually tilted toward the spectator. The figures are also close to the picture plane in half- or three-quarter-length, as in the *Pancake Bakery* of 1560 (Boymans-van Beuningen Museum, Rotterdam). In his rather humorless treatment of the figures, Aertsen rejects the moralizing or ironic comment found in Bruegel. His style is more sculptural, and closer to the Romanist school of Flemish painting. Sometimes an ostensibly genre subject provides the foreground for a religious scene, and takes visual precedence over it. For example, in the *Butcher's Shop* (Royal Collection of Uppsala University) the carefully arranged meat and cooking utensils of the foreground frame a scene of the Flight into Egypt seen through an opening on to the landscape.

Aertsen's genre subjects anticipate similar works by several late-16th-century Italian artists, notably Annibale Carracci. Technically, his vigorous, broad brushwork places him in the Flemish tradition that was to produce such artists as Rubens and Jordaens in the 17th century.

Agam Yaacov 1928–

An Israeli painter and sculptor, Yaacov Agam was born in Rishon-le-Zion. He studied at Bezalel School of Art, Jerusalem, and from 1949 to 1951 at the School of Arts and Crafts, Zurich. He then settled in Paris, but went to teach at Harvard University during 1968–9. Entirely Abstract, Agam's paintings depend either on spectator movement or manual manipulation, devices developed in Paris during the early 1950s. His highly-structured painted reliefs—"polymorphic paintings"—in bright colors change as the spectator moves past, often from isolated color areas to grids, fusing independent themes into new relationships. Agam's "transformables" consist of linear elements in wood and metal, pivoted against plain grounds. From 1969 he has made stainless steel sculptures of repeated elements. His artistic career has included work with sound, tactile sculpture, and both interior and exterior architectural projects.

Agoracritus 5th century BC

The work of the Greek High Classical sculptor Agoracritus represents the Rich style. He emigrated from his native Paros to Athens, presumably to collaborate on the Parthenon sculptures, and became the favorite pupil of Pheidias. His style was a direct development of his master's: it shows a special interest in the sensuous renderings of richly contrasted draperies that seem almost independent of the human body. To Agoracritus and his workshop have been attributed the reliefs on the marble parapet around the temple of Athena Nike on the Acropolis (Acropolis Museum, Athens) and the sculptural decoration of the temple of Nemesis at Rhamnus.

An apocryphal tradition had it that Pheidias was the lover of Agoracritus, and had even made his pupil's two most renowned works: the colossal marble cult-statues of *Nemesis* at Rhamnus and of the *Mother of Gods* in Athens. Nemesis was the Greek goddess of retribution; appropriately, the statue was thought to have been carved in a piece of Parian marble abandoned by the Persians after their invasion of Attica. Agoracritus is reputed to have been defeated by his rival Alcamenes in a competition for a statue of Aphrodite in Athens, and subsequently to have sold his version to Rhamnus as *Nemesis*. Fragments of the statue and its elaborate base survive in the National Museum, Athens,

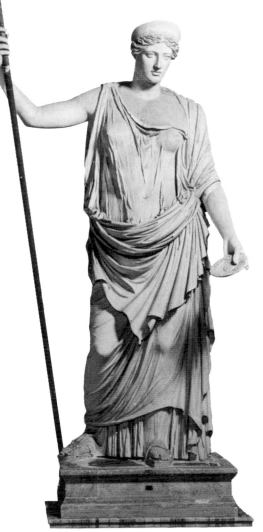

Agoracritus: statue of Hera; marble; a Roman copy of a late Hellenistic version possibly of the original of c430 BC. Vatican Museums, Rome

and in the British Museum, London, and there are many copies. The goddess was represented standing with a libation bowl in her right hand and an apple bough in her left. She was crowned with a wreath of deer and little victories. The signature of Agoracritus was inscribed on a small tablet attached to the bough. The *Mother of Gods* was described as seated on a throne holding a tambourine and flanked by lions. Another famous work of his was the bronze group of *Athena and Hades*, in Coronea, now lost.

Albani Francesco 1578–1660

Born in Bologna, Francesco Albani studied with Denys Calvaert (1540–1619), and then at the Carracci Academy, before joining Annibale Carracci's Roman studio *c*1602. He implemented Annibale's designs for frescoes in the S. Diego chapel in S. Giacomo degli Spagnuoli (1604–7). Between 1609 and 1615 he executed important fresco cycles, including painted ceilings in the Palazzo Giustiniani, Bassano di Sutri (1609), and in the Palazzo Verospi (*post* 1609). Although he adhered to Domenichino's classicism and was influenced by Raphael, his style is gentler and sweeter. He returned to Bologna in 1616, visiting Rome briefly in the 1620s. His most successful late works are small, idyllic paintings of mythological and allegorical subjects in landscape settings.

Albers Josef 1888–1976

The American painter and designer Josef Albers was born in Bottrop, Germany. He first worked in the Expressionist tradition of Erich Heckel and Karl Schmidt-Rottluff. In 1920 he entered the Bauhaus school at Weimar, where he became a teacher. After the school's closure by the Nazis in 1933, he emigrated to America. He taught first at the Black Mountain College in North Carolina (1933–49) and then at Yale, where he was Chairman of the Department of Architecture and Design

Josef Albers: Study for Series Homage to the Square: Departing in Yellow; oil on board; 76×76cm (30×30in); 1964. Tate Gallery, London

(1950–8). Albers is best known for his famous series of paintings and lithographs based on the square which exploit very subtle chromatic harmonies. *Homage to the Square*, as the series is generally known (Tate Gallery, London, and many other galleries), was a development of an interest in abstraction which went back to the 1920s. Albers' work included furniture design: he designed a pioneering bent laminated chair, intended for mass production.

Further reading. Albers, J. *Interaction of Colour*, London and New Haven (1971). Spies, W. *Josef Albers*, London (1971).

Alberti Leon Battista 1404–72

The Italian art theorist, architect, author, and diplomat Leon Battista Alberti was probably born at Genoa. He was the illegitimate son of the Florentine Lorenzo Alberti, who had been exiled in 1401. After a humanist education under Gasparino da Barzizza (1359–1431) at Padua, he studied law at the University of Bologna, entered minor orders, and became a papal civil servant. He remained in papal service for most of his life; although he lived principally in Rome, his duties took him to a number of Italian cities and possibly as far afield as the Netherlands.

Throughout his life, Alberti wrote constantly, composing plays, philosophical works, treatises, and letters on a wide variety of subjects. Between 1434 and 1436 he was in Florence (which he seems to have regarded as his home, despite his cosmopolitan life) and it is during this

Francesco Albani: The Earth, from The Four Elements; oil on canvas; diameter 180cm (71in); c1626–8. Galleria Sabauda, Turin

period that his interest in the visual arts first becomes apparent. The undated treatise *Della Statua (On Sculpture)* was probably his first essay in this field. In it, Alberti recommends the sculptor to be guided both by an observation of nature and by academic study, entailing a knowledge of proportional theory. It also contains the first known definition of sculpture as an additive process, as in clay modeling, or a subtractive one, as in carving.

His better-known and more ambitious *Della Pittura (On Painting)* was written in Latin in 1435 and translated into Italian the following year. Divided into three books, it deals with the technicalities of "one-point" perspective, the theory of human proportions, composition, and the use of color, and considers the nature of beauty and the behavior appropriate to an artist. When compared with earlier treatises, *Della Pittura* emerges as a fundamentally new departure: the first Rennaissance treatise on art. Although partly a humanist utopia, replete with numerous Classical references, the treatise was also a working handbook. As Alberti's dedication to Brunelleschi and his references to Masaccio, Donatello, Luca della Robbia, and Ghiberti imply, the book was a codification of current Florentine artistic practice. In certain respects, particularly in his observations on aerial perspective, Alberti's theory went further and was actually in advance of contemporary practice. His request, at the beginning of Book One, that he be judged as a painter rather than as a mathematician, is the only surviving evidence that Alberti himself painted. Although no surviving works by his hand have been identified, there seems to be little reason to doubt this claim.

Alberti seems to have turned to architecture in the 1440s. His treatise *De Re Aedificatoria (On Architecture)* was substantially complete in 1452. Drawing upon a critical reading of Vitruvius and a first-hand antiquarian knowledge of Classical remains, he put forward the first coherent theory of the use of the five orders since Antiquity, relating their use to different classes of building. He also expounded a lucid theory of architectural beauty, dependent upon the harmonic relationship between certain fixed proportions, mitigated by ornamental forms. As the first comprehensive treatise on Renaissance architecture, this book is in many respects comparable with the earlier *Della Pittura*, although it was more a work of original

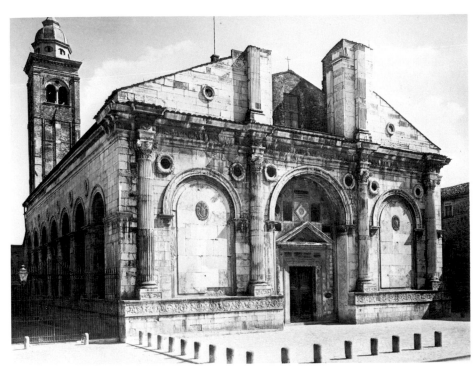

Leon Battista Alberti: the exterior of the Tempio Malatestiano (church of S. Francesco), Rimini; conversion begun c1450 but never completed

research, and was more influential.

By this time Alberti appears to have been employed as a papal consultant on town planning and the conservation of Classical remains. His first known architectural commission was undertaken c1450 for Sigismondo Malatesta of Rimini. This prince, who was as steeped in Classical culture as Alberti himself, wished to convert the Gothic church of S. Francesco in Rimini into a splendid mausoleum for himself and his court. Faced with this unprepossessing task, Alberti's solution was both ingenious and simple. Retaining the interior with minor decorative modifications, he enclosed the old fabric within an architectural shell. The facade was recast as a temple front incorporating a triumphal facade motif, and the sides were masked with a massive series of piers, framing deep, round-head niches. The walls were taken up to a sufficient height to conceal the church within. It seems that the crossing was to have been crowned with a huge semicircular dome, though this was never built. Despite its incomplete state, the church stands as an austere evocation of Roman Antiquity, such as had never before been seen in the Quattrocento.

Shortly afterwards, Alberti was called upon to complete the facade of the church of S. Maria Novella in Florence. Incor-

porating the extant Gothic arcading of the lower story, Alberti monumentalized the facade with the addition of a great arched central doorway, and unified it with side pilasters and a high attic zone. As at Rimini, the end result is a triumphal arch motif. In the upper story, he retained the old circular window and surrounded it with a visually dominating square element. Decorated with pilasters and surmounted by a pediment, this formed an applied temple front. The difference in height between this story and the aisles was effectively masked by a pair of great volutes. At S. Maria Novella, Alberti had formulated a lucidly structured Classical facade, working within the traditional Tuscan formal repertoire dictated by the existing building. The true genius of his design is that it appears as a convincing aesthetic whole and in no way as a compromise.

Alberti's last two church designs were for new buildings, commissioned by Ludovico Gonzaga of Mantua. The first, S. Sebastiano, was begun in 1460 but never properly completed. It was conceived as a central cube spanned by an enormous domical vault, contained within a Greek cross. Three arms ended in apses, the fourth led out to a pedimented facade with a broken entablature. The main story was elevated upon a crypt, giving a strange emphasis to the facade. This would prob-

ably have been masked by a mighty stairway, firmly anchoring the facade to street level, but it was never built. The second church S. Andrea, was begun in 1470 and completed according to Alberti's plans after his death. On a Latin cross plan, the church was enclosed with a great coffered barrel vault. This coffering was echoed in the chapels that lined the nave, in the entrance porch that serves as a centerpiece to the facade, and in the remarkable window niche that stands high above the majestic main pediment and its giant order. Both churches were of an extremely unconventional design, although they reveal a deliberate application of proportional theory, and the use of a wide range of antique sources, closely related to the theories in *De Re Aedificatiora*.

In addition to these works, Alberti designed the Palazzo Rucellai and the tiny shrine of the Holy Sepulcher (Rucellai Chapel) in the adjoining church of S. Pancrazio. His total oeuvre is small, but highly significant. With his unparalleled knowledge of antique architecture, Alberti set out to transcend his models. In so doing, and in providing a literary explanation of his aims and ideas, he provided a secure basis for the subsequent development of the classical style in European architecture. When his other literary works, in particular his treatises on sculpture and painting, are added to this achievement, his contribution to Renaissance culture justly appears immense. Alberti is often regarded as the embodiment of the *Uomo Universale*, but the range and quality of his activities are not typical of his own or any other age.

Further reading. Alberti, L.B. (trans. and ed. Grayson, C.) *On Painting and On Sculpture*, London (1972). Borsi, F. *Leon Battista Alberti*, Oxford (1977). Grafton, A. *Leon Battista Alberti: Master Builder of the Italian Renaissance*, New York (2002). Heydenreich, L. and Lotz, W. *Architecture in Italy: 1400–1600*, Harmondsworth (1974). Wittkower, R. *Architectural Principles in the Age of Humanism*, 4th ed., London (1988).

Albright Ivan 1897–1983

The American painter Ivan Le Lorraine Albright was born in Harvey, Illinois. He studied architecture at the University of Illinois and later studied art both in Europe (the École des Beaux-Arts, Nantes) and America (the Art Institute of Chicago). The dominant influence on his style, though, was his father, a painter who had studied under Thomas Eakins. Albright's works show an obsession with the relentless decay wrought by time, their mood one of the poignancy of unfulfilled ambitions and missed opportunities—the work which established his career, *That Which I Should Have Done I Did Not Do* (1931–41; Art Institute of Chicago), shows a withered hand reaching for a funeral wreath hanging on a weathered door. His painstaking attention to minute details of fabrics and wrinkled skin, finely etched against a dark background, creates images of hallucinatory intensity, as in one of his best-known portraits, *Fleeting Time Thou Hast Left Me Old* (1929–30; Metropolitan Museum of Art, New York).

Alcamenes 5th Century BC

The Greek High Classical sculptor Alcamenes came from Athens or Lemnos, and was a member of the Attic School. He is said to have won a competition against Agoracritus for a statue of Aphrodite commissioned by Athens. Medieval tradition believed he had been a rival of Pheidias for the bronze *Athena Promachos*. He was one of the strongest artistic personalities of his time; the Greeks attributed to him works ranging in date from 480 BC to the end of the 5th century BC. It is possible that he worked on the pediments of the temple of Zeus at Olympia (468–456 BC) as a young man, and later collaborated in the Parthenon.

Alcamenes executed a number of cult-statues for the temples of Athens, notably an ivory and gold *Dionysos* and a bronze group of *Athena and Hephaestus* (Hephaestus' club foot disguised by falling drapery). He also carved an *Ares*, now tentatively identified as the prototype of the *Ares Borghese* (Louvre, Paris). His statue of Aphrodite, which used to stand in the "Gardens" (a suburb of Athens), was much praised for its lovely hands, while the finishing touches were ascribed to Pheidias.

Some of Alcamenes' sculptures seem to have embodied archaistic features along with innovations, following a trend of the period. He created the much imitated type of *Hecate*, with three bodies in archaistic dress set around a pillar, which stood on the bastion of the Athena Nike temple on the Acropolis. Inscribed copies of a herm by Alcamenes have been found in Ephesus and Pergamon.

Aleijadinho: the Prophet Hosea, a detail of one of the 12 prophets carved for the church of Bom Jesus de Matozinhos, Congonhas do Campo, Brazil; stone; 1800–5

Aleijadinho 1738–1814

The great Brazilian sculptor and architect António Francisco Lisboa is best known by his nickname, "O Aleijadinho" or "the little cripple". He was a mulatto, son of the Portuguese architect Manuel Francisco Lisboa.

Aleijadinho was the most original exponent of the Rococo in the Americas; he worked in the province of Minas Gerais, which in the 18th century was booming with the gold and diamond rush. He designed, built, and decorated the church of São Francisco, Ouro Preto (1766–94), a rare example of a building in a completely unified style. His sculptural work includes processional images of the Passion (1797–99) and 12 remarkable, dynamic, open-air statues of the prophets (1800–5) at Bom Jesus de Matozinhos, Congonhas do Campo. His simple and dignified Rococo interiors use straight columns and refined ornament.

Algardi Alessandro 1598–1654

The Italian sculptor Alessandro Algardi was born in Bologna. For one brought up in a city without a local stone an inclination towards modeling seems natural and was to prove as fundamental to his art as was the support of Bolognese patrons to his career.

Algardi studied with the painter Lodovico Carracci as well as with the sculptor Giulio Cesare Conventi, with

whom he collaborated on the stucco statues of the four patron saints of Bologna in the Oratory of S. Maria della Vita. At the age of 19 he went to Mantua, where he worked for the Duke and became familiar with antique works of art placed in his care as well as with the paintings of Giulio Romano (c1499–1546).

In 1625, after a brief visit to Venice, he arrived in Rome where artistic life was dominated by Bernini. For many years Algardi earned his living by restoring antiques and making small models which were cast either in bronze or in precious metals. His first major commission was for the tomb of Pope Leo XI in St Peter's (1634–44), followed by that for the marble *St Philip Neri* in the sacristy of the Vallicella (1635?–46). Some of his rivals in Rome doubted his ability to work in marble. To silence them he carved *Sleep* (1635–6) in the harder medium of black marble (Museo e Galleria Borghese, Rome). Meanwhile, for the high altar of the Spada church of S. Paolo in Bologna, he produced the two-figure marble group of the *Beheading of St Paul.*

With the election of Innocent X in 1644 and the disgrace of Bernini, Algardi had a chance to exercise his talents more extensively. He carved the high-relief altarpiece of *Leo and Attila* in St Peter's (1646–53), the altar group of *St Nicholas of Tolentino* (begun 1651; S. Nicola da Tolentino, Rome); and made the full-scale model for the unexecuted altar relief of the *Miracle of St Agnes* (Vallicella, Rome). He also designed the delicate stucco reliefs of the Villa Pamphili which were to prove so influential for the Neoclassicists of Robert Adam's generation.

Throughout his life, Algardi produced numerous portrait busts, many of them for tombs. They are marked by a feeling for solidity and a sensitivity to surface texture and detail, and are imbued with a straightforward naturalism and life-like veracity.

As the principal rival to Bernini, Algardi is often regarded as a classicist, and indeed his major sculptures in white marble are comparatively detached and undramatic, avoiding the more spectacular effects of the Baroque. But he displays an inventive talent in his decorative ornamentation.

Further reading. Pope-Hennessy, J. *Italian High Renaissance and Baroque Sculpture,* London (1963). Wittkower, R. *Art and Architecture in Italy, 1600–1750,* London (1958).

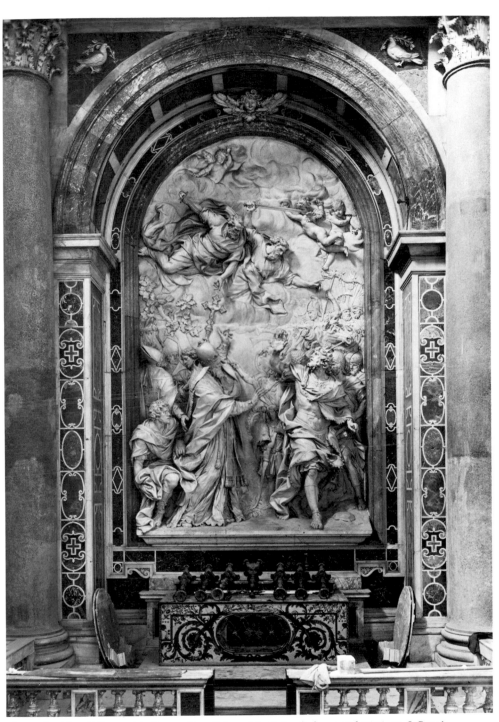

Alessandro Algardi: Leo and Attila; marble relief; model 1646, relief executed 1646–53. St Peter's, Vatican, Rome

Allston Washington 1779–1843

Washington Allston was the first major American Romantic landscape painter. Born near Charleston, Virginia, he went to London in 1801 to study with Benjamin West. From 1803 to 1808 he traveled in Europe with a fellow American, John Vanderlyn, studying particularly in the Louvre, then filled with spoils from Napoleon's wars. His taste ranged from Claude Lorrain to Salvator Rosa to Fuseli to Turner; the work of the latter may have influenced Allston's *Rising of a Thunderstorm at Sea* (1804; Museum of Fine Arts, Boston). Allston returned to America in 1818, tried and failed to become a history painter, and instead became one of the precursors of the Hudson River School.

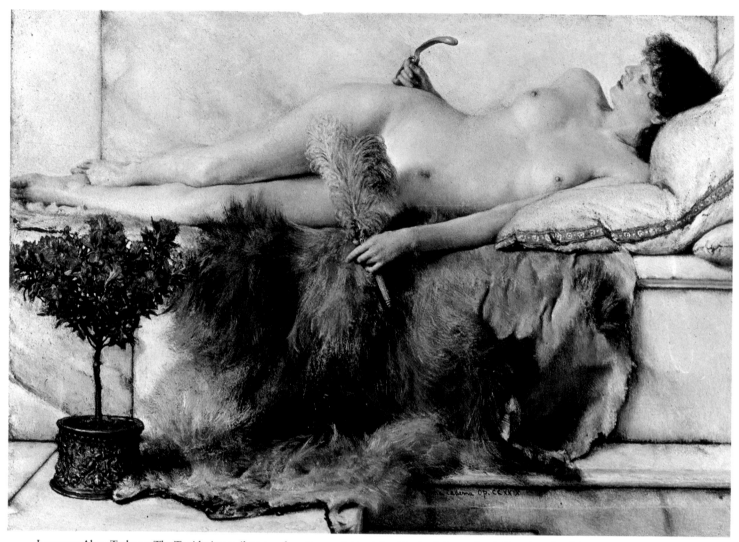

Lawrence Alma-Tadema: The Tepidarium; oil on panel; 24×33cm (9×13in); 1881. Lady Lever Art Gallery, Port Sunlight

Alma-Tadema Lawrence
1836–1912

The painter Sir Lawrence Alma-Tadema was born in Holland, but became a naturalized Englishman. Trained in Antwerp, he began by painting imitation Dutch 17th-century works, then turned to subjects from Merovingian history such as *Venantius Fortunatus* (1862; Dordrecht Museum). Later he made increasing use of subjects from Antiquity (occasionally Egyptian but predominantly Classical) for scenes of historical and domestic genre. Technically brilliant, they depicted modern sentiment in both generalized and historical settings. An example of the first is *There He Is* painted in 1875 (Walker Art Gallery, Liverpool), and of the second, *The Roman Flower Market* of 1868 (City of Manchester Art Gallery). Some works like *A Favourite Custom* (1909; Tate Gallery, London) were mildly pornographic, but all were very popular, and their allure should not obscure the artist's thoughtful skill.

Almonacid Sebastián de
c1460–1526

Sebastián de Almonacid was born in Torrijos, near Toledo, and became a significant figure in the transition to the Renaissance in Spanish sculpture. His four major works are the cloister door of Segovia Cathedral (completed by 1487), the tomb of the Condestable Álvaro de Luna and his wife, the high altar in Toledo Cathedral (by 1505), and a monument to Cardinal Alonso Carrillo de Acuña (*ob.* 1482) in Alcalá de Henares. It is probably wrong to attribute to him the famous *Doncel de Sigüenza* in Sigüenza Cathedral. His style is of Flemish derivation, possibly acquired from Flemish-trained craftsmen in Toledo.

Altdorfer Albrecht c1480–1538

A German painter born at Regensburg, Albrecht Altdorfer was the son of a painter of illuminated manuscripts. Among his earliest surviving dated works are drawings of 1506, one of which copies the dancing muses in the Italian print after the *Parnassus* of Mantegna. Other Italian influences on his style included engravings after the architecture of Bramante. His painting of architectural space remained empirical, however: the *Nativity of the Virgin* (1520–5; Alte Pinakothek, Munich) takes place in a church setting, but only the ring of joyful angels gives credence to an otherwise fanciful grouping of piers and side-chapels.

Altdorfer's major contribution to the history of European painting is his powerful imaginative vision of landscape. Two journeys along the Danube, c1503–5 and

1511, had a decisive impact on his style and brought him into contact with the Danube school of landscape art. Early works such as the *St John the Evangelist and St John the Baptist* (*c*1510; Alte Pinakothek, Munich) show a dense, untamed landscape which dominates the figures. Perhaps in response to the influence of Cranach, Altdorfer increased the size and scope of his work by *c*1515. His figures become more slender. In 1518 he completed a major altarpiece for St Florian, near Linz. In the *Resurrection of Christ* panel (still at St Florian) the cavernous setting and brightly colored figures, illuminated by Christ's presence, are set before a landscape with a stormy sky. Here he seems to have captured the vigorous and highly charged emotional style of Cranach's early religious paintings.

The dominance of nature over man is a permanent feature of the artist's work. In the early *Nativity of Christ* (*c*1515; Staatliche Museen, Berlin) vegetation invades the cracks of a rambling, decaying brick and wood structure where the Holy Family kneel cowed in a corner. The sharp contrast of light and dark is accentuated by the stippled effect of highlights on the brickwork and foliage. In the masterpiece of his later years, the *Battle of Alexander* (1529; Alte Pinakothek, Munich), the field of battle is seen from a great height with the landscape stretching away to an infinite blue distance where sky and mountainous horizon meet. The artist avoids confusion in the multitude of figures by showing the clear direction the battle is taking. The outcome is shown by the cord hanging from the inscription above the scene, which points to Alexander, and by the sun setting on the side of the eventual victors. In less ambitious paintings, Altdorfer created some of the first pure landscapes in Northern art, including the small *Landscape with a Footbridge* (*c*1518–20; National Gallery, London), where only a distant church suggests the presence of man.

Altdorfer's output was small and he painted little in his last years when his duties as a city councillor of Regensburg took precedence. In 1535 he traveled to Vienna to explain the city's religious views to the authorities. He died at Regensburg.

Further reading. Benesch, O. *Der Maler Albrecht Altdorfer*, Vienna (1940). Ruhmer, E. *Albrecht Altdorfer*, Munich (1965). Winzinger, F. (ed.) *Albrecht Altdorfer: Graphik*, Munich (1963).

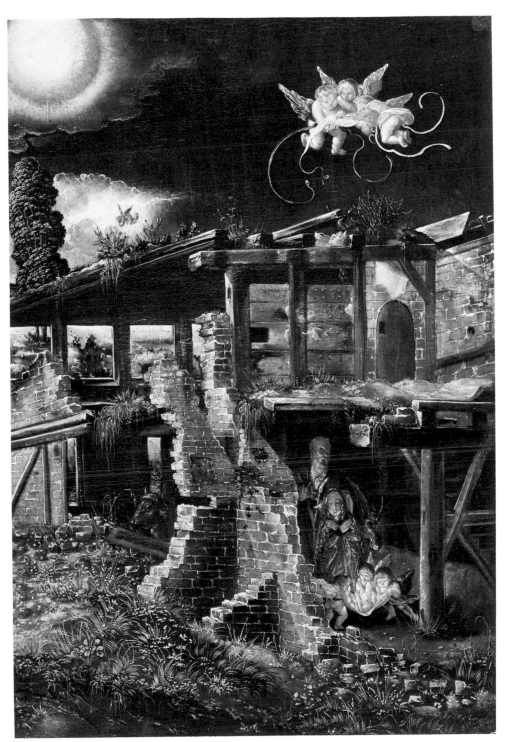

Albrecht Altdorfer: Nativity of Christ; limewood panel; 36×25cm (14×10in); *c*1515. Staatliche Museen, Berlin

Altichiero *fl.* 1369–*c*1390

Altichiero and Avanzo are the two names associated with the fresco decoration of the chapel of St James in the Santo, Padua, and the Oratory of St George nearby. Recently discovered documents show, however, that only Altichiero should be credited with the work. Altichiero is a distinct artistic personality about whom much is known. Avanzo, on the other hand, could be one of several painters of that name, and remains a shadowy figure.

He should now be excluded from Altichiero's work.

Altichiero, a Veronese painter probably trained in Tuscany, was one of the most gifted and interesting north-Italian painters of his time. He is documented in Verona in 1369, but his major surviving Veronese fresco, in the Cavalli Chapel, S. Anastasia, should probably be dated to the late 1380s. Between these dates he was probably working in Padua. He was paid for painting the Chapel of St James in 1379 and the Oratory of St George in 1384.

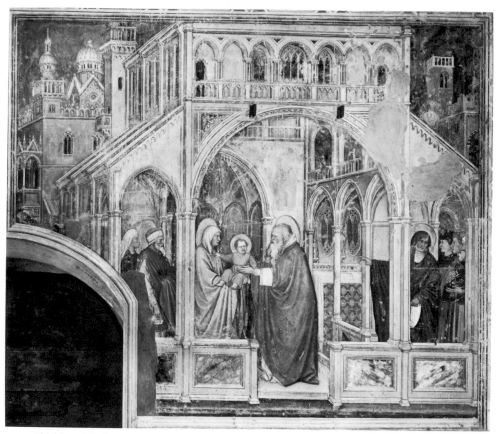

Altichiero: The Presentation in the Temple; fresco; c1384. Oratory of St George, Padua

Every possible surface of the Chapel of St James is painted, creating a rich decorative impression when combined with the white and red marble paterns of the floor and facade, and the sculptures of Andriolo dei Santi. The *Crucifixions* here and in the Oratory are powerfully naturalistic and full of realistic detail. Altichiero was profoundly influenced by Giotto, but his scenes are characterized by their diffuse, anecdotal realism, and bewilderingly sophisticated architecture, rather than by Giottesque dramatic power.

Altichiero was remarkable for his scholarly interest in Classical Antiquity, and it is easy to see in his work interests similar to those of the artists of the early Renaissance, including Donatello and Mantegna, who were active in Padua barely a generation or so after his death.

Amaral Tarsila do 1896–1973

The Brazilian painter and sculptor Tarsila do Amaral was born in Sao Paulo. She studied there with Pedro Alexandrino in 1917, and at the Académie Julian in Paris from 1920. She later met Léger, Lhôte, and Gleizes, who oriented her towards a classical Cubism. On returning to Brazil in 1924 she was active not only as a painter but in promoting modern art. She exhibited in Paris and Sao Paulo. A fine colorist, she adapted Cubism to create bold, simple forms, using local Brazilian subject matter. Increasingly modernist from the 1940s, she sent works to the First and Second Sao Paulo Biennales, and at the Seventh Biennale in 1963 she exhibited 51 works in a special room. Her famous painting *EFBG* (1924) is in the Museum of Modern Art, Sao Paulo.

Amasis Painter c560–525 BC

Amasis was an Athenian-trained potter of black-figure vases, and was probably the father of the potter Kleophrades. He signs eight complete vases "made by Amasis". These, and more than 90 other pieces, were painted by one man, probably by Amasis himself, but in the absence of a painter's signature, we must call him the Amasis Painter. "Amasis" is a Hellenization of the common Egyptian name "Ahmosis" and there are additional

reasons for believing that he was born in Egypt: he introduced to Athens the so-called alabastron—a clay equivalent of an Egyptian shape made of alabaster; and his rival Exekias named two black men on his *amphorae* "Amasis" and "Amasos".

He enjoyed a long career and had at every stage of his work a favorite shape. His earliest vases are panel *amphorae* decorated with centripetally arranged figures. A fine *amphora* in New York (Metropolitan Museum) shows a warrior putting on his greaves, and facing him, a robust lady holding his spear and *aryballos*. Surrounding the group, like parentheses within parentheses, are a pair of perky youths, reminiscent of contemporary *kouroi*. The lustrous black figures are pleasantly taut, their incised features precise and elegant.

A slightly later *amphora* in Berlin, (Antikenabteilung) showing the *Introduction of Herakles to Olympus*, illustrates the painter's early development. The composition has fewer figures than before and the center of attention (Zeus) is moved to the edge of the panel. The picture has a warm, friendly atmosphere: Zeus, sporting informal dress, chats with Hermes; next come Athena and a nude youth with an impatient Herakles between them. For Amasis, the august introduction becomes a casual family get-together, complete with two restless dogs.

His small vases, later than early *amphorae*, are of the same high quality and reveal the work of a gifted miniaturist with an engaging flair for decoration. The shapes are exquisitely fine and painted with neat, elastic figures, nude or dressed in robes with delicate fringes and colorful embroidery. Some unusual scenes occur on his small vases—a wedding procession by torchlight (Metropolitan Museum, New York), women preparing and weaving wool (Metropolitan Museum, New York)—as well as some quite ordinary scenes: winged youths and horsemen (National Museum, Athens), heated combat (Museum Haaretz, Tel Aviv), and Dionysos with his entourage (Cabinet des Médailles, Paris).

Amasis loved to paint satyrs and maenads and in contrast to the sober Exekias, Dionysos was his favorite god. A later *amphora* in the Antikenmuseum, Basel, shows Amasis in his element: great bearded satyrs vintaging, with Dionysos as supervisor. A very hairy and bottom-heavy satyr stands in a large bowl, trampling the slippery grapes and holding on to a loop

above for balance. The new wine rushes out of the bowl and into a pot sunk in the ground. Facing him, a satyr pours water into the bowl and helps himself to some wine from a mug. Dionysos holds out his *kantharos* for a fill while the satyr behind him pipes a tune in his ear. To the right, a spirited couple rush forward in strangling embrace. The face, arms, and feet of the maenad are outlined in black paint (as are a number of his other late females): an indication of his acknowledged role in the formation of the red-figure technique.

His latest pots are neck-*amphorae*, decorated with two or three large figures and spirals winding under the handles. The neck-*amphora* with Achilles receiving armor from Thetis (Museum of Fine Arts, Boston) typifies his late career: the old jollity has almost vanished, yielding to a lofty atmosphere of heroic figures full of grandeur and even a hint of gravity. But these late, serious pictures seem more a matter of inspiration from his colleague Exekias than a natural expression of Amasis' own personality. Exekias and his figures seem touched by something deep within, perhaps the thought of death; while Amasis and his figures seem touched by nothing deeper than the joy of being alive.

Amigoni Jacopo 1682–1752

Jacopo Amigoni was born in Naples, but when very young moved to Venice. There, influenced by Giordano, Ricci, and Tiepolo, he developed a charming Rococo style and became internationally successful. He spent about 12 years in the service of the Bavarian court and painted frescoes in Nymphenburg, Ottobeuren, and Schlessheim. From 1729 to 1739 he lived in England, where he painted portraits and executed decorative commissions. He returned to Venice in 1739, and from 1747 spent his final years as court painter in Madrid where he worked at the palaces of Aranjuez and Buen Retiro.

Amman Jost 1539–91

The Swiss draftsman Jost Amman was born in Zurich. In 1560 he settled at Nuremberg where he took citizenship in 1577. His output of more than 540 graphic works is a valuable record of contemporary German life and customs, as in *Fireworks at Nuremburg*, a print of 1570. His book illustrations are especially im-portant. They include works on heraldry, costume, animals, and Roman history, and the Frankfurt Bible of 1564 which was to be a major influence on the young Rubens. His illustrations served as designs for a range of applied arts, including jewelry.

Ammanati Bartolomeo 1511–92

Born near Florence, the sculptor Bartolomeo Ammanati trained in the workshop of Pisa Cathedral, where his first independent work is found (1536). Next he worked with Giovanni Angelo Montorsoli (1507?–63), a follower of Michelangelo, on a tomb for Naples. Later he went to Urbino. In 1540 he tried to make his mark in Florence with a private commission for a tomb, but it was sabotaged by the jealous Baccio Bandinelli, leaving only the effigy and the good allegorical group *Victory* (both Museo Nazionale, Florence), closely based on Michelangelo's projected groups for his tomb of Pope Julius II. Ammanati retreated to Venice where he was helped and influenced by his fellow-countryman Jacopo Sansovino. His principal sculptures in north Italy were Michelangelesque allegories for the palace and tomb of the humanist M.M. Benavides in Padua. On the election of Pope Julius III (1550) Ammanati moved to Rome and executed, in a chapel designed by Vasari under the supervision of Michelangelo, the sculpture on the paired monuments to members of

Jacopo Amigoni: Juno receives the Head of Argus; oil on canvas; 1730–2. Moor Park, Hertfordshire

Jost Amman: detail of The Arrival of the Turkish Ambassadors in Frankfurt; woodcut; 1562. Ashmolean Museum, Oxford

the Papal family (Del Monte) in S. Pietro in Montorio: these effigies and allegories are among Ammanati's masterpieces. Moving with Vasari to Florence, he entered the service of the Medici Dukes, producing a spectacular *Fountain of Juno* with six over-life-size marble figures mounted on a rainbow for the Hall of the Palazzo Vecchio (components now in the Museo Nazionale, Florence). Ammanati's best-known sculpture is the *Fountain of Neptune* in the Piazza della Signoria, Florence (*c*1560–75): the central figure was carved out of a colossal block of marble (height approximately 30 ft, 9 m.), already

begun by Bandinelli, which inhibited Ammanati's treatment. More successful are the surrounding bronze figures, modeled and cast under his supervision. These figures and his *Ops*, a female nude statuette, which Ammanati contributed to the *Studiolo* of Francesco de' Medici (1572–3), epitomize his style, which is distantly derived from Michelangelo, but concentrates on grace of form at the expense of emotion. Ammanati also rivaled Vasari as a Mannerist architect, with his amazingly bold but capricious rustication in the courtyard of the Pitti Palace (1558–70) and his graceful bridge of S. Trinità (1567–70).

Anderson Laurie 1947–

The American Performance artist Laurie Anderson was born in Wayne, Illinois. Trained as a classical violinist, she studied art history at Barnard College (B.A., 1969) and sculpture at Columbia University (M.F.A., 1972).

Anderson first pursued Performance art in 1972, when she staged a "symphony" of honking car horns in a public square. In the 1970s she added increasingly elaborate layers of visual and textual elements to her performances, reaching a crescendo with the epic multimedia show *United States* (1983), which incorporated music, spoken word, film, and animation. Divided into four parts ("Transportation," "Politics," "Money," and "Love"), *United States* touched on Post-Modern themes that would occupy Anderson throughout her career. Anderson took this and other shows on the road and also released albums and films. In 1981 she achieved a surprise pop-music hit with her recording "O Superman." At the turn of the 21st century, Anderson has continued to record and to stage multimedia events.

Andokides Painter *fl. c*530–510 BC

The unknown artist who painted four of the vases signed by the potter Andokides is referred to simply as "the Andokides Painter". He worked in Athens and may well have been the first to use the red-figure technique regularly. He decorated mainly large *amphorae*. On several of these and on a cup in the Museo Archeologico Nazionale, Palermo (Inv. V. 650), one side was painted in the black-figure technique. There is considerable doubt as to whether the same artist painted both sides, and it is generally held that the black-figure side was painted by the Lysippides Painter and that both were pupils of the vase-painter Exekias. These "bilingual" vases seem to be the Andokides Painter's earlier works. On them he struggled with the new technique, still using large splashes of added red and elaborately patterned drapery in the black-figure manner. He was hesitant in overlapping his figures and for the internal markings used the solid relief line, where black-figure artists had used incision and later red-figure artists were to use the diluted glaze line.

On his later works he no longer collaborated with the Lysippides Painter. His subjects are taken from myth and the realm of Dionysos, but he also loved scenes

of daily life, in which he reflected the refinement of Pisistratid Athens. An *amphora* in the Antikenabteilung, Berlin (Inv. 2159), shows on one side Herakles struggling with Apollo for the Delphic tripod, while Athena and Artemis watch from the wings—a scene which no doubt symbolized some historical attempt to take over control of Apollo's oracle at Delphi. The other side shows two pairs of wrestlers and a trainer. The style is now much more mannered, faces are rather too pretty, gestures too refined, and drapery rich but lifeless. In the wrestlers, however, we can perhaps see the beginnings of an interest in new poses and actions which were to grip the "Pioneers" of the next generation— Euphronios, Euthymides, and Phintias.

André Carl 1935–

The American Minimalist sculptor and poet Carl André was born in Quincy, Massachusetts. He studied with Patrick Morgan at Phillips Academy, Andover from 1951 to 1953. During the years 1955–6 he served as an intelligence analyst in the U.S. army and worked for the Pennsylvania Railroad from 1960 to 1964.

Influenced by Brancusi, André's first major sculptures in carved wood date from 1958–9, when he was working in Frank Stella's New York studio. A series of stacked sculptures in modular units of wood, styrofoam, and concrete followed, until 1966 when he deployed eight groups of 120 bricks directly on a gallery floor in rectangular formats: *Equivalents VIII* (Tate Gallery, London). He has since emphasized the horizontal ground plane in sculptures made from square metal plates, timber and other materials.

Further reading. *Carl Andre: Works on Land*, Leuven, Belg. (2001).

Andrea da Firenze *fl.* 1343–77

The work of Andrea da Firenze (Andrea Bonaiuti) is typical of much contemporaneous Florentine painting which was influenced by Sienese art. As a result, Andrea's work is full of elegant decorative qualities of line and color, and the space in

Bartolomeo Ammanati: Victory; marble; height 262cm (103in); 1540. Museo Nazionale, Florence

his pictures is often imaginatively unrealistic.

His major surviving works are two fresco decorations: the frescoes in the Spanish Chapel in the Dominican church of S. Maria Novella, Florence, and three scenes from *The Life of S. Ranieri* in the Camposanto, Pisa. In 1365 he was given two years to finish the Spanish Chapel frescoes, which may have been started in the previous decade. The subject matter owes much to *The Mirror of True Penitence*, a devotional work by the painter Passavanti who was a friend of the merchant who paid for the building and its frescoes, Buonamico di Lapo Guidalotti. On the Chapel's left-hand wall is the *Apotheosis*

of *St Thomas Aquinas*, on the right, an allegory of the *Road to Salvation*, on the altar wall the *Road to Calvary*, *Crucifixion*, and *Descent into Limbo*. The vault contains the *Navicella*, *Resurrection*, *Pentecost*, and *Ascension*; while on the entrance wall are scenes from the *Life of St Peter Martyr*. Perhaps the most famous of these is the *Road to Salvation*, with intriguing details including a view of the Cathedral at Florence (Andrea was on its building advisory committee in 1366), a group of delightful dancing girls, and Christian sheep protected by black and white dogs representing Dominicans (a pun on the Latin *domini canes*, "the dogs of the Lord".)

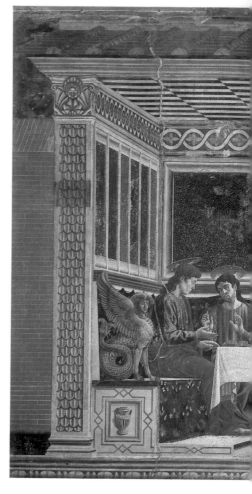

Andrea da Firenze: detail of the Church Militant and Triumphant; fresco; c1365. Spanish Chapel, S. Maria Novella, Florence

Andrea was paid in 1377 for the S. Ranieri frescoes in Pisa. Although little else can be connected with him, in his surviving frescoes Andrea shows himself to be more strongly influenced than any of his Florentine contemporaries by Sienese artists, especially by Simone Martini and the Lorenzetti brothers.

Andrea del Castagno *fl.* 1440–57

The Italian painter Andrea del Castagno was one of the most capable Florentine artists of the generation following Masaccio.

The identity of Castagno's master is not known, but his association with Uccello is an important factor the results of which are seen throughout his career. His first recorded works were the portraits of the rebels hanged after the Battle of Anghiari (the *Impiccati*) painted c1440 on the exterior of the Bargello, now the Museo Nazionale, Florence, which gave Castagno a reputation for the vivid portrayal of the

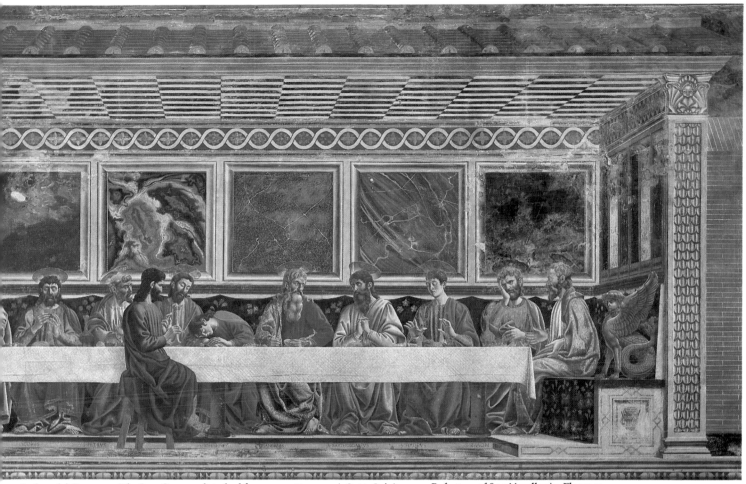

Andrea del Castagno: The Last Supper; detached fresco; 470×975cm (185×384in); 1447. Refectory of Sant'Apollonia, Florence

human figure. Following a visit to Venice *c*1442, where he signed frescoes in the church of S. Zaccaria, Andrea embarked upon a prolific series of works for buildings in and around Florence, which ended with his death from the plague in 1457.

An important group of Passion scenes in the monastery of S. Apollonia (Florence) now forms the core of a museum of Castagno's works (the Cenacolo di Sant'-Apollonia). These paintings reveal his ability to portray movement and drama in the scientific depiction of space. The emotional atmosphere depends to a great extent on his use of vivid color contrasts.

His later works, such as the frescoes of *Famous Men and Women*, formerly in the Villa Carducci, Legnaia (*c*1450; now in the Uffizi, Florence) show an emotion and linear quality akin to Donatello's works of the 1440s. These features are also seen in the equestrian portrait of Niccolò da Tolentino (1455–6, Florence Cathedral) painted as a pendant to Uccello's Hawkwood fresco of 1436

Andrea del Sarto 1486–1530

Andrea del Sarto was born Andrea d'Agnolo in Florence where he trained first with Piero di Cosimo and then Raffaellino del Garbo. This experience left its mark on the figures and the setting of the *c*1509 *Pietà* (Museo e Galleria Borghese, Rome). It also influenced both the style of the landscapes and the small scale of the actors in the series of frescoes of 1509–10 in SS. Annunziata, Florence, *Scenes from the Life of S. Filippo Benizzi*.

The painter's early work reveals his study of early-16th-century Florentine painting by Leonardo, Fra Bartolommeo, and Raphael. The work of these three painters probably suggested the psychological energy of the Christ Child in the small *Madonna* of 1509 (Galleria Nazionale d'Arte Antica, Rome). A similar energy is found in Andrea's *Marriage of St Catherine* (Gemäldegalerie Alte Meister, Dresden) of *c*1512. There the excitement pervades both the angels who hold back

Andrea del Sarto: Self-portrait (?); panel; 86×67cm (34×26in). National Gallery of Scotland, Edinburgh

the Baldacchino and the saints who are more involved in the action than are those of Fra Bartolommeo. The figure of St John the Baptist at the bottom of the panel has been positioned to create not just the usual pyramidal grouping but a diamond that echoes the form of Andrea's signature. Other altars of this decade continue the inventive approach to the compositional principles introduced by Leonardo. The *Madonna of the Harpies* (Uffizi, Florence) of 1517 retains the symmetrical balance achieved by Fra Bartolommeo, but the twisting poses of the saints are contrasted and their balletic movement looks forward to Mannerism. The sculptural quality that Andrea achieves is the result of his collaboration with Jacopo Sansovino, who prepared wax *modelli* for him.

Andrea's development as a frescoist was slower. Although the Benizzi frescoes show his appreciation of Leonardo's *Adoration of the Magi* (1481; Uffizi, Florence), in their spacing of the figures they also look back to the Quattrocento. He only fully breaks with this heritage in the *Birth of the Virgin* of 1514 (SS. Annunziata, Florence) whose bulky figures are comparable to those of Leonardo's London cartoon (c1494–5; National Gallery). In the following year he returned to the cloister of the Scalzo, where he had already painted a *Baptism* some five years earlier, to continue the grisaille frescoes of scenes from the life of St John the Baptist. The pyramidal *Preaching* of 1515 draws upon Dürer's *Passion* cycle, including many bizarre details among the spectators, and later frescoes also draw upon Roman sources. The *Capture* of 1517 probably reflects Michelangelo's near-contemporary design of the *Flagellation* in S. Pietro in Montorio for Sebastiano del Piombo. The final frescoes in the series (the *Feast of Herod* and the *Visitation*) show Andrea's new feeling for the space within which the figures move, which may have been suggested by Raphael's Stanza d'Eliodoro in the Vatican.

This development is matched in the late altars from the 1520s, where his interest in both Raphael and Michelangelo leads to a new elegance. Elegance never became an end in itself, as in the work of Pontormo (1494–1557); the energy with which the saints react and are composed into schemes that derive from Leonardo and Fra Bartolommeo mark Andrea del Sarto as the last representative (in painting) of the High Renaissance.

Further reading. Comandé, G.B. *L'Opera di Andrea del Sarto*, Palermo (1952). Freedberg, S.J. *Andrea del Sarto* (2 vols.), Cambridge, Mass. (1963). Shearman, J. *Andrea del Sarto* (2 vols.), Oxford (1965).

Angelico Fra c1400–55

Fra Angelico was the popular name given to the major painter of the Florentine Renaissance, Fra Giovanni da Fiesole. His real name was Guido di Pietro, and he was born in the Mugello a decade later than has been traditionally thought. Still a layman in 1417, he is not mentioned as Fra Giovanni until 1423.

The young Angelico was proposed to a Florentine church guild in 1417 by Battista di Biagio Sanguigni, an illuminator of antiphonaries. His familiarity with a miniature-painting milieu probably included Lorenzo Monaco's school in the Camaldolese convent of S. Maria degli Angeli. This would explain the peculiar translucence and brilliance of his tempera style. That Angelico himself worked as a miniaturist is testified by Vasari; his hand has now been detected in at least one missal at S. Marco (no. 558; c1428–30) and in a single leaf of the *Crucifixion* at S. Trinità (c1435–40).

By 1418 he was already known as a panel painter. His early repertoire—conventional Gothic triptychs with *predelle* below—represents a synthesis of Sienese-influenced tradition (Lorenzo Monaco), International Gothic intrusion (Gentile da Fabriano), and Florentine innovation (Masaccio). A comparison between his first major surviving altarpiece (c1424–5; S. Domenico, Fiesole) with the later *San Pietro Martire* triptych (1429; Museo di San Marco, Florence) shows that Masaccio's influence was decisive.

By the 1430s Angelico had arrived at his own indubitable style. We recognize it in the *Annunciation* in the Museo Diocesano, Cortona (c1432). Here, volume reminiscent of Masaccio has been chastened into something more slender, but no less spacious, as in the proportions of the arcaded loggia which accommodates the Virgin and the vermilion-clad angel before her.

To the same period belongs the Tabernacle commissioned by the Arte dei Linaiuoli, the guild of flax workers (1432–3; Museo di San Marco). Derived from the Madonna of Humility as evolved by Lorenzo Monaco and Gentile da Fabriano, the type of the Linaiuoli Madonna was to appear in

a whole series of devotional Madonnas of the utmost gentleness which Angelico and his workshop produced during the 1430s. Variants occur in the two polyptychs painted for Cortona (1435–6) and Perugia (1437), and in the central panel of a dismantled polyptych now in the Uffizi, Florence (c1440).

Aided by an increasingly productive workshop, Angelico, during these years, was working in the secluded Dominican Observant house at S. Domenico in Fiesole. He was, despite growing fame in the outside world, preeminently a conventual painter—"most gentle and temperate, living chastely, removed from the cares of the world", said Vasari—and it is this "medieval" reclusion which has led to him being considered as somehow reactionary. On the contrary: the works Angelico produced during the later 1430s were fundamentally innovative in composition, color harmony, perspective, portraiture, and landscape. Progress in all these directions gained momentum in the decade following the removal of the Dominican Observants from Fiesole to the former Silvestrine convent of S. Marco in Florence (1436). Cosimo de' Medici, who instigated its reconstruction, commissioned Angelico to paint a major new altarpiece for the church's high altar (1438). The central panel (Museo di San Marco, Florence)—an enthroned Madonna, encircled by a meditative entourage of angels and saints—is full of novel features: the prototype of the typically Renaissance *sacra conversazione*.

The panel is much damaged, and to form an impression of Angelico's tempera style at its most brilliant we must consider the *Deposition* he painted for the Strozzi Chapel in S. Trinità (c1442–5; Museo di San Marco, Florence). Originally commissioned from Lorenzo Monaco (who completed the three pinnacles on top), the limitations of the panel's tripartite shape have been resolved by Angelico's unified figural composition. Unlike Rogier van der Weyden's almost contemporary *Deposition* in the Prado, Madrid, Angelico's version has been given a spatial setting of unparalleled depth. It is as if a door has been flung open on the confined schemata of Florentine panel-painting and we have emerged into the real world. Its flowers are before us. And as we advance into the picture space, a majestic panorama unfolds before us: Jerusalem on one side, dominated by its ziggurat-like Temple of Sol-

omon, and on the other, the hills of Tuscany receding, with the most fastidious gradations of light, into haziness. Angelico shows equal lucidity in his variation of color: delicate mutations preponderantly of pink, vermilion, lilac, and blue reinforce the spatial construction.

It is above all for his frescoes in S. Marco (the majority *c*1440–5) that Angelico is remembered. They fall into two groups: those for communal contemplation (of which the *Annunciation*, at the top of the stairs leading to the upper corridor, is again set in an arcaded loggia), and those for private meditation in the individual cells (among these the *Noli Me Tangere*, the *Coronation of the Virgin*, and the *Transfiguration* are especially beautiful).

At the call of Pope Eugenius IV, Angelico left Florence for Rome (*c*1445), where, in the Vatican Palace, he decorated the Cappella del Sacramento with scenes from the Life of Christ. These were destroyed by Paul III in the following century.

On Eugenius IV's death, Pope Nicholas V commissioned Angelico to decorate his own small private chapel in the Vatican. It survives intact (1447–8). Angelico's frescoes—richer in style than those in S. Marco—form an ensemble. Narrative scenes in magnificent architectural settings, from the lives of St Stephen (upper lunettes) and St Lawrence (lower rectangles), are flanked by eight full-length Doctors of the Church (on the lateral pilasters). On the ceiling are the Four Evangelists; the embrasures of the two windows are decorated with alternating prophet heads and rosettes; the lower wall surfaces are painted with a green textile design. Documents show that Angelico did not produce this alone: in May 1447 his workshop included Benozzo Gozzoli and four other assistants. But the speed at which he worked, despite studio assistance, is remarkable. In the summer of 1447 he painted frescoes on part of the ceiling of the Capella di S. Brizio in Orvieto Cathedral. In 1449 he began, and apparently completed, the decoration of the study of Pope Nicholas V (lost).

Angelico probably left Rome at the end of 1449. In the following year he succeeded his brother as Prior of S. Domenico in Fiesole. After serving his term, he returned to Rome, where he died in February 1455. He is buried in the Dominican Church of S. Maria sopra Minerva.

Further reading. Baldini, U. *L'opera Completa dell'Angelico*, Milan (1970). Hood, W. *Fra Angelico: San Marco, Florence*, New York (1995). Morachiello, P. *Fra Angelico: The San Marco Frescoes*, London (1996). Pope-Hennessy, J. *Fra Angelico*, London (1974).

Fra Angelico: The Annunciation; fresco; 230×321cm (91×126in); c1440 or c1449. Upper corridor of S. Marco, Florence

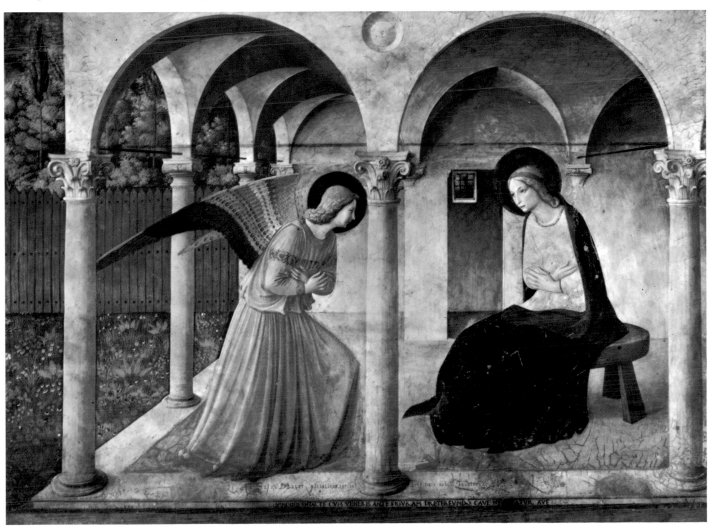

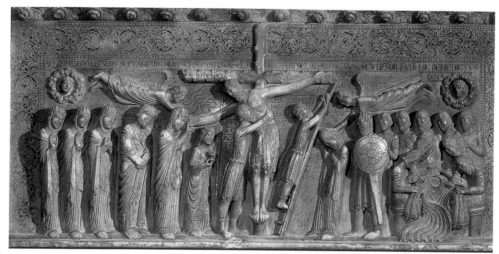

Benedetto Antelami: Deposition from the Cross; marble relief; 1178. Parma Cathedral

Antelami Benedetto *fl. c1175–1225*

Benedetto Antelami was an Italian architect and sculptor during the period of transition from Romanesque to Gothic. His first known work is the relief, probably an altar frontal or part of a screen, showing the *Deposition from the Cross*, in Parma Cathedral, signed and dated 1178. It is a worthy descendant of the art of Wiligelmo of Modena; austere in form and expression but also indebted to French art emanating from Chartres.

Antelami and his assistants worked at Borgo S. Donnino (richly decorated facade, c1185) and at the Abbey of S. Andrea at Vercelli (1219–24), but it is the baptistery of Parma Cathedral that is considered his masterpiece. This massive, octagonal structure was started in 1196 in an essentially Romanesque style, with some Gothic features such as ribbed vaulting. Of the three deeply recessed portals, one is devoted to the Virgin and another to the Last Judgment, the iconography derived from France. Surprisingly, there are no column-figures here, as could be expected in works whose inconography and style both show links with French art. The portals are flanked by niches with large statues; there is a decorative frieze encircling the building and numerous reliefs.

It is often said that the style of Antelami's sculptural works originated in Provence (St-Gilles, Arles), but the Provençal art of the second half of the 12th century is in itself very Italianate. It is far more likely that Antelami grew up in the traditions of Italian art, itself so strongly rooted in the art of the Roman past; he may have made one or even two journeys to France, and seen there the early Gothic churches, and also absorbed some ideas from the emerging proto-Gothic style in sculpture.

Anthemius and Isidore
6th century AD

Anthemius and Isidore were Byzantine *mechanikoi*—architects with a grounding in mathematics. They designed and built S. Sophia in Constantinople (532–7) for the Emperor Justinian, apparently producing plans for this extraordinary structure in only 39 days, after the destruction of its predecessor during the Nika Riot (532). Procopius of Gaza in *The Buildings* (c560) mentions them again only in connection with a dam at Dara in Mesopotamia. The 6th-century historian Agathias, however, implies that Anthemius was responsible for other buildings; later Byzantine tradition associated the church of the Holy Apostles in Constantinople with him. Anthemius, from Tralles, wrote a treatise on reflectors. Isidore, from Miletus, published works of the mathematician Archimedes (*ob.* 212 BC) and wrote a commentary on a 3rd-century AD work on vaulting. His nephew Isidore the Younger rebuilt the dome of S. Sophia after it collapsed in 558.

Antonello da Messina *c1430–79*

Antonello da Messina was the only major painter of the 15th century who originated in the south of Italy. Today he is considered important mainly for his brief stay in Venice (1475–6), and also as the most direct link in Italy with the art of Jan van Eyck (c1390–1441).

According to Summonte, writing in 1524,

Antonello was the pupil of Colantonio in Naples, but by 1456 he had settled in Messina. His earliest dated work, the *Salvator Mundi* (1465; National Gallery, London) shows a strong Flemish influence both in format and in the oil technique employed: it is clear that by this date he had been in contact with Flemish art. This could have occurred either through direct contact with Flemish artists (we know that Antonello returned home from a "long journey" in 1460) or through his familiarity with the Flemish paintings recorded at an early date in Neapolitan collections.

The group of early works still in museums in southern Italy consists chiefly of altarpieces of the old-fashioned polyptych type. He made a great advance in the altarpiece for S. Cassiano, Venice, *The Madonna and Saints*, the most important work of his Venetian stay. Only three fragments survived its partial destruction in the 17th century (Kunsthistorisches Museum, Vienna); but Johannes Wilde's scholarly reconstruction of its original appearance shows that here, probably for the first time in Venice, the architecture of the single arched frame was extended into the picture to act as the setting for the figures surrounding the Virgin's throne. The brilliant clarity of the lighting seen in the fragments from this painting is also found in Antonello's portraits, many of which were executed during the Venetian stay (for example *Il Condottiere*, 1475; Louvre, Paris; and the *Portrait of a Man*, 1476; Museo Civico, Turin).

Apelles *4th century BC*

The Greek painter Apelles was trained in Sicyon and Ephesus, and worked mainly in the east Greek area during the second half of the 4th century BC. He was best known for his portraits of Alexander the Great, and it was said that Alexander was a regular visitor to his studio and would allow no other artist to paint him. No works survive, but Pliny describes his style and career in some detail, attributing to him grace and subtlety. These qualities can be detected in certain Roman wall-paintings which may copy or derive from his work (panels by him were known to have been brought to Rome).

Antonello da Messina: Portrait of a Man; oil on poplar panel; 36×25cm (14×10in); c1475. National Gallery, London

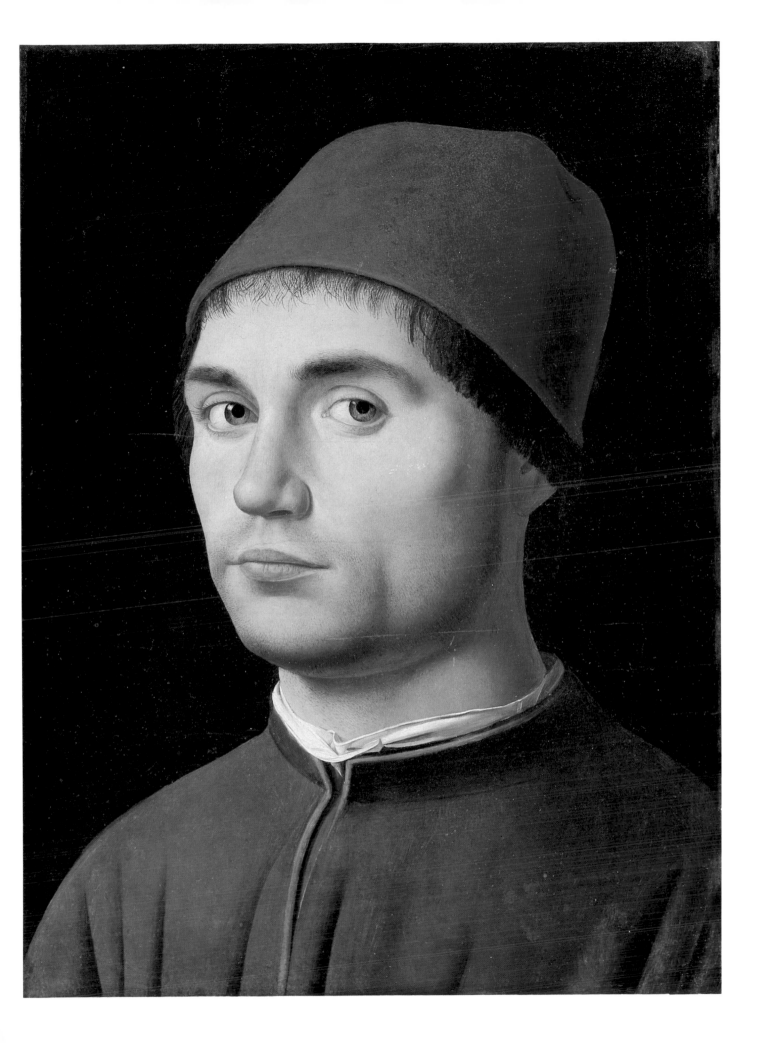

His most famous works were an *Aphrodite* rising from the sea, wringing out her hair, on the island of Cos; *Alexander* with a thunderbolt, in the Temple of Artemis at Ephesus; and a number of personifications, for example, *War*. By this period extreme realism in painting was readily achieved: Apelles was said to have painted a horse so realistically that live horses neighed at it. A famous anecdote tells how Apelles visited the rival painter Protogenes; finding he was away, Apelles left as identification a very fine line drawn across a panel. Protogenes on his return drew an even finer one over it; at which Apelles, with ultimate finesse, split the two. He was also alleged to have fallen in love with and been awarded Alexander's favorite, Pankaspe, after painting her in the nude. Apelles was charged with political conspiracy against Ptolemy. He celebrated his eventual acquittal by creating a famous painting of Calumny with other allegorical figures. The story inspired Botticelli's *Calumny of Apelles*(c1495; Uffizi, Florence).

Apollinaire Guillaume 1880–1918

The French poet, author, and art critic Guillaume Apollinaire was the originator of the terms "Orphism" and "Surrealism". Born in Rome, he first came to Paris in 1898; between 1912 and his death he was one of the most influential creative figures among Parisian painters and poets. A friend of Matisse, Picasso, Delaunay, and Duchamp, Apollinaire was one of the first to acclaim these artists. His seminal influence was later acknowledged by the Dadaists and the Surrealists. His most important critical writing was probably the collected essays *Les Peintres Cubistes* (1913). Among Apollinaire's own works, the lyrics *Bestiaire ou Cortège d'Orphée* (1911), *Alcools* (1913), and *Calligrammes* (1918) typify his originality.

Apollodorus 5th century BC

An Athenian painter of the later 5th century BC, little is known of Apollodorus and no original work by him survives, but it is clear that he was an artist of influence and importance. He was said to have first developed *skiagraphia* or shading. There had earlier been an unsystematic use of shading in painting (on vases and no doubt also on panels), but the essentially linear effect of Greek painting and drawing allowed little realistic rendering of figures or

limbs in the round until the principles of shading were observed and understood. This was an important step in the progress to the *trompe-l'oeil* painting of the 4th century BC.

Appel Karel 1921–

The Dutch expressionist Karel Appel studied at the Royal Academy of Fine Arts, Amsterdam (1940–3). In 1948 he helped to create the Experimental Group in Amsterdam, which later formed the basis of CoBrA. He moved to Paris in 1950 and has lived in France ever since.

During the late 1940s and early 1950s, Appel captured the postwar mood of reconstruction and fresh beginnings by trying to see things with the eyes of a child. Like Jean Dubuffet (1901–85), Appel painted monumental graffiti-like images of people, animals, and primitive carvings, in which influences of late works by Klee, Miró, and Nolde can be detected. About 1953 Appel's style became more painterly; the figures formed part of a violently swirling mass of bright paint, like mythical creatures welling up from the unconscious. This surrealist-automatic approach gave way in the 1970s to a more decorative style.

Aqa Riza fl. 1585–1625

The Persian painter Aqa Riza was the father of the famous Abul Hasan. He trained under Muhammadi of Herat, then served the Mughal Emperor Jahangir (1605–27) from c1589, when the latter was still Prince Selim. Jahangir did not regard him as highly as Abul Hasan or Mansur. Riza introduced the new Persian style which prevailed during the first part of the reign of Shah Abbas (1587–1629). He was liked for his charming drawings and colors rather than for original works. His paintings and drawings are to be found in the British Museum *Anwar-i-Suhayli*, in the Museum of Fine Arts, Boston, and on borders of the Jahangir Album (Gulistan Palace Library, Teheran).

Archermus 6th century BC

A Greek sculptor of the Archaic period, from Chios, Archermus was the father of the artists Bupalus and Athenis, famous for their caricature of the satiric poet Hipponax. Archermus was reputedly the first to represent Victory with wings. The base

of a votive sculpture from Delos signed by Archermus as sculptor and Micciades as dedicant is associated with a marble flying Victory found near it (mid 6th century BC; National Museum, Athens). Archermus' signature also survives on a fluted column base of the dedication (now lost) of Iphidice on the Acropolis of Athens.

Archipenko Alexander 1887–1964

The Russian-born sculptor Alexander Archipenko worked in Paris from 1908 to 1921. He emigrated to America in 1923, and lived there until his death.

Archipenko was one of the leading sculptors mixing in Cubist circles from c1912. In his sculpture he explored some of Cubism's ideas: the interaction of space and form, the separation of colors from forms, and the use of new materials.

Walking Woman (1912; Denver Art Museum) was one of the first pierced-form sculptures, and turned conventional form: space ratios upside down—the densest solids of torso and head are voids, penetrated by space and light. In *Médrano* (1915; Solomon R. Guggenheim Museum, New York) he improvised elements of tin, glass, wood and oil-cloth—some painted, some transparent—into a circus figure standing on a colored base, against a colored screen. It is a whimsical puppet-like image: an inventive, shifting dialogue of flat and curved planes and lines.

In his later works, the *Archipentura* (1924) and "light modulators" (1946 onwards; internally lit Plexiglass constructions) he continued to explore color, light, movement, and space. Archipenko was influential as a teacher in various American universities and at his sculpture school in New York from 1937 to 1964.

Arcimboldo Giuseppe c1530–93

Born in Milan, Giuseppe Arcimboldo was court painter in Prague from 1562 to 1587 when he returned to his birthplace. He worked in Milan Cathedral (1549–58), designed tapestries for Como (1558), and was a successful portrait painter. He is best known for his Mannerist fantasies of monstrous human faces of figures made from fish, flowers, fruit, and commonplace objects. Some are allegorical representations, containing subtle moral allusions, of *The Four Seasons* or *The Four Elements*. Others are personifications; *The Librarian* (Collection of Baron von Essen, Skoklos-

Kenneth Armitage: Family Going for a Walk; bronze; 20×27 ×14cm (8×11×6in); c 1951. Albright-Knox Art Gallery, Buffalo

and less frontal and he began single figures which during the period 1960–3 were extremely abstract; later figures had flanges and funnels for limbs. In 1965, his series based on the legend of the Yugoslavian town Skadar introduced a flat frontal plane with protruding limbs and breasts. During the late 1960s he used fiberglass and aluminum plate for casting smooth, doll-like figures, either in silhouette or rounded joined to tables, plinths, and screens, with drawn or silkscreened details.

Further reading. Lynton, N. *Art in Progress: Kenneth Armitage*, London (1962). Spencer, C. *Kenneth Armitage*, London (1973).

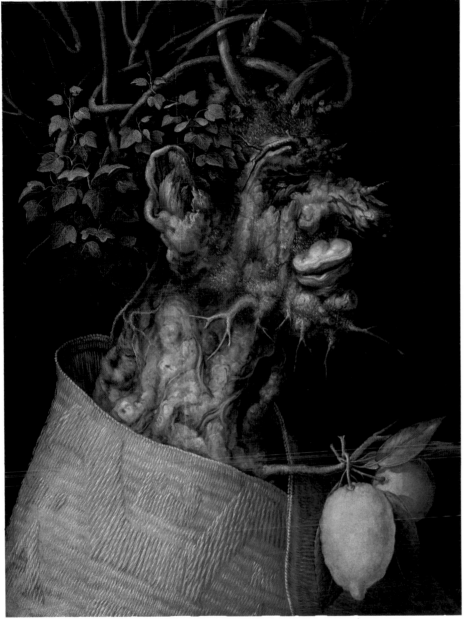

Giuseppe Arcimboldo: Winter; limewood panel; 67×51cm (26×20in); 1563. Kunsthistorisches Museum, Vienna

ter, Sweden) is constructed entirely of books. Several pictures he painted for Rudolf II are now in Vienna (Kunst-historisches Museum) and a complete Seasons series, 1573, at the Louvre, Paris.

Arman Augustin 1928–

The French/American Artist Augustin Fernandez Arman studied in Nice and at the École du Louvre in Paris. In 1946 he met Yves Klein. In 1960 the group *Nouveaux-Réalistes* formally came into being. Arman was a co-founder and signatory of their manifesto, along with Yves Klein, Claude Pascal, and Pierre Restany. Their aim was to develop "new perceptive approaches of the real". In Arman's work this took the shape of accumulations of everyday objects (for example toy automobiles or the

contents of a friend's wastebasket), packed into a box or block of transparent plastic (*Garbage I*, 1960; assemblage; Kaiser Wilhelm Museum, Krefeld). He moved to the U.S.A. in 1963 and became a citizen of the United States.

Armitage Kenneth 1916–2002

An English sculptor born in Leeds, Kenneth Armitage studied at Leeds College of Art (1934-7) and the Slade School of Fine Art, London (1937-9). He taught at the Bath Academy of Art (1946-56), and was Gregory Fellow at Leeds University from 1953 to 1955. The stone carvings of his earlier years led in 1946 to flat groups of small limbed figures in plaster with metal armatures, cast in bronze. In the mid 1950s the groups became more massive

Arnolfo di Cambio *fl.* 1264–?1302

The Italian sculptor and architect Arnolfo di Cambio was a pupil of Nicola Pisano. He almost certainly worked with Pisano on the shrine of St Dominic in the church of S. Domenico at Bologna (1264-7) and definitely assisted him in the construction of the Siena Cathedral pulpit (1265-8). Arnolfo's next works were in Rome: the tomb of Cardinal Annibaldi della Molara in S. Giovanni in Laterano (1276), which has been ascribed to him on stylistic grounds, and the seated statue of Charles of Anjou (Palazzo dei Conservatori, Rome) probably completed by 1277.

His tomb of Cardinal de Braye (*ob.*1282) in S. Domenico at Orvieto is a key work in the history of sepulchral monuments. It has been reconstructed and is no longer

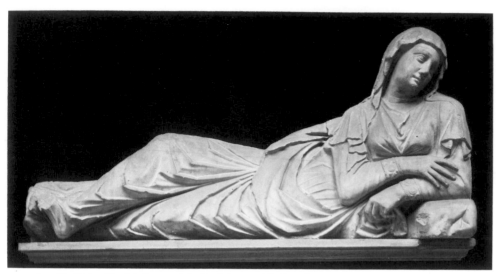

Arnolfo di Cambio: Madonna of the Nativity; marble; length 174cm (69in); c1296–1302. Museo dell'Opera del Duomo, Florence

crowned by its original Gothic canopy which showed the body of the dead man on a bier and the Madonna and Child above—a pattern followed and developed by Giovanni Pisano, Tino di Camaino, and others during the next century.

Arnolfo designed altar canopies (*ciboria*) for two Roman churches: S. Paolo fuori le Mura (1285) and S. Cecilia in Trastevere (1293). On the evidence of a lost inscription, the tomb of Boniface VIII (Grotte Vaticane, Rome) has been ascribed to him. Documented as master mason of Florence Cathedral in 1300, he was probably responsible for the design of the western bays of the nave and the lower part of the facade, for which he made a number of sculptures. Also attributed to him, on stylistic grounds, are S. Croce and the church of the Badia, both in Florence.

The fragmentary nature of his surviving work and the lack of documentary evidence make it difficult to draw conclusions about his artistic personality. However, works that are definitely attributable to Arnolfo show a highly original mind. Restrained in organization, he was receptive to and skillful in the manipulation of antique, Romanesque, and Gothic styles.

Arp Jean 1887–1966

The Alsatian sculptor, painter, and poet Jean (or Hans) Arp was a leading member of the Dada movement and was later associated with the Surrealists. He was born in Strasbourg, and between 1904 and 1907 studied in art schools there and in Weimar and Paris. In 1908 he returned to

his family in Weggis in Switzerland, and devoted himself to studying literature, philosophy, and modern art. By 1910 he had painted his first abstract pictures. He visited Kandinsky in Munich in 1911, and was briefly associated with the *Blaue Reiter* group. On the eve of the First World War, he traveled to Paris, where he remained for several months, associating with Apollinaire, Modigliani, Picasso, and Delaunay. He was deeply impressed by Delaunay's "Orphic" paintings and by recent developments in Cubist painting and collage. Regarded in Paris as an enemy alien, Arp decided to return to neutral Switzerland, and settled in Zurich in 1915.

In Zurich, Arp met his future wife, the dancer and painter Sophie Taeuber (1889–1943). From this time on, they often collaborated on projects and were influenced by each other's work; in general, however, Taeuber's work was more geometrical and abstract than Arp's. Together they joined the group in Hugo Ball's *Cabaret Voltaire* in 1916, helped to engineer the transformation into Dada, and figured prominently in all the Dada activities in Zurich. In 1919 they joined Max Ernst in Cologne and Arp collaborated with him on Dada events there.

In 1914 Arp had made his first reliefs, creating them from superimposed layers of wood. In some, like *Stag* (1914; private collection), his mature style, which he later described as "concretion", is already present in its essentials. Its characteristics are simplified, asymmetrical, organic forms that are abstracted, but still suggestive of natural forms, spontaneous, flowing, unbroken

contours, clarity and economy of execution, freedom of composition, a sense of movement, and lightness of mood.

Sharing the Dadas' disrespect for the European artistic heritage, Arp experimented with diverse materials and techniques, employing automatic procedures in his poems and allowing chance to intervene in the creation of some of his collages. Stressing the importance of the life of the unconscious, he believed that a new and pure kind of beauty was released when the artist relaxed his conscious control. He felt that an abstract art employing the vocabulary of primitive, organic forms could have a regenerative function and was, indeed, equivalent to nature itself. Works such as *Forest* (1916; private collection) realize this ideal.

In 1925, Arp settled in Meudon, outside Paris, and, except for the war years, lived there for the rest of his life. He became involved with the Surrealists, without sacrificing his independence. He later joined two abstract-oriented groups—Cercle et Carré ("Circle and Square") in 1930, *Abstraction-Création* in 1932—while maintaining contact with Surrealism. The most important development in his art at this time was his decision, in 1930, to translate his ideas into three-dimensional, freestand-

Jean Arp: Portrait of Tristan Tzara; relief of painted wood; 51×50×2cm (20×20×1in); 1916. On loan to the Musée d'Art et d'Histoire, Geneva

ing sculptures; these were even richer than his reliefs in the multiplicity of suggestions of plant, animal, and human life.

Like Brancusi, whose work has much in common with his, Arp has had a profound and widespread influence, particularly in the 1920s on such Surrealist painters as Miró, Tanguy, and Dali, and on the later generation of Moore and Hepworth.

Further reading. Arp, H. (ed. Jean, M.; trans, Neugroschel, J.) *Collected French Writings*, London (1973). Read, H. *Arp*, London (1968). Seuphor, M. *Arp*, Paris (1964).

Asam family 17th and 18th centuries

The Asams were the dominant artistic personalities in the creation of the Bavarian Baroque style. The family included Hans Georg Asam (1649–1711) and his sons Cosmas Damian (1686–1739) and Egid Quirin (1692–1750). Hans Georg's importance lies principally in the two extensive cycles of frescoes he painted in the abbey churches of Benediktbeuern (1683–1686) and Tegernsee (1688–94). Trained in Munich, Hans Georg had later traveled to northern Italy and on his return became Bavaria's first significant fresco-painter.

In the execution of his last frescoes, decorating the pilgrimage church at Freystadt in the Upper Palatinate (1708), Hans Georg was assisted by the young Cosmas Damian. After Georg's death the brothers were sent by their patron, Abbot Quirin Millon of Tegernsee, to study in Rome. Cosmas Damian studied under the painter Pierleone Ghezzi and in 1713 won a prize at the Accademia di San Luca; the nature of Egid Quirin's activities is not known. Cosmas Damian's earliest known frescoes in Germany, in the abbey church of Ensdorf, are signed and dated 1714; Egid Quirin presumably continued his training, now with Andreas Faistenberger in Munich, until 1716.

In 1714 Cosmas Damian received his first architectural commission, for the rebuilding of the abbey church of Weltenburg (consecrated 1716, major decorations completed by 1740). From the middle of the 1720s Cosmas Damian was mainly active as a fresco-painter, with Egid Quirin working as a sculptor and *stuccatore*, but both occasionally worked as architects. The huge frescoes executed by Cosmas Damian in the abbey church of Weingarten (1718–20) are a landmark in the development of fresco painting in southern Ger-

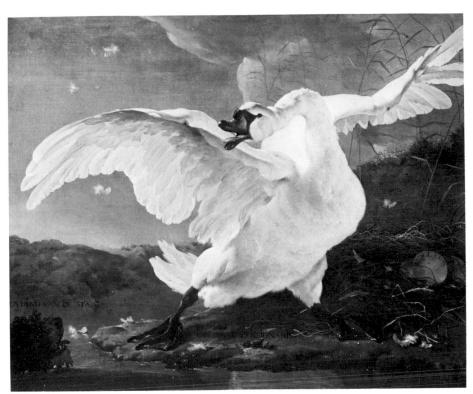

Jan Asselijn: The Threatened Swan; oil on canvas; 144×171cm (57×67in). Rijksmuseum, Amsterdam

many. The strongly Berninesque high altars at Weltenburg and the nearby abbey church of Rohr (both 1721–3) reveal the full maturity of the Bavarian Baroque.

The Asam brothers worked as a team for the decoration of the abbey church of Aldersbach (1720), St Jakobi in Innsbruck (1722–3), Freising Cathedral (1724), and above all the great abbey church of Einsiedeln in Switzerland (1724–6). Cosmas Damian also undertook independent fresco commissions further afield, including Kladruby and Břevnov in Bohemia (mid 1720s). Attempts have been made to identify a development towards the Rococo in the work of the Asams. Rococo forms are undoubtedly included in their decorative repertoire, for example in Freising Cathedral, but the spirit remains firmly Baroque. Vast illusionistic frescoes by Cosmas Damian in the abbey church of Legnickie Pole in Silesia (1733) and in S. Maria de Victoria at Ingolstadt (1734) recall the late Baroque vault decorations of Rome. The Asams collaborated earlier on the immensely rich interior of the abbey church of Osterhoven (1728–32), but their interpretation of the Baroque *Gesamtkunstwerk* reaches its climax in the Nepomukkirche which the brothers designed and built for their own use in Munich (1733–46).

Asselijn Jan 1610–52

Jan Asselijn was a Dutch painter whose career was dominated by the experience of Italian landscape, and especially its interpretation in the Arcadian paintings of Claude Lorrain (1600–82). Asselijn, like Claude, rearranged natural forms on his canvas to achieve pictorial balance or effects of distance. In this and the suffusion of his scenes with golden light he is distinct from the naturalistic painters of his native landscape. His paintings frequently depict the Campagna di Roma and its ancient ruins, and they often include beggars, peasants, and other genre motifs. He also produced more exotic, semi-imaginary pictures of ports and harbors on the Mediterranean littoral. His most famous animal painting, *The Threatened Swan*, his *Italian Landscape*, and *View in an Italian Port* are in the Rijksmuseum, Amsterdam.

Attavante degli Attavanti
1452–c1525

Attavante degli Attavanti was one of the major Florentine miniaturists of the Renaissance. The undeserved obscurity into which he soon sank—the fate of nearly all artists whose works are consigned to manuscript—is exemplified in the garbled

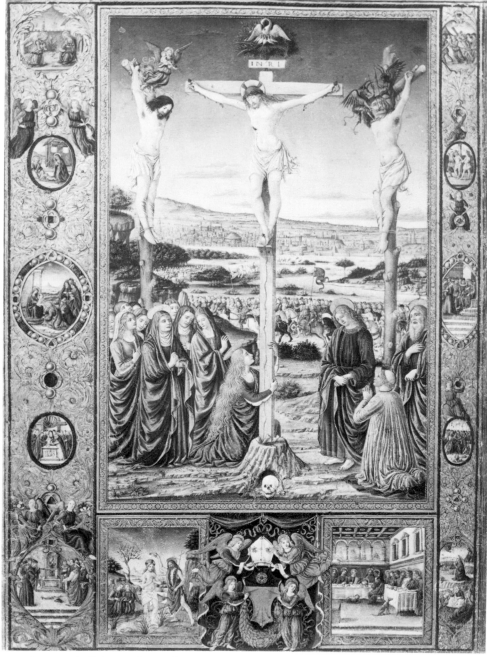

Attavante degli Attavanti: Crucifixion, a leaf from the missal illuminated for Thomas James, Bishop of Dol; 1483. Nouveau Musée des Beaux-Arts, Le Havre

account of him which Vasari anachronistically appended to his "Life of Fra Angelico". Attavante's mature style, based on a study of antique ornament and on contemporary Florentine art, belongs essentially to the latter part of the 15th century and the first years of the 16th century.

Born into a Florentine noble family, Attavante was trained during 1471–2 in the workshop of Francesco d'Antonio del Cherico, the most distinguished Florentine miniaturist during the third quarter of the 15th century. Later he seems to have collaborated with his master on the illumination of the Bible for Federico da Montefeltro (1476; Vatican Library, Rome; Urb. lat. 1 and 2).

Established as an independent miniaturist

by the 1480s, Attavante's first signed and dated work is the sumptuous missal for Thomas James, Bishop of Dol in Brittany (1483; Lyons Cathedral). A loose leaf from the missal (Nouveau Musée des Beaux-Arts, Le Havre) depicts the Crucifixion, with a superb background panorama of Rome, where the Bishop had been Castellan of the Castel S. Angelo.

Two years after its completion, Attavante began working for Matthias Corvinus, King of Hungary, a lover of humanism whose library of lavishly illuminated Italian manuscripts in Budapest was dispersed soon after his death. The first of the many manuscripts illuminated for him by Attavante (over 30 have been identified) is the signed and dated missal in Brussels

(1485; Bibliothèqe Royale Albert I; Cod. 9008). The classical style of its ornate title page is especially indebted to Domenico Ghirlandaio (1449–94), who led the archaeological study of the Antique in late 15th century Florence. Like many of the miniatures Attavante and his workshop produced for Corvinus, it shows sarcophagus reliefs, candelabra panels, acanthus scrolls, imitation cameos, medallions, and similar motifs.

Not all the codices commissioned by Corvinus had been completed on his death in 1490 (for example the beautiful *breviarium* in the Vatican Library: Urb. lat. 112). Some were bought by Lorenzo de' Medici, who shared a taste for Attavante's work, as several manuscripts preserved in the Biblioteca Laurenziana, Florence, testify. An important documented work of Attavante's subsequent career is the monumental Bible donated by Pope Julius II to King Emanuel of Portugal (1494; Archivo Nacional da Torre do Tombo, Lisbon): Attavante's hand is discernible in six of its seven volumes.

We have meager but conflicting reports of Attavante's later career. He was distinguished enough in 1503 to sit on the committee chosen to recommend a location for Michelangelo's *David,* but was also so impoverished that he borrowed money from Leonardo da Vinci—perhaps the flow of secular commissions was drying up. At all events he seems, in old age, to have concentrated on ecclesiastical work, including a series of antiphonaries for Florence Cathedral (*c*1510).

Audubon John 1785–1851

John James Audubon was an American artist and naturalist. He was born in Haiti, the son of a French sea captain and his creole mistress. He may have studied in Paris with Jacques-Louis David, but at 18 was sent to the United States to enter business. Most of his life was devoted to the recording of animal and bird life in America, resulting in his *magnum opus* illustrating at life size *The Birds of America, from Original Drawings with 435 Plates Showing 1,065 Figures.* Because of lack of interest in America, this was first published in England, between 1827 and 1838. Audubon's two sons, John and Victor, worked with him both on this project and on his later study of American quadrupeds. Audubon was one of the greatest artist-naturalists of all time.

Auerbach Frank 1931–

The British painter Frank Auerbach was born in Berlin. He came to Britain in 1939 and trained at the St Martin's School of Art (1948–52) and at the Royal College of Art (1952–5). He also attended evening classes given by David Bomberg, by whom he was considerably influenced, particularly through the thick textures of Bomberg's mature style. Auerbach has developed this feature to the point where the pigment can be as much as an inch (2.5 cm) thick, giving his imagery a tactile as well as a painterly character. The imagery itself is often rather conventional, in a Euston Road School manner.

Avercamp Hendrick 1585–1634

The Dutch painter Hendrick Avercamp was known to his contemporaries as "Die Stomme van Campen" ("the Mute of Kampen", the town where he spent most of his life). Certain features of his style, such as the high horizon line of his landscapes and his thinly painted figures, suggest a training with an artist of the Bruegel school, possibly David Vinckeboons. There is little stylistic development through surviving paintings, dated from 1608 to 1632, probably because he specialized almost exclusively in winter landscapes. The circular *Winter Scene* (c1609; National Gallery, London) is a skillful blend of contemporary figures and idealized setting in which the colors become transparent so as to suggest distance.

Avery Milton 1893–1965

Although he studied briefly at the Connecticut League of Art at Hartford, the American painter Milton Avery was largely self-taught. At a time when many progressive American artists were responding to Cubism and Futurism (Charles Demuth, Max Weber and Joseph Stella, for example) and others were developing various home-grown forms of realism (Edward Hopper and Thomas Benton, among them), Avery was one of the few to be inspired by Matisse. Avery's style, consequently, is characterized by flat areas of luminous, finely harmonized colors, the simplified forms enclosed by flowing outlines. His many portraits of friends and family include *Seated Blond* (1946; Walker Art Center, Minneapolis). In his seascapes—he lived at Cape Cod for many

Frank Auerbach: Mornington Crescent; oil on board; 122×147cm (48×58in); 1967. Metropolitan Museum, New York

years—he often employed elements of childlike naivety (such as schematic birds) and a simplicity of form that is close to total abstraction, for example *Green Sea* (1954; Metropolitan Museum, New York). His many etchings are more Expressionist in character. Through his increasingly free use of broad areas of flat color, Avery strongly influenced Abstract artists such as Adolph Gottlieb and Mark Rothko.

Further reading. Hobbs, R. *Milton Avery: The Late Paintings*, New York (2001).

Hendrick Avercamp: detail of A Winter Landscape; panel; full size 25×34cm (10×13in). Wallraf-Richartz Museum, Cologne

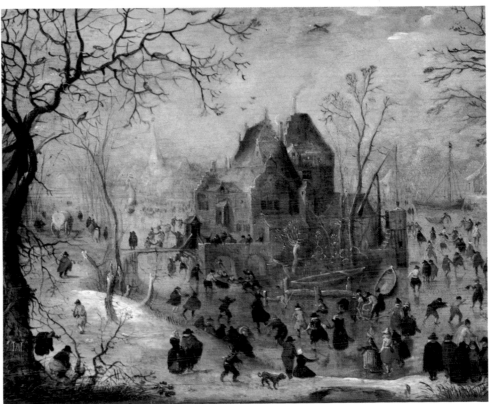

B

Bacon Francis 1909–92

The British painter Francis Bacon was born in Dublin. In 1928 or 1929 he went to London where he worked as an interior decorator. He was self-taught as a painter; the small number of his surviving works from before 1944 show the influence of Picasso in their distorted, attenuated figures. This influence is also apparent in his earliest important painting, *Three Studies for Figures at the Base of a Crucifixion* (1944; Tate Gallery, London), a triptych depicting sinister, stunted creatures, both threatening and agonized, starkly modeled in gray against a piercing orange background. The impact this made when first exhibited in London in April 1945 should be understood not only in the light of contemporary events, but also in contrast to the apparent trend in British painting towards mellow romanticism, or a new humanism.

His later paintings are similarly horrific. They include a series of *Popes* with mouths wide open in a scream or a yawn based on Veláquez, a motif he began to use in 1949 which reappears throughout his work. The juxtaposition of living flesh alongside hunks of meat in these pictures and elsewhere acts as a *memento mori*. Their similarity is emphasized by Bacon's handling of paint, heavily worked in smears to suggest the vulnerability and flexibility of flesh and blood. His technical procedures result in a blurring of the image reminiscent of photography, a constant source for Bacon. He was fascinated by the way in which a figure caught in violent action loses its human identity, a theme he explored in paintings based on Eadweard Muybridge's studies of the body in motion.

Bacon's art is dominated by a sense of risk, an element he believed vital to life; it is expressed both in his intense, unpremeditated manner of working, which necessitated the destruction of many spoiled paintings, and in the mood of the finished canvas. Even portraits of friends are precariously poised in the briefest indication of support and space.

Further reading. Hobhouse, J. "Francis Bacon: Retrospective at the Grand Palais", *Arts* vol. XLVI, New York (1972). Russell, J. *Francis Bacon*, London (1971). Sinclair, A. *Francis Bacon: His Life and Violent Times*, London (1993).

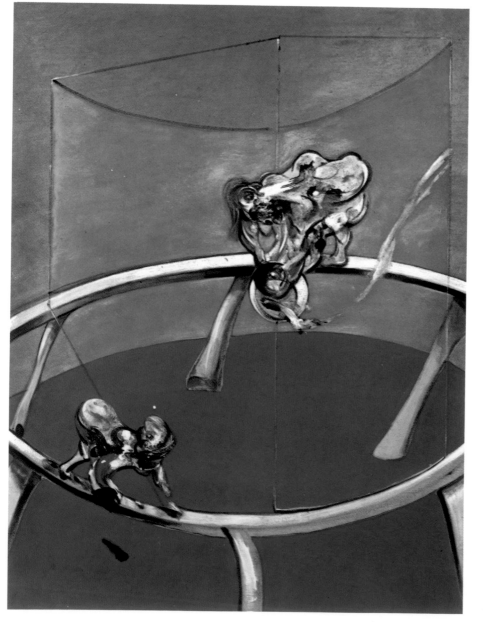

Francis Bacon: After Muybridge—Woman Emptying a Bowl of Water and Paralytic Child on all Fours; canvas; 197×147cm (78×58in); 1965. Private collection

Bacon John, the Elder 1740–99

The self-taught English sculptor John Bacon the Elder worked in a picturesque style, and his statues and decorative sculpture were much in demand. He was the designer for Eleanor Coade's artificial-stone factory, and for the Wedgwood and Derby porcelain factories. His largest work is the Chatham monument in Westminster Abbey (1779–83). Although his work could be monumental, his technique indicates a preference for modeling rather than carving. Bacon was considered the most fashionable sculptor of his day, and his prolific output was aided by his invention of an efficient pointing machine, by means of which a mason could hew marble in half the time previously taken.

Baiitsu Yamamoto 1783–1856

A Japanese painter, Yamamoto Baiitsu was one of the last masters of the *Bunjinga* (scholar-painting) style. Born in Nagoya, he moved to Kyoto as a young man and studied Chinese styles. With access to

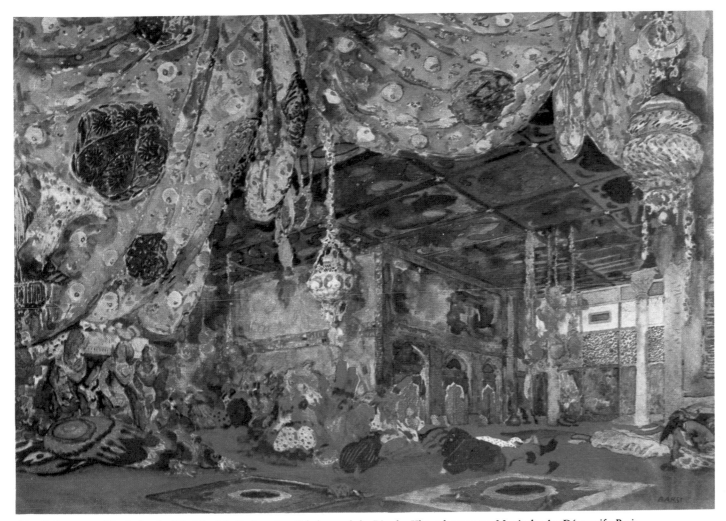

Léon Bakst: part of the design for Diaghilev's ballet based on Scheherazade by Rimsky-Khorsakov; 1910. Musée des Art Décoratifs, Paris

original works not available to earlier *Bunjinga* artists, he developed a style as close to the Chinese as possible, without losing Japanese feeling. Equally talented in ink monochrome landscape or colored bird-and-flower compositions, he shows a beauty and facility of brushwork unequaled in the school, but he lacks the originality of some of his predecessors. His masterpiece is the pair of sixfold screens depicting scholars in a lakeside landscape (Freer Gallery of Art, Washington, D.C.).

Bakst Léon 1866–1924

Léon Bakst was a Russian painter and stage designer. Born in St Petersburg and called Lev Samilovich Rosenberg, he studied in Moscow and Paris. He became involved with Sergei Diaghilev and Alexandre Benois in the attempt to reinvigorate Russian art, both by establishing closer contacts with the West through exhibitions, and by the publication from 1898 of a review, *Mir Iskusstva* ("World of Art"). The three friends then became interested in ballet as a total expression of their modernist theories. Bakst designed his first stage sets and costumes in 1902.

Among his outstanding designs are those for *Scheherazade* (1908) and *L'Après-midi d'un Faune* (1912) for Diaghilev's Russian Ballet. The latter was first produced in Paris in 1912.

Further reading. Pruzhan, I. *Bakst*, Harmondsworth (1987).

Balchand c1570–1650

The Hindu painter Balchand was the brother of the painter Payag at the Mughal court; his work spanned the reigns of Akbar (1556–1605), Jahangir (1605–27) and Shah Jahan (1627–56). He was one of the most versatile painters, particularly of the last monarch, showing great skill both in penetrating portraiture and in historical subjects. He contributed to the manuscript history of Shah Jahan's reign, the *Shah Jahan-nama* (Royal Library, Windsor). A famous work is the equestrian portrait of Shah Jahan with three sons (Victoria and Albert Museum, London). His *Royal Lovers at Twilight* (private collection), dated c1645, with its hazy background landscape, is typical of the romantic phase of Mughal art. The figures, Shah Shuja and

his mistress, are not idealized but treated with sympathy, and details like the eyelashes are meticulously rendered.

Baldovinetti Alesso c1425–99

The Florentine painter Alesso Baldovinetti also worked extensively in glass and mosaic. His early work was influenced by Domenico Veneziano. The major works of his maturity include frescoes and panel paintings for the Cardinal of Portugal's chapel in S. Miniato (1466–73) and, also in Florence, frescoes (mostly destroyed) at S. Trinità (1471–97?). Their poor condition is evidence of unsuccessful technical experiments. He was curator of the Baptistery mosaics in the 1480s. Baldovinetti's works are lovingly executed; with their purity of line, the freshness and charm of their figures, and their exquisite landscape backgrounds, they are the quintessence of later Quattrocento painting in Florence.

Balduccio Giovanni fl. 1315–49

The sculptor Giovanni Balduccio was born in Pisa, and worked in several places in the first half of the 14th century. He carved the

tomb of St Peter Martyr (1339; S. Eustorgio, Milan), and the reliquary of St Augustine (S. Pietro in Ciel d'Oro, Pavia) which derives from it. His was the main workshop in the Po Valley. The tomb in S. Eustorgio is his masterpiece and was clearly influenced by the *arca* of Nicola Pisano in S. Domenico, Bologna. The tabernacle that tops the work can be connected with Tino da Camaino's tomb of Cardinal Petroni (*c*1318; Siena Cathedral). Giovanni's style hovers between that of Nicola and that of Giovanni Pisano: sometimes austere and consciously monumental in the manner of Nicola, sometimes sinuous and intricate like that of Giovanni.

Baldung (Grien) Hans
1484/5–1545

Hans Baldung (Grien) was a German painter and engraver. He was born at Swäbisch-Gmünd but settled in Strasbourg where he became a member of the city council in his later years. He is said to have worked with Albrecht Dürer *c*1503, but this assertion rests on stylistic evidence alone since documentary links are tentative. His first dated work, the St Sebastian altar (1507) for the Stadtkirche, Halle (now in the Germanisches Nationalmuseum, Nuremberg) shows a painterliness uncharacteristic of Dürer. Baldung is at his most original in works where a visionary theme allows freedom of action for painterly effects; in *The Trinity and Mystic Pietà* (1512; National Gallery, London) a tiny frieze of donor figures witnesses an explosion of vivid yellow and red surrounding the devotional image of Christ in the tomb.

Baldung remained constantly inventive as a painter and engraver of religious subjects, rarely repeating compositional ideas. Perhaps his most important commission was to paint the high altar for Freiburg Minster in 1516. Generally, however, his later work is dominated by secular subjects, where he indulges his fascination for the elemental and supernatural.

The painter's friendship with the literary circles of Strasbourg may explain the origin and meaning of the often obscure allegorical references found in his nonreligious work. *Death and the Woman* (1517; Öffentliche Kunstsammlung, Kunstmuseum Basel) comments on the transience of life. The *Two Witches* (1523; Städelsches Kunstinstitut, Frankfurt am Main) are portrayed naked against a livid

sky of contrasting colors. Woodcuts explore similar themes, such as the power of animal instinct in the series of *Horses* of the 1530s, and *The Spellbound Stable Boy* of 1544 which has been most convincingly explained as an allegory of lust.

Balla Giacomo 1871–1958

An Italian painter, born in Turin, Giacomo Balla's early style, seen, for example, in *Bankrupt* (1902; Giuseppe Cosmelli Collection, Rome) evoked personal drama through an acute observation of the environment. By 1910, when he signed the *Manifesto of Futurist Painters,* he had become an established artist, his work of that time seeking to capture the abstract values of velocity and light. It then evolved from the charming *Dynamism of a Dog on a Leash* (1912; Conger Goodyear Collection, New York), through the study of organic and mechanical motion, to the cosmic motion implied in *Mercury Passing the Sun* (1914; Gianni Matteoli Collection, Milan). After 1918 his painting was Abstract and colorful, but static.

Further reading. Balla, G. (et al.) *Manifesto dei Pittori Futuristi*, Milan (1910). Dortch-Dorazio, V. *Giacomo Balla: an Album of his Life and Works,* New York (1970). Martin, M.W. *Futurist Art and Theory,* Oxford (1968).

Balthus 1908–2001

The French painter Balthus (Balthasar Klossowski de Rola), whose Polish father was a painter and art critic, was born in Paris but spent most of his childhood in Switzerland with his mother. Encouraged from an early age by the poet Rainer Maria Rilke and later the artists Derain and Bonnard, he was largely self-taught. By the 1930s he had developed a distinctive style; the almost doll-like, self-absorbed figures and blending of the everyday and the mysterious create a Surrealistic mood of stillness and brooding intensity, as in his *Street* (1933; Museum of Modern Art, New York). He painted a few landscapes and several striking portraits (*André Derain*, 1936; Museum of Modern Art, New York), but his most characteristic works depict adolescent girls asleep or daydreaming in quiet, middle-class interiors, their poses languidly erotic. This eroticism creates an ambiguous relationship between the frank and nostalgic depiction of awakening sexuality, and

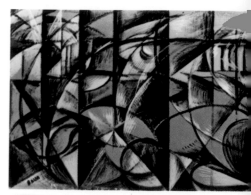

Giacomo Balla: Speed of an Automobile and Lights; oil and paper on cardboard; 50×70cm (20×28in); 1913. Collection of M.G. Neumann, Chicago

thinly disguised voyeurism. He also designed stage sets, notably for Antonin Artaud.

Further reading. Carandente, G. *Balthus,* New York (1983).

Bamboccianti fl. 1630–60

The Bamboccianti were a group of artists, predominantly Dutch and Flemish, who worked in Rome from *c*1630 to 1660 painting small-scale genre scenes of everyday life set in Rome and the nearby Campagna. They were so-called, in scorn, after the nickname of their hunchbacked leader Pieter van Laer, *il Bamboccio* ("big baby, fool"). The group's concentration on the antics of the poorest classes, which were recorded with great realism, was felt by many native Italian artists and their patrons to be foreign to the idealizing function of high art. The diversions of the vulgar could not be admired by the learned, whose interests the Bamboccianti appeared to flout.

In their depiction of the real, often enlivened with dramatic effects of light, the Bamboccianti appeared to contemporary critics to be the heirs of Caravaggio and his followers, and so they inherited the derisory criticisms to which this earlier group of painters had been subjected. Despite this welter of opposition, their paintings were occasionally bought by such well-known collectors as Vincenzo Giustiniani and Niccolò Simonelli; but their clientele came largely from the middle classes.

Pieter van Laer (1592/5–1642), leader of the Bamboccianti, was a Dutch painter, born in Haarlem. By 1625 he had moved to Rome where he joined the *Schildersbent,* an association of northern artists.

Already a fully trained painter, he sold his works through dealers and rapidly established a successful practice in small genre scenes. Shortly before his death he returned to Haarlem.

Bandinelli Baccio 1488–1560

The Italian sculptor Baccio Bandinelli first trained in Florence under his father, a Medicean goldsmith, and later under Giovanni Francesco Rustici (1474–1555), the sculptor associated with Leonardo da Vinci. He was also influenced by the work of Michelangelo and dedicated his career to emulating it. His family's old allegiances brought Bandinelli commissions from Car-

dinals, Popes, and Dukes of the Medici, his earliest being a *St Peter* in Florence Cathedral (1515). He excelled when carving variations of Classical themes (for example *Orpheus and Cerberus*, 1519, Palazzo Medici, Florence) and when working in low relief (*Triumphal Scene*, under the statue of *Giovanni delle Bande Nere*, Piazza S. Lorenzo, Florence). Bandinelli's attempts to rival Michelangelo, or predecessors such as Donatello, were recognized as failures in his own day, for instance his *Hercules and Cacus* (Piazza delle Signoria, Florence), unveiled in 1534 and intended as a pendant to the *David*. Even so, Bandinelli was unchallenged as court sculptor to Duke Cosimo I until the

return of Benvenuto Cellini from France in 1545: then they became fierce rivals, as we know from their respective autobiographies. Bandinelli produced drawings, paintings, and engravings, as well as bronze statuettes and busts.

Banks Thomas 1735–1805

The Neoclassical sculptor Thomas Banks worked mostly on a small scale. He produced reliefs of Classical subjects, and from 1772 worked in Italy where he was influenced by Henry Fuseli (1741–1825), and by the theories of Johann Winckelmann (1717–68). For a year he worked in St Petersburg where he was patronized by Catherine the Great. His "poetic statue", *The Falling Titan* (1784; Royal Academy of Arts, London), is typical of his lofty approach to sculpture.

Barbari Jacopo de' c1445?–1516

The painter and engraver Jacopo de' Barbari is called "Venetian" in some documentary sources, but he is also referred to as "Jacob Walch", suggesting German origins. He certainly worked in Venice, where he produced a celebrated and highly accurate woodcut map of the city in 1500. In the same year he was appointed court painter to the Emperor Maximilian at Nuremberg, and his life thereafter was spent at the courts of Germany and the Netherlands. His engraved work includes Classical subjects influenced by Italian art, by Mantegna in particular. Among his few surviving pictures is one of the earliest "still-life" subjects (1504; Alte Pinakothek, Munich).

Baccio Bandinelli: The Dead Christ supported by Nicodemus; marble; c1554–60. SS. Annunziata, Florence

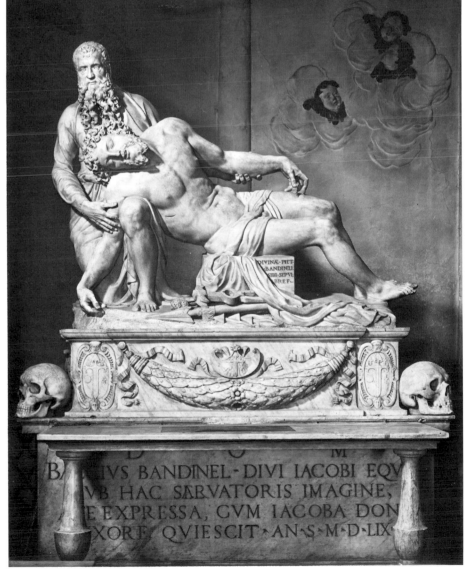

Jacopo de' Barbari: SS. Giovanni e Paolo with the old Scuola di Sant'Orsola, a detail of his woodcut map of Venice; 1500

Barlach Ernst 1870–1938

The Expressionist sculptor and writer Ernst Barlach was born in Wedel, near Hamburg, in 1870. He studied at the Hamburg Technical School (1888–91), at the Dresden Academy (1891–5), and settled in Gustrow, Mecklenburg in 1910. Following a visit to Russia in 1906 he abandoned Art Nouveau and quickly developed his characteristic style. In Barlach's work draped figures and groups, carved in wood and stone, or cast in bronze, express single emotions through gestures. *Frenzy* (1910; Ernst Barlach Haus, Hamburg) and *Avenger* (1914; Herman D. Shickman Collection, New York), are typical figures, imbued with spiritual power and humanity, derived from Gothic sculpture and German mysticism. Though he was awarded national honors, his work was later classed as "degenerate" by the Nazis and many works were destroyed.

Barna da Siena *fl.* mid 14th century

Nothing is known about the life of the 14th-century Sienese painter Barna da Siena, but he was the most important follower of Simone Martini and was surely a pupil of his, if not related to him. He was active in the middle of the century and his major work is *The Life of Christ* fresco cycle in the Collegiata church at S. Gimignano. These scenes were probably painted c1350 and cover the right-hand aisle wall

Ernst Barlach: Have Pity; bronze; height 37cm (15in); 1919. Ernst Barlach Haus, Hamburg

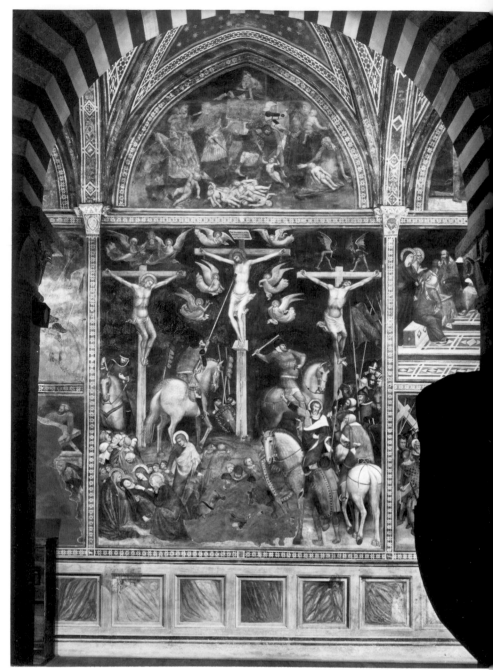

Barna da Siena: Crucifixion and (above) Massacre of the Innocents; fresco; c1350–5. Collegiata, San Gimignano

of the nave. Arranged in three tiers, there are 26 scenes including a large *Crucifixion*. The series displays great skill in narrative composition, dramatic power, and characterization, for example, in *The Pact of Judas*.

Barragán Luis 1902–88

On leaving Mexico University, the Mexican architect Luis Barragán traveled widely in Europe, where he was strongly influenced by Corbusier and by the traditional architecture of the Mediterranean, particularly the Moorish architecture of Spain. His first works on his return to Mexico were in the International Style,

though by the mid 1940s he had evolved a personal idiom that combined a spare Minimalism with traditional Mexican influences (including rich textures and vibrant colors, such as pink and yellow). He argued for what he called an "emotional architecture", one that concerned itself not only with function, but also with developing a sense of beauty, serenity and "other spiritual values". His designs strive to achieve an intimate relationship with the natural environment.

Further reading. Ambasz, E. *The Architecture of Luis Barragán*, New York (1976). Portugal, A.S. *Barragán*, New York (1992).

Barry Charles 1795–1860

A prolific early Victorian English architect, Charles Barry made a Grand Tour of Europe and the Near East when a young man. He built in the Greek, Gothic, and Renaissance styles. In the latter, his best-known works are the Travellers' Club (1830–2) and the neighboring Reform Club (1838–40) in London.

Barry's grandest achievement was the Houses of Parliament (1840–65), a masterly fusion of balanced and irregular features, of the Classical and the Picturesque, with late Gothic detail and interior work by the Catholic and remarkable neo-Gothic architect A.W.N. Pugin (1812–52).

Barry James 1741–1806

The Irish history painter James Barry was probably self-taught. In 1766, after spending a year in London, he traveled to Italy where he developed a heroic, linear style based on painstaking analysis of Renaissance masters. His major work, the series of paintings comprising *The Progress of Human Culture* (1777–83; Royal Society of Arts, London), was enthusiastically received and established his reputation as the period's leading history painter. Thereafter his career declined, largely as a result of his independent but quarrelsome temperament which exasperated his patrons and alienated his fellow artists. He died in extreme poverty in 1806.

Charles Barry: Bridgewater House, London; begun in 1848

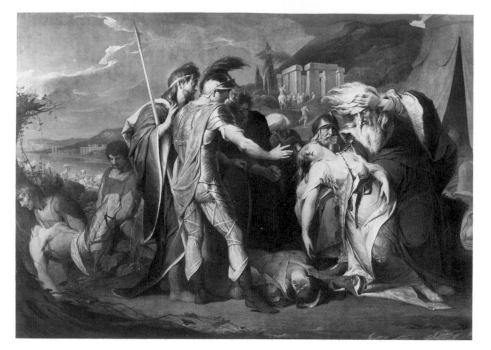

Bartolo di Fredi *c1330–c1410*

The Sienese painter Bartolo di Fredi was a follower of Simone Martini. We know he was active from 1353 to 1397. His most important paintings are his frescoes in the Collegiata church at S. Gimignano (1367) and *The Adoration of the Magi* in Siena (1390?; Pinacoteca Nazionale, Siena). His style is similar to that of the brothers Lorenzetti and of Barna da Siena. Barna also worked in the Collegiata at S. Gimignano, painting *The Life of Christ* fresco cycle during the 1350s. Bartolo's compositions are crowded and vital, and sometimes, as in *The Crossing of the Red Sea* at S. Gimignano, show a propensity for horror and violence. Their main effect comes from anecdote and the accumulation of detail. The decorative nature of the drawing accentuates the flatness of the space within the picture, thereby increasing its teeming life.

Bartolommeo Fra *1472–1517*

Fra Bartolommeo was born Baccio della Porta in Florence where he trained in the workshop of Cosimo Roselli. His first work, the *Annunciation*, dated 1497 (Volterra Cathedral) shows his assimilation of the complex overweighted draperies of his contemporary Lorenzo di Credi.

In 1499 he began the upper part of *The Last Judgment* for S. Maria Nuova (now in the Museo di San Marco, Florence), which was left unfinished when, under the belated influence of Savonarola, he retired in 1500 to the Dominican monastery of S. Marco. It was completed by Albertinelli (1474–1515) and shows in embryo the principles of High Renaissance art. Fra Bartolommeo was influenced by Leonardo, after the latter's return to Florence in 1500. His *Vision of St Bernard* (Galleria dell' Academia, Florence), begun in 1504, still shows the heavy drapery folds of his Quattrocento training, but has already been influenced by Leonardo's *sfumato* and softer handling of color. Fra Bartolommeo was not, however, affected by the more somber chiaroscuro of Leonardo's later work; a visit to Venice in 1508,

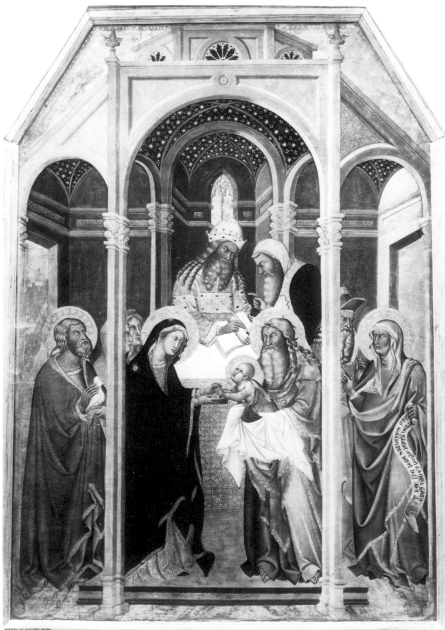

Above: James Barry: King Lear Weeping over the Dead Cordelia; oil on canvas; 269×367cm (106×144in); 1786–8. Tate Gallery, London

Left: Bartolo di Fredi: The Presentation of Christ in the Temple; panel; 180×125cm (71×49in); c1390. Louvre, Paris

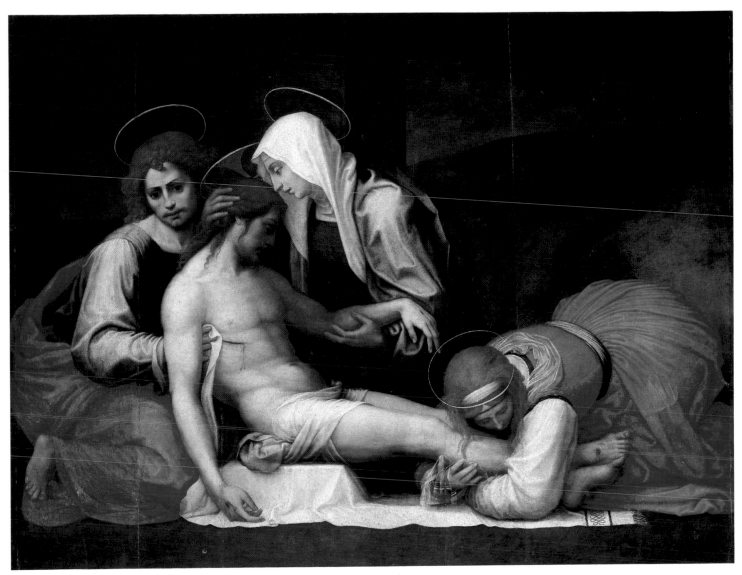

Fra Bartolommeo: Pietà; panel; 158×199cm (62×78in); c1516–17. Palazzo Pitti, Florence

when he came into contact with the stronger, brighter colors of Venetian art, had a marked effect on his development. Venetian influence can be seen, for example, in *The Marriage of St Catherine* (1511; Louvre, Paris) which shows a knowledge of Bellini's altarpiece *Virgin and Child for Saints* painted in 1505 for the church of S. Zaccaria, Venice, although Bartolommeo's figures have a breadth and assurance which is central Italian and can only have come from Leonardo.

By this time Fra Bartolommeo was a High Renaissance artist, and the balanced scheme of *The Marriage of St Catherine*, which also reflects Raphael's *Madonna del Baldacchino* (1507–8; Galleria Palatina di Palazzo Pitti, Florence), is extended in a number of other large commissions, in which the holy figures are set on flights of steps in grand architectural settings. In these the interplay of balancing and contrasting shapes becomes increasingly complex; but, for all the rhetoric of the figures, their movements remain comparatively soft and gentle, and the overall mood is sweet.

Around 1514 Fra Bartolommeo visited Rome and the movement and contrapposto of his later paintings show the influence of Raphael's Roman works. This can be seen in the heroic figures of *St Paul* and *St Peter* (unfinished) which he painted for S. Silvestro while in Rome (now in the Vatican Museums) and in large altarpieces like the *Madonna della Misericordia* of 1515 (Pinacoteca Nazionale di Palazzo Ducale, Lucca) and the *Salvator Mundi* of 1516 (Palazzo Pitti, Florence) commissioned after his return. In these there is an energy not found in his earlier paintings. The figures are in vigorous contrapposto, and the architecture—for example the background of the *Salvator Mundi*—shows knowledge of Bramante's Roman work. Tenderness remains, however, the hallmark of Fra Bartolommeo's most personal and successful work and this can be seen in the touching humanity of his late *Presentation of Christ in the Temple* (c1516; Kunsthistorisches Museum, Vienna).

Further reading. Fischer, C. *Fra Bartolommeo: Master Draughtsman of the High Renaissance*, Rotterdam (1990). Patch, T. *The Life of Fra Bartolommeo*, Florence (1972).

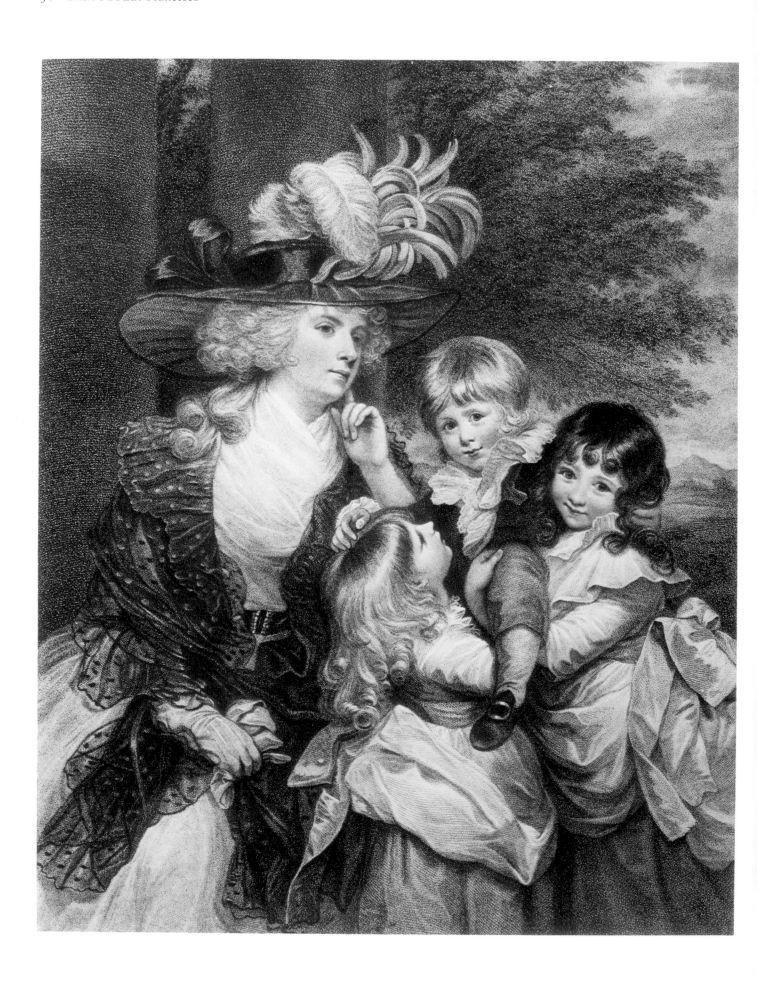

Bartolozzi Francesco 1727–1815

Francesco Bartolozzi trained in Florence, and there became an accomplished engraver. His importance rests with his popularizing of the stipple process of color engraving which, by using a "dotted" technique, avoids the harsh contours of line engraving. This was particularly suitable for the soft interpretation of the Old Masters favored by 18th-century engravers. His most celebrated Old Master engravings are after Guercino (1591–1666), whose drawings in Windsor (Royal Art Collection) he engraved in 1772. He lived in London from 1772, and reproduced the work of many of his European contemporaries, including Cipriani, Copley, and Angelica Kaufmann.

Barye Antoine-Louis 1796–1875

The French Romantic sculptor Antoine-Louis Barye was noted for his spirited portrayal of wild animals. He studied painting under Jean-Antoine Gros, and was influenced by Géricault and Delacroix. His works, based on drawings made in the Jardin des Plantes zoo in Paris (for example *Lion Crushing a Serpent*; bronze; 1832; Louvre, Paris) were admired by the Romantics. He sculpted decorative groups in stone for the Louvre (1854–60) and made an equestrian statue (*Napoleon I as a Roman Emperor*; bronze; 1860; Place de Gaulle, Ajaccio). His works, showing realism and fine craftsmanship, often depict scenes of natural savagery as in *Jaguar Devouring a Hare* (bronze; 1852; Louvre, Paris).

Basawan 1556–1605

A Hindu of the Ahir caste from Uttar Pradesh, Basawan was the major Mughal painter of the Akbar period (1556–1605); he ceased work c1600. The chronicler Abul Fazl writes: "In designing, portrait-painting, coloring ... and painting illusionistically ... he became unrivaled in the world and many connoisseurs prefer him to Daswanth". His apprenticeship involved work on the first great project of Akbar's studio, the *Hamza-nama* produced in the 1580s (collections of miniatures from this are in the Österreichisches

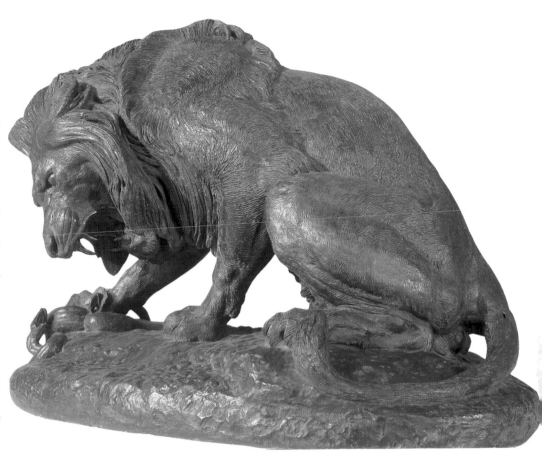

Museum für Angewandte Kunst, Vienna, and the Victoria and Albert Museum, London). His mature style can be found in the *Akbar-nama* (Victoria and Albert Museum, London), the *Babur-nama* (British Library, London), the *Razm-nama* (Maharaja Sawai Man Singh II Museum, Jaipur), and in the *Murakka-i-Gulshan* (the *Gulshan* Album; Gulistan Palace Library, Teheran). Although all these albums were painted in collaboration with other artists, Basawan's style remains perceptible. Works entirely by his own hand include the *Darab-nama* (British Library, London), the *Tuti-nama* (Cleveland Museum of Art), the *Baharistan* of Jami (Bodleian Library, Oxford), and the *Anwar-i-Suhayli* (Bharat Kala Bhavan, Varanasi).

The strong features of his art are dramatic composition, the depiction of diverse human types, and the experimental use of perspective and foreshortening. He learned a great deal from European paintings.

Baselitz Georg 1938–

The German painter and sculptor Georg Baselitz came to prominence as one of the leading figures of the Neo-Expressionist movement of the 1970s and '80s. His style

Antoine-Louis Barye: Lion Crushing a Serpent; bronze; height 135cm (53in); modeled 1832, cast 1835. Louvre, Paris

(reminiscent of early Expressionists such as Christian Rohlfs and Emil Nolde) is characterized by vivid colors, vigorous, gestural brushwork, and distorted forms. He has denied that art has any social or political meaning, art being totally autonomous, though his disturbing images have been interpreted as vivid expressions of contemporary (often specifically German) anxiety and insecurity. Typically, his figures are painted upside down, as in *The Girls of Olmo* (1981; National Museum of Modern Art, Paris). During the 1980s he worked increasingly as a sculptor (usually of roughly hewn wood carvings) and as a photographer. He remains a controversial figure: some see his work as bold and relevant, others as facile and inflated.

Bassano family 15th–17th centuries

A family of provincial Venetian painters who took the name from their native city of Bassano, this group of artists were otherwise known by the name of "da Ponte" apparently from the fact that their

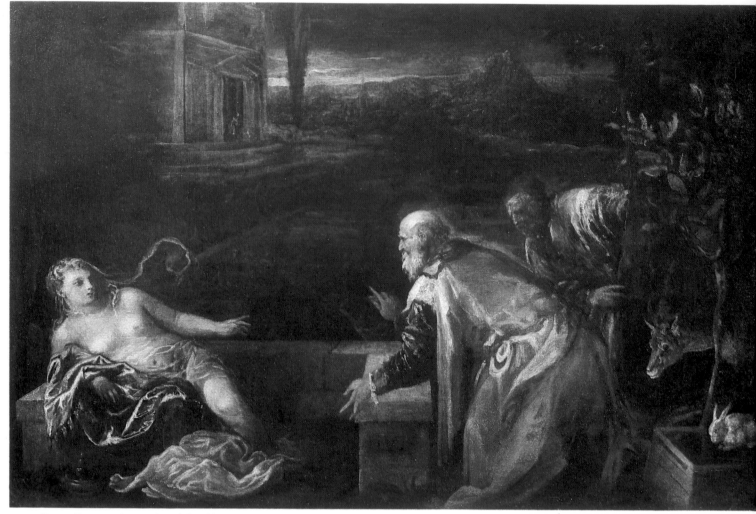

Jacopo Bassano: Susannah and the Elders; oil on canvas; 85×125cm (33×49in); 1571. Musée des Beaux-Arts, Nimes

house in Bassano lay near the bridge.

Francesco da Ponte [1] (1470/80–c1540) was a painter of purely local interest, but his son Jacopo (1510/19–92) was an important painter of the generation of Tintoretto. He presumably received his first teaching from his father in Bassano but we know that he was in Venice in 1535 and he may have been there earlier. He was strongly influenced by the expatriate Veronese painter Bonifazio di Pitati (1487–1553) in whose studio he probably worked. It is unlikely that he worked in Titian's studio but like all painters of his generation he was influenced by his works, and also by those of Pordenone (c1484–1539). He seems to have soon returned to Bassano where he then lived permanently although he probably visited Venice on later occasions. In his earlier work we can also trace the influence of Central Italian and German engravings.

Jacopo's earliest datable works are three canvases painted for the Palazzo Pubblico in Bassano, *Nebuchadnezzar and The Three Children*, *Christ and the Adulteress*, and *Susannah and the Elders* (1534–6; Museo Civico, Bassano del Grappa) in which the influence of Bonifazio is plainly seen. *The Way to Calvary* (c1540; Fitzwilliam Museum, Cambridge) borrows its composition *via* an engraving from Raphael, and the *Adoration of the Magi* (c1540; National Gallery of Scotland, Edinburgh) shows the influence of Albrecht Dürer in its background architecture. In *The Rest on the Flight into Egypt* (1550; Pinacoteca Ambrosiana, Milan) we can see the influence Parmigianino (1503–40) probably exercised through the medium of engravings. This is an important factor in Jacopo's development.

The great *Crucifixion* (1562; Museo Civico Luigi Bailo, Treviso) is a highly original and striking work. The main image probably derives from Titian, but

with the sharp contrast between the horizontal streaks of cloud and the vertical accents of the cross, the Virgin, and St John, the composition becomes almost abstract. It seems a transcendental evocation of the gospel narrative on which St Jerome—portrayed more naturalistically in the foreground with stone and open book—is meditating. This type of kneeling St Jerome exists in several versions as a separate composition. He is accompanied by a donkey rendered naturalistically (for example, *St Jerome in his Cave*; Alte Pinakothek, Munich); this type of treatment leads on to genre compositions of peasants and domestic animals, often with biblical subject matter. Such scenes, which are particularly characteristic of the productions of the Bassano family as a whole, make their first fully-fledged appearance in *The Departure of Jacob for Canaan* (c1565; Hampton Court Palace, London). The way in which these subjects are treated

seems to reflect contemporary developments in Northern painting, but their great popularity among Venetian patrons may also be linked to the extensive development of land-reclamation and farming on the *terra firma* at this period.

The votive lunette of *The Rectors Moro and Capello before the Virgin* (1572; Museo Civico, Vicenza) is painted in a rather different, more monumental style and, in addition to its obvious dependence on Titian's *Madonna of the Pesaro Family* altarpiece (1519–26; S. Maria dei Frari, Venice), shows the influence of Tintoretto. This is also to be seen in his portraits, one of the finest of which is the *Portrait of a Man* (c1570; National Gallery of Scotland, Edinburgh). In his later work Jacopo seems to have received considerable help from his sons and probably painted little during the last decade of his life.

Four of Jacopo's sons were painters. Francesco da Ponte [II] (1549–92) assisted his father in some of his later work and produced a number of peasant and animal pictures in his father's manner such as the *Spring* and *Autumn* (c1575?; Kunsthistorisches Museum, Vienna). In 1579 he left Bassano and established himself in Venice, participating, unlike his father, in the great scheme for the redecoration of the Doge's Palace after the disastrous fire of 1577. Here he executed the central oval in the ceiling of the Sala del Scrutinoio and four historical scenes in the Sala del Maggior Consiglio. He was to have assisted Paolo Veronese (1528–88) in the execution of the *Paradise* on the end wall of this room, but this was prevented by Veronese's death; the commission passed to Tintoretto.

Another son, Giambattista (1553–1613), was also active as a painter as was the youngest son Gerolamo (1566–1613), but neither of them was an independent artist of great significance. Leandro (1557–1622) was a more considerable figure. He completed some of the works in the Doge's Palace undertaken by his brother Francesco but left unfinished at his death, and executed other works there on his own. He was best known as a portrait painter, and it was for his eminence in this field that he was knighted by Doge Marin Grimani c1596.

Further reading. Berenson, B. *Italian Painters of the Renaissance*, London (1898). Freeberg, S. *Painting in Italy, 1500–1600*, London (1970). Hale, J. *Italian Renaiss-*

Leandro Bassano: Penelope; oil on canvas; 92×85cm (36×33in); c1575–85. Musée des Beaux-Arts et d'Archéologie, Rennes

ance Painting, Oxford (1977). Marano, M. "The Jacopo Bassano Exhibition", *Burlington Magazine* vol. XCIX, London (1957). Tietze, H. and Tietze-Conrat, E. *The Drawings of the Venetian Painters*, New York (1944).

Batoni Pompeo 1708–87

The Italian painter Pompeo Batoni was born in Lucca. In 1727 he came to Rome where he was to remain all his life. He studied briefly with Sebastiano Conca and Agostino Masucci, but was largely self-educated. By 1740 he had established a reputation rivaling that of Mengs, but he was not prolific and his fame was not based on any extensive decorative schemes. He painted the altarpiece, *The Fall of Simon Magus* (1746–55) for St Peter's. From 1754 he specialized in portraits, his clientele including Englishmen

on the Grand Tour. Batoni was influenced by Raphael and the Antique.

Baudelaire Charles 1821–67

The French poet and critic Charles Baudelaire was most famous for his controversial poems *Les Fleurs du Mal*, but he was also a perceptive and original commentator on the art of his day. He evolved a critical method which rejected a cold, neutral approach in favor of one "partial, impassioned, and political", as well as being amusing and poetic.

Baudelaire's first Salon review of 1845 was unremarkable and primarily factual, and although it showed the influence of Diderot and Stendhal its most important feature was the first of many homages to Delacroix, who was to constitute Baudelaire's artistic yardstick—the painter by whom all others were judged. The Salon

of 1846 showed a transition from factual to philosophical preoccupations, and encapsulated his critical theories, including his definition of Romanticism as being expressed by "intimacy, spirituality, color, and aspiration towards the infinite". This latter point was the basis of an argument against the clichés and restrictions of the ideal beauty of the classicists, in favor of the variable beauty reflected in contemporary taste. A lengthy appraisal of Delacroix also appeared, as did a section entitled "The Heroism of Modern Life", in which Baudelaire urged painters to look to the present for subjects rather than choosing retrospective themes. This idea was expanded in relation to Constantin Guys, an illustrator of military subjects and Parisian life, in the essay "The Painter of Modern Life" (1863).

Baudelaire was commissioned to write a series of articles on the *Exposition Universelle* of 1855 for *Le Pays*. He concentrated on Delacroix, whom he praised as usual, and on Ingres, condemned for lacking the essential quality of imagination. In the Salon of 1859 he critized what he saw as the prevailing artistic mediocrity and again turned to Delacroix as the paragon of the modern artists.

While recognizing the practical applications of photography, Baudelaire condemned artists who adopted a "photographic" approach to painting, attempting to copy nature in every detail. He believed with Delacroix that "Nature is but a dictionary" from which the artist must select the elements of his painting, combining them under the transforming power of imagination which he called "the Queen of Faculties". This aesthetic opposed him to the Realist school, though he was for a period in close association with Courbet and other Realists.

Baudelaire was a close friend of Manet from 1858 onwards; yet although the latter was the victim of much adverse criticism, Baudelaire never wrote in his defence. While recognizing Manet's talent and praising his quality of modernity, Baudelaire found that Manet's forthright, visual approach did not agree with some of his own most cherished principles formulated from the art of Delacroix.

Baudelaire wrote an extended critical

Lubin Baugin: Dessert with Wafers; panel; 52×40cm (20×16in). Louvre, Paris

essay on Delacroix on the occasion of the painter's death in 1863, and also essays on Poe (1856–7) and Wagner (1861), whom he saw as representing Romanticism in literature and music. His essays on caricature, which appeared in 1857, assert its validity as a form of fine art, and defends the talent of Honoré Daumier.

Baugin Lubin c1610–63

Born in Pithiviers (Loiret) the painter Lubin Baugin is occasionally called "le petit Guide", because he introduces a sentiment reminiscent of Guido Reni (1575–1642) into his compositions. Some of his paintings also derive from Parmigianino (1503–40), probably through the latter's fine etchings. Baugin is notable, in the art politics of 17th-century France, for being forced by the new Academy of Painting and Sculpture to close his public drawing school. He had joined the old Corporation of Painters in 1645 and, when this was amalgamated with the new Academy in 1651, apparently went his own way. Indeed, legal action was required to make a success of the new body, and in 1663 it was declared what we would call a "closed shop": those within got work, those without did not. Baugin died in Paris the same year.

Bazille Frédéric 1841–70

The French painter Frédéric Bazille was born in Montpellier. In 1862 he entered Charles Gleyre's studio in Paris, where he met Monet, Renoir, and Sisley; Monet and Renoir became his close friends. Some of his paintings were accepted at the Salon in the late 1860s, for instance his *Family Reunion*, an open-air group portrait, shown in 1868 (Musée du Jeu de Paume, Paris); however, in 1870 the Salon jury rejected his more conventional *La Toilette* (Musée Fabre, Montpellier). He favored a broad handling of paint and a bold modeling of figures, in the tradition of Manet; less devoted to open-air painting than his friends, he treated both monumental modern subjects and more traditional themes. He was killed in the Franco-Prussian War in November 1870.

Baziotes William 1912–63

William Baziotes was one of the original members of the New York School. Like Robert Motherwell, he was closer than most American painters to the European Surrealist exiles in New York during the Second World War. By 1939 Baziotes was painting strangely juxtaposed marine forms in a boxed framework; by 1946 he

was using automatism to produce floating biomorphic figures against a lyrical Abtract ground. He continued to develop this formula in works such as *Congo*, painted in oils in 1954 (Los Angeles County Museum of Art, Los Angeles). In 1948 he was co-founder, with Robert Motherwell, Barnett Newman, and Mark Rothko of "The Subject of the Artist", an informal teaching group central to the New York School in the late 1940s.

Beardsley Aubrey 1872–98

The English illustrator Aubrey Vincent Beardsley was born in Brighton. He began his professional life in 1888 as a clerk in a surveyor's office in London, transferring shortly afterwards to the Guardian Life Insurance Company—cruel irony, since he was already suffering from the tuberculosis that was to claim his life. To counteract the boredom of his routine office job, he resorted during his free time to music, literature, and, especially, drawing. By 1890 he was determined to put his talents as a draftsman to more appropriate use. In 1891 he met Edward Burne-Jones, who encouraged him to study art seriously and to pursue it as a profession. He attended classes at the Westminster School of Art under Fred Brown and, although his initial enthusiasm for instruction soon waned, it was revived within the same year when Beardsley saw Whistler's *Harmony in Blue and Gold: the Peacock Room* (1876–7; Freer Gallery of Art, Washington, D.C.). Whistler's adaptation and transformation of Japanese motifs fascinated Beardsley and encouraged him to collect original Japanese prints. He also became interested in the work of Mantegna, Pollaiuolo, and Botticelli, which he saw in the National Gallery, and in the work of Albrecht Dürer, studied in reproductions.

Beardsley discovered additional sources of inspiration when he went to Paris in 1892. Armed with a letter of introduction from Burne-Jones, he went to see Puvis de Chavannes who repaid Beardsley's compliment of a visit by praising the young artist's work.

Public recognition first came to Beardsley when the owner of a bookshop, Frederick Evans, recommended him to the publisher John Dent as the most suitable illustrator

Frédéric Bazille: View of the Village; canvas; 130×89cm (52×35in); 1868. Musée Fabre, Montpellier

Aubrey Beardsley: prospectus cover for The Yellow Book; drawing; 20×18cm (8×7in); 1894. Victoria and Albert Museum, London

for Dent's republication of Malory's *Morte d'Arthur*. Dent granted Beardsley the commission, which occupied him for the next 18 months. One of these illustrations, *Merlin and Nimüe* (in *Morte d'Arthur*, vol. I, London, 1893) serves to demonstrate his early style. Beardsley's treatment of this subject, depicted earlier by Burne-Jones, retains some of the details of the older master's style. Merlin is still the robe-swathed magus outwitted and undone by his powerful pupil, the beautiful Nimüe. The setting remains naturalistic—the action takes place in an appropriate forest glade. Yet there is a languid, morbid mood to the scene, underlined by the facial expressions, which is altogether absent from the work of Burne-Jones. This departure from his master's style is taken even further in the border: a riot of vegetable forms swirls around the central illustration while a snake emerges from the foliage to support the *banderole* of the title. Some of these elements may derive from Japanese decoration, but the composition as a whole defies the identification of specific prototypes.

Beardsley's next noteworthy commission involved the illustration of Oscar Wilde's *Salome*. Here Whistler's influence becomes overt, as witnessed in *The Peacock Skirt* (1894; William Hayes Fogg Art Museum, Cambridge, Mass.). The principal motif comes directly from Whistler's decorative scheme which Beardsley had seen three years earlier. But again, he forsakes the application of the original for a flight of fancy peculiar to himself. The peacock

does not simply adorn the skirt, it appears in a cloud-like vision at the upper left. Peacock feathers form a crown from the left-hand figure, and dart from this point to the corners of the drawing. The curving, sinuous line, the fantastic exaggeration of natural forms, and the emphasis on the dramatic potential of black and white were later to become incorporated into the language of the international Art Nouveau style.

Contemporary with the *Salome* illustrations was Beardsley's appointment as art editor of the *Yellow Book*. His contributions to this periodical brought his work before a wider, and generally hostile audience. The critics objected to the grotesque misrepresentation of famous figures and recoiled from the macabre and perverse imagination responsible for their distortion.

This adverse reaction to his work, together with his tenuous links with Wilde, led to Beardsley's dismissal from the *Yellow Book* following the Wilde scandal of 1895. Shortly afterwards, he joined the staff of the recently founded *Savoy Magazine*, in which some of his best designs were published. *The Rape of the Lock* drawings display a knowledge of 18th-century French art, well-illustrated in *The Battle of the Beaux and the Belles* (1896; Barber Institute of Fine Arts, Birmingham, England), which uses intermediate tones reminiscent of stipple engraving. This conveys a warmer, more sympathetic atmosphere than the stark juxtaposition of black and white values found in his earlier work. However, in keeping with his graphic style as a whole, certain aspects of the drawing remain highly stylized and are intended for strictly decorative effects.

At the end of his life, Beardsley regretted some of his transgressions against conventional taste and morals. He wrote to his publisher and patron, Leonard Smithers, requesting that his morally questionable drawings be destroyed. Despite this plea, Smithers preserved all his drawings and saved a representative selection of the grotesque creations of a brilliant draftsman.

Further reading. Gallatin, A.E. and Wainwright, A.D. *The Gallatin Beardsley Collection in the Princeton University Library*, Princeton (1952). Reade, B. and Dickinson, F. *Aubrey Beardsley Exhibition Catalogue*, London (1966). Walker, R.A. *The Best of Beardsley*, London (1947).

Beaumetz Jean de *fl. 1361–96*

The 14th-century Franco-Flemish painter Beaumetz was active in Artois, Paris, and Burgundy. He owned property in Arras, and by 1361 is recorded in Valenciennes with the title "bourgeois". In 1375 he was in Paris, where he was engaged as court painter to Philip the Bold. With a large atelier, he designed altarpieces and adorned the vault of the Chartreuse de Champmol in Dijon. He also painted murals for the castle chapel of Argilly from 1388 to 1391 and several rooms for the Duchess in the castle at Germolles. In 1393 Philip the Bold sent Beaumetz with Claus Sluter to see the new works André Beauneveu had executed for Duke John of Berry at Mehun-sur-Yèvres. Beaumetz also went on a mission to Bruges.

Though his career is richly documented, his surviving works are a matter of controversy. Attributed to Beaumetz and a collaborator are a *Crucifixion* in the Cleveland Museum of Art depicting an emaciated, blood-spattered figure of Christ and a bulky Carthusian monk at the foot of the cross; so is a *Crucifixion* in the Louvre, with somewhat different proportions. Both show a mixture of Netherlandish and Sienese stylistic traits, a common feature in painting assigned to the Dijon School.

Beauneveu André *c1330–c1400*

The French sculptor, painter, and illuminator André Beauneveu was born in Valenciennes in the county of Hainaut. The 14th-century chronicler Froissart (himself a native of Hainaut) regarded him as the supreme sculptor and painter of his time, but the destruction of work known to have been commissioned from him has been heavy, and his career is now traceable only in documents and in two extant groups of works: a series of tomb effigies executed for Charles V of France between 1364 and 1366, and 24 illuminated pages showing prophets and apostles in a Psalter made for the Duke of Berry *c1386*.

Nothing survives of Beauneveu's early activity as painter and sculptor in Valenciennes, but he entered the service of Charles V in 1364 as an esteemed and highly paid artist with workshop assistants. Of the four royal tombs commissioned from him for the abbey of St-Denis only three effigies survive; only that of Charles V, distinguished by its sensitive portrayal of the King's features, is considered to be entirely by Beauneveu.

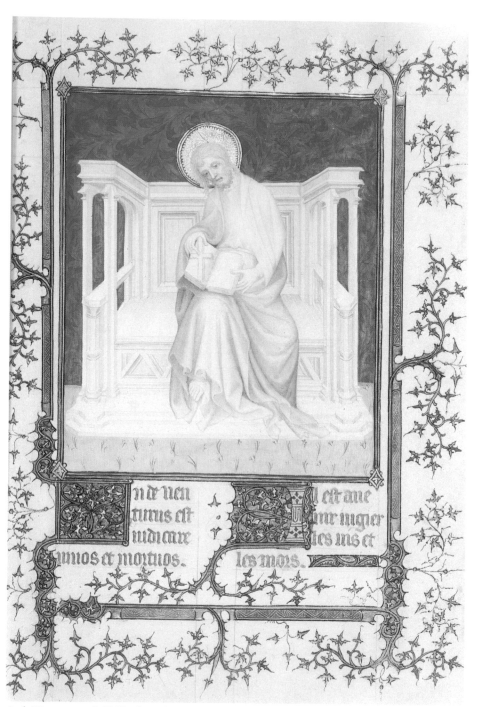

André Beauneveu: St Philip, from the Berry Psalter; c1386. Bibliothèque Nationale, Paris

Between the completion of the tombs and 1372 Beauneveu's whereabouts are unknown, though he may have visited England. Froissart, who implies this, was at the English court of Philippa of Hainaut until her death in 1369—and the Queen is known to have been hospitable to her countrymen.

The remainder of Beauneveu's career falls into two main phases: between 1372 and 1384, when his activity was concentrated in Flanders and northeast France, and a final phase from 1386 until his death c1400 when he was in the service of the Duke of Berry, primarily in Bourges.

From the documents he emerges as a somewhat restless artist. The Flemish phase, when his leading patron was Louis de Mâle, Count of Flanders, was dominated by the construction of a tomb,





commissioned in 1374, but still incomplete in 1384 when the count died after a period of political turmoil. A figure of St Catherine in the church of Notre-Dame at Courtrai is probably the only survival of what was once intended to be a sumptuous funerary chapel. Beauneveu was also active in Valenciennes (1374), Malines (1374–5 and 1383–4), Ypres (1377), Cambrai (1377–8), and Ghent (1384). No works are known to survive.

By 1386 at the latest, Beauneveu was employed at Bourges as the Duke of Berry's leading sculptor; he also seems to have acted as director of works in the extravagant decoration of the Duke's château at Mehun-sur-Yèvre and in the Ste-Chapelle of the palace at Bourges. Various fragments of sculpture and stained glass survive from these now-destroyed buildings. Beauneveu's participation in their design or execution has to be gauged by comparison with the authenticated but more unusual commission for 24 miniatures in the Berry Psalter (Bibliothèque Nationale, Paris; Ms. fr. 13091). They reveal him as a sculptor rather than a painter, and are stylistically connected with some half-life-size prophets from the Ste-Chapelle at Bourges (Hôtel Jacques Coeur, Bourges) and stained glass now in Bourges Cathedral.

Beccafumi Domenico c1486–1551

The highly individual style of the Sienese painter Domenico Beccafumi is sometimes associated with early Mannerism. Very little is known of his training and early career, and a period in Rome (1510–12), coinciding with Raphael's earlier work in the Vatican Stanze, seems to have made little permanent impact on his art. Beccafumi's mature works are characterized by an illogical treatment of spatial recession and human proportion, showing a greater concern for emotional expressiveness than for classical beauty, and by a very personal use of eerie lighting and glowing color, with which the early works of Rosso Fiorentino (1494–1540) provide the only contemporary parallel.

Further reading. Ciaranfi, A. *Domenico Beccafumi*, Florence (1966).

Beckmann Max 1884–1950

Trained at the Weimar Academy of Art, Max Beckmann worked at first in a conser-

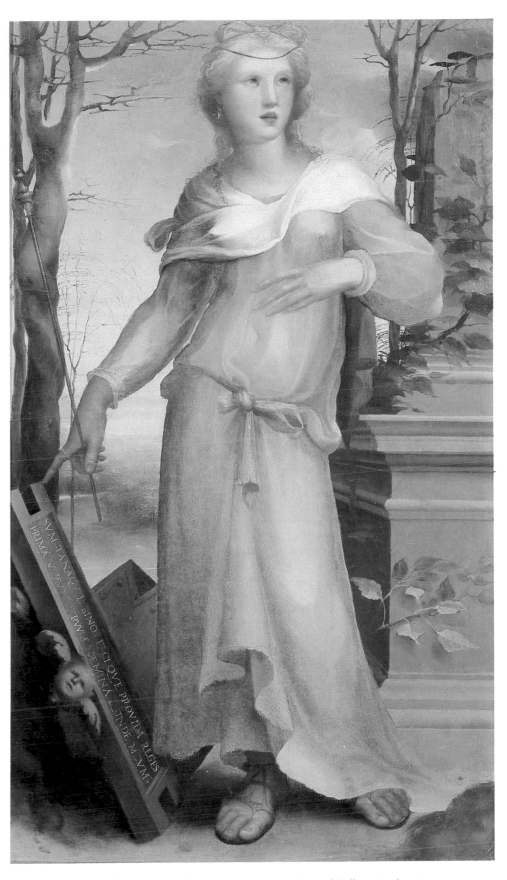

Domenico Beccafumi: Tanaquil; panel; 91×53cm (36×21in). National Gallery, London

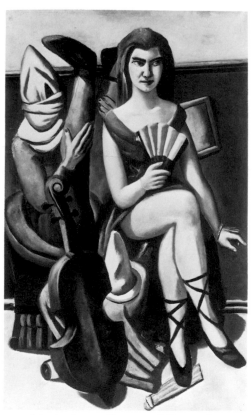

Max Beckmann: Pierette and Clown; oil on canvas; 160×100cm (63×39in); 1925. Städtische Kunsthalle Mannheim

vative style. Later his experiences in the First World War led him to paint brutally expressive images of physical and psychological mutilation, emphasized by tension between forms and space (for example, *The Night*, 1918–19; Kunstsammlung Nordrhein-Westfalen, Düsseldorf). During the 1920s his work was influenced by medieval art. His less morbid compositions, in black and a few strong colors, are concerned with general humanitarian themes rather than with specific postwar conditions. His work was included in *Die Neue Sachlichkeit* exhibition in Mannheim in 1925. He moved to Amsterdam in 1937 and then to America in 1947. His most important works were allegorical triptychs such as *The Departure* (1932–5; Museum of Modern Art, New York).

Behrens Peter 1868–1940

Initially a painter, the German artist Peter Behrens moved into architecture *via* design and the Arts and Crafts movement. He was a co-founder of the *Vereinigte Werkstätten* ("United Workshops") in Munich for which he designed glassware. His first building, in 1901, was a house in Darm-

stadt; this displayed rationalist tendencies as well as the influence of Henri van de Velde and Charles Rennie Mackintosh. In 1907 he was appointed designer and architect to AEG (the Allgemeine Elektricitäts-Gesellschaft, German power company). His responsibilities included both small-scale and large-scale design problems, ranging from factories to electrical products, including lamps and cookers. His functionally designed AEG turbine factory (in Berlin; built 1908–9) advanced the use of glass and steel to span a wide space, and the serious design of factory buildings by architects without resorting to decorative styles from the past.

After 1914 Behrens designed in an Expressionist idiom, using steel-framed construction faced with brick for the dyeworks at Höchst am Main (1920–5). For prestigious offices Behrens used a style he called "Scraped Classicism" (for example, the administrative buildings of the Mannesmann Corporation in Düsseldorf; 1913–23). Later he worked in the International style, as in his design for the State Tobacco Administration (Linz, Austria; 1930). Although he was a pioneer in the use of glass and steel, Behrens' work showed an essentially classical feeling for proportion. This can be seen in the solid structural walls of a country house at

Vanessa Bell: Portrait of Mrs Hutchinson; oil on board; 74×58cm (29×23in); 1915. Tate Gallery, London

Schlachtensee (Berlin; 1920) and in a luxury house in the Taunus Mountains (near Frankfurt am Main; 1932).

Bell Vanessa 1879–1961

The British painter and designer Vanessa Bell was born in London, the daughter of Sir Leslie Stephen and sister of Virginia Woolf. She studied under Sir Arthur Cope (c1899–1900) and then at the Royal Academy of Arts (1901–4). In 1907 she married the writer and critic Clive Bell, and must always be considered a key member of the so-called Bloomsbury Group. Between 1913 and 1920 she worked as a designer for the Omega Workshops, founded by Roger Fry. Her early paintings are in the New English Art Club tradition but she soon came under the spell of the Fauves (with side-glances at Lautrec and Van Gogh), partly as a result of the two Post-Impressionist exhibitions mounted by Fry in London in 1910–11 and 1912. She showed four pictures at the second of these. After c1920, however, she reverted to a conventional form of Impressionism, retaining from her best and most interesting "Fauve period" only the liking for strong colors. She painted still life (for example, *Still Life on Corner of a Mantelpiece*, 1914; Tate Gallery, London), landscape, domestic interiors, and portraits of E.M. Forster, Virginia Woolf, Aldous Huxley, and Roger Fry among others. Examples of her work can be seen in the Courtauld Institute Galleries, London.

Further reading. Spalding, F. *Vanessa Bell*, London (1983).

Bellange Jacques 1594–1638

Jacques Bellange was a French painter and etcher. He is documented in Nancy between 1600 and 1617 as a portrait-painter, and also as the executor of large-scale murals and designs for theatrical performances and pageants for the Duke of Lorraine. Nothing survives of all this, and Bellange's authenticated output consists entirely of prints and drawings, mostly religious in subject matter, but partly also genre. The elegant attenuation of his figures, and the disturbing ambiguity of his treatment of space, derive principally from the School of Fontainebleau; but at the same time, his art expresses a religious intensity characteristic of the Counter-Reformation.

Jacques Bellange: The Three Maries at the Tomb; etching touched with burin; 43×28cm (17×11in). Museum of Fine Arts, Boston

Bellechose Henri fl. 1415–40

The Franco-Flemish painter Henri Bellechose was born in Brabant. Court painter to the Dukes of Burgundy, he succeeded Jean Malouel in 1415 as *valet de chambre* to John the Fearless. In 1416 Bellechose received colors to complete an altarpiece of the life of St Denis, begun by Malouel for the Chartreuse de Champmol in Dijon. *The Martyrdom of St Denis*, a panel usually credited to Bellechose, has episodes from the life of the saint flanking Christ on the cross; the lavishly embroidered pluvials (cloaks) and sinuous figure of the executioner of St Denis show affinities with Sienese painting. From 1416 to 1425 Bellechose adorned the ducal palace in Dijon and the castles at Talant and Saulx. At Saulx he painted an altarpiece of the Virgin and Child, with John the Fearless, Philip the Good, and their patron saints.

Bellini family 15th and 16th centuries

The Bellini were a family of Italian painters active in the second half of the 15th century and in the early 16th, during which time they dominated artistic life in Venice.

Henri Bellechose: The Holy Communion and Martyrdom of St Denis; panel; 161×210cm (63×83in); 1416. Louvre, Paris

Very few authenticated works by Jacopo (c1400–70/1) survive, though many are known from records. According to a lost inscription he was apprenticed to Gentile da Fabriano after whom he named his eldest son; he may be identifiable with one Jacopo, a pupil of Gentile da Fabriano who was charged with assault in Florence in 1423. These Tuscan connections must be responsible for his highly decorative International Gothic style, enriched with Renaissance detail and with at least some interest in the spatial experiments then occupying the foremost Florentine artists (seen in, for example, Madonna and Child; Uffizi, Florence). Jacopo is documented in Padua and Verona in the 1430s and in 1441 was chosen, in preference to Pisanello, to execute Leonello d'Este's portrait: his activity as portraitist is well recorded in literature but no certain portraits survive from his hand. In Venice, where he died, Jacopo executed large-scale paintings (now lost) for the Doge's Palace and for the major scuole.

Jacopo was the master of both his sons Gentile and Giovanni, and with them he signed a now-lost altarpiece in Padua in 1460. What are probably his most important surviving works, two sketchbooks (Louvre, Paris, and British Museum, London), contain studies, which were used as models by Gentile and Giovanni and also by Andrea Mantegna who in 1454 married their sister Nicolosia. These books contain more than 230 studies and provide precious evidence of artistic practice in Renaissance Italy: several sheets are devoted to studies of antique fragments, some of which certainly formed part of Jacopo's collection of antiquities, later to be inherited by Giovanni.

Gentile (c1429–1507), as the eldest son, appears to have taken over the management of his father's studio and replaced him in his position as the foremost painter of the Venetian Republic. In 1469 he was ennobled by the Emperor Frederick III, and ten years later visited Constantinople to paint portraits of Sultan Mahomet II. During the 1470s he was occupied in the execution of a cycle of paintings of historical subjects for the Sala del Maggior Consiglio in the Doge's Palace in Venice, a task that involved the replacement of some paintings dating from his father's time. These paintings by Gentile were destroyed in the great fire of 1577. As is the case with his father, therefore, Gentile's most important work is now lost and we must judge him from his lesser (but nonetheless impressive) works such as the cycle of paint-

ings for the Scuola di S. Giovanni Evangelista in Venice and the canvases he contributed to the series for the Scuola Grande di S. Marco (Pinacoteca di Brera, Milan, and Gallerie dell'Accademia, Venice). In these we can appreciate his skill in depicting large crowd scenes and panoramas: together with similar paintings by Carpaccio, who owed much to Gentile, they are superb records of the ceremony and pomp that filled the lives of Venetians c1500.

From the point of view of art history, Giovanni (c1430–1516) was the most important member of the Bellini family. More than any other Venetian artist he paved the way for the innovations to be found in the art of Giorgione and Titian, and was therefore responsible for the conversion of Venice from an artistic backwater into one of the most important centers of the Italian High Renaissance. From 1479 Giovanni collaborated with Gentile in the important (but now lost) series of paintings for the Doge's Palace and he received important State commissions thereafter. In 1506 Albrecht Dürer, during his second visit to Venice, wrote that Giovanni "though he is old, is still the best in painting" in the city.

Giovanni's art progressed from a style clearly learned in the studio of Jacopo, but enriched by the influence of his brother-in-law Mantegna—as in Giovanni's Transfiguration of the 1450s (Museo Correr, Venice)—to one relying heavily on a thorough study of light and color. Antonello da Messina's visit to Venice in 1475/6 was crucial in the development of Giovanni's style both for the introduction of the technique of oil painting (first seen in the Pesaro Altarpiece, c1475) and in introducing Giovanni to the unified altarpiece in which the painted space is an extension of that occupied by the beholder (for example the S. Giobbe Altarpiece, c1480; Gallerie dell'Accademia, Venice).

In his later work other spatial devices are used as subjects are more and more often set outdoors. In the S. Corona Altarpiece (1500s; S. Corona, Vicenza) the figures are clearly related to the landscape background by means of both light and color; in addition the drapery becomes increasingly important. Another crucial late work is The Feast of the Gods (National Gallery of Art, Washington, D.C.) completed by Giovanni in 1514 for Alfonso d'Este but subsequently worked on by Titian. Here figures and objects in the painting are

treated as in a still life, a quality more easily studied in small-scale devotional paintings and portraits (for example, *The Doge Leonardo Loredan*, *c*1501–5; National Gallery, London). During the later years of his long life Giovanni saw his pupils—particularly Titian and Giorgione—rise in popularity and importance. Giorgione's short life was contained within Giovanni's own, and the changes that artist brought about, both in painterly style and in subject matter, must have impressed the older artist. A painting such as *The Drunk-*

enness of Noah (Musée des Beaux-Arts, Besançon) which dates from Bellini's last years, shows how he adapted his style to suit the new post-Giorgione era.

Further reading. Goloubew, V. *Les Dessins de Jacopo Bellini au Louvre et au British Museum* (2 vols), Brussels (1912). Heinemann, F. *Giovanni Bellini e i Belliniani*, Venice (1962). Robertson, G. *Giovanni Bellini*, Oxford (1968). Walker, J. *Bellini and Titian at Ferrara*, London (1956).

Bellotto Bernardo 1720–80

Bernardo Bellotto, an Italian painter of townscapes and topographical views, was taught by his uncle Canaletto, whose name he later adopted. His earliest paintings of Venice imitate Canaletto's style. He visited Rome *c*1742, and Florence, Turin, and Verona in 1744, painting views in each town. He left Venice in search of employment, settling in Dresden where, from 1747 to 1757, he painted views of the city. He lived in Vienna from 1757 to 1761, moving finally to Warsaw in 1763. His

Giovanni Bellini: The Feast of the Gods; oil on canvas; 170×188cm (67×74in); 1514. National Gallery of Art, Washington, D.C.

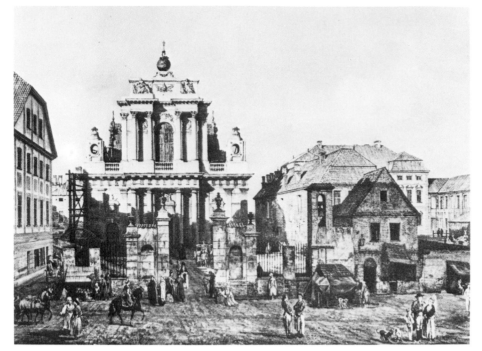

Bernardo Bellotto: The Carmelite Church on
Krakowskie Pzedmiescie, Warsaw; oil on
canvas; 113×170cm (44×67in); 1780.
National Museum, Warsaw

colors, darker than those of Canaletto,
accurately record the light of central and
northern Europe.

Bellows George 1882–1925

The American realist George Wesley Bel-
lows studied under Robert Henri and was
closely associated with The Eight. Like
them, he painted urban scenes, delighting
in the teeming life of New York's poorer
districts. He also excelled at sporting sub-
jects—he had trained as a football player—
among his best-known works being *The
Stag at Sharkey's* (1907; Museum of Art,
Cleveland). His early work was charac-
terized by vigorous brushwork and somber
tones, his later works, often landscapes
and portraits, by a more colorful palette
and a more studied approach to composi-
tion and style. This increased concern with
formal qualities marked a decline in his
spontaneity and vigor, though some of his
late portraits are among the finest of the
period. An outstanding graphic artist, he
was one of the major figures in the revival
of lithography in the United States.

Further reading. Doezema, M. *George
Bellows and Urban America*, New Haven
(1992). Quick, M. et al. *The Paintings of
George Bellows*, New York (1992).

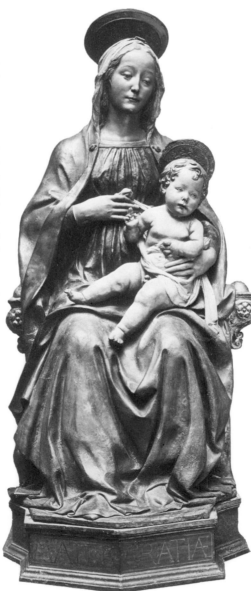

Benedetto da Maiano: Madonna and Child;
terracotta; Staatliche Museen, Berlin

Benedetto da Maiano 1442–97

The Italian sculptor Benedetto da Maiano
matriculated in the sculptor's guild at
Florence in 1473, after training as a wood
carver; he was associated with Antonio
Rossellino. His portrait busts of Pietro
Mellini and Filippo Strozzi (Museo
Nazionale, Florence) are almost photo-
graphic likenesses, and may be compared
with paintings by Domenico Ghirlandaio.
Benedetto's strength was in narrative re-
liefs, for example the Franciscan scenes on
the pulpit in S. Croce, Florence (terracotta
models in the Victoria and Albert Museum
London), and *The Annunciation* in S.
Anna dei Lombardi, Naples, as well as
many versions of the Virgin and Child.
Benedetto's style influenced sculptors of
the High Renaissance such as Andrea San-
sovino and Michelangelo.

Bening family
15th and 16th centuries

The Benings were a family of Flemish book
illuminators. Alexander (Sanders) Bening
joined the guild of painters in Ghent in
1469 and was sponsored by Hugo van der
Goes and Justus van Ghent. He also joined
the Bruges guild for a year in 1486 and at
various later dates. He died in Ghent in
1519. No documented work by him has
come to light.

Alexander married Catherine van der
Goes, who was perhaps a niece of Hugo,
and had two sons, Paul and Simon. No
works by Paul are known, but Simon, born
in Ghent in 1483, joined the Bruges guild
in 1508 and became the leading il-
luminator of his time. Among the major
works attributable to him are a Missal at
Dixmude (payments made to him in 1530),
The Genealogy of the House of Portugal
(British Library, London; Add. MS.
12531; documented as begun in 1530), the
Hours of Cardinal Albrecht of Branden-
burg (Bodleian Library, Oxford; Astor
Deposit, c1521–3).

Simon's daughter, Levina, who married
George Teerlinc, also had a considerable
reputation and was called to England by
Henry VIII in 1545. She painted a portrait
of Queen Elizabeth as princess in 1551, the
whereabouts of which is not known, and
she died in 1576.

Benozzo c1420–97

Benozzo di Lese Gozzoli, called Benozzo,
was a Florentine painter. He was a pupil of

Ghiberti and an assistant of Fra Angelico. Fra Angelico had achieved a particularly happy union between International Gothic and the style of Masaccio. Benozzo substituted a highly decorative anecdotal style more simply related to International Gothic. This is typified in his most famous work, the *Journey of the Magi*, commissioned in 1459 for the Medici Palace (Palazzo Medici-Riccardi, Florence). The

frescoes cover all four walls of the tiny chapel and overwhelm the spectator by sheer richness and detail of decoration. It seems clear that Benozzo was influenced by such works as Gentile da Fabriano's *Adoration of the Magi* (Uffizi, Florence) painted about 40 years earlier. Benozzo's other important work is a fresco cycle of Old Testament scenes in the Camposanto at Pisa (1468–84).

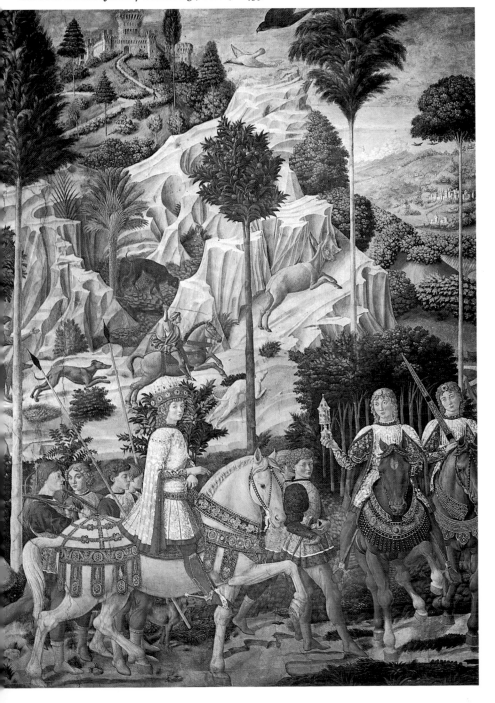

Benozzo: detail of Journey of the Magi; fresco; c1459. Palazzo Medici-Riccardi, Florence

Benton Thomas 1889–1975

The American painter and muralist Thomas Hart Benton founded the so-called Regionalist School. Born in Neosho, Missouri, he studied briefly in Chicago, visited Paris, and, under the influence of Stanton Macdonald-Wright, became an Abstract artist. Benton rapidly abandoned modernism for a highly stylized, rather frenetic and folksy realism. In works such as *Boom Town* (1928; Memorial Art Gallery of the University of Rochester, N.Y.) Benton records pioneer small-town life in the Midwest. He worked widely as a muralist, especially in the New York School for Social Research, New York, and in the Missouri State Capitol. Always a contentious figure, Benton aimed to produce a native American art free of the supposed decadence of Europe.

Berchem Nicolaes 1620–83

The Dutch landscape painter Nicolaes Pietersz. Berchem was born at Haarlem, the son of Pieter Claesz, a painter of still life. He is reputed to have studied with Jan van Goyen before entering the Haarlem guild in 1642. He then paid an extended visit to Italy, making sketches of landscapes and figures which furnished ideas for paintings on his return. His first works, for example *The Education of Bacchus* (1648; Royal Museum of Art, Mauritshuis, The Hague) attempted to emulate the large-scale Flemish decorative tradition then popular at court; but he soon specialized in small landscape subjects.

Following the return from Italy of Jan Both in 1641 the fashion for Italianate landscape painting grew rapidly in Holland. Berchem's output extends to about 800 landscapes, of largely small-scale pastoral subjects with figures painted in bright local colors against softly lit skies of pink and gray. Works such as *The Round Tower* (1656; Rijksmuseum, Amsterdam) show the dominantly picturesque qualities of his art. There is generally a carefree attitude about his figures, even when they are set against grandiose ruins as in the painting of *Ruins* (c1650; Alte Pinakothek, Munich). Berchem's proficiency led to his employment as a figure-painter in the landscapes of Jacob van Ruisdael and Meyndert Hobbema.

His extensive workshop produced artists following his own style, such as Karel Dujardin, and others with quite different specialities such as Pieter de Hooch. Ber-

Nicolaes Berchem: Ramparts at Winter Time; panel; 40×50cm (16×20in); 1647. Frans Hals Museum, Haarlem

chem's work was both highly praised and highly priced during the 18th century. It prefigures the *capriccio* landscape of the Rococo style, and it was at that period that a great many overtly picturesque engravings after his work were produced.

Berg Claus (c1485–c1535)

The German wood sculptor Claus Berg was born in Lübeck. He spent most of his working life in Denmark where he kept a workshop at Odense. His work there includes the complex carved altarpiece of 1517–22 whose delicate, rather brittle, late Gothic scrollwork forms a frame for scenes from the Passion of Christ. At the center is a combined representation of *The Crucifixion*, *The Coronation of the Virgin*, and *The Tree of Jesse*. The vigorous and rather mannered 11 Apostles in Gustrow Cathedral from the 1530s are probably his last known work. He appears to have left Denmark at the onset of the Reformation, and little is known of him thereafter.

Berlinghieri Berlinghiero 1200–43

Milanese by birth, Berlinghiero Berlinghieri was a painter active in Lucca in the second quarter of the 13th century, and is best thought of as a Tuscan artist. He is the earliest Italian panel-painter known by name and is mentioned in a document of 1228 together with his painter sons, Barone, Marco, and Bonaventura. The basis for identifying his work is a splendid signed *Crucifixion* for the Church of S. Maria degli Angeli, Lucca. Christ is shown still alive (typical of Tuscan painting of this period) with the figures of the Virgin and St John on the apron of the cross.

Bonaventura Berlinghieri (*ob.* 1274?), his son, signed and dated the altarpiece of *St Francis and Scenes from his Life* (S. Francesco, Pescia). This was painted in 1235, only nine years after the death of St Francis.

Berlin Painter *fl. c505–460 BC*

The Berlin Painter is the conventional name for the painter of the splendid tall *amphora* F. 2160 of *c*490 BC in the Staatliche Museen, Berlin; one side shows Hermes and the satyr Oreimachos, the other features the satyr Orochares. The Berlin Painter was one of the greatest painters of large vases of his generation in Athens, second only to the Kleophrades Painter. His earliest work may be the fine cup from the Agora at Athens, which owes much to Phintias. Two very early *pelikai*, however, show clearly his greater debt to Euthymides (no. 11200 in the Archaeological Museum, Madrid, and no. 50755 in the Villa Giulia, Rome).

His career can be divided into three main phases. After the initial works, mentioned above, comes his long early period to which his best pieces belong. One of these is an *amphora* of rather rare shape in New York (Metropolitan Museum; 56.171.38). On one side a youth, richly clad, plays a

Berlinghiero Berlinghieri: St Francis and scenes from his life; panel; 1235. S. Francesco, Pescia

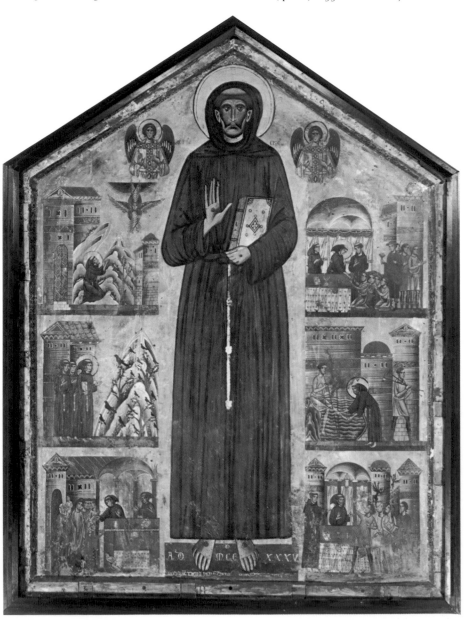

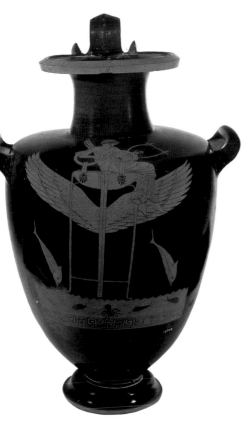

Berlin Painter: a red-figure hydria showing the god Apollo; height 52cm (20in); early 5th century BC. Vatican Museums, Rome

Bernard Émile 1868–1941

Émile Bernard was a French artist, poet, book-illustrator, critic, and editor. His paintings, executed during the second half of the 1880s, were among the first to reject the traditional photographic representation of nature.

Born in Lille, Bernard moved to Paris in 1878 and joined the Atelier Cormon in 1884. Here he met Toulouse-Lautrec and Vincent van Gogh, formed a friendship with Louis Anquetin (1861–1932), and, through the latter, was introduced to the literary Symbolist circles of Paris. In the spring of 1886 he was dismissed from the Atelier for insubordinate behavior.

Dissatisfied with all other styles of art, Bernard sought to create a new sort of painting based upon the Old Masters' respect for form and the Impressonists' adherence to brilliant, pure color. He passed rapidly through Impressionism and Neo-Impressionism, then turned his attention to the early work of Cézanne, the pastels of Degas, Japanese prints, stained-glass windows, and paintings and drawings from Van Gogh's Dutch period. By the summer of 1887, these studies provided the basis for a new style of painting, "Cloisonnisme", evolved with the help of Anquetin and well illustrated in Bernard's *Portrait of the Artist's Grandmother* (1887; Rijksmuseum Vincent van Gogh, Amsterdam). The bold outline and areas of flat color provide an evocation rather than a photographic representation of the old lady. A year after this "decorative" deformation of nature there emerged Synthetism, or Pictorial Symbolism.

In mid August 1888 at Pont-Aven, Brittany, Bernard introduced Gauguin to Pictorial Symbolism in the form of his *Breton Women in the Meadow* (1888; Collection of D. Denis, St-Germain-en-Laye). This painting provided Gauguin with the solution to his long search for a visual vocabulary capable of creating symbolic rather than representational painting. Gauguin then applied these new principles to his *Vision after the Sermon* (1888; National Gallery of Scotland, Edinburgh). Bernard's painting also established a fruitful, but ultimately ill-fated collaboration between the two artists. They became the leaders of the School of Pont-Aven. Together with Émile Schuffenecker, they mounted their influential "manifesto" exhibition at the Café Volpini on the edge of the Paris *Exposition Universelle* of 1889.

The relationship broke up in 1891. The critic Albert Aurier wrote an article published in February of that year in which he heralded Gauguin as the initiator of Pictorial Symbolism, a position seconded by Gauguin himself at his atelier sale of 24 February. In addition, Bernard had passed through a religious crisis during the winter of 1890–1 and this directed his artistic interests away from Gauguin's experiments and towards the schools of Byzantine and Northern primitive painting. After brief flirtations with the Nabis and with Sar Peladan's Salon de la Rose et Croix, Bernard left for Egypt in 1893.

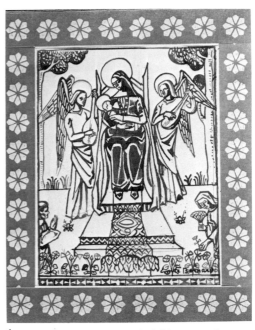

Émile Bernard: Madonna and Child supported by two Music-making Angels; pen on paper; including frame 34×27cm (13×11in); 1894. Collection Flamand-Charbonnier, Paris

Bernard returned to France in 1904, having traveled in Spain and Italy as well, and he founded (and edited) the review *La Rénovation Esthétique*. Apart from articles on Cézanne, Baudelaire, and Pictorial Symbolism, the paintings and writings he completed between 1904 and his death in 1941 reflect a complete rejection of contemporary art and society. He called for a return to the aesthetic ideals of the Old Masters, which he practiced in his own paintings such as *Après le Bain: Nymphes* (1906; Musée d'Art Moderne de la Ville de Paris). He also published correspondence with Van Gogh, Gauguin, Redon and Cézanne.

kithara with great passion, his head held back, mouth open, and body gently swaying. The bearded trainer on the other side is a sharp contrast: he is tense, intent only on the purity of the youth's notes. Both figures are isolated in a sea of black glaze, unsupported by a groundline. This system, which can be seen first among the works of Euphronios and his followers, was particularly loved by the Berlin Painter. He also reveals a surprisingly constant scheme for delineating the details of the anatomy of the body. His tense, long-limbed figures seem always about to move.

His middle period is shorter. The figures are slightly more massive, less nimble, and more rigidly conventional. In his last period all is mechanical. Here belong his prize Panathenaic *amphorae* (for example, the one in the Vatican Museums, Rome), which demonstrate that he, like the Kleophrades Painter, was also adept at black-figure. The Berlin Painter can be seen to have had several pupils: first the Providence Painter, then Hermonax, and finally the Achilles Painter (*fl. c*460–430 BC), who was one of the greatest masters of the pure Classical style in vase-painting.

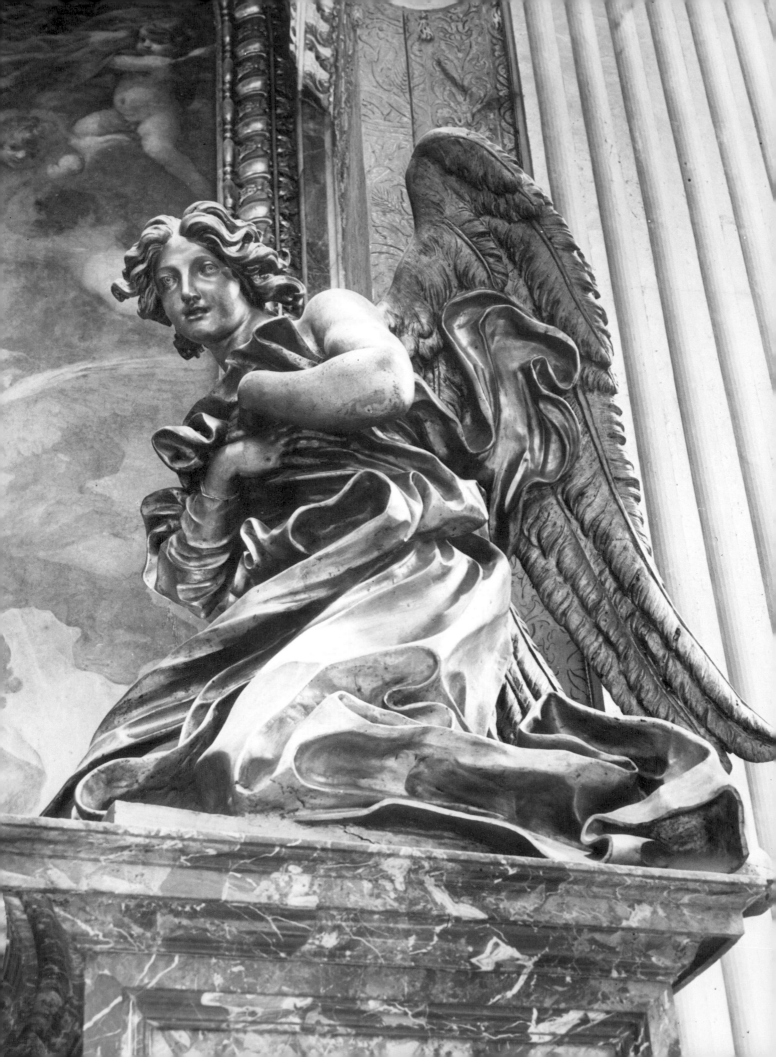

Bernini 1598–1680

Gian Lorenzo Bernini, the Italian sculptor, architect, and occasional painter, was a brilliant exponent of the Italian Baroque. His career was spent almost exclusively in Rome. His contemporaries rated his genius as highly as Michelangelo's, but in his affable and worldly manner he possessed a temperament utterly different. Whereas Michelangelo was a solitary artist who rarely communicated the essence of his art to others, Bernini was a great teacher capable of delegating many tasks to his flourishing school. He could thereby undertake the vast building projects for which he was employed by the papacy, ambitious for the material aggrandizement of Rome.

Bernini was born in Naples. His father, Pietro Bernini (1562–1629), was a Florentine sculptor who worked in a late Mannerist style. By about 1584 Pietro had moved to Naples where he had executed, among other works, the *Madonna* in the Certosa di S. Martino. In 1604/5 Pietro Bernini was called to Rome by Camillo Borghese (created Pope Paul V in 1605), to assist in the sculptural decoration of the Cappella Paolina, S. Maria Maggiore; his work in this chapel includes the relief, *The Assumption of the Virgin*. Gian Lorenzo, who had moved to Rome with his family in 1604/5, and who was by all accounts a prodigy, was trained by his father. He was thus able to master quickly the techniques of marble carving. In Rome he studied antique sculpture as well as the works of Raphael and Michelangelo. The influence of Hellenistic marbles is visible in the realistic rendering of one of his first surviving works, *The Goat Amalthea* (c1615; Museo e Galleria Borghese, Rome) which was itself long thought to be an antique marble.

With his father's employment by Paul V, Bernini gained access to Borghese patronage, particularly that of the Pope's nephew Scipione Borghese for whom his first large sculpture, the *Aeneas, Anchises, and Ascanius* (Museo e Galleria, Borghese, Rome) was executed c1619. Here the delicate Mannerist style of his father can be seen in the richness of detail, but the spiraling movement of the intertwined figures recalls the sculpture of the Florentine, Giovanni da Bologna (1524–1608). There then followed a brilliant series of large, freestanding marble sculptures, commissioned by the same patron and still in the Museo e Galleria Borghese, Rome. Here Bernini tried in sculpture to equal the naturalism attained by the paintings of the Carracci School in Rome. Works in this series include *Pluto and Persephone* (1621–2), *Apollo and Daphne* (1622–5), and *David* (1623–4). In each one Bernini created a painterly effect: texture is subtly varied and marble achieves plastic effects never before obtained. In the *David*, the last of the series, the closed form of High Renaissance sculpture is denied by the figure's vigorous centrifugal motion. The representation of instantaneous movement had become the property of sculpture as well as painting.

With the election of a Barberini to the papacy as Urban VIII (1623–44) Bernini found another devoted patron. It was for Urban that Bernini undertook his first architectural commission, the building of the entrance facade and portico of the church of S. Bibiana, Rome. For the high altar of the same church he carved his first major religious sculpture, *S. Bibiana at her Martyrdom*. Here Bernini's new sculptural techniques, developed in the Borghese statues, were put to the services of the religious zeal of the Counter-Reformation.

Urban wished to embellish the completed Basilica of St Peter's. He called upon Bernini, who was made architect of St Peter's in 1629, to erect a monumental canopy or *baldacchino* over the site of the tomb of St Peter. The Baldacchino (built 1624–33), which was made of bronze, was composed of four giant twisted columns surmounted by four volutes terminated by an orb and a cross. It successfully created a point of emphasis at the center of the building. To decorate further the zone of the crossing, Bernini was directed to supervise the placing of four monumental statues in niches of his design in the four giant piers. Only one of the statues, the *Longinus*, 1629–38, is his. It was designed to be seen at a distance and in the context of the immense space of the crossing. Its open form of white marble was intended as a striking contrast to the colored background of the niche. Its surface was therefore not worked with intricate detail but left rough so that its broad masses could be readily comprehended.

In 1632 Bernini interrupted his work for Urban in St Peter's to make a portrait bust of Scipione Borghese (Museo e Galleria Borghese, Rome). In this sculpture he developed his skill in capturing the momentary. He showed the Cardinal turning briefly to the spectator as if in conversation. His employment by Scipione Borghese was only an interlude in his work for Urban. Besides the projects already mentioned, this included the completion of the Palazzo Barberini (1629–33), the tomb of Countess Matilda, St Peter's (1633–7, in which a moderate classical phase in the sculptor's development is best seen), the tomb of Urban VIII, St Peter's (1628–47, which was to be a prototype for later Baroque papal tombs), the project to construct lateral towers for the facade of St Peter's (1637–41), and the Triton fountain, Piazza Barberini (1642–3).

With Urban's death in 1644 and upon the election to the papacy of Innocent X, Pamphili (1644–55), Bernini fell out of favor. Innocent, who was opposed to Urban's extravagance, at first no longer required Bernini's services. Unfettered by official commissions, Bernini was able to undertake work for private patrons. His chief commission of this period, executed for Cardinal Federigo Cornaro, was the decoration of the Cornaro Chapel, S. Maria della Vittoria, Rome, 1647–c55. The marble group on the high altar, the *Ecstasy of St Theresa*, is perhaps Bernini's greatest masterpiece in sculpture and shows the moment in one of the Saint's ecstatic visions when she believed an angel was stabbing at her heart. The group receives dramatic illumination from a hidden window at the rear of the altar niche. Reliefs representing members of the Cornaro family, who appear to witness this event, are placed in shallow panels in the two side-walls of the Chapel. This combination of architecture, painting, and sculpture brought together into one unified whole gives an impression of theater.

However, it was not long before Innocent was to employ Bernini. In 1648 he commissioned the sculptor to erect a large fountain representing the Four Rivers in the middle of the Piazza Navona, Rome. The fountain symbolizes the center of the world and has the form of a rock on which personifications of four major rivers are seated: the Danube, the Nile, the Plate, and the Ganges. On top of the rock an obelisk rises, surmounted by a dove.

With the pontificate of Alexander VII, Chigi (1655–67), Bernini was again restored to favor. Turning his attention increasingly towards architecture, Bernini now built his two most famous churches,

Bernini: an Angel, detail of the altar in the Cappella del SS. Sacramento, St Peter's, Vatican, Rome; gilt bronze; 1673–4

S. Andrea al Quirinale, Rome, and S. Maria dell'Assunzione, Ariccia. Cardinal Camillo Pamphili commissioned him to build S. Andrea. He tried to create in the space of this oval church a fitting environment for the representation of a religious event—the ascension into heaven of the Apostle. By so doing he extended the theatrical conception of the Cornaro Chapel to a far larger field. To narrate this event he populated the lower dome with sculpted figures, headed by St Andrew who floats above the pediment of the high altar. Bernini invigorated the space of his churches with sculptural decorations; but this drama is not integral to the architecture itself as it is in the churches of Borromini.

Like Urban before him, Alexander was anxious to embellish St Peter's. The piazza in front of the Basilica, in which pilgrims frequently congregated for papal benediction, required definition. Bernini worked on the project from 1656–67. To enclose the space he constructed two massive colonnades which form an oval piazza symbolizing the world gathered together before the Pope, and which correspond to the arms of the church open in greeting. Inside the Basilica he placed a monumental reredos at the high altar. Contained in this construction (known as the *Cathedra Petri*) is the throne of St Peter, a symbol of the Apostle's power as Christ's vicar and a witness to papal legitimacy. The *Cathedra* uses several different media: bronze in the throne and in the four "Fathers" of the church that support it, stucco and wood in the glory of angels above. Illumination through a window with orange lights tints the whole structure. Bernini intended that from the nave, the *Cathedra* should be seen framed by the columns of the *baldacchino*. Also for St Peter's, 1663–6, he constructed the Scala Regia, a stairway leading from the Vatican Palace to St Peter's. It occupies a narrow site between the Basilica and the Sistine Chapel. By constructing an illusionistic colonnade on the main flight of stairs, and by cleverly creating light-filled caesuras on the landings, he turned what was formerly a dark passage into a gracious stairway.

In 1665 Bernini went to Paris, ostensibly to supervise the erection of a new facade on the east front of the Louvre, the plans for which he had already submitted to Louis XIV's first minister, Colbert. The visit was a diplomatic slight to Alexander VII whom Louis XIV desired to humiliate for political reasons. Bernini had to relinquish his work on St Peter's to undertake the journey. His visit is vividly described in a diary written by Sieur de Chanteloup who was directed to accompany the sculptor throughout his stay. In Paris Bernini made a portrait bust of the King, now in the Louvre. In his final plan for the east facade, Bernini used a design that abandons the curves present in the first two projects. It resembles the facade he had already designed for the Palazzo Chigi-Odescalchi, under construction when he left Rome. Although foundations for the facade were laid while Bernini was in Paris, building was abandoned in 1666—the year after he had left the city.

Bernini's late works executed in Rome after 1665 have a strong spiritual and subjective quality. The origins for this style are already present in *Truth Revealed by Time* (1646; Museo e Galleria Borghese, Rome), a statue that shows an unclassical distortion of the figure through an emphasis on feeling and expression. The development is continued in four other statues: *Habakkuk* and *Daniel* (1655–61; S. Maria del Popolo, Rome); *St Mary Magdalen* and *St Jerome* (1661–3; Siena Cathedral). But the best examples of his mystical late style are the over-life-size *Angel with the Crown of Thorns* and *Angel with the Superscription* (1668–9; S. Andrea delle Fratte, Rome). These two statues were commissiond by Clement IX for the decoration of the Ponte S. Angelo, Rome, but were never erected there because they were considered too precious for exposure in the open air. Bernini's spirituality is further shown in other late works: the altar and *ciborium* (1673–4; Cappella del SS. Sacramento, St Peter's Rome), the tomb of Alexander VII (1671–8; St Peter's Rome), and the *Death of the Blessed Ludovica Albertoni* (1674; S. Francesco a Ripa, Rome). He was not so extensively employed at the end of his life, partly through old age and partly because of the increasing poverty of the papacy which could no longer finance large-scale commissions.

Bernini possessed great personal charm and was much admired by his contemporaries. His brilliant universal achievements were well summed up by the English diarist John Evelyn who attended an opera given by Bernini "wherein he painted the scenes, cut the statues, invented the engines, composed the music, writ the comedy and built the theatre".

Further reading. Avery, C. *Bernini: Genius of the Baroque*, London (1997). Baldinucci, F. (ed./trans. Enggass, C.) *The Life of Bernini*, University Park, Pa. (1966). Wittkower, R. *Bernini*, Oxford (1981).

Berruguete family (15th and 16th centuries)

The painter Pedro Berruguete (1450–1504) was born in Paredes de Nava. He began his career in Spain, but by 1480 was painting at the court of Duke Federico da Montefeltro in Urbino, where he worked with Justus van Ghent, Piero della Francesca, Luca Signorelli, and Melozzo da Forli. He collaborated in the decoration of the ducal library and Studiolo and in 1480–1 finished a portrait of *Duke Federico da Montefeltro and his Son* (Galleria Nazionale delle Marche, Urbino). On the death of Federico in 1482 he returned to Spain, working first on the murals of Seville Cathedral (now lost) and later on the frescoes of Toledo Cathedral. After 1490 he obtained, through a family connection with Torquemada, the contract to decorate the Dominican house of St Thomas in Avila. Although he is essentially a painter of the Renaissance, Berruguete's style maintains some traces of Hispano-Flemish tradition.

Pedro's son Alonso Berruguete (1488–1561) was also born at Paredes de Nava. He studied painting with his father, but studied also in Rome and Florence—especially with Michelangelo—and there his interest turned to sculpture. On his return to Spain (c1517–19) he established himself in Valladolid, although he also worked in Salamanca, Medina del Campo, and Toledo. His early project for the Royal Chapel of Granada (1523) was rejected, but from 1527 to 1532 he worked on his masterpiece, the complex altarpiece of S. Benito in Valladolid, which involves both independent figures and figures in relief.

In 1529 he carved the altarpiece of the Irish College in Salamanca. From 1539 to 1543 he executed the Epistle-side choirstalls and the bishop's throne in Toledo Cathedral at the invitation of Cardinal Taverao. He also did the alabaster *Transfiguration* (1543–8). His style displays little concern for naturalism, or for precise representation of the human figure; but his deliberately dramatic distortions are effective in suggesting emotional and spiritual tensions.

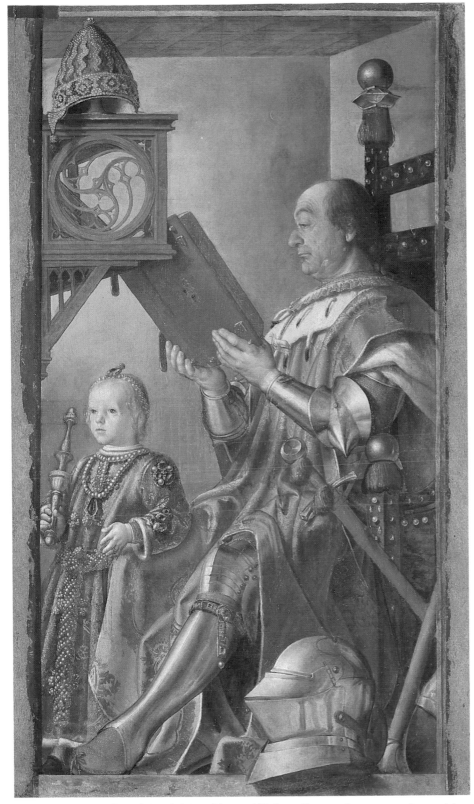

Pedro Berruguete: Duke Federico da Montefeltro and his Son; oil on panel; 134×77cm (53×30in); 1480–1. Galleria Nazionale delle Marche, Urbino

Conspiracy (1478). At the end of his career he was made curator of the Medici collections of sculpture, and played a role in the training of talented young artists hand-picked by Lorenzo the Magnificent. In this capacity he formed a living link between his master Donatello and Michelangelo, who may have learned the techniques of modeling from Bertoldo c1490.

Beuys Joseph 1921–86

The German sculptor Joseph Beuys was born in Cleves. Following war service as a pilot in the German Air Force, he studied under Ewald Mataré at the Düsseldorf Academy of Art from 1947 to 1952. Throughout the 1950s he created a succession of highly original sculptures, assemblages in a variety of materials, and cast bronzes such as SaFG-SaUG (1953–8; Hessisches Landesmuseum, Darmstadt), their imagery drawn from his personal experiences, natural science, and mythology. He also created a group of intensely personal drawings (exhibited in 1974 as The Secret Block for a Secret Person in Ireland), whose imagery he would use consistently during the 1960s and 1970s.

In 1961 Beuys was appointed Professor of Sculpture at the Düsseldorf Academy, a post he held until 1972 when he was dismissed for his political activity. In the early 1960s his work and reputation were linked to the Fluxus group. But a succession of "actions" (performances) Siberian Symphony, Section 1 (1963; Düsseldorf), The Chief (1964; Berlin), and How to Explain Pictures to a Dead Hare (1965; at the opening of his first solo exhibition, Düsseldorf) took him away from Fluxus concerns into his own highly personal forms of creativity. These first performances contained the essential elements of his actions for the next decade: fat, felt, batteries, dead hare, and blackboards. Most of his sculptures were created during or resulted from actions, such as Eurasia (1966; Galerie René Block, West Berlin), Three Pots Action Object (1974; Scottish National Gallery of Modern Art, Edinburgh), Directional Forces (1974; Nationalgalerie, West Berlin), and Tallow (1979; Art Institute of Chicago). In Edinburgh in 1970 he combined action with lecture for the first time in Celtic (Kinloch Rannoch) Scottish Symphony. Of the many actions, Coyote (1974; Ronald Feldman Gallery, New York) in which he spent a week in a gallery with a wild coyote, is

Bertoldo di Giovanni c1420–91

The origins of the Italian bronze sculptor Bertoldo di Giovanni are obscure. He made his name as one of the assistants who helped the elderly Donatello to work up narrative reliefs for the bronze pulpits of S. Lorenzo, c1460–70. He was an associate of the Medici, producing small bronze statuettes, reliefs, plaquettes, and medals, mostly for their circle. His most famous works are Battle of the Horsemen, originally set over a mantelpiece in the Medici Palace (now in the Museo Nazionale, Florence) and a medal recording the assassination of Giuliano de' Medici in the Pazzi

Thomas Bewick: The Wild Bull in the Park at Chillingham Castle, Northumberland; wood engraving; including border 26×18cm (110×7in); 1789. British Museum, London

probably the most memorable.

In the late 1960s Beuys' art and political ideas came together in a unified aesthetic in which art is inseparable from social organization. He was instrumental in setting up several political groups; most significantly he founded the Free International University, whose manifesto he and the novelist Heinrich Böll wrote in 1972. In 1976 Beuys represented West Germany in the Venice Biennale with one work *Tram Stop* (1976; Kröller-Müller Museum, Otterlo). He was given a major retrospective exhibition at the Solomon R. Guggenheim Museum, New York, in 1979.

Further reading. Beuys, J. "Joseph Beuys: Public Dialogue", *Avalanche*, New York (May/June 1974). Jappe, G. "A Joseph Beuys Primer", *Studio International*, London (September 1971). Mauer, 0. *Beuys*, Eindhoven (1968). Tisdall, C. *Joseph Beuys*, London (1979).

Bewick Thomas 1753–1828

The animal artist and draftsman Thomas Bewick is usually considered to be the father of 19th-century wood engraving and among the most outstanding of English graphic artists. He was born in Newcastle upon Tyne where he established a school of engravers. His most famous illustrations are those of birds and animal life in *Select Fables* (1784) and *A History*

of British Birds (1797 and 1804). Bewick's vignettes and tailpieces of natural life and landscape show acute observation. By using the end grain rather than the plank, and cutting it with a burin, Bewick achieved a wide range of middle tones for foliage and textures. This method of engraving did much to arrest the decline of engraving into a primarily reproductive technique.

Bibiena family
17th and 18th centuries

The Bibieni were a family of theatrical designers who worked in many European countries. The name "da Bibiena" derives from the birthplace of the father of the family, Giovanni Maria Galli (1625–65). Moving from his home town to Bologna, he studied under Francesco Albani with whom he remained as an assistant. His more famous son Ferdinando (1657–1743) founded the family's fortunes. After studying painting under Carlo Cignani, and architecture under several masters, he designed theater sets, decorations, and several buildings for the Farnese of Parma. Subsequently, he worked for the Hapsburgs, first in Barcelona, later in Vienna.

His son Giuseppe (1696–1756) decorated the new theaters at Dresden and Bayreuth, and designed the sets for operas at Vienna, Linz, Venice, and Berlin. He also designed catafalques, triumphal arches, and similar

ephemeral decorations. His career included work in Prague, Munich, Augsburg, Stuttgart, Frankfurt, and Paris. (Eight of his designs survive in the Department of Prints and Drawings, British Museum, London.) Like his father, Giuseppe's son Carlo (1728–c78) was employed by the Imperial aristocracy—at Bayreuth, Württemberg, Brunswick, and Berlin. Carlo worked at Naples and Padua and visited France, the Netherlands, Britain, and Russia.

Other artist members of the Bibiena family include the children of Giovanni Maria—Maria Oriana (1656–1749) and Francesco (1659–1739), the three sons of Ferdinando—Alessandro (1687–*ante* 1769), Antonio (1700–74), and Giovanni Maria the Younger (c1739–69), and Francesco's son Giovanni Carlo (?–1760).

Because their chosen medium was so inherently perishable, the Bibieni are often forgotten. However, in their day, the family enjoyed European renown for their illusionistic stage sets and must be counted among the creators of the Baroque opera. Some of their drawings survive, notably in collections at Vienna, Dresden, and Munich. Two hundred of their designs were reproduced in contemporary prints.

Bichitr c1550–c1650

Bichitr was one of the most polished Mughal portraitists of the Shah Jahan period (1628–58), though the active life of this Hindu painter spans the reigns of the previous two emperors—Akbar and Jahangir—as well. His refined draftsmanship shows evidence of European influence. The painting of a saint in the Chester Beatty Library, Dublin, shows a mastery of facial expression. His paintings, consisting of enamel-like surfaces, express majestic solidity. He often used a low horizon to underline the importance of the central figure, as in the portrait of Asaf Khan. He employed bluish tones to convey atmospheric perspective, and reduced distant architectural background to abstract shapes. The *Shah Jahan-nama* (Royal Art Collection, Windsor) contains his work.

Biederman Charles 1906–92

Charles Biederman, the most important American Constructivist artist and theorist, was born of Czech parents in Cleveland, Ohio, and lived in Red Wing, Min-

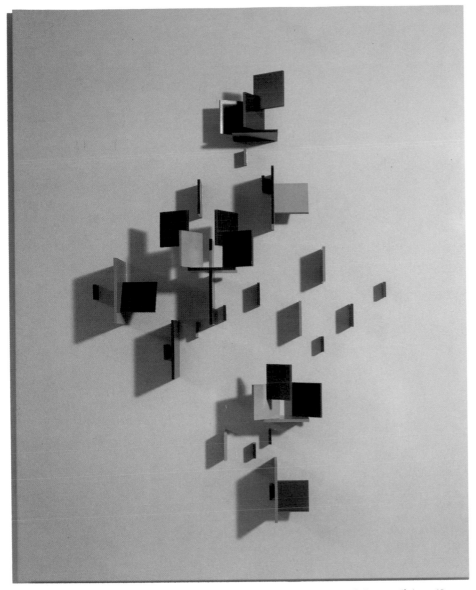

Charles Biederman: No. 23, Red Wing; painted aluminum; 98×79×14cm (38×31×6in); 1968–9.
Collection of Mr and Mrs Carl R. Erickson, Minnesota

nesota after 1942. A major retrospective was held at the Minneapolis Institute of Arts in 1976. Following the publication of his magisterial study *Art as the Evolution of Visual Knowledge* (Red Wing, Minn., 1948), Biederman's influence as a theorist has been profound. Later books include *The New Cézanne* (Red Wing, 1958) and *Towards a New Architecture* (Red Wing, 1979).

Biederman studied at the Art Institute of Chicago School (1926–9). He moved to New York in 1934 and lived in Paris from 1936 to 1937. There he met Mondrian, Léger, and other mainstream artists, coming under the influence of Mondrian, De Stijl, and Constructivism. During these years his obviously derivative paintings ranged from Cézannesque landscapes and still lifes to geometric and biomorphic abstraction. He gradually revealed a concern for three-dimensional sculptural forms in space, such as *Paris, March 7,*

1937 (artist's collection). From 1937 he has worked exclusively in the relief format, designating his style as "Structurist" in 1952 to disassociate his works and himself from all previous Constructivist and De Stijl theory and practice.

Since 1949 his aluminium, spray-painted reliefs have taken on their distinctive and unique appearance. At first he relied on vertical elements alone, perpendicular to the background plane, as in *No. 36, Red Wing* (1950; artist's collection). He later added horizontal and slanting elements (*No. 39, Red Wing*, 1961–71; artist's collection). He uses no more than ten colors for each relief; their essential quality is the balance of color, space, and light, creating structural unity. According to Biederman, the reliefs emulate the structure and building methods of nature, and depend upon varying natural light and the changing viewpoint of the spectator to create an infinite number of readings.

Bihzad Kamal al-Din c1450–1536

The Persian miniature painter Kamal al-Din Bihzad worked in Herat where he was a pupil of Miraq. He was patronized by the minister and poet Mir Ali Shir Nawa'i and by his master Sultan Husayn Bayqara, the Timurid ruler of Khurasan (1469–1506). During his lifetime he achieved an unrivaled reputation which has persisted in Iran and Mughal India; his work has therefore been much copied and imitated, often with the addition of forged signatures. His genuine surviving work is hard to identify with certainty. The best attested are three miniatures in a *Gulistan* of Sa'di (private collection) dated 1486, four miniatures and a double-page frontispiece showing Sultan Husayn at a picnic in a garden courtyard in a *Bustan* of Sa'di dated 1488 (Egyptian National Library, Cairo), a double-page album picture of the same Sultan in a garden enclosure in his harem, c1485 (Gulistan Library, Teheran), five miniatures added to a *Khamsa* of Nizami (originally copied in 1442) in 1486, 1490, or 1493, according to different readings of a date on one of them (British Library, London; Add. MS. 25900), and the frontispiece and five miniatures, one dated 1494, in a second Nizami manuscript (British Library, London; Or. 6810).

In a manuscript of the *Concert of the Birds* by Attar dated 1483 (Metropolitan Museum, New York) a Bihzadian miniature of a *Beggar at Court* is dated 1487/8, while at least one more—a funeral procession—is worthy of his hand. Probably also by Bihzad are six double-page scenes illustrating the *Zafar-nama* (the history of the conquests of Timur) copied in Herat in 1467. They have suffered much overpainting in India and the date of their production is controversial; they are either early work of c1480, or later work from the 1490s. They stand apart from the other works in subject, but are masterly in dynamic composition and include single figures within the repertory of Bihzad (The Walters Art Gallery, Baltimore).

Bihzad was a Timurid and Herati painter, excelling in that tradition. He was no innovator, but an artist of great sensibility and color sense, an expressive draftsman and brilliant at composition. Light is shed on the working of his studio by the identification of tightly knit groups of figures transferred from one composition to another, sometimes in reverse.

Bill Max 1908–1994

The Swiss painter, sculptor, designer, theorist, and teacher Max Bill was born in Winterthur. He trained as a silversmith at the Kunstgewerbeschule, Zurich (1924–7) and at the Dessau Bauhaus (1927–9). He was a member of *Abstraction-Création* from 1932 to 1936. Bill was both co-founder and Rector of the Hochschule für Gestaltung, Ulm, heading the architecture and product-design departments from 1951 to 1956.

Bauhaus ideals and the works of Mondrian (1872–1944) and Georges Vantongerloo (1886–1965) all contributed to Max Bill's constructivism and the formulation of the principles of Concrete art in 1936. He first attempted to interpret the Möbius strip in 1935, achieving success in 1953. Thereafter, his sculptures in carved stone, polished bronze, and stainless steel explore the properties of continuous surfaces in space. His paintings are strictly logical and geometric structures of color, exploiting optical properties combined with rhythmical sequences of forms.

Bishndas c1550–c1650

Bishndas was a Hindu portraitist at the Mughal court, the nephew of the painter Nanha. He collaborated with Nanha on *Babur-nama* (British Museum, London) and with the painter Inayat on a *Shah-nama*, during the Akbar period (1556–1605). A portrait by Daulat in the *Gulshan Album* (Gulistan Palace Library, Teheran) shows him as a young man. Bishndas rose to prominence during the reign of Jahangir (1605–27) who considered him "unequalled in his age for taking likenesses". He was sent to Persia to paint the portraits of the Shah and his courtiers (1613–20), and on his return was awarded an elephant. *The Sultan of Baghdad and Chinese Princess* (1599–1600) in the British Museum *Anwar-i-Suhayli* (a book of fables) is one of his finest works, showing movement, agility, and restrained emotions. Among his portraits are one of Shaikh Phul (Chester Beatty Library, Dublin), a simple but perceptive painting of Suraj Singh of Jodhpur, and two paintings of Shah Abbas in the Hermitage, St Petersburg.

Blake Peter 1932–

The British painter Peter Blake was born at Dartford in Kent, and studied at the Gravesend School of Art from 1946 to

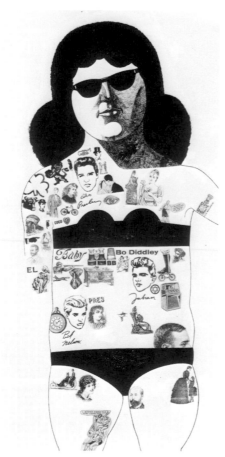

Peter Blake: Tattoed Woman; pen and ink with collage on paper; 79×41cm (31×16in); 1961. Collection of Mr and Mrs Gordon House, London

1951. After National Service in the Royal Air Force he studied at the Royal College of Art from 1953 to 1956. In 1956 he won a Leverhulme Research Award to study popular art and traveled in Holland, Belgium, France, Italy, and Spain. He was influenced by American realist painters and was a pioneer in the development of Pop art in Britain. *On the Balcony* (1955–7; Tate Gallery, London) is characteristic of his sharp, precise, almost *trompe-l'oeil* style, and reveals his fondness for the details of life: old magazines, snapshots, badges, and buttons.

Blake William 1757–1827

William Blake, born in London where he spent all but three years of his life, was both poet and visionary artist. Despite having a number of artist friends, he was one of the first unrecognized geniuses of the Romantic age. Partly inspired by Henry Fuseli, James Barry, and John Hamilton Mortimer, he evolved a completely personal style, closely linked in imagery and symbolism to the mythology and to the personal form of Christian philosophy found in his writings. He saw both poetry and the visual arts as aspects of a single poetic or prophetic genius

which expressed eternal truths, the only justification for true art.

In 1767 Blake entered Henry Pars' drawing school and from 1772 to 1779 was apprenticed to the engraver James Basire (1730–1802) for whom he made copies of Gothic tombs in Westminster Abbey. He continued engraving for the rest of his life, both in an individual manner for his own designs and in a more conventional style for the commercial world by which he hoped to earn his living. In 1779 he entered the Royal Academy Schools, but was dissatisfied with the emphasis placed on richness of chiaroscuro and drawing from life.

Blake first exhibited at the Royal Academy in 1780 and then at infrequent intervals until 1808, arousing neither public nor critical interest. His early works show a development from the rather flaccid Neoclassicism of his watercolor illustrations of English history (for example, *The Death of Earl Godwin*, c1779; British Museum, London), to the more powerful and accomplished Neoclassicism of the three watercolors illustrating the story of Joseph in Egypt exhibited in 1785 (Fitzwilliam Museum, Cambridge). The first appearance of one of Blake's most personal images, *Glad Day* or *The Dance of Albion*, is thought to date from this period, though the engravings bearing the date 1780 were probably executed considerably later. "Ideal" dates, relating to the date of a work's first conception rather than its actual execution, occur more than once in Blake's work. At this time he was associated with such political radicals as Joseph Johnson, Thomas Paine, Joseph Priestley, Mary Wollstonecraft, and William Godwin.

From 1788 until 1795 Blake developed his own unique combination of text and illustration in a series of "illuminated books" in which he simultaneously printed both his verses and his designs, coloring the latter at a second stage; examples are *Songs of Innocence* (1789) and *Songs of Experience* (1794), *The Marriage of Heaven and Hell* (1790–3), *America* (1793), and *Europe* (1794), copies of which are in the British Museum, London, Fitzwilliam Museum, Cambridge, and elsewhere. At first the coloring was done in watercolor, but in *Urizen* (1794) Blake started printing the colors in his own form of tempera (based on glue rather than the egg-yolk of the Renaissance masters). This technique produced a rich, heavy texture

suited to the imagery of the book, and was soon used by Blake in separate color-prints of designs taken from the books. In 1795 he used the same technique for the splendid set of 12 large color prints of subjects taken from such diverse sources as the Bible, Shakespeare, Milton, and history. These illustrate Blake's views of the predicament of mankind following a fall from grace—the division of the unified man into his diverse, conflicting elements. (The best selection from the series, ten in all, is in the Tate Gallery, London.) *Elohim Creating Adam* shows the Creation as a completely negative act; *Nebuchadnezzar* is man in his purely bestial aspect, and *Newton* in his purely rational, for instance.

In 1799 Blake found his most important patron, the minor government official Thomas Butts, and began painting small pictures of Biblical subjects, at first in tempera and then, from 1800 to c1805, in watercolor (examples in the Tate Gallery, London, and elsewhere). Although more direct illustrations of their subjects than the large color prints, they also contain many examples of Blake's personal imagery. These works were followed by Blake's first series of watercolor illustrations to the Book of Job (c1805–6; Pierpont Morgan Library, New York), and by a number of sets of illustrations to Milton's poems. Some of these, including those to *Paradise Lost*, 1808 (mainly in the Boston Museum of Fine Arts), duplicate with variations sets already done for another patron, the Revd Joseph Thomas (Huntington Library and Art Gallery, San Marino).

Meanwhile Blake had suffered three setbacks. The first was the three years he spent living at Felpham near Chichester (1800–3). There he worked for the well meaning but unimaginative poet and man of letters, William Hayley, who employed him on such uncongenial tasks as decorating his library, illustrating his books, and painting miniature portraits. The second was over his illustrations to Robert Blair's poem *The Grave*, which were published in 1806, engraved by the fashionable Luigi Schiavonetti instead of by Blake himself, as had been promised. The third was Blake's exhibition of his own works at his brother's house (1809–10), which aroused hardly any comment and that mostly hostile. It included the subsequently engraved painting of *The Canterbury Pilgrims* (Pollok House, Glasgow), *The Spiritual Form of Nelson*, and *The Spiritual Form of Pitt* (both Tate Gallery, London).

William Blake: The Good and Evil Angels; color-printed monotype, finished with pen and watercolor; 45×59cm (18×23in); 1795. Tate Gallery, London

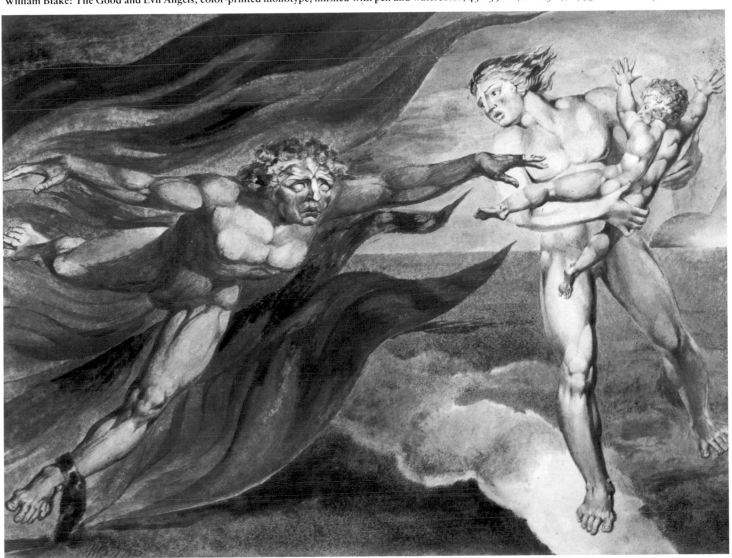

These and other failures to achieve commercial success led to a period of neglect, occupied largely by further illustrations to Milton and the completion of the poems *Milton* (c1804–15) and *Jerusalem* (c1804–1820; the only complete fully colored copy is in the Paul Mellon Collection, U.S.A.). However, from 1818 onwards Blake became friendly with a group of young artists: John Linnell, Samuel Palmer, George Richmond, and Samuel Calvert. For Linnell's teacher, John Varley, Blake drew, mainly in 1819, his notorious *Visionary Heads:* heads or complete figures of personages reputedly seen in visions (though it is at least possible that he was partly teasing his credulous friend). These include Biblical and historical personages and the *Ghost of a Flea* (both a drawing of the head and a full-length painting are in the Tate Gallery, London).

For Linnell, Blake painted a second series of Job watercolors (1821; mainly in the William Hayes Fogg Art Museum, Cambridge, Mass.) which were subsequently engraved. He also painted over 100 illustrations to Dante's *Divine Comedy* (1824–7; dispersed, between the Tate Gallery, London, the William Hayes Fogg Museum, Cambridge, Mass., the National Gallery of Victoria, Melbourne, etc). Again Blake's illustrations embodied his own ideas and criticisms of the texts.

Also from these last years are the tiny woodcut illustrations for Dr Thornton's schoolboys' edition of Virgil. Relatively untypical in their stress on landscape, these proved to have the greatest influence of all Blake's works on subsequent British artists —not only on Palmer, Richmond, and Calvert but also well into the 20th century in the early work of Paul Nash (1889–1946) and Graham Sutherland (1903–80). The years following Blake's death saw him almost forgotten, but the publication of Alexander Gilchrist's *Life of William Blake* in 1863 and the enthusiasm of D.G. Rossetti (1828–82) and his circle started a cult of Blake as poet-painter-philosopher that has grown to this day.

Further reading. Bentley, G.E. Jr *Blake Records*, Oxford (1969). Bentley, G.E. Jr and Nurmi, M. *A Blake Bibliography*, Minneapolis (1964). Bindman, D. *Blake as an Artist*, London (1977). Blunt, A. *The Art of William Blake*, London and New York (1959). Butlin, M. *The Paintings and Drawings of William Blake*, London (1981). Erdman, D.V. *Blake, Prophet against Empire*, Princeton (1969). Erdman, D.V. *The Illuminated Blake*, London (1975) and New York (1976). Gilchrist, A. *Life of William Blake*, London (1863, revised 1945). Keynes, G. *The Complete Writings of William Blake*, London (1957).

Blakelock Ralph Albert
1847–1919

The American landscape painter Ralph Albert Blakelock was born in New York. He first worked in the Romantic style of the Hudson River school, and after several years traveling in Western states (1869–72) he introduced motifs such as the campfire at evening. His work was not, however, a celebration of the grandeur of the American landscape (in the manner of Bierstadt [1830–1902], for example), but an evocation of its poetic moods; typically, trees are silhouetted against evening or night skies, the mood one of melancholy reverie, as in *Moonlight Sonata* (c1888; Museum of Fine Arts, Boston). Endless financial difficulties, coupled with critical neglect and then hostility, took their toll and in 1899 he was committed to an insane asylum. He was released shortly before he died, largely unable to appreciate his growing critical acclaim.

Further reading. Gebhard, D. *Ralph A. Blakelock*, New York (1969).

Bloemaert Abraham 1564–1651

The principal importance of the Dutch painter Abraham Bloemaert lies in his influence as the teacher of such artists as Jan Both and several members of the Utrecht School (notably Terbrugghen and Gerrit van Honthorst). His paintings include brightly colored Biblical and mythological works, such as *The Marriage of Peleus and Thetis* (1638; Royal Museum of Art, Mauritshuis, The Hague): pictures in which his early Mannerist figure-style was gradually replaced by a more classical idiom. Figures are subordinated to landscape in many of his historical and mythological paintings, and it is for landscapes that Bloemaert is principally remembered. These are rather schematic in character when compared with the drawings of natural details on which they were based, and especially when compared with realistic Dutch landscapes of the later 17th century. Their depth is somewhat shallow and they are usually composed of carefully arranged motifs of a rustic or picturesque kind: tumbledown farmhouses, groups of peasants or shepherds, farm animals and implements, and clumps of gnarled trees. The "Drawing Book" Bloemaert compiled from his pen and chalk studies influenced the many pupils who trained under him.

Boccioni Umberto 1882–1916

Umberto Boccioni was an Italian Futurist painter and sculptor. Works like the Romantic *Paola and Francesca* (1908; Palazzoli Collection, Milan) reflect the feeling for Symbolism and Impressionism outside France. Other works are neo-Impressionist evocations of the new industrial city on the outskirts of Milan.

Boccioni was fired by the poet Filippo Marinetti's *Manifesto of Futurism* (1909), which called for a violent rejection of the cultural past and glorified the machines of the new technological age in a style reminiscent of political manifestos: "a roaring motor car, which looks as though it runs on shrapnel, is more beautiful than the *Victory* of Samothrace". He adapted Marinetti's ideas in his *Technical Manifesto of the Futurist Painters* (1910), in which the goal of dynamism in painting is first stated. At first Boccioni could find no suitable technical means to express it. Although he chose aggressive, modern subject matter, as in *The City Rises* (1911; Museum of Modern Art, New York), dynamism is conveyed by the pattern of rapid brush strokes delineating strenuous, heroic men and horses, and not through the use of the mechanical images of the *Manifesto*.

The stylistic liberation of Boccioni and the Futurists came through exposure to Cubism in Paris in 1911. The effect can be traced in his sketches for the *States of Mind* project, pictures with the contemporary theme of leave-taking at a railway station. The earliest sketches of limp linear waves gives way to Cubist angularity, with numbers and fragments of machinery.

The Futurists' concern for "states of mind" is a version of the then fashionable idea of "simultaneity". This was elaborated by the French philosopher Henri Louis Bergson (1859–1941), who argued that life is experienced as a series of fleeting, intuitively grasped impressions. Boccioni and the Futurists interpreted this both in a simple way, by superimposing transient visual data, and also in a more sophisticated manner, by attempts to

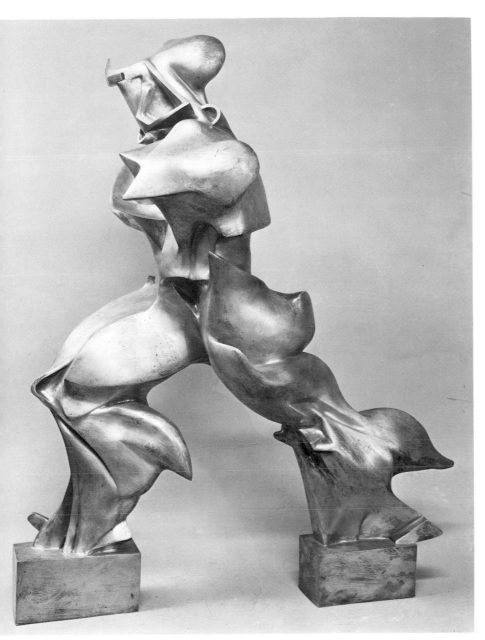

Umberto Boccioni: Unique Forms of Continuity in Space; cast bronze; 112×89×41cm (44×35×16in); 1913. Museum of Modern Art, New York

depict the response of the mind to all sorts of stimuli.

Boccioni also tried to convey the essence of movement, although his images of horses, cyclists, and figures tended to be organic rather than mechanical. The most striking of these attempts is the polished bronze *Unique Forms of Continuity in Space* (1913; Museum of Modern Art, New York), an analysis of a man walking.

The choice of subject was never a matter of indifference to Boccioni: one that involved him intensely was his mother. She appears throughout his work as an hierarchic, monolithic image, emanating "lines of force". Her presence is maintained even in the extraordinary series of sculptures we know only from photographs. These were assembled from incongruous, but logical, materials—a fragment of a window frame,

plaster, wire, and cardboard.

Boccioni was called up in 1914 to fight in the war the Futurists had glorified. He was killed in a fall from his horse, while on maneuvers.

Further reading. Balla, G. *Boccioni*, Milan (1964). Tisdall, C. and Bozzola, A. *Futurism*, London (1977). Zeno, B. (ed.) *Umberto Boccioni: Gli Scritti Editi e Inediti*, Milan (1971).

Böcklin Arnold 1827–1901

Born in Basel, the Swiss painter Arnold Böcklin studied painting at the Düsseldorf Academy under Johann Schirmer. His early work embodied ideas based on German Romanticism. During a visit to Paris in 1848 he studied the work of Corot

and Thomas Couture. The paintings he did in Rome between 1850 and 1857 interpret Classical landscapes through mythical figures from Antiquity (for example, *Pan Among the Rushes*, 1857; Neue Pinakothek, Munich). He worked in Munich and in Basel, where he was a successful portrait painter (for example, *The Actress Jenny Janauschek*, 1861; Städelsches Kunstinstitut, Frankfurt am Main) and muralist (for example, the staircase of the Kunstmuseum Basel, 1868–70). But he drew his inspiration from Italian art, particularly from Raphael, whose Vatican frescoes he first admired in 1862. In 1874 he met the German painter Hans von Marées in Florence, and with him shared an interest in depicting pseudo-Classical figures in mysterious landscape settings.

His mature work is reminiscent of French Symbolist paintings such as those of Gustave Moreau (for example, *Couple in the Tuscan Landscape*, 1878; Nationalgalerie, Berlin). It also shows the influence of the Old Masters, including Northern painters of the 16th and 17th centuries such as Grünewald, Dürer, and Ruysdael; but Böcklin's landscapes were more intense both in mood and atmosphere. These somber characteristics are evident in his best-known work, *The Island of the Dead* (1880; five versions from the first, in tempera, which is in the Öffertliches kunstsammlung, Kunstmuseum Basel; one is in the Metropolitan Museum, New York). The title was invented by a dealer, not by the artist: Böcklin described the painting simply as "a picture for dreaming about". His reputation in Europe was eclipsed during the 19th century by developments in France; but Böcklin's art came into its own in the 20th century when it was reassessed by the Expressionists and Surrealists, particulary by de Chirico and Salvador Dali.

Boffrand Gabriel-Germain
1667–1754

The French architect Gabriel-Germain Boffrand was a pupil of J.H. Mansart. His eminence lies in his exportation of the French ideal of royal architecture. He was employed at Luneville (1702–6) by the Duke of Lorraine, whose Premier Architect he became, at Bouchefort by the Elector of Bavaria (1705), and he designed both the Residenz at Würzburg (1723) and Schloss Favorite at Mainz (1724). All these works were on a regal scale and in a style derived

from the Baroque of Louis Levau (1612–1670). But he was eclectic and his domed centralized schemes such as those for Bouchefort or his second project for Malgrange (1712) demonstrated his versatility and imaginative range. His stylistic vocabulary ran from echoes of Vaux-le-Vicomte at Malgrange to Palladio's Villa Capra at Bouchefort. For this reason he marks a turning point between the Baroque and the advent of Neoclassicism; he had some influence in the latter movement through the publication of his *Livre d'Architecture* in 1745.

Bol Ferdinand 1616–80

The Dutch painter Ferdinand Bol was born at Dordrecht but spent most of his working life in Amsterdam. In the 1630s he became one of Rembrandt's closest and most esteemed pupils and he adopted his master's portrait style of that period, often placing his sitters at an open window. The *Portrait of Elizabeth Jacobsdr. Bas* (c1635–45; Rijksmuseum, Amsterdam), once attributed to Rembrandt, is now recognized as a work of Bol. In succeeding years his style lightened in tone as that of Rembrandt darkened, and though he remains close to his master in religious works (for example, *Jacob's Dream*, c1635–45; Gemäldegalerie Alte Meister, Dresden), his portraits are more obviously fashionable. His last dated work is of 1669.

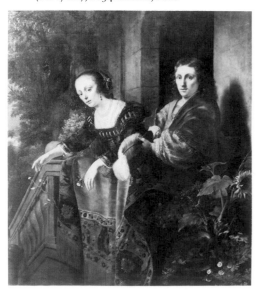

Ferdinand Bol: Ferdinand Bol and his wife Elisabeth Dell; oil on canvas; 205×180cm (81×71in); 1654. Louvre, Paris

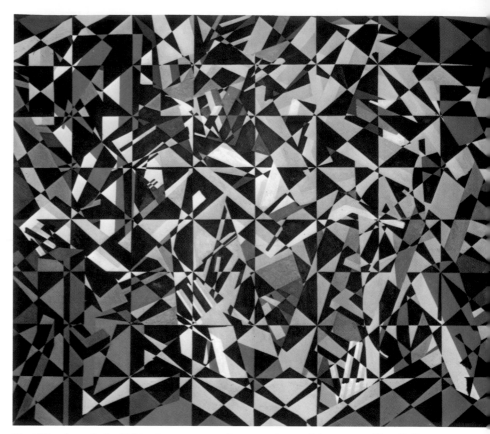

David Bomberg: In the Hold; oil on canvas; 196×231cm (77×91in); 1913–14. Tate Gallery, London

Bomberg David 1890–1957

The British painter David Bomberg was born in Birmingham, the fifth son of a Polish immigrant leather-worker. Apprenticed to a lithographer (1906–7), but more interested in becoming a painter, he studied at the Slade School of Fine Art (1911–13) and in 1914 was a founder member of the London Group. Bomberg's historical significance lies in his four major early works (for example *The Mud Bath*, 1913–14; Tate Gallery, London), in which he applies Cubist-inspired forms to relatively traditional subjects. They should also be seen in the context of Vorticism. In the mid 1920s, Bomberg moved away from abstraction to a heavily worked, representational style somewhat Expressionist in character. He gained recognition near the end of his life. In 1953 his pupils formed a School around him, the Borough Bottega, which lasted until his death.

Further reading. Cork, R. *David Bomberg*, New Haven (1987).

Bondol Jean *fl.* 1368–81

The Flemish-born artist Jean Bondol became "Painter and Valet de Chambre" to Charles V of France in 1368. His only known works were created within the milieu of the French court, where he was known as "Jean" or "Hennequin de Bruges". He was granted a pension for life in 1380 and is last recorded in March 1381.

Bondol is best known as the designer of the cartoons for the Angers *Apocalypse* (Musée des Tapisseries, Angers), one of the longest series of tapestries in the world and a rare survival from the 14th century of a complex subject portrayed in this medium. The series was commissioned by the King's brother, Louis, Duke of Anjou, who borrowed both the King's painter and an illustrated text of the Apocalypse from the royal collection to help with the designs. Cartoons and weaving progressed simultaneously, and the task, begun after 1373, was probably completed by 1380. The most famous weaver in Paris, Nicolas Bataille, translated Bondol's full-scale cartoons into tapestry. The tapestry, renowned throughout the Middle Ages, suffered some mutilation during and after the French Revolution. The disposition of scenes in two registers and in seven sections, each associated with the figure of a reader under a tall architectural setting, is original. Bondol clearly drew for inspiration on more than one illustrated text of the Apocalypse. He evokes the vision of St John and the events recorded in the Book of Revelation in a highly dramatic way; his figures show great individuality both in character and in their reaction to events.

Although Jean Bondol is invariably described in documents as a painter and not as an illuminator, the only other work undoubtedly by his hand is a dedication miniature in a Bible given to Charles V by his counsellor Jean de Vaudetar in March 1372 (Rijksmuseum Meermanno-Westreenianum, The Hague; MS. 10 B 23). A Latin inscription facing the miniature tells us it was painted by order of King Charles, and also that John of Bruges, painter to the King, made it with his own hand. The painting shows the counsellor kneeling and presenting a Bible to the seated King, who is dressed in the gown and close-fitting cap of a Master of the University of Paris. Grisaille painting gives a sculptural effect to the figures, and the setting is presented in a sophisticated way by the perspective treatment of the floor pattern and the implication that space continues behind the arch of the frame. The rest of the Hague Bible is lavishly illustrated in styles associated with the workshop of the Maître aux Boqueteaux, so-called because of the clumps of little umbrella-like trees (or *boqueteaux*) featured in his landscapes. Juxtaposition of this Master's work with the authenticated work of Bondol has led some authorities to identify him with this illuminator. The evidence is inconclusive. Tendencies towards an earthy realism, often regarded as characteristically Flemish, may well have been intensified by the influence of Bondol on other Flemish artists working in Paris from the 1350s onward and employed by Charles V as illuminators.

Bonington Richard Parkes
1801–28

Richard Parkes Bonington was born in Arnold near Nottingham, where his father was a drawing master. In 1817 the family moved to Calais, France, where Richard's father set up a lace factory. Here Richard received tuition from François Louis Francia, who was familiar with the Girtin school of English watercolor painting. Thus Bonington's initial teaching was within the English tradition. About 1818, while studying Flemish artists in the Louvre, Bonington met Eugène Delacroix. Afterwards he entered the École des Beaux-Arts and became a pupil of Baron Gros.

Before his debut at the 1822 Salon, where he exhibited watercolors of Normandy, Bonington toured northern France. In

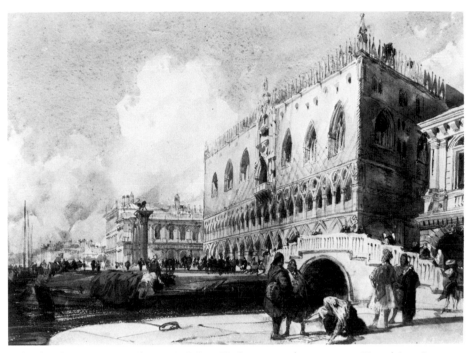

Richard Parkes Bonington: The Doge's Palace, Venice; watercolor; 20×27cm (8×11in); c1827. Wallace Collection, London

1823 he made a tour of medieval towns, the probable basis of his lithographs for Baron Taylor's *Voyage Pittoresque dans l'Ancienne France*. Bonington's prowess in landscape is again evident in five contributions to the "English" Salon of 1824. In 1825 he visited England with Delacroix and was impressed by the work of Turner. After this, Bonington and Delacroix shared a studio in Paris and their close friendship influenced the development of both artists. Bonington began to paint "costume pieces" with themes drawn from medieval history. In 1826 he traveled in Italy, studying the Venetian school, and in 1827 exhibited views of Venice as well as history pieces in the Salon: a mastery of rich color and atmosphere replaced an earlier affiliation to cool grays and greens.

Ill with consumption, Bonington returned in 1828 to England where he exhibited at the British Institution and at the Royal Academy of Arts. He died in London—his funeral cortege was led by Sir Thomas Lawrence and representatives of the Academy.

Bonington worked in both watercolor and oil, rapidly developing a luminosity and breadth of style which were later to engage the attention of Corot. His costume pieces and picturesque landscapes place him firmly within the Romantic tradition.

Bonnanus of Pisa 12th century

Bonnanus of Pisa (also known as Bonnano or Bonnano da Pisa) was a bronze-founder who, in the 1180s, cast two doors for Pisa Cathedral, only one of which survives. These were followed in 1186 by a bronze door for Monreale Cathedral in Sicily. Unlike the Carolingian bronze doors at Aachen, the Ottonian at Hildesheim, and the Romanesque at Gniezno (Poland), which are cast as two complete halves, the Italian bronze doors consist of small panels, which are then nailed on to a wooden core. Bonnanus, like most Pisan artists of the Romanesque period, was profoundly influenced by Byzantine art: some of his reliefs are copies of Greek ivories. Andrea Pisano (c1290–1348/9) must have known Bonnanus' work when he revived the art of casting doors in Florence in 1330.

Bonnard Pierre 1867–1947

The French painter, book-illustrator, and graphic artist Pierre Bonnard was born near Paris. He studied law from 1885 to 1888, but after failing his examination he attended classes at the École des Beaux-Arts and then at the Académie Julian, where he met Maurice Denis, Paul Sérusier, and Jean Édouard Vuillard. In 1889, he produced his first poster, *France-*

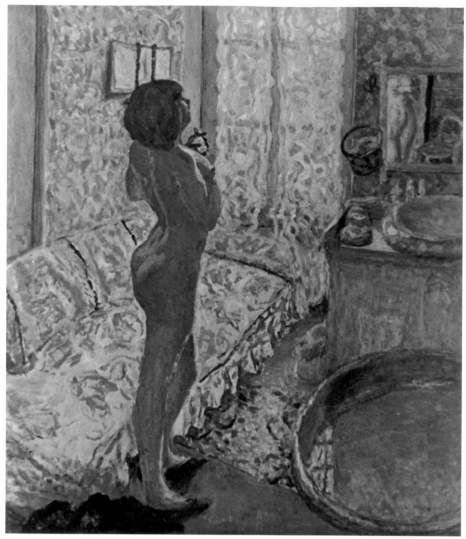

Pierre Bonnard: Standing Nude; oil on canvas; 125×109cm (49×43in); c1908. Musées Royaux d'Art et d'Histoire, Brussels

Post-Impressionist palette (and he absorbed the lessons of Monet and Renoir, especially in their late styles). He also produced more landscapes. Yet he always remained a devotee of the human figure, expressed above all in an extensive series of nudes. A "dry" middle period produced its reaction. Color and light flooded back into his pictures, and pattern and texture were now combined with a taut, simple composition.

Further reading. Fermigier, A. *Pierre Bonnard*, New York (1987).

Bordone Paris 1500–71

The Trevisan painter Paris Paschalinus Bordone worked principally in Venice and was trained there by Titian. The starting point for his many paintings of the Madonna and Child with saints seated in a landscape is Titian's early work; but his style, both in figures and landscape, gradually becomes more Mannerist, with oddly tilted figures, sharply silhouetted planes, and artificial foliage.

His *Bathsheba* (Wallraf-Richartz-Museum, Cologne), typical of a number of quasi-erotic paintings with nudes, shows these qualities. It displays, too, a charac-

Champagne. After military service (1889–1890) he took a studio in Paris with Vuillard. From 1891, he exhibited regularly at the Salon des Indépendants. He became friendly with the Natanson brothers and hence produced illustrations for *La Revue Blanche*; he produced theater designs for several avant-garde theaters and worked with Alfred Jarry.

A meeting with Ambroise Vollard in 1894 led to the publication of Bonnard's lithographs, *Quelques Aspects de la Vie de Paris* (1895), *Parallèlement* (1900), and *Daphnis and Chloë* (1902). In 1904, he illustrated Jules Renard's *Histoires Naturelles*. He met Maria Boursin in 1895. She became his mistress, his model, and in 1925 his wife. She died in 1940.

In 1896 Bonnard held his first one-man show at Durand-Ruel's gallery, but he subsequently signed an exclusive contract with Bernheim-Jeune. From 1900 he began to concentrate on painting. He knew both Renoir and Monet, and was a pall-bearer at Monet's funeral in 1926. He spent some of his time in the Seine Valley, where he

had a house, and some in the South, where in 1925 he bought a small villa at Le Cannet. He died there in 1947.

In the 1890s, Bonnard was a member of the group known as Les Nabis: they were influenced by Post-Impressionism, especially by Gauguin. They were also greatly attracted to Japanese prints, and none more so than Bonnard who was known as "Le Nabi Japonard". The Nabis wished to move away from what they considered the tyranny of the easel-picture: hence their contributions to poster and theatrical designs, to screens, tapestries, and book illustrations. Bonnard became a master of lithography, using shapes, color, and line with decorative wit and subtle changes of texture. His brilliancy as a designer in the 1890s matched that of Toulouse-Lautrec. His paintings of the same decade share similar features of flattened shapes and witty arabesques, but their *intimisme* is conveyed in dark, even somber colors, as though Impressionism and Gauguin had never existed.

After 1900, Bonnard began to use a more

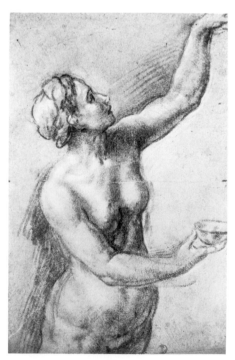

Paris Bordone: Nude Woman; black pencil and white chalk on blue card; 32×20cm (12½×8in). Uffizi, Florence

teristic contrast between a decorative front plane and an architectural perspective background, which creates a typically Mannerist dislocation of space. This artificial perspective vista is likely to have been suggested by the Renaissance theater; after Bordone, it finds its way into the early works of Tintoretto and El Greco.

Bordone visited Lombardy in the late 1520s and was influenced by Moretto and by Brescian painting. He also seems to have visited France.

Borrassá Lluís c1390–1424

The Spanish painter Lluís Borrassá was born in Gerona. He was the leading Catalan exponent of the International Gothic style which, at the end of the 14th century, succeeded the Italo-Catalan tradition founded by Ferrer Bassa (c1290–1348). He painted the altarpiece of the archangel Gabriel in Barcelona Cathedral by 1390; his later works include the altarpieces of Vich, Tarrasa, and Cruilles. His sense of color is characterized by powerful reds and greens, and careful use of light and shade. His works convey a striking impression of violent movement, for example, the Retable of Peter (1411–13; Museum of S. Maria, Tarrassa); and the Retable of S. Clara (1414–15; Episcopal Museum of Archaeology and Art, Vich): this manner is foreign to the essentially static traditions of earlier Spanish painting.

Borromini Francesco 1599–1667

The Italian architect Francesco Borromini was born at Bissone on Lake Lugano, the son of the architect Giovanni Domenico Castelli. After a stay in Milan, he arrived at Rome c1620. At this time, his relation Maderno was the architect in charge of St Peter's. After Borromini had worked for a while as a stone-carver on decorative features of the new Basilica, Maderno employed him as an architectural draftsman. In this capacity, he worked not only on St Peter's, but also on the Palazzo Barberini and on the church and dome of S. Andrea della Valle. After his kinsman's death in 1629, Borromini worked under Bernini, who was appointed architect to the first two of these projects. From the appearance of certain architectural details executed during this period, it would appear that Bernini allowed his assistant a certain freedom of action in matters of design. With the completion of the major part of

the Palazzo Barberini in 1633, the two architects parted company.

In the following year Borromini received his first independent commission, the design for the monastery of S. Carlo alle Quattro Fontane. Building began in 1638 and was completed by 1641, with the exception of the facade. Working on a small, irregular site, Borromini designed not only a masterpiece of compression, but also a highly innovatory work of art—a most important milestone in the history of High Baroque. Rejecting the modular system of proportion usual in Renaissance architecture, he constructed the church on a diamond configuration of two equilateral triangles laid base to base. The severe geometry upon which this design rests is mitigated by capacious niches that break through the angles of the diamond. The resultant effect is of a sinuous oval space. This is taken up by the true oval of the honeycombed dome, the whole being held in play by an attached colonnade and a powerful entablature. The basic forms of the church interior find some reflection in that of the monastery cloister—an essentially oblong space softened by convex curvatures at the corners and enlivened by the elongated octagonal disposition of the colonnade.

As early as 1632 Bernini had recommended Borromini to the authorities of the Roman Archiginnasio as the architect to complete their scheme for the Archiginnasio (later Rome University). In 1642 Borromini began their church, S. Ivo, at the east end of the cortile built by Giacomo della Porta in the previous century. By 1650 work was substantially complete. Once again, Borromini turned to the geometry of the equilateral triangle—this time interpenetrated to form a hexagon. He tamed the angles of this underlying construction by manipulating the wall space into three semicircular bays interposed with three straight-sided ones culminating in convex curvatures. This sophisticated spatial configuration is varied still further by the use of three different types of wall niche—major ones of alternating type forming a central element to each bay, framed by pairs of a smaller uniform type. Borromini kept this highly pitched composition in order with stringcourses, a giant order of pilasters, and a heavy entablature. The entablature emphasizes the hexagonal form upon which the whole ensemble is based, and serves as a secure foundation for the extreme verticality of

the dome which maintains this star shape up to the circular terminating point of the lantern. The exterior of S. Ivo was as innovatory as its interior. On the outside the fundamentally hexagonal drum appears as a lobed circle. In place of an orthodox dome, this is surmounted by a stepped pyramid, itself vertically divided by concave ribs which spring outwards from the center to be let down by pedestals on to the perimeter of the drum. The lantern is also six-sided, consisting of paired columns framing concave faces which contrast with the convex forms of the dome and drum. Above this the building terminates in a remarkable ziggurat-like spiral.

With its complex and unorthodox orchestration of form, its rhythmical sense of movement and its dramatic intensity, S. Ivo was Borromini's masterpiece. Although he never surpassed this work as an artistic statement, he received many other important commissions. In 1646 he was faced with the difficult task of restoring the decayed interior of the Lateran basilica while preserving the old fabric. The architect resolved these contradictory requirements by encasing consecutive columns of the nave within a series of broad pillars, each framed by a pair of giant pilasters echoing the original disposition of the interior. In 1653 he was asked to complete the church of S. Agnese in Agone (Piazza Navona), which Rainaldi had begun the previous year. Borromini was only in charge of the work for two years before work was suspended, to be resumed two years later by the original architect. By careful alterations to the plan, Borromini succeeded in leaving his characteristic stamp of monumentality and spatial variety upon the ultimate design. The interior was recast as an octagon, enlivened by wall openings of varying size, and ennobled by a lofty drum; the facade was redesigned as a concave form with a slight central projection, the whole framed by two lofty towers.

Between 1653 and 1665, Borromini turned to S. Andrea delle Frate, adding a massive dome with a contrasting tower of intriguing complexity. During the 1650s, he began S. Maria dei Sette Dolori which remained unfinished on his death. In 1662 he began the church of the Propaganda Fide—to a daring design in which the verticals of the wall pilasters are continued by strips across the ceiling, forming a net vault. Between 1665 and 1667 he returned

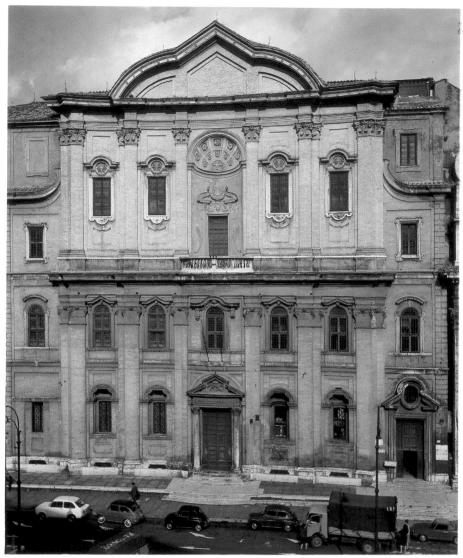

Francesco Borromini: the facade of the Oratory of St Philip, Rome; begun in 1637

Further reading. Blunt, A. *Borromini*, Harmondsworth (1979). Portoghesi, P. "Borromini, Francesco", *Encyclopedia of World Art* vol. II, London (1960). Portoghesi, P. *Borromini nella Cultura Europea*, Rome (1964). Wittkower, R. *Art and Architecture in Italy: 1600–1750*, Harmondsworth (1973). Wittkower, R. "Francesco Borromini, his Character and Life" in Wittkower, R. *Studies in the Italian Baroque*, London (1975).

Bosch Hieronymus *c*1450–1516

Hieronymus Bosch spent his working life in 's-Hertogenbosch, a peaceful Dutch city. References to his life and to professional transactions occur in the municipal archives from 1474, and in those of the Brotherhood of our Lady, of which Bosch was a member from 1486 to 1516. Apart from these few documented facts, information is sparse. Nothing is known of Bosch's training or journeys, there are no dated or datable paintings, and his iconography is unusual and often baffling. Both his subject matter and his free and painterly brushwork, which contrasts sharply with the jewel-like brilliance of the Eyckian tradition, set him apart from the mainstream of Flemish art.

Bosch's outlook was deeply pessimistic and his art gave vivid expression to the profound anxieties that troubled the human mind as the Gothic world drew to its close. He was obsessed by sin and depravity, by the snares laid by the devil for the unwary human soul on its perilous journey through this life, and by the torments of hellfire. Bosch's powerful imagination created a haunted world where good and evil wage perpetual war. It is filled with strange monsters and hideous plants bearing evil fruits; fantastic structures and strange mineral forms are scattered through fiery landscapes. Yet, despite its difficulties, Bosch's art must be examined in the context of the orthodox religious beliefs of his time. Many of the sources of his iconography may be found in contemporary language, proverbs, and folklore, and in late medieval sermons and visionary poetry.

Bosch's chronology is highly controversial. A small group of biblical scenes and didactic genre paintings, characterized by

to his first church, S. Carlo alle Quattro Fontane, to execute the facade. This consists of three two-story bays—a convex center, framed by concave elements. The horizontal "ripple" this imparts is matched by a vertical movement as the central bay abruptly switches from convex to concave at mid-upper story height before terminating in an oval medallion, which projects diagonally forwards and upwards. Although Borromini's fame rests primarily upon his church designs, he also executed a number of domestic buildings. The most important of these are the Oratory of St Philip Neri (1637–50), the Collegio di Propaganda Fide (1646–67), and the remodeling of the Palazzo Falconieri (*c*1640).

Borromini is a fascinating contrast to his great contemporary Bernini. The latter was an outgoing man of the world, the former a brooding melancholic who ultimately committed suicide. Bernini was an all-rounder, as much a sculptor as an architect; Borromini was an architectural specialist of great technical expertise. Like the rest of his contemporaries, Bernini sought to enhance the Renaissance tradition, which he could not seriously call into question. Borromini, on the other hand, broke with the past by a combination of fearless invention and respect for geometrical form and structural principles: it is precisely these characteristics that his work shares with the Gothic buildings it sometimes seems to imitate. And it was these same qualities that made Borromini the most revolutionary architect of his day.

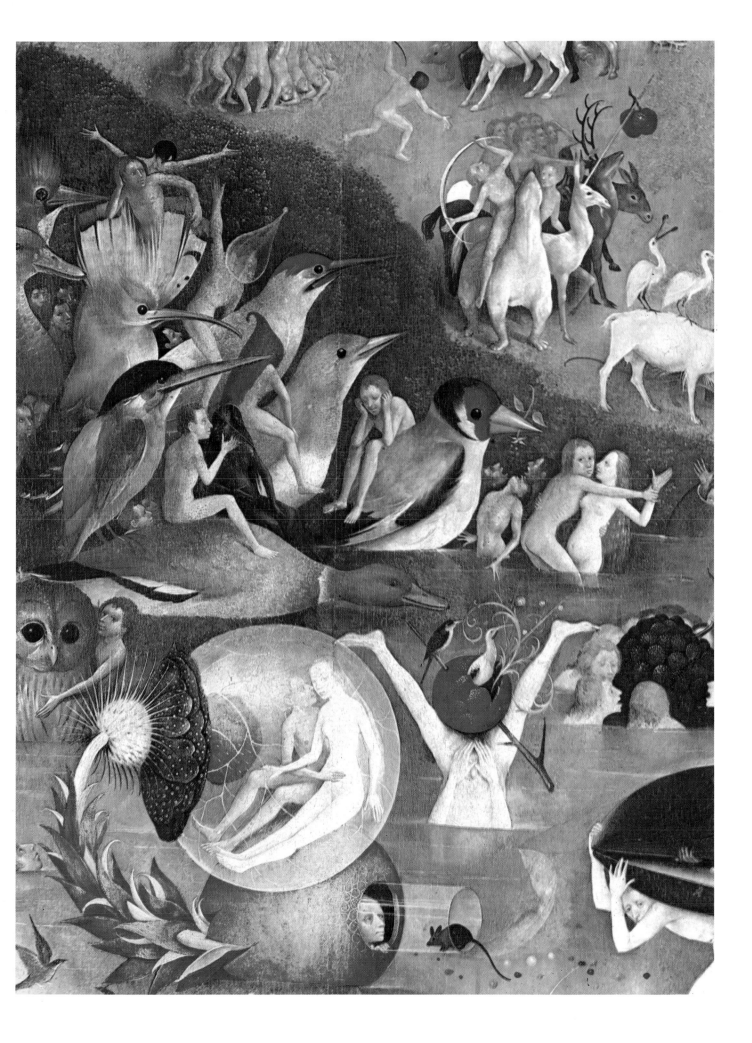

stiff, awkwardly placed figures and hard, sharp brushwork, are generally accepted as early works. The themes of the genre paintings—*The Ship of Fools*, (Louvre, Paris), *The Stone Operation* (Prado, Madrid), and the *Seven Deadly Sins* (Prado, Madrid)—are those of contemporary satirical writing. Bosch castigates the vices of charlatans and quacks, of rich men, and of lecherous monks and nuns.

Two important triptychs, *The Last Judgment* (Alte Pinakothek, Munich) and *The Haywain* (Prado, Madrid), stand at the center of Bosch's middle period (c1485–1500). In the central panel of *The Last Judgment* Bosch created a highly original hellish landscape, infested by a swarm of devils and covered by burning pits and furnaces, bizarre constructions, and instruments of torture. Many of the monsters are half animal, half human. Others combine animal forms with inanimate ones, and startling juxtapositions of scale increase the horror of the effect—as in the egg, pierced by an arrow, that scuttles about on booted legs. Some of Bosch's imagery is developed from traditional medieval symbols and he was further inspired by the grotesques that appear on medieval manuscripts; yet there is no precedent for the extraordinary fertility of his invention.

The subject of *The Haywain* was new in Netherlandish art. The inner and outer wings show the Creation and Fall of Man (inner) and Hell (outer). On the central panel a crowd of demons pulls a vast haycart, with a pair of lovers on top, towards hell. Behind ride dignitaries of Church and State, while beside it an unruly mob fight over handfuls of hay. Their greed and depravity is the subject of the painting. Bosch's source was a contemporary ballad or proverb; the hay also symbolizes the worthlessness of all material gain.

The Deadly Sin of Lust is almost certainly the subject of Bosch's most difficult triptych, *The Garden of Earthly Delights* (Prado, Madrid), probably painted after 1500. The central panel, again set between the Creation of Man and Hell, shows a garden landscape of enchanting and fragile beauty, painted in pearly pinks and blues. Here, groups of small nude figures, spread out decoratively as though on a tapestry, indulge in every kind of sexual activity. They ride on beasts, cavort in ponds and streams, nibble at luscious fruits, and entwine themselves with giant birds. Almost all the details are erotic symbols drawn

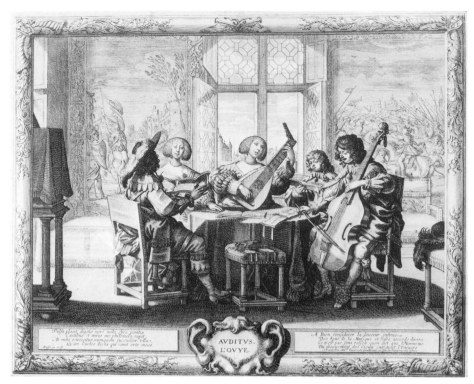

Abraham Bosse: Hearing, from the series The Five Senses; etching. Metropolitan Museum, New York

from contemporary folklore. Bosch certainly intended to represent not innocence but depravity; the surface beauty of the painting underlines the alluring and deceptive pleasures of sin, and the soft fruits symbolize the transience of carnal pleasure.

Especially in his later years, Bosch was fascinated by the temptations and torments that beset those hermits and holy men who sought to achieve union with God by a life spent in contemplation and mortification of the flesh. A series of paintings on this theme culminates in the brilliantly colored, signed triptych of *The Temptation of St Anthony* (c1500; National Museum of Art, Lisbon). Bosch drew the details of the story from the *Lives of the Fathers* and *The Golden Legend*. The left and right wings show traditional scenes—the saint attacked by demons and rescued, unconscious, by his friends, and his temptation by a naked devil-queen. The central scene, however, is far more complex and its details have been interpreted in many different ways. St Anthony, his hand raised in blessing, kneels before a ruined tomb. He is surrounded by a throng of devils who symbolize the temptations that had beset him in the desert. They cluster and press around him with a terrifying intensity, and many of their bodies are fearsome mixtures of human, animal, and inanimate forms.

Bosch painted many other traditional Christian subjects from the life of Christ, especially scenes from the Passion. The

triptych of the *Adoration of the Magi* (Prado, Madrid) is one of his most baffling works. The scene takes place before a dilapidated hut, in which lurks a crowd of men with menacing faces and bizarre clothing. Their presence has never been satisfactorily explained, but they suggest the universal conflict of good and evil: reminders of the all-pervading presence of evil recur throughout the splendid panoramic landscape which links the three panels. A series of half-length paintings of the Passion of Christ, which may date from late in Bosch's life, are more straightforward. These exploit to the full the contrast between Christ's humility and the bestiality of his persecutors. In Bosch's last Passion scene, *Christ carrying the Cross* (Museum of Fine Arts, Ghent), the deformed and leering faces of the mob are grotesquely ugly. Yet Christ remains aloof and serene; his carrying of the cross promises a victory over evil which was Bosch's final message.

Further reading. Galdass, L. von *Hieronymous Bosch*, London (1960). Gibson, W. *Hieronymous Bosch*, London (1973). Whinney, M. *Early Flemish Painting* London (1968).

Bosse Abraham 1602–76

The French print-maker and book-illustrator Abraham Bosse wrote one of the first treatises on engraving. His early work consists of illustrations to novels and re-

ligious books. During the 1630s he produced prints illustrating contemporary life, including the *Mariage à la Ville* and *Mariage à la Campagne* series, 1633. He also produced biblical prints, notably the *Wise and Foolish Virgins* series (c1635) in which the figures are depicted in contemporary bourgeois costume.

Botero Fernando 1932–

Botero was born in the remote provincial capital of Medellín, Colombia. By the age of 16 he was contributing illustrations to the local newspaper, *El Colombiano*, and in 1951 was given his first one-man show in Bogotá. His early watercolors were influenced by Orozco (1883–1949) and Picasso (1881–1973). From 1952 to 1955 he lived in Europe, studying at the Academy of Fine Arts of San Fernando in Madrid and subsequently in Florence, spending vacations in Paris. Although he was interested in modern art, he concentrated on the Old Masters in the Prado, the Louvre, and in Italy. By the late 1950s he was elaborating his idiosyncratic mature style. He has described a crucial discovery made when seeing how a small mark placed on the drawing of a mandoline emphasized its plasticity and monumentality. He began to treat all his subject matter in this way, rendering figures, fruits, still lives, and landscapes in huge, visually powerful forms. Images that he plundered from such European painters as Mantegna, Velazquez, Rubens, Ingres, Manet, and Bonnard he dealt with in the same way, sometimes subtly altering the original. When asked why he painted fat figures, he replied, "I don't. They all look rather slim to me." His figures are not so much fat as rendered formally massive through carefully adjusted changes of scale.

The world Botero creates is imaginary, a poetic distortion of the ordinary world, but rooted in Latin America. "Latin America is one of the few places left in the world which can be transformed into myths", he said. "People have a cloudy idea about Latin America and that is a good thing for an artist. Places which have been overexplained and overexposed offer little possibility for poetic transformation..." Botero finds this transformation easier at a distance, and having lived in Mexico City and in the U.S.A. now lives in Paris. He draws his subject matter from the provincial towns of his youth: parents and children, priests, nuns (as in *The Nun*,

1979; private collection), bishops, cardinals, soldiers gaze impersonally out of the canvas as in anonymous *ex-votos* (see, for example, his *New-born Nun*, 1975, and *Mother Superior Levitating*; both in private collections). He has made sculptures based on the figures in his oil paintings, and he also draws abundantly. The sensual brilliance of his color, particularly in his studies of tropical fruit (for example, *Still Life with Water Melon*, 1974; Collection of Mrs Frances K. Lloyd, Paris), is sometimes unjustly overlooked.

Both Jan c1618–52

Jan Both was a Dutch landscape painter and etcher. After training under Bloemaert in Utrecht he traveled to Rome, where between 1638 and 1641 he developed a style of painting which was to make him, along with Asselijn, Dujardin, and Nicolaes Berchem, one of the principal Dutch "Italianizing" landscapists of the mid 17th century. Claude's ideal landscapes of the Roman Campagna, with their warm, golden light and Arcadian settings, were a decisive influence, although Both's own paintings reveal a rather more objective, precise approach to naturalistic detail and light effects. His views are less often imaginary than Claude's, and he tended to replace figures from myth or legend with peasants, travelers, or such motifs as artists sketching. These figures and the grazing animals in Both's scenes may sometimes have been the result of collaboration with other painters. Both was instrumental in popularizing Italianate landscapes in Holland, and his serene views with their

Fernando Botero: The Nun; oil on canvas; 150×170cm (59×67in); 1979. **Private collection**

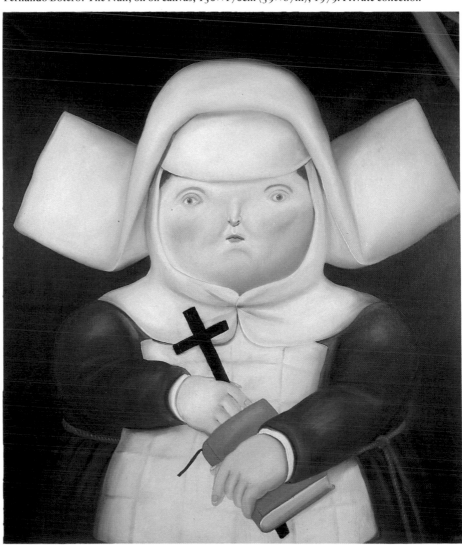

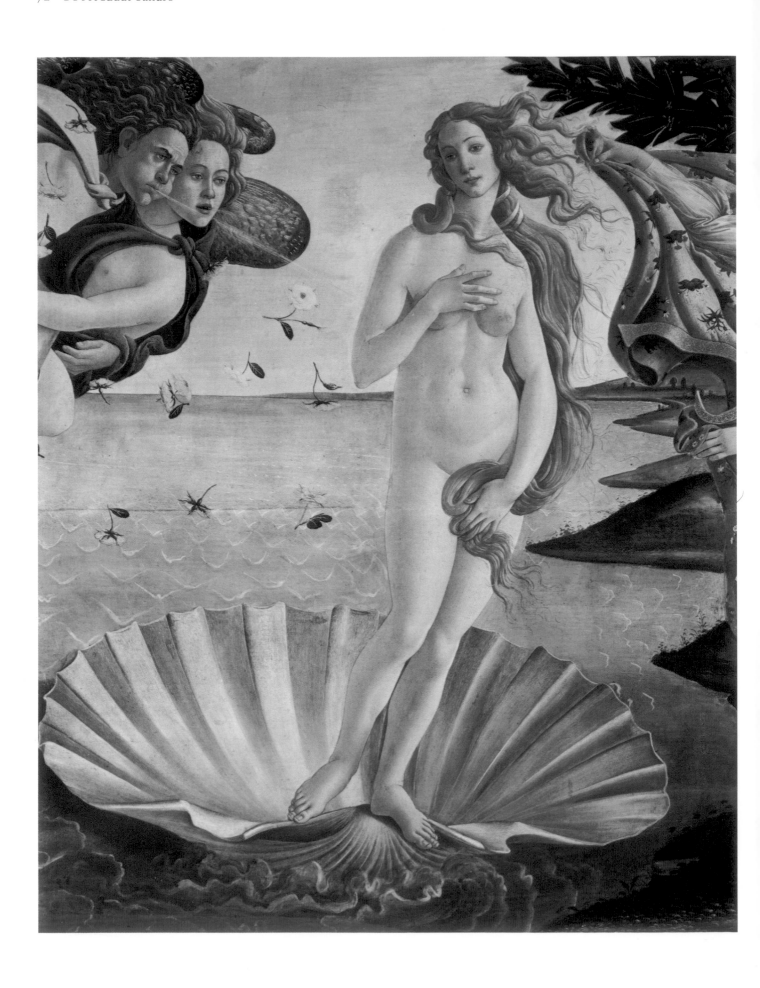

mellow light effects were also influential on those artists such as Aelbert Cuyp (1620–91) who remained faithful to their native scenery. He painted a few pictures of the Dutch countryside himself, but it was his Italianate landscapes that collectors admired, and which gave him an international reputation until the mid 19th century.

Botticelli Sandro 1444–1510

The nickname "Botticelli", meaning "little barrels", was given to Alessandro dei Filipepi, one of the leading Italian painters of the Florentine school. Vasari describes him as the pupil of Filippo Lippi, and he was probably among that master's assistants during the painting of the frescoes at Prato and Spoleto in the 1460s. He is also mentioned as being a member of the Compagnia di San Luca in Florence "with" Filippino Lippi in 1472. His first datable work is *Fortitude* (Uffizi, Florence) for which he was paid in 1470. This panel was intended for the Council Room of the Mercatanzia in Florence, together with six other personifications of Virtues by Piero del Pollaiuolo. It is therefore not surprising that the work of that artist proved an important influence on Botticelli. The linearity of contour this new contact brought about can be seen particularly clearly in *St Sebastian* (Staatliche Museen, Berlin) which was apparently dated January 1473 on its original frame.

From 1474 Botticelli's name appears regularly in the account books of members of the Medici family, for whom he painted banners, portraits, and altarpieces as well as paintings with allegorical or mythological subject matter. The *Adoration of the Magi* (c1477; Uffizi, Florence) which originally hung in the church of S. Maria Novella, contains portraits of several members of the Medici family and other prominent Florentine citizens. The composition, with its strong pyramidal structure and partly architectural background, acts as an important predecessor to Leonardo's unfinished *Adoration* of 1481–1482. A similar solidarity and mastery of spatial contruction is seen in the frescoed figure of *St Augustine* painted by Botticelli at the same time as Ghirlandaio's compan-

Jan Both: A View on the Tiber near the Ripa Grande, Rome (?); oak panel; 43×56cm (17×22in). National Gallery, London

ion fresco of *St Jerome*, which is dated 1480.

In the following year Botticelli, with Ghirlandaio, Perugino, and Cosimo Rosselli, was called to Rome by Pope Sixtus IV to decorate the walls of the Sistine Chapel with scenes from the Old and New Testaments. Botticelli was in control of the scheme and executed three of the frescoes: *The Story of Moses, The Punishment of Korah,* and *The Temptation of Christ.* The large scale of these works and the attempt to include several stages of narrative in one composition were not fully mastered by the artist: they remain confused and disorganized.

Botticelli's allegorical paintings, his most successful and best-known works, are largely undocumented but should be dated in the late 1470s. Their precise meaning, as well as the circumstances surrounding their commissioning, is still uncertain. The *Primavera* (Uffizi, Florence) was probably painted for Lorenzo di Pierfrancesco de' Medici (a member of a cadet branch of the family) to hang in the Villa di Castello which Lorenzo bought in 1477. The theme was almost certainly provided by the Humanist Poliziano, and concerns Mercury with the three Graces, Spring, Flora, and a nymph being pursued by Zephyr or

the North Wind. Precise identification of the figures is frustrated by the fact that Botticelli's female types rarely change, whether he is depicting the Virgin Mary, Pallas, or Venus. This observation has led Sir Ernst Gombrich, among others, to believe that the allegories were partially intended as exemplars, with Venus and Pallas representing Beauty and Reason. The *Primavera* is clearly related to *The Birth of Venus* (Uffizi, Florence), in which the precise event depicted is clearer. Complex political undertones have been read into *Pallas and the Centaur* (Uffizi, Florence), in which the Medicean connection is stressed by the family emblems adorning Pallas's gown. To these allegories must be added Botticelli's exquisite illustrations to Dante's *Inferno*, drawn for Lorenzo di Pierfrancesco de' Medici (now divided between the Staatliche Museen in West and East Berlin and the Vatican Library, Rome). Apart from his works for members of the Medici family, Botticelli received many commissions from other prominent members of Florentine society. Among his allegorical paintings these included an important (but now fragmentary) series of frescoes at the Villa Lemmi, which probably commemorated the marriage of Lorenzo Tornabuoni to Giovanna degli

Albizzi in 1486 (Louvre, Paris). *Mars and Venus* (National Gallery, London) was probably painted for a member of the Vespucci family. Although we know nothing about the commissioning of the *Calumny of Apelles* (c1495; Uffizi, Florence), Vasari reports having seen it in the house of Fabio Segni.

Both the *Calumny* and the Dante illustrations can be dated on stylistic and historical evidence to the last decades of the 15th century. In them we see a heightening of emotion, an elongation of human proportions, and the development of a swirling and swaying movement which is more characteristic of late Gothic than of Renaissance art. These antinaturalistic tendencies of Botticelli's late works are seen at their most extreme in religious works: the *Allegory of the Cross* (William Hayes Fogg Art Museum, Cambridge, Mass.), the Munich *Pietà* (Alte Pinakothek, Munich), and the *Mystic Nativity* (1500; National Gallery, London). All of these are datable to the last decade of the artist's life, and are related to the preaching activity of Savonarola in the 1490s. In the *Mystic Nativity*, Botticelli's only signed work, the scale of the figures is decided by their relative importance rather than their distance from the viewer: the dramatic intensity resembles the work of contemporary artists of northern Europe (particularly Grünewald) rather than that of any Italian of the period.

The *Mystic Nativity* is Botticelli's last major work, although he did not die until 1510, nine years after it was completed. His previous standing among the leading artists of his day ensured that even though the new generation of artists, such as Leonardo, Raphael, and Michelangelo, received the most important commissions, Botticelli's opinion was still valued. In 1502 Francesco Malatesta suggested to Isabella d'Este that Botticelli should be invited to complement Mantegna's contribution to her Studiolo, and two years later he was among those who were called upon to decide on the placing of Michelangelo's *David* in Florence.

Further reading. Deimling, B. *Sandro Botticelli*, Cologne (2000). Ettlinger, L.D. and H.S. *Botticelli*, London (1976). Gombrich, E. "Botticelli's Mythologies", *Journal of the Warburg and Courtauld Institutes* vol. VIII, London (1945). Santi, B. *Botticelli*, New York (1986). Venturi, L. *Botticelli*, London (1961).

Botticini Francesco 1446–97

The Florentine painter Francesco Botticini trained under Neri di Bicci. His only documented work is the *Tabernacle of the Holy Sacrament* (Galleria della Collegiata, Empoli), commissioned in 1484, delivered in 1491, then finished by his son Raffaello in 1504. All other works are attributions. Their variety of styles betrays a variety of influence—Verrochio, Antonio Pollaiuolo, and Botticelli among others. This may indicate a rather unimaginative eclecticism or possibly the inclusion in his oeuvre of works not actually his. The *Assumption of the Virgin* (c1474–6; National Gallery, London) is a rare instance in the Quattrocento of the depiction of a heresy.

Bouchardon Edmé 1698–1762

Born at Chaumont, the son of a provincial sculptor, Edmé Bouchardon was a pupil first of his father and later, in Paris, of Guillaume I Coustou. In 1722 he won the first prize for sculpture at the Académie in Paris, and the following year left for Rome. He was to remain there for nine years, gaining considerable fame. His bust of Philipp Stosch (1727; Staatliche Museen, Berlin) in strict classical Roman form is representative of this period. Bouchardon was the champion of the return to classical values in French sculpture; his style is a complete antithesis of that of Jean-Baptiste Lemoyne, who represents the Rococo current. He was an artist of reason and

Francesco Botticini (attrib.): Madonna and Child; panel; 81×66 cm (32×26 in). Brooks Memorial Art Gallery, Memphis, Tenn.

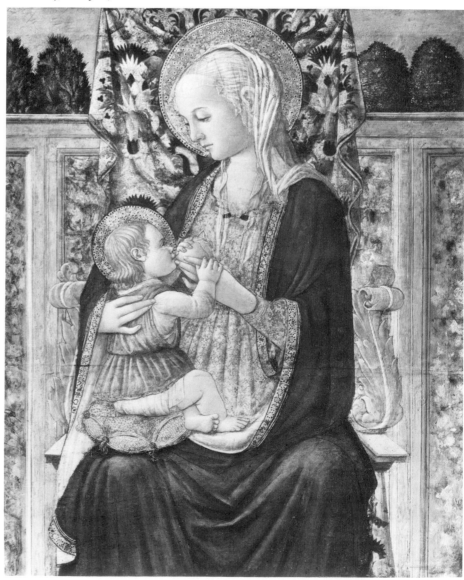

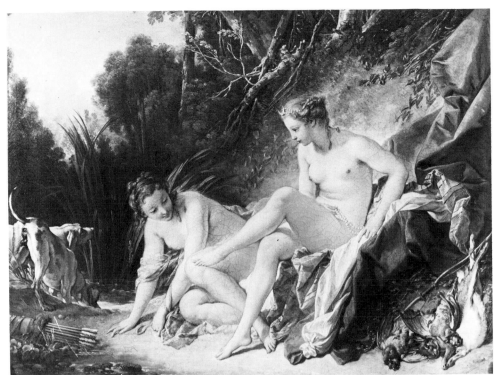

François Boucher: Diana Resting after her Bath; oil on canvas; 57×73cm (22×29in); 1742. Louvre, Paris

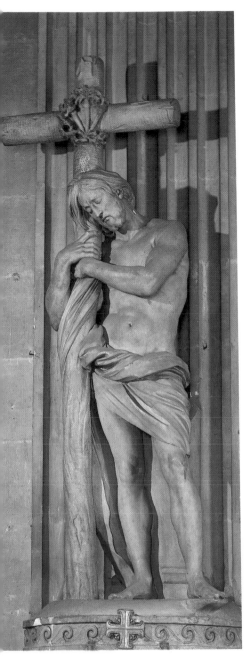

Edmé Bouchardon: Christ at the Column; stone; height 240cm (94in); c 1735. St-Sulpice, Paris

intellect, rather than of passion and expression; his work appealed to the intelligentsia of the time rather than to the King, who preferred Lemoyne.

In his day Bouchardon was thought to be the greatest sculptor alive—a reputation not wholly deserved. His art has proved a little too frigid and cerebral for the taste of later generations. Bouchardon was one of the finest draftsmen of his time, and his monumental sculpture, such as the fountain of the Rue de Grenelle, Paris (commissioned in 1739), is superbly designed. In his last years he was occupied with the colossal equestrian statue of Louis XV for the Place de la Concorde. The work was designed as a reevocation of a Roman Imperial monument; it was completed after Bouchardon's death by Jean-Baptiste Pigalle, and was destroyed during the Revolution.

Boucher François 1703–70

The French artist François Boucher was born in Paris. The son of a minor painter, he spent some months as a pupil of François Lemoyne. However, his talents as a draftsman attracted him to book illustration, and he worked for the prolific engraver J.F. Cars. This in turn led him in the early 1720s to work on the *Oeuvre Gravée* of Watteau, sponsored by Jean de Jullienne. His intense study of Watteau's works confirmed his spirited and graceful draftsmanship, his sense of fantasy, and his fine observation. The results of this influence are to be seen in his elegant and celebrated illustrations to an edition of Molière's works (1734). Meanwhile, he had won the *Prix de Rome* in 1723, and traveled to Italy in 1728. He spent three years in Rome and almost certainly north Italy and Venice. He took note of the lighter aspects of late Baroque and Rococo art in Rome, where Franco-Italian artistic relations were close.

His reception piece for the Académie, *Rinaldo and Armida* (1734; Louvre, Paris) already displays the amorous subject matter, graceful style, and artificial color of his maturity. In the same year, Oudry employed him as a designer at the tapestry works in Beauvais. Among his most delightful and amusing designs for Beauvais are those with fanciful Chinese subjects (oil sketches c1742; Musée des Beaux-Arts, Besançon) for the *Chinese Tapestries* given by Louis XV to Emperor Ch'ien Lung of China, which reveal Boucher's brilliance and facility. In 1755, he was made Inspector of the Gobelins tapestry works. Working on tapestry design encouraged the decorative qualities of Boucher's art, and many of his paintings were made for a specific decorative context. Thus, together with other artists, he executed paintings for the new Rococo rooms at the Hotel de Soubise by Boffrand, and for the *Petits Appartements* at Versailles in the mid–late 1730s. His work perfectly suited the smaller and more intimate scale of 18th-century Parisian interiors. His subjects are mainly shepherds and shepherdesses, or minor gods and goddesses, sporting in impossibly pastel Arcadian landscapes.

With the ascendancy of Madame de Pompadour in the favor of Louis XV, during the 1740s, Boucher found a ready patroness: their names will always be linked, Boucher expressing her fashionable and influential Rococo taste. He also made some sensitive and cultivated portraits of her. The most important pictures that Boucher painted for her are the *Rising-* and the *Setting of the Sun* (1753; Wallace Collection, London); these were originally designed as tapestry cartoons, but were completed and acquired for Madame de

Eugène Boudin: Entering the Port of Le Havre; oil on canvas; 42×55cm (17×22in); 1864. Private collection

Pompadour's Château de Bellevue. They represent Boucher's grand manner, and mark the high point of his career. In 1765, he was made First Painter to the King, and Director of the Académie.

By the 1760s Boucher's pictures had become rather cluttered and his style more mannered. His work failed to appeal to that rising taste for a more "serious" art which culminated in Neoclassicism, and he was increasingly attacked by critics such as Denis Diderot.

Boucicaut Master fl. c1400–c20

The Boucicaut Master is the name by which the anonymous artist of a Book of Hours made for the Maréchal de Boucicaut c1405–8 (Musée Jacquemart-André, Paris, MS. 2) is known. The 42 full-page miniatures in this work supply the basis for further attributions to the artist or his workshop, and show that he was extremely active in Paris during the first two decades of the 15th century.

The Boucicaut Master ranks as one of the important forerunners of 15th-century Flemish realism. His outstanding innovations were in landscape painting, where he was a pioneer of aerial perspective (for example the *Visitation* in the Boucicaut Hours), and also in the development of architectural interiors conceived as realistic settings for figure compositions. In religious manuscripts, church interiors are often associated with the scene of the Annunciation or with the celebration of the Mass for the Dead (for example the Book of Hours MS. 16997 in the British Library, London). Domestic settings that encourge the depiction of naturalistic detail are also explored. The most sumptu-ous is in the *Dialogues de Pierre Salmon* (Bibliothèque Publique et Universitaire, Geneva); it shows Charles VI receiving Salmon in the presence of princes. The consistency with which he pursues the investigation of these specific artistic problems distinguishes his entire career.

In Paris the Boucicaut Master clearly associated with the most distinguished artists and patrons of his time. His "international style" developed there, but it also owes much to Italy and Flanders. Numerous surviving works, now scattered throughout the world, include a Book of Hours bearing the arms of the Visconti family of Milan (Biblioteca Reale, Turin).

The identification of the Boucicaut Master with Jacques Coene, a member of a family of painters in Bruges, has been suggested. Coene was living in Paris in 1398, when he dictated notes for a treatise

on painting (published in Merrifield, M. *Original Treatises dating from the 12th–18th centuries on the Arts of Painting . . .*, London, 1849). In 1399 he was sent to Milan to design the Cathedral; but he returned to Paris before 1404, when he was one of three artists illustrating a Bible commissioned by Philip the Bold, Duke of Burgundy. No authenticated works by him are known to survive, but his identification with the Boucicaut Master would be compatible with the origins of the latter's style.

Boudin Eugène 1824–98

The French painter Eugène Boudin was born in Honfleur. In 1844 he opened a stationery shop in Le Havre, the town in which he met Constant Troyon, Eugène Isabey, Thomas Couture, and Millet. He became a painter in the late 1840s, studying in Paris and the Low Countries, and began to paint coastal scenes in the 1850s. He met the young Monet c1856, and introduced him to landscape painting. Boudin is best known for his paintings of Trouville beach, from 1862 onwards (of which there are many examples in the Nouveau Musée des Beaux-Arts, Le Havre), which show the resort's fashionable holidaymakers. He also traveled widely to paint—to the Low Countries, to Venice, and all over France. He greatly valued the spontaneity of his first impressions of nature, but seems to have worked up his paintings in the studio.

Bourdon Sébastien 1616–71

The French painter Sébastien Bourdon was born in Montpellier. After living for some time in Paris, he spent the years 1634–7 in Rome. Here he imitated the styles of the Bambocciati and Castiglione, as well as those of Poussin and Claude. He visited Venice, then returned to Paris. He was appointed Court Painter to the Queen of Sweden in 1652. Returning to Paris in 1654 he then spent the years 1659–63 in Montpellier. Bourdon is the perfect mirror to the development of French 17th-century painting (and its fashionable expansion through Europe) because of his imitative abilities. He moved from genre scenes, which always sold well, to imitations of Claude that verged on fraud (hence Claude's *Liber Veritatis*—to protect him against copyists). He found success in Paris with a loose, Venetian-based Baroque

style, and also as a portrait-painter. But in the mid 1650s he adopted the very severe manner of Poussin, as in his *Martyrdom of St Andrew* (Musée Fabre, Montpellier).

Bourgeois Louise 1911–

The French-born American artist Louise Bourgeois studied mathematics at the Sorbonne, Paris, then art at the École de Louvre, the Académie des Beaux-Arts and in the studio of Ferdinand Léger. She emigrated to America in 1938 and in the 1940s produced totem-like sculptures consisting of slender wooden forms (often painted black or white) loosely suggesting groups of human figures. Sensitive to the work of sculptors such as Isamu Noguchi,

she had by the 1960s evolved her mature style. Using latex and plaster, she created a variety of semi-Abstract forms which, with breast-like domes, phallic columns, fleshy openings and deep hollows, are strongly if obscurely reminiscent of the body, with a sometimes disturbingly visceral, fetishistic quality, as in *The Quartered One* (1964–65; Museum of Modern Art, New York).

Further reading. Herkenhoff, P. and Storr, R. *Louise Bourgeois*, London (2003).

Bouts Dieric c1415–75

The painter Dieric Bouts, born in Haarlem, had settled in Louvain by 1457; he had married there c1448. His solemn works

Dieric Bouts: The Last Supper; oil on panel; 180×150cm (71×59in); c1464–7. St Pierre, Louvain

are full of religious feeling; they are deliberately restrained in gesture and expression, and occasionally border on a naive stiffness. He was a gifted colorist and exceptionally sensitive to the effects of light.

He was early influenced by Albert van Ouwater, but in Flanders came into contact, perhaps as a pupil, with Rogier van der Weyden. The attitude of the latter is strong in a group of early works, among them a *Deposition* in the Louvre, Paris, and a triptych of the *Deposition* (Royal Chapel Museum, Granada). Bouts' figures are calmer than van der Weyden's and his compositions less powerfully rhythmical.

Two fully documented works date from late in his life. In the triptych of *The Last Supper* (1464–7; St Pierre, Louvain) Christ's dramatic words are greeted by the Apostles with deep reverence. The scene, set in a realistic Flemish interior, is hushed and still. In the four wing panels Bouts excels as a landscapist; the terrain is rocky and open, and his treatment of the effects of shimmering light on distant hills shows a remarkable understanding of atmospheric perspective.

Two large panels, *The Judgment of the Emperor Otto* (Musées Royaux des Beaux-Arts de Belgique, Brussels) belong to an uncompleted commission for four paintings about the administration of justice, ordered by the town council of Louvain in 1468. In the right panel a hideous injustice is revealed and the austere control of the tall, dignified figures underlines the pathos of the situation. His one dated work is the *Portrait of a Man* (1462; National Gallery, London). He also did a series of tender paintings of the Virgin and Child.

Brailes W. de *fl.* 1230–60

The English medieval illuminator W. de Brailes can almost certainly be identified with a resident of Oxford called William de Brailes. De Brailes appears to have been an ecclesiastic head of a professional workshop that produced liturgical books illustrated in a distinctive style. His signed portrait is to be found in two of these. One of them consists of picture leaves from a Psalter (c1240–50; Fitzwilliam Museum, Cambridge) where his soul is shown being received by St Michael in a Last Judgment.

De Brailes was often dependent upon earlier native traditions of imagery; for example the beasts beneath the feet of Christ and the type of mouth of hell shown in the Last Judgment can be found in Anglo-Saxon and later English art. In many of his illustrations an unusual aspect of a subject is given prominence, or a particular figure in the action vividly characterized, thus revealing the artist's considerable originality. Among the scenes in a Book of Hours (c1250; British Library, London) are some episodes from Christ's Passion. By juxtaposing these with the three denials of St Peter, as well as adding the weeping saint outside the frame, de Brailes interprets a standard biblical subject as a human story seen from an individual point of view. A similar lively and idiosyncratic approach to narrative illustration is found in the scene from a Psalter (c1250–60; New College, Oxford) of Jonah being thrust vigorously into the mouth of a whale. This is probably the latest manuscript known from the workshop because it is the most advanced in style.

Particularly characteristic of de Brailes' personal style are the tightly drawn, open-eyed faces of his neat, active figures. However, the arrangement of the compositions in medallions, the delicate foliate ornament, and the elegant proportions of the figures are more generally typical of mid-13th-century English Gothic painting.

Bramante Donato c1444–1514

Donato Bramante, considered by his contemporaries to have restored the true principles of ancient architecture, is acknowledged today as the founder of the High Renaissance architectural style. Under the patronage of Julius II (1503–13), Bramante, Michelangelo, and Raphael renewed the artistic greatness appropriate to Rome as heir to the Roman Empire and as the center of Christendom. The city's heritage was symbolized by Bramante redesigning St Peter's as "the dome of the Pantheon over the vaults of the Temple of Peace".

Although we know nothing of his early life, Bramante was probably trained as a painter in Urbino, near his birthplace. At the court of Federico da Montefeltro he could have met Alberti, Piero della Francesca, and, most important as an architectural influence, Francesco di Giorgio. His first certain work, the facade painting of the Palazzo del Podestà, Bergamo (1477), already demonstrates an interest in architecture, as well as in perspective illusion. A signed engraving of 1481 contains many elements which were to appear in his buildings in Milan, where he was by then living, attracted, like Leonardo, to the court of Lodovico il Moro. Leonardo's architectural drawings, the early Christian churches of Milan, and the logical harmonies of the buildings in Urbino, were the formative influences on Bramante's architecture. Alberti's Mantuan churches are also reflected in Bramante's first church, S. Maria presso S. Satiro (1482–6). During his work on this building it developed from a simple rectangular oratory to a Latin Cross basilica with nave and aisles. Site restrictions forced him to truncate the choir into a *trompe-l'oeil* backcloth, using the perspective skills of his painter's training. The somber monumentality of the nave, with its massive arch and pier system and illusionistically coffered barrel vault, owes something to Alberti's S. Andrea.

The tribune of S. Maria delle Grazie (1493) was commissioned by Lodovico Sforza as a vast family mausoleum. The plan is like a gigantic version of Brunelleschi's Old Sacristy, with semicircular apses added on three sides. The uncluttered articulation of huge spaces foreshadows Bramante's mature Roman works. His other Milanese work was at S. Ambrogio: it includes the elegant Corinthian loggia of the Canonica (1492), with its bizarre tree-trunk columns at the corners, and the Doric cloister (1497–8), whose upper story suggests a first-hand knowledge of ancient Roman examples. From 1488 he was consulted, as were Leonardo and Francesco di Giorgio, about the rebuilding of the Duomo at Pavia. At Vigevano (1492) he designed the town's central piazza, whose arcaded sides were painted with illusionistic frescoes.

By 1499 the French occupation of Milan had forced Bramante to Rome. Taken up by the entourage of Alexander VI, he first designed the cloister of S. Maria della Pace. More consistently antique than his S. Ambrogio cloisters, it retains the graceful linearity characteristic of Urbino. The commission for the *tempietto* at S. Pietro in Montorio followed. Despite the inscription dated 1502, the masterly design of this tiny round church has often earned it a later dating. The first Renaissance building to employ correctly the full Doric order, it was inspired both by the column-encircled temples of Antiquity and by Francesco di Giorgio's architectural drawings. Bramante's "House of Raphael" (Palazzo

Donato Bramante: the cloister of S. Maria della Pace, Rome; designed in 1499, built 1500–4

Caprini, now destroyed) probably also dates from before 1505. Built in the new street leading to the Vatican, it provided a perfect model for the small palaces needed by the expanding papal bureaucracy. Its sequence of rusticated ground floor with shops and applied Classical orders on the first floor influenced domestic architecture up to the 20th century, as did its innovatory use of stucco-covered brick.

Bramante was to be the architect of Julius II's plan for the renewal of Rome. It began at the Vatican, where he connected the palace and the Villa Belvedere with an ascending series of courtyards flanked by arcaded corridors. From the papal apartments a perspectival vista (now interrupted by a library wing) ran through ramps and fountains to an *exedra* at the uppermost level. While its axiality recalled the ancient temple complex at Palestrina, the symbolism of the Cortile del Belvedere (1507–7) combined overtones of Roman villa and theater. Julius II's most optimistic project was to replace Old St Peter's with a great

new basilica. The foundation medal and Bramante's "parchment plan" give some idea of the unexecuted first project: a vast Greek Cross with four subsidiary crosses and corner towers, it recalled Leonardo's centralized church plans. The single-shelled Pantheon-type dome was to be supported on four great isolated piers of original and influential design. Work began on these piers; by Bramante's death in 1514 they had been vaulted with crossing arches, and a choir had been built, using the 15th-century foundations built for Nicholas V. A giant pilaster order—Doric on the exterior, Corinthian on the inside—gave vertical unity.

The plan for the new Rome extended beyond the Vatican. Across the river in the old city Bramante built a new street, the Via Giulia, to be dominated by a colossal Palace of Justice, of which only the rusticated base was executed. The church of S. Celso (now destroyed), a small scale version of the first St Peter's plan, was begun (in 1509) on another new street, the Via

de' Banchi. The tribune of S. Maria del Popolo (c1507–9) remains relatively unchanged. Here Bramante added a funerary chapel and choir to an existing church. The coffered barrel vault and simplified shell-niche apse are a stripped version of the destroyed St Peter's choir, and the square tomb chapel is lit by the so-called "Serliana" windows invented by Bramante.

As Vasari realized, the ambition of Julius II was necessary for the fulfillment of Bramante's architectural genius. Their joint enthusiasm for destruction and renewal earned the architect the nickname "Bramante ruinante", and in a contemporary satirical dialogue the dead Bramante is heard outlining to St Peter his plan for the redevelopment of heaven.

Further reading. Bruschi, A. *Bramante*, London (1977). Heydenreich, L. and Lotz, W. *Architecture in Italy: 1400–1600*, Harmondsworth (1974). Murray, P. *The Architecture of the Italian Renaissance*, London (1969).

Bramantino c1460–1536

The Lombard painter Bartolommeo Suardi known as Bramantino was, as his name suggests, trained by Bramante. His style remained relatively free from the influence of Leonardo, and his works, for instance the *Adoration of the Magi* (1501–3; National Gallery, London) and *Crucifixion*, (1510–11; Pinacoteca di Brera, Milan) show a severe, static, and monumental vision of Antiquity. He was inspired partly by Milanese masters like Vincenzo Foppa, but also by Mantegna and the still, mathematical tradition of Piero della Francesca, which he must have learned from his master. All his figures are like statues, and his backgrounds, often very abstracted, are rocky and of a steely hardness. In 1508 Bramantino was sufficiently successful to be summoned to Rome to paint in the Stanze of the Vatican, but he was soon replaced by Raphael and returned to Milan. Alongside Leonardo he had a considerable influence on the next generation of Lombard painters, notably on Bernardino Luini and Gaudenzio Ferrari, though his later works were increasingly dry and abstracted.

Brancusi Constantin 1876–1957

Constantin Brancusi left his peasant family in the village of Hobitza in Rumania when he was 11 years old. He lived and worked in Paris for over 50 years, becoming the great innovator in early modern sculpture. But he never broke his ties with his homeland, and in his old age his peasant roots became a significant part of his legend.

After leaving home, Brancusi supported himself by menial work, first at Tirgu Jiu, later at Craiova where, in 1895, he entered the School of Arts and Crafts and specialized in sculpture. After graduating with honors in 1898, he went on to the School of Fine Arts in Bucharest for a further three years' study. During this period he won several prizes and modeled a number of portraits of flawless academic competence. An outstanding work was his lifesize *écorché* anatomical figure (without the skin, displaying the muscles) which he made under the guidance of his anatomy instructor. A cast of this *écorché* is now in the Medical Institute, Jassy.

Leaving Bucharest in 1903, Brancusi traveled slowly across Europe. He arrived in Paris in 1904 and in 1905 enrolled at the École des Beaux-Arts. Few works from these years have survived, though the records taken by Brancusi himself—he was an enthusiastic photographer—show that by 1906, when he was 30, he was a sculptor of ability and refinement. Yet he remained a student, perhaps because he received a small grant from Rumania, perhaps because he had yet to discover his own vision. Two works that do survive, *Portrait of Nicolae Darascu* (1906; bronze; Museum of Art, Bucharest) and *Torment* (also called *Pain*; bronze; David Thompson Collection, Pittsburgh, Pa.), the bust of a small boy, are works of real power, strongly influenced by Rodin. Indeed, Brancusi worked briefly in Rodin's studio. But he quickly left, saying: "nothing can grow in the shadow of great trees".

Nineteen hundred and seven was the turning point for Brancusi, as for other artists of his generation. Because of his age, he had to leave the École des Beaux-Arts. Also, he received a commission to make a memorial (now in Dumbrava Cemetery, Buzau, Rumania) to Petre Stanescu (completed in 1910). The bronze figures—a bust of Stanescu and a symbolic naked female mourner—are modeled in bold, simple forms. It was a determined rejection of Rodin and the tradition Brancusi later called "beefsteak" sculpture. He emphasized this rejection most significantly when he chose Rodin's most famous motif for his own major work of 1907. Brancusi's *The Kiss* is the antithesis of Rodin's; it is directly carved, not modeled in clay, its forms are simple and block-like, and, above all, it is spiritual not sensual. This *Kiss*, the first of six versions, marked Brancusi's conversion: he called it his "road to Damascus". (*The Kiss*, 1908, limestone, is in the Musée National d'Art Moderne, Paris, as are three versions from 1910).

In the following three years he experimented with styles of simplification and primitivism, like his contemporaries Picasso, Derain, and Epstein. Throughout his career, Brancusi was to invent a handful of basic motifs and make numerous variations on them. By 1910, he had established the most important of these motifs, a female head and neck often called *The Muse* (marble; Solomon R. Guggenheim Museum, New York). The strange variant of this—the head on its side, like an egg—was later developed as *The Sleeping Muse* (two versions from 1908: plaster in Musée d'Art Moderne de la Ville de Paris, bronze example in the Art Institute of Chicago), *Prometheus* (1911; marble; Philadelphia Museum of Art), *The New Born* (1915; marble; Philadelphia Museum of Art), *Sculpture for the Blind* (1924; Philadelphia Museum of Art), and the fragmentary *Female Torso* (1909; marble; Craiova Museum of Art). In 1912 he created the first *Maiastra* (white marble; Museum of Modern Art, New York)—the golden bird of Slav folklore—which led to numerous birds throughout his career, including at least 16 versions of *Bird in Space*: an image like a frozen flame. (The first version, from 1919, in polished bronze, is in the Museum of Modern Art, New York.)

By 1910, Brancusi was one of the circle of the avant-garde in Paris. His friends included Picasso, Matisse, and Apollinaire. He taught Modigliani to carve: his own *Head of a Girl* of 1907 (now lost) anticipates Modigliani's style. In 1913, he had five pieces in the famous Armory Show in New York. The following year he had his first one-man exhibition in New York, at Alfred Stieglitz's Gallery of the Photo-Secession. It was also in New York, in the same year, that he found his most important patron, the lawyer John Quinn. By the time Quinn died, in 1924, he had bought 27 pieces by Brancusi for almost 21,000 dollars.

Because of his nationality, Brancusi was exempt from French military service during the First World War and worked steadily throughout it. He emerged to become one of the most famous sculptors of the day, celebrated by the international smart set of the 1920s. In 1921 *The Little Review* devoted an entire issue to him.

By this time Brancusi had developed two distinctive kinds of image. There were the images he would develop in several or many versions, in marble or bronze, or in both. These images appear at first sight to quite abstract and very simple, geometrical and symmetrical. But in fact they are always representational and their forms are elusive and subtle. As Brancusi said: "they are imbeciles who call my work Abstract; that which they call Abstract is the most realist, because what is real is not the exterior form but the idea, the essence of things."

These extremes of simplification lead to ambiguities. *Princess X* was removed from the Salon des Indépendants of 1920 because her bosom, neck, and head had been reduced to bulbous curves that looked undeniably phallic. And in 1926, U.S.

Constantin Brancusi: The Prodigal Son; oak on stone base; height 45cm (18in); c1915. Philadelphia Museum of Art

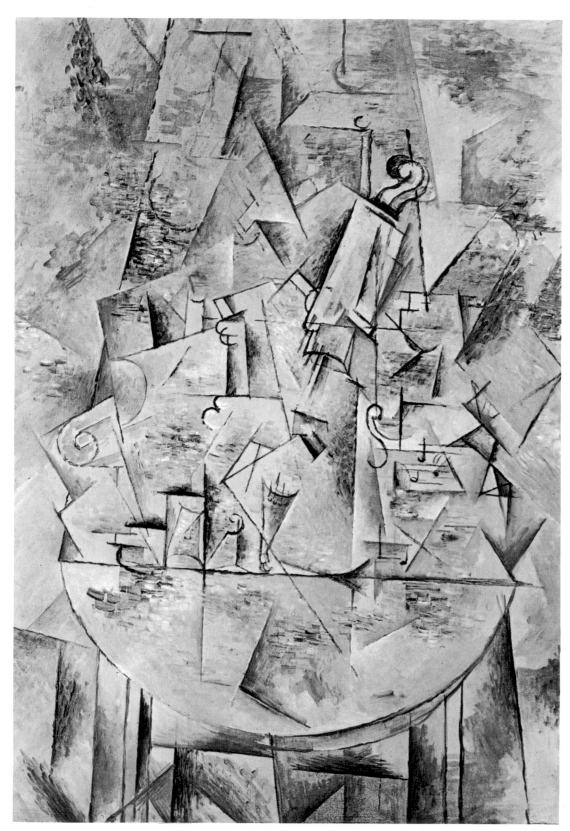

Georges Braque: The Guéridon; oil on canvas; 117×81cm (46×32in); 1912. Musée National d'Art Moderne, Paris

Customs officials declared that a *Bird in Space* (the one now in the Museum of Modern Art, New York) in polished bronze was a object of manufacture, not a work of art. Only after a court case, which lasted throughout 1927–8, was judgment given in the artist's favor.

When he turned to wood carving, Brancusi's imagery was utterly different. He had studied the craft as a student at Craiova and returned to it for many works after 1913. His wood carvings are essentially rough and primitive, echoing peasant craftsmanship and tribal art. He seldom created variants on these images in wood. Yet the polish of the marbles and bronzes and the crudity of the wood carvings are aspects of the same imagination; they are sometimes combined in one piece, such as the two versions of *Fish* (1928–30) each with a fetish-like wooden pedestal. On rare occasions, Brancusi did carve in wood the smooth forms of his marble and bronze images: these pieces include *Torso of a Young Man* (versions of 1922 in Philadelphia Museum of Art and Musée d'Art Moderne de la Ville de Paris), *Cock* (1924; Museum of Modern Art, New York), and two portraits, of *Nancy Cunard* (1928; Collection of Mrs Marcel Duchamp, New York) and *Mrs Eugene Meyer Jr* (*Undisdainful Queen*, 1910; Musée National d'Art Moderne, Paris).

In 1926 Brancusi was 50; in the following years, although he produced new variations of earlier motifs, he conceived only three new images: *Nocturnal Animal* (1930?), *The Seal* (first version 1936), and *Turtle* (1941 in wood, Musée National d'Art Moderne, Paris; and 1943, marble, Solomon R. Guggenheim Museum, New York). This was because his creative imagination had taken a new direction in the 1930s. He had become interested in mysticism and in particular the writings of the Tibetan, Milarepa. Then, in 1933, he met the Maharajah of Indore, who bought three versions of *Bird of Space* and proposed that Brancusi should design a Temple of Meditation. Despite a visit to India in 1937, the project fell through. However, another commission, of greater importance, was executed. In 1934, he was asked to design a memorial to the heroes of the First World War for Tirgu Jiu, the town where Brancusi himself had spent his adolescence. By 1937, he had created three monuments that are as much architectural as sculptural, designed for spiritual as well as aesthetic contemplation. The *Endless*

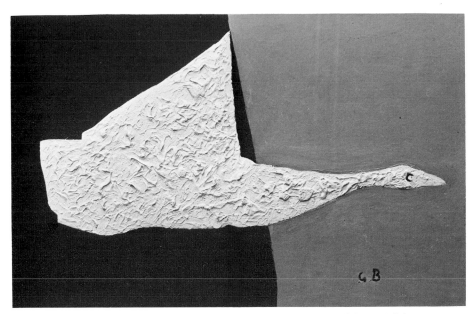

Georges Braque: Le Canard; oil and gouache on paper; 60×84cm (24×33in); 1956. Private collection

Column, based on a peasant decorative motif that Brancusi had used for several earlier versions, is a rigid rosary of rhomboidal beads reaching over 96 ft (32 m) into the sky. In the public park a *Table of Silence* set on the grass is like a giant millstone set round with 12 stone stools. The *Gate of the Kiss* (also in the park) is his crowning achievement, completing the development that began in 1907. Its pair of massive rectangular columns and lintel are developed from his own *Kiss*, now refined to a hieroglyph, a symbol of the fusion of opposites: it is a union transcending sexuality, with male and female as equal halves of the whole, the ultimate antithesis of Rodin's *Gates of Hell*.

Brancusi lived to be 81, producing little in his last 20 years. He survived as a legendary figure. At the last, he became a French citizen and left his studio and its contents to the French nation.

Further reading. Geist, S. *Brancusi, a Study of the Sculpture*, London (1968). Miller, S. *A Survey of Constantin Brancusi's Work*, Oxford (1994). Varia, R. *Brancusi*, New York (1987).

Braque Georges 1882–1963

The French painter Georges Braque was one of the major artists of the 20th century, whose partnership with Picasso from 1908 to 1914 generated Cubism.

The son of a house painting contractor, Braque decided at 15 to become a painter, but his characteristic caution prompted him at first to follow his family's trade in Le Havre. He enrolled as a part-time student at the local art school in 1897 and was apprenticed to a painter-decorator in 1899. He went to Paris in 1900, continuing his trade apprenticeship until his military service in 1901. He then studied mainly at the Académie Humbert and briefly at the École des Beaux-Arts.

His boyhood friends Raoul Dufy and Orthon Friez probably introduced him to the Fauve group, with whom he exhibited in 1906. His Fauvism was not of the muscular variety of Derain and Vlaminck, but was more meditative and lyrical, with luminous bright colors and a strong constructive element (for example, *Landscape of l'Estaque*, 1906; Galerie Beyeler, Basel).

In 1907 he subdued his colors and strengthened the underlying constructive qualities reminiscent of Cézanne, but was then galvanized by Picasso's newly painted *Les Demoiselles d'Avignon* (1907; Museum of Modern Art, New York). Braque's *Grand Nu* (1908; Collection of Mme Marie Cuttoli, Paris) was the earliest coherent response to Picasso's startling initiative; it was the start of their association which produced Cubism and lasted until 1914. The critic Louis Vauxcelles inadvertently christened the movement in a review of Braque's first one-man show at Kahnweiler's in 1908 when he referred to the reduction of forms to "little cubes".

Braque's contribution to Cubism was considerable: he was responsible for the development of the overlapping planes that created the new Cubist space; he first used letters as part of composition (*Le Portugais*, 1911; Öffentliches Kunstsammlung, Kunstmuseum Basel); and soon after Picasso had created the first *collage*, Braque made the first *papier collé* (*Fruit Dish and Glass*, September 1912; Douglas Cooper Collection, France), which was of great importance to his philosophy of art.

Braque enlisted in 1914, breaking the already weakening partnership. He was wounded in 1915 at Artois, and when he returned to painting in 1917 he found he was unable to concur with the paths Picasso and other artists had taken. He continued working the themes of his prewar works but the forms became bolder and more recognizable and the colors tended towards dark grays, browns, and greens with creams and whites vigorously scrubbed over them. His personal Cubist vision is continued in works like *The Marble Table* (1925; Musée d'Art Moderne de la Ville de Paris), in which simplified Cubist forms create volume rather than space, and house painter's imitation marbling becomes the occasion for a virtuoso display. While retreating from actual *collage* or *papier collé* he went on using the formal possibilities revealed by them.

He continued to respond to some of Picasso's thematic innovations; for instance he painted a series of Classically inspired figures called *Canephorae* from 1922 (examples in Musée d'Art Moderne de la Ville de Paris). Their characteristics are frontality, massiveness, a peculiar treatment of the drapery, and an obsessive pattern of lines describing the stomach. His reaction to Picasso's beach scenes of the late 1920s was to produce a series of *Bathers* in 1931 (an example in the Collection of M. and Mme Claude Laurens, Paris), which lack Picasso's sharpness but have a strong arabesque linear quality.

Braque painted several series of works on similar themes, which enabled him to build up slowly to complex pictures. The "studio" series, for instance, begins in the mid 1930s and reaches its first climax in 1939 in *The Painter and his Model* (Collection of Walter P. Chrysler Jr, New York). This brings together the Classical figure, the image of the Artist (bearded, so not a self-portrait), imitation wood graining, the picture within a picture, and collage-like panels. The human relationship implied is immediately taken over by the demands of art: the focus is on the brightly colored picture on the easel, and the two figures minister to it.

The awareness of Art as the subject of art is increasingly apparent throughout the 1940s; palettes, easels, and pictures within pictures appear regularly, culminating in a series of five paintings each called *The Studio* in 1949. In numbers I, II, III, and IV of these the bird motif, which had occurred earlier in his work, takes on its metaphys-

ical function as the symbol of aspiration. In his later paintings the symbolism of the bird takes over from the hitherto basic earthiness of his vision.

Braque worked in many graphic media: book illustrations which include drawings for Paul Reverdy's *The Roof Slates* (1918), etchings for Hesiod's *Theogony* published by Ambrose Vollard (1931), lithographs for Reverdy's *Liberty of Seas* (1959), and engravings for *The Order of Birds* with poems by Saint-John Perse (1962). He also designed sets for Diaghilev's ballets *The Bores* (1923) and *Zephyrus and Flora* (1925), as well as sets and costumes for the ballet *Salade* with music by Milhaud (1924) and the sets for Molière's *Tartuffe* (1949). In 1952–3 he decorated the ceiling of the Etruscan room in the Louvre, and in 1954 he produced mural decorations for the Mas Bernard at St-Paul-de-Vence and stained-glass windows for the small church at Varengeville.

Braque's achievement was recognized during his career by ever-widening circles of acclaim. He won the Carnegie Prize in 1937, was given a special exhibit at the Salon d'Automne in 1943, and won the Grand Prize at the Venice Biennale of 1948. In 1961 the Louvre honored him with a reconstruction of his studio, exhibiting the work of a living artist for the first time in the museum's history.

Further reading. Cogniat, R. *Georges Braque*, New York (1980). Zurcher, B. *Georges Braque Life and Work*, New York (1988).

Breton André 1896–1966

The French poet and writer André Breton was dominant in Parisian Dadaism and was the co-founder and the leader, and principal theorist of the Surrealist movement. Author of the Surrealist manifestos of 1924 and 1929, and of such important Surrealist texts as *Les Champs Magnétiques* (with Philippe Soupault; 1920) *Nadja* (1928), and *L'Amour Fou* (1937), Breton was also the chief apologist of Surrealist painting: he published his pioneering essay *Le Surréalisme et la Peinture* in 1928. A refugee in America from 1941 to 1946, he came into fruitful contact with young artists there, including Arshile Gorky; he was sympathetic to Abstract Expressionism and Tachism, and continued to support new Surrealist artists.

Breuer Marcel 1902–81

Born in Hungary, Marcel Lajos Breuer was a student at the Bauhaus and became head of its furniture workshop in 1925. His major contribution to design was in furniture. In 1925–6 he furnished the Dessau Bauhaus and produced his first chair from tubular steel, simplifying this in the S-shaped cantilever chair of 1928. He worked in Berlin as an architect and designer from 1928, moving to London in 1935. Two years later he joined Walter Gropius at Harvard, and from 1946 had an architectural practice in New York. His later architecture, such as the Unesco building, Paris (with Zehrfuss and Nervi, 1953), appears less functionally determined than his prewar work.

Bril Paul 1554–1626

Paul Bril was a Flemish landscape painter who worked in Rome. He was born at Antwerp though his family came originally from Breda. He is mentioned in the workshop of Daniel Wortelmans in 1568. In 1574 he left Antwerp and, after a stay at Lyons, settled in Rome, where his brother Matthew (1550–83) was already working as a landscape painter. Both brothers obtained commissions for extensive fresco work. Paul Bril painted six frescoes in the Lateran Palace (1589), others for S. Cecilia in Trastevere, and the *Seascape with St Clement* for the Sala Clementina in the Vatican (1602).

His fame now rests mainly on the smaller landscapes he painted for private patrons; these ensure his place in the development of the classical landscape at Rome in the 17th century. The earliest of them are small, often on copper; they follow the style of late-16th-century Mannerist painters, with emphatic diagonals into depth and sharply divided planes of light and dark accented by bright color contrasts. The influence of the German artist Adam Elsheimer (1578–1610), also resident at Rome, helped Bril to a new style based on closer observation of nature. *The Roman Forum with the Temple of Castor and Pollux and the Basilica of Hadrian* (1600; Gemäldegalerie Alte Meister, Dresden, and several early copies, including one in the Fitzwilliam Museum, Cambridge) shows a more gentle recession of space. The highly idealized setting of the Forum is used as a stage for a blend of the everyday and the picturesque: a scene of a cattle market. By the time he painted *Fishermen* (1624;

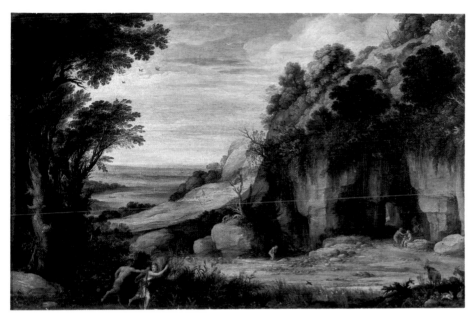

Paul Bril: Pan and Syrinx; 38×60cm (24×15in); c1620. Louvre, Paris

Louvre, Paris) he had anticipated, on a small scale, the coloring and quiet, poetical mood of later classical landscapes. In this respect it is significant that one of Bril's Roman pupils was Agostino Tassi, the teacher of Claude Lorrain.

Broederlam Melchior
fl. 1381–1409

Melchior Broederlam was a Flemish painter from Ypres, first documented in 1381 as court painter to the Count of Flanders, Louis of Male. With the Count's death in 1384 Flanders passed to his son-in-law Philip the Bold, Duke of Burgundy. Broederlam joined the Burgundian court, and was granted a salary. Occasional documentary evidence shows him to have been in the Duke's employment throughout the next two decades, though from 1392 he seems also to have run his own workshop at Ypres. His major commission from the Duke was the decoration of an altarpiece for the Chartreuse (Carthusian monastery) at Champmol near Dijon, the burial place of the ducal family. The work, paid for in 1394 but probably not installed till 1399, involved painting the exterior of the wings of the large wooden altarpiece carved by Jacques de Baerze. Broederlam is last mentioned in 1409.

References to him convey some idea of the duties of a late medieval court painter. During the years 1386 to 1392 he undertook the decoration of the Duke's castle at Hesdin in the county of Artois. He made tournament equipment, including pavilions, repaired machinery for springing practical jokes on the Duke's guests, painted flags and banners, and designed tiled floors. In 1386 he directed the decoration of ships being prepared for an expedition against England. At his workshop in Ypres he carried out commissions for glass windows, worked as a goldsmith, and fitted out civic dignitaries with uniforms. In this variety of undertakings Broederlam is typical of Franco-Flemish artists of his time; also typical is that almost all his work has been lost or destroyed (much of it was of a temporary nature).

His only surviving work, the Dijon altarpiece (Musée des Beaux-Arts, Dijon) consists of two panels, each containing a pair of New Testament scenes. The left-hand panel shows *The Annunciation and the Visitation*, the right-hand *The Presentation and the Flight into Egypt*. The figures, with their soft flowing draperies, are French in style, but the architecture and landscape background contain strong echoes from Italian painting, particularly from the work of the early-14th-century Sienese artists Simone Martini and the Lorenzetti brothers. Many of the details are symbolic. Mary in *The Annunciation* holds a skein of purple wool, a reference to the account in the Apocrypha in which she is interrupted by the angel while working the wool for a new veil for the Temple. The three windows in the same scene, representing the light of the Trinity, are an example of architecture being used for symbolic pur-

poses. This sort of imagery was expanded and used extensively by later Flemish painters like the Master of Flémalle (c1375–1444) and Jan van Eyck (c1390–1441). With its figure-style, gold background, rich coloring, delicate, exquisite detail, and its realism (particularly the much-imitated rustic figure of Joseph drinking from his water flask), the Dijon altarpiece is a major example of the International Gothic style current in Europe c1400.

Bronzino 1503–72

Born Angelo or Agnolo di Cosimo near Florence, Bronzino studied under Raffaellino del Garbo before joining Jacopo da Pontormo's workshop in 1519. This relationship was important throughout Bronzino's career, for he helped with Pontormo's decoration of the Medicean villas at Careggi and Castello in the 1530s and completed the frescoes in the choir of S. Lorenzo, Florence (now destroyed) after Pontormo's death in 1557. Bronzino was slow to develop; the early *Temptation of St Benedict* (1526–8; Badia, Florence) sets stiff, awkward figures (at best a crude approximation to those of Pontormo) in a simplified landscape that has its origin in the Quattrocento.

The *Pietà* that Bronzino painted for SS. Trinità (Uffizi, Florence) at the end of the 1520s draws away from Pontormo both in its somber tonality and its composition, reminiscent of Andrea del Sarto. His first portrait, that of Guidobaldo delle Rovere (Uffizi, Florence) was painted while he was working at the Villa Imperiale near Pesaro from 1530 to 1532. It depends on the influence of Titian for the introduction of the dog on which the Duke rests his hand; the pose, although stiffer than in Titian, has not yet achieved the artificiality of Bronzino's mature portraits. This is reached in the portrait of Duke Cosimo I (Uffizi, Florence). The twist of the shoulders is set against the head and this, with the expressionless gaze, freezes the figure and gives it the unnatural elegance of art. His portraits show a considerable range: some of those from the 1530s in which the buildings in the background are used as attributes rather than as settings look back to Pontormo, while in others the sitters hold a book or a statue. The *Eleonora of Toledo with her Son* (Uffizi, Florence) of the 1540s shows no emotion, but every detail of the brocade of her dress is accurately recorded.

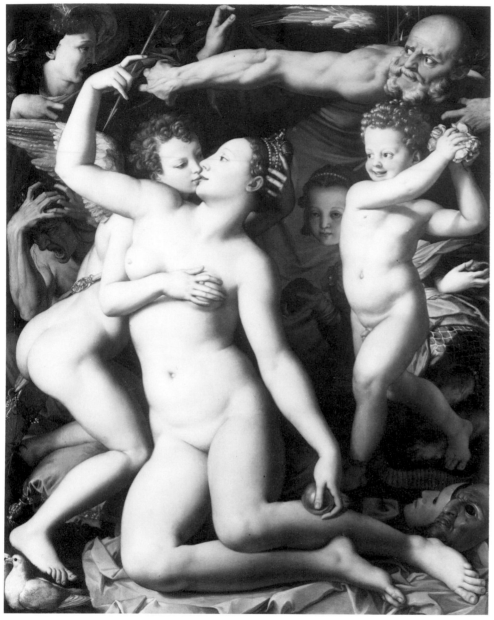

Bronzino: Venus, Cupid, Folly, and Time; panel; 147×117cm (58×46in); c1540–5. National Gallery, London

From 1540 Bronzino began the decoration of Eleonora's chapel in the Palazzo Vecchio, Florence. Scenes from the life of Moses appear on the walls and four saints on clouds decorate the ceiling, which is divided by a framework of swags and putti. The style of the frescoes is Roman, although Bronzino had not at this date visited Rome, and comparable to that of his near-contemporary Francesco Salviati in his 1538 Visitation (S. Giovanni Decollato, Rome). The style that Bronzino achieves in these frescoes was repeated in his later altars in S. Croce and SS. Annunziata, and also in Venus, Cupid, Folly, and

Time (c1540–5; National Gallery, London). In the later 1540s he designed tapestries for the Medici and while the first of them share the complexity of this style the later, most notably the suite of scenes from the life of Joseph (Palazzo del Quirinale, Rome), achieve a new clarity in their handling of narrative. His last major work, the Martyrdom of St Lawrence in S. Lorenzo, Florence (c1565–9) shows a belated reaction to Michelangelo's Last Judgment. He has modified the bulk of the figures in his search for greater complexity of movement; the result, however, is unpleasant.

Further reading. Baccheschi, E. L'Opera Completa del Bronzino, Milan (1973). Freedberg, S.J. Painting in Italy: 1500–1600, Harmondsworth (1979). McCorquodale, C. Bronzino, London (1981). Smyth, C.H. Bronzino as a Draughtsman, an Introduction, Locust Valley (1971).

Brosse Salomon de 1571–1626

Salomon de Brosse stands in French architectural history between Philibert Delorme (c1510–70) and François Mansart (1598–1666), though he was a less sensitive and inventive designer than either of them. Like Mansart, whom he influenced, he worked essentially in the provinces around Paris, but few of his buildings have survived. His grandest and most intriguing work is the Luxembourg Palace, begun in 1615 for Marie de Medici; fortunately this building remains largely intact. In it de Brosse showed a much more unified composition than in his earlier châteaux of Blerancourt (1612) and Verneuil (c1608), both now ruined. The Luxembourg Palace, was followed by the equally monumental Palais du Parlement at Rennes (1618) and later by the more ponderous exercise in Vitruvian principles, the Protestant Temple of Charenton (1623) which set the form for much 17th-century Protestant architecture.

Brown Ford Madox 1821–93

The English painter Ford Madox Brown was associated with the Pre-Raphaelite movement though he never actually became a member of the Brotherhood. He was born in Calais where his father, a ship's purser of English birth, had chosen to retire. In 1833 the family moved to Belgium to allow their talented son to study art. Brown attended various studios culminating in that of Baron Gustaf Wappers in Antwerp. Between 1840 and 1844 he lived in Paris. Brown then entered the important cartoon competitions for the decoration of the new Houses of Parliament at Westminster in 1844 and 1845. After passing the winter of 1845–6 in Rome, Brown, encouraged by the state of English history painting, settled permanently in London.

His early works reflect his mixed training, carrying a flavor of French Romanticism, but also strongly biased towards the archaism of the Nazarene School of painters whom he admired and visited in

Paul Bril: Pan and Syrinx; 38×60cm (24×15in); c1620. Louvre, Paris

Louvre, Paris) he had anticipated, on a small scale, the coloring and quiet, poetical mood of later classical landscapes. In this respect it is significant that one of Bril's Roman pupils was Agostino Tassi, the teacher of Claude Lorrain.

Broederlam Melchior
fl. 1381–1409

Melchior Broederlam was a Flemish painter from Ypres, first documented in 1381 as court painter to the Count of Flanders, Louis of Male. With the Count's death in 1384 Flanders passed to his son-in-law Philip the Bold, Duke of Burgundy. Broederlam joined the Burgundian court, and was granted a salary. Occasional documentary evidence shows him to have been in the Duke's employment throughout the next two decades, though from 1392 he seems also to have run his own workshop at Ypres. His major commission from the Duke was the decoration of an altarpiece for the Chartreuse (Carthusian monastery) at Champmol near Dijon, the burial place of the ducal family. The work, paid for in 1394 but probably not installed till 1399, involved painting the exterior of the wings of the large wooden altarpiece carved by Jacques de Baerze. Broederlam is last mentioned in 1409.

References to him convey some idea of the duties of a late medieval court painter. During the years 1386 to 1392 he undertook the decoration of the Duke's castle at Hesdin in the county of Artois. He made tournament equipment, including pavilions, repaired machinery for springing practical jokes on the Duke's guests, painted flags and banners, and designed tiled floors. In 1386 he directed the decoration of ships being prepared for an expedition against England. At his workshop in Ypres he carried out commissions for glass windows, worked as a goldsmith, and fitted out civic dignitaries with uniforms. In this variety of undertakings Broederlam is typical of Franco-Flemish artists of his time; also typical is that almost all his work has been lost or destroyed (much of it was of a temporary nature).

His only surviving work, the Dijon altarpiece (Musée des Beaux-Arts, Dijon) consists of two panels, each containing a pair of New Testament scenes. The left-hand panel shows *The Annunciation and the Visitation*, the right-hand *The Presentation and the Flight into Egypt*. The figures, with their soft flowing draperies, are French in style, but the architecture and landscape background contain strong echoes from Italian painting, particularly from the work of the early-14th-century Sienese artists Simone Martini and the Lorenzetti brothers. Many of the details are symbolic. Mary in *The Annunciation* holds a skein of purple wool, a reference to the account in the Apocrypha in which she is interrupted by the angel while working the wool for a new veil for the Temple. The three windows in the same scene, representing the light of the Trinity, are an example of architecture being used for symbolic pur-

poses. This sort of imagery was expanded and used extensively by later Flemish painters like the Master of Flémalle (c1375–1444) and Jan van Eyck (c1390–1441). With its figure-style, gold background, rich coloring, delicate, exquisite detail, and its realism (particularly the much-imitated rustic figure of Joseph drinking from his water flask), the Dijon altarpiece is a major example of the International Gothic style current in Europe c1400.

Bronzino 1503–72

Born Angelo or Agnolo di Cosimo near Florence, Bronzino studied under Raffaellino del Garbo before joining Jacopo da Pontormo's workshop in 1519. This relationship was important throughout Bronzino's career, for he helped with Pontormo's decoration of the Medicean villas at Careggi and Castello in the 1530s and completed the frescoes in the choir of S. Lorenzo, Florence (now destroyed) after Pontormo's death in 1557. Bronzino was slow to develop; the early *Temptation of St Benedict* (1526–8; Badia, Florence) sets stiff, awkward figures (at best a crude approximation to those of Pontormo) in a simplified landscape that has its origin in the Quattrocento.

The *Pietà* that Bronzino painted for SS. Trinità (Uffizi, Florence) at the end of the 1520s draws away from Pontormo both in its somber tonality and its composition, reminiscent of Andrea del Sarto. His first portrait, that of Guidobaldo delle Rovere (Uffizi, Florence) was painted while he was working at the Villa Imperiale near Pesaro from 1530 to 1532. It depends on the influence of Titian for the introduction of the dog on which the Duke rests his hand; the pose, although stiffer than in Titian, has not yet achieved the artificiality of Bronzino's mature portraits. This is reached in the portrait of Duke Cosimo I (Uffizi, Florence). The twist of the shoulders is set against the head and this, with the expressionless gaze, freezes the figure and gives it the unnatural elegance of art. His portraits show a considerable range: some of those from the 1530s in which the buildings in the background are used as attributes rather than as settings look back to Pontormo, while in others the sitters hold a book or a statue. The *Eleonora of Toledo with her Son* (Uffizi, Florence) of the 1540s shows no emotion, but every detail of the brocade of her dress is accurately recorded.

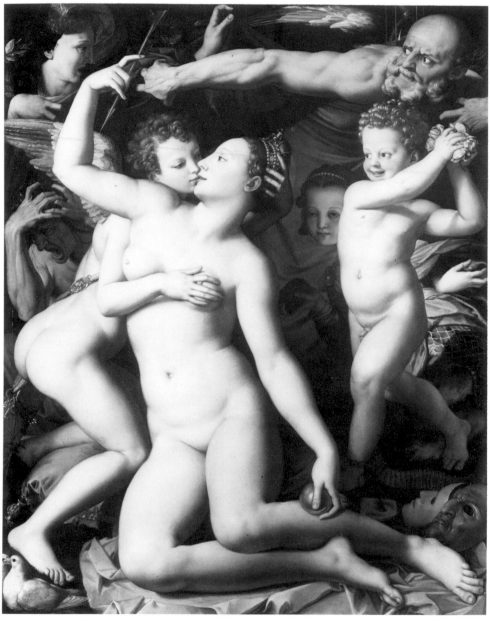

Bronzino: Venus, Cupid, Folly, and Time; panel; 147×117cm (58×46in); c1540–5. National Gallery, London

From 1540 Bronzino began the decoration of Eleonora's chapel in the Palazzo Vecchio, Florence. Scenes from the life of Moses appear on the walls and four saints on clouds decorate the ceiling, which is divided by a framework of swags and putti. The style of the frescoes is Roman, although Bronzino had not at this date visited Rome, and comparable to that of his near-contemporary Francesco Salviati in his 1538 *Visitation* (S. Giovanni Decollato, Rome). The style that Bronzino achieves in these frescoes was repeated in his later altars in S. Croce and SS. Annunziata, and also in *Venus, Cupid, Folly, and* *Time* (c1540–5; National Gallery, London). In the later 1540s he designed tapestries for the Medici and while the first of them share the complexity of this style the later, most notably the suite of scenes from the life of Joseph (Palazzo del Quirinale, Rome), achieve a new clarity in their handling of narrative. His last major work, the *Martyrdom of St Lawrence* in S. Lorenzo, Florence (c1565–9) shows a belated reaction to Michelangelo's *Last Judgment*. He has modified the bulk of the figures in his search for greater complexity of movement; the result, however, is unpleasant.

Further reading. Baccheschi, E. *L'Opera Completa del Bronzino*, Milan (1973). Freedberg, S.J. *Painting in Italy: 1500–1600*, Harmondsworth (1979). McCorquodale, C. *Bronzino*, London (1981). Smyth, C.H. *Bronzino as a Draughtsman, an Introduction*, Locust Valley (1971).

Brosse Salomon de 1571–1626

Salomon de Brosse stands in French architectural history between Philibert Delorme (c1510–70) and François Mansart (1598–1666), though he was a less sensitive and inventive designer than either of them. Like Mansart, whom he influenced, he worked essentially in the provinces around Paris, but few of his buildings have survived. His grandest and most intriguing work is the Luxembourg Palace, begun in 1615 for Marie de Medici; fortunately this building remains largely intact. In it de Brosse showed a much more unified composition than in his earlier châteaux of Blerancourt (1612) and Verneuil (c1608), both now ruined. The Luxembourg Palace, was followed by the equally monumental Palais du Parlement at Rennes (1618) and later by the more ponderous exercise in Vitruvian principles, the Protestant Temple of Charenton (1623) which set the form for much 17th-century Protestant architecture.

Brown Ford Madox 1821–93

The English painter Ford Madox Brown was associated with the Pre-Raphaelite movement though he never actually became a member of the Brotherhood. He was born in Calais where his father, a ship's purser of English birth, had chosen to retire. In 1833 the family moved to Belgium to allow their talented son to study art. Brown attended various studios culminating in that of Baron Gustaf Wappers in Antwerp. Between 1840 and 1844 he lived in Paris. Brown then entered the important cartoon competitions for the decoration of the new Houses of Parliament at Westminster in 1844 and 1845. After passing the winter of 1845–6 in Rome, Brown, encouraged by the state of English history painting, settled permanently in London.

His early works reflect his mixed training, carrying a flavor of French Romanticism, but also strongly biased towards the archaism of the Nazarene School of painters whom he admired and visited in

Salomon de Brosse: the Luxembourg Palace, Paris; begun in 1615

Rome. In 1848 Rossetti made himself Brown's pupil, and promoted his works among the gathering Pre-Raphaelite circle, but Brown refused to become a full member. In 1851 he turned to Realism, taking his whole canvas out of doors. In 1852 he began his greatest pictures, *The Last of England* (City of Birmingham Museums and Art Gallery) and *Work* (City of Manchester Art Gallery).

The Last of England shows an emigrant family setting out from Dover. Inspired by the experiences of the Pre-Raphaelite sculptor Thomas Woolner, it combines close character study with a wider sense of the picture as a social document. *Work*, a much larger painting, was not completed until 1865. Then, in a retrospective exhibition, Brown wrote long catalog notes to prove that the picture could be approached as a sociological tract akin to the writings of Ruskin and Carlyle. *Work* is one of the great achievements of the English Realist school. The scene, centered upon navvies laying drains in Hampstead, contains all levels of society including the unemployed poor and the idle rich, and all is, as the artist himself claimed, "rendered exactly as it would appear".

After 1860, Brown's work became more decorative, reflecting his involvement with the firm Morris, Marshall, Faulkner and Company, of which he was a founder member. The most significant of his late works are the murals in the Town Hall, Manchester, a series of symbolic and historical scenes which occupied him from 1878 until his death. Brown was an individualist, and his idiosyncratic outlook is reflected in his art. During the 1850s he lived in penury, but after receiving some recognition he moved from Hampstead to Bloomsbury where, during the 1860s and 1870s, his house was a center of intellectual and artistic life. (*See* overleaf.)

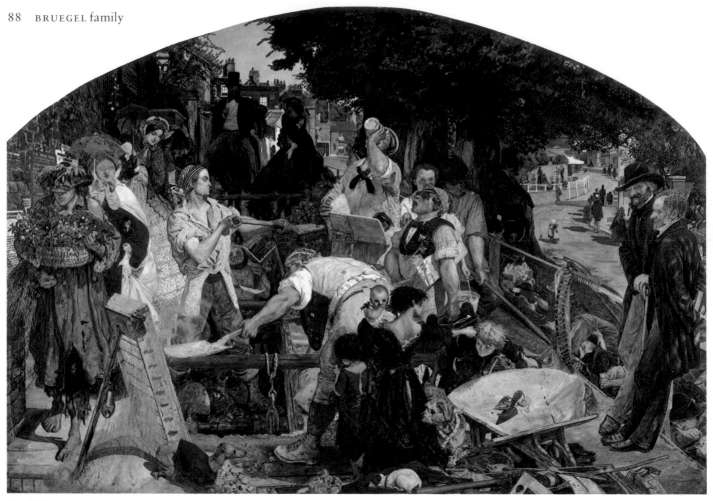

Ford Madox Brown: Work; oil on canvas; 135×196cm (53×77in); 1852–65. City of Manchester Art Gallery

Bruegel family
16th and 17th centuries

Pieter Bruegel the Elder (1525–69), Pieter Bruegel the Younger (c1564–1637/8), and Jan Bruegel (1568–1625) were a family of Flemish painters. Pieter the Elder, the greatest moralist in the Netherlands since Bosch (c1450–1516), and a major landscape artist, was born at Breda. His origins are uncertain; the claim made by van Mander in 1604 that he was of peasant stock may be only an attempt to explain the original subject matter of his pictures and to excuse a number of picturesque stories. There is little documentary evidence either for the assertion that he trained in the workshop of Pieter Coecke van Aelst (1502–50), though he did eventually marry his daughter, Mayken. In 1551 he was registered as Master in the Antwerp guild but left for a journey through France and Italy shortly afterwards. He reached Reggio Calabria and Sicily and is recorded at Rome in 1553.

The journey south did not have the predictable impact on a Northern artist. His interest was more in landscape and particularly the mountainous scenery so foreign to his homeland, than in contemporary art or the Antique. His landscape drawings seek to convey the expanse and atmosphere of his surroundings rather than exact geographical detail; they are the first step toward an imaginative use of his experience of landscape in his paintings.

On his return to the Netherlands (by 1555) Bruegel's first success came through drawings for engravings published by Hieronymous Cock in Antwerp. They are the first indication of a strong moralizing tendency in his work and a talent for illustrating proverb and parable. It is significant that Cock issued Bruegel's *Big Fish eat Little Fish* of 1556 as a work of Hieronymus Bosch. Many contemporaries, and especially Italian critics like Vasari, saw Bruegel's panoramic settings and half-man, half-animal forms as successors to the paintings of Bosch. He comes closest to Bosch in works of 1562 such as *The Triumph of Death* (Prado, Madrid) and *The Fall of the Rebel Angels* (Musées Royaux des Beaux-Arts de Belgique, Brussels). In other works such as *Netherlandish Proverbs* (Staatliche Museen, Berlin), he replaces Bosch's blend of the playful and the demonic by a ruthless observation of everyday action as the basis for moral comment. The *Battle between Carnival and Lent* (1559; Kunsthistorisches Museum, Vienna) is perhaps the most vivid of these early works which juxtapose the lighthearted and the darker sides of man's existence, here enacted as a play of Netherlandish Shrovetide customs. The market square, seen from the high viewpoint common to his early works, has become a stage for the contest between greed and self-denial.

Bruegel's work appealed chiefly to private patrons and connoisseurs. For the Antwerp art collector Nicholas Jonghelinck he painted a series of pictures (1565–6) representing the months. Only five of these survive from a possible original 12. Their panoramic landscapes mark the high point of Bruegel's use of observed reality for imaginative purpose. The *Hunters in the Snow* (Kunsthistorisches Museum, Vienna) probably depicts January. The viewpoint is slightly lowered from earlier works and transition from foreground to background is effected by sharply plunging diagonals. Throughout the series the artist's message seems to be that the changing face of season and landscape domi-

nates and determines human activity.

The relative insignificance of man in Bruegel's world picture is manifest even in some of his religious works; *The Conversion of St Paul* (1567; Kunsthistorisches Museum, Vienna) is a tiny detail in a vast mountain-top landscape. Other religious works, however, show a marked increase of figure-scale to picture-field. The *Adoration of the Kings* (1564; National Gallery, London) dispenses with landscape; and a grisaille painting of 1565, *Christ and the Woman Taken in Adultery* (Home House Collection, Courtauld Institute of Art, London) shows an expansive space dominated by monumental figure forms and a lack of any setting at all.

A lower viewpoint and much larger figure forms are used in his last scenes of peasant life, such as the *Peasant Wedding* (Kunsthistorisches Museum, Vienna) and his late allegories. In the *Blind leading the Blind* (1568; Museo e Gallerie Nazionali di Capodimonte, Naples) the figures move as in a frieze across the canvas towards the man falling into the ditch at the right. Bruegel has moved away from the bright juxtapositions of color in his early works to a muted and delicate palette of browns, greens, and shades of gray. His technique of painting had always been to apply his colors thinly, edging the contours with soft, black lines; in the Naples picture the landscape is hardly more than a thin wash of transparent colors.

The Magpie on the Gallows (1568; Hessisches Landesmuseum, Darmstadt) is probably his last work. It seems to mark a new departure in the reconciliation of a high viewpoint with the soft light and color of other late works. In this respect it is close to the style of the landscape drawings, where light and atmosphere are rendered by short, meticulous pen strokes, echoed here in the dappled treatment of the foliage. Numerous studies of the peasant figures that populate his paintings also survive, many of them annotated with color and descriptive notes. Direct preparatory studies are rare, however; Bruegel's artistic process was one of assimilation of observed detail rather than direct transcription.

Bruegel's impact on Flemish painting in the century after his death was due partly to engravings after his work and partly to the family workshop which continued his style. Pieter the Younger, his elder son, became Master at Antwerp in 1585 and efficiently produced copies and derivations

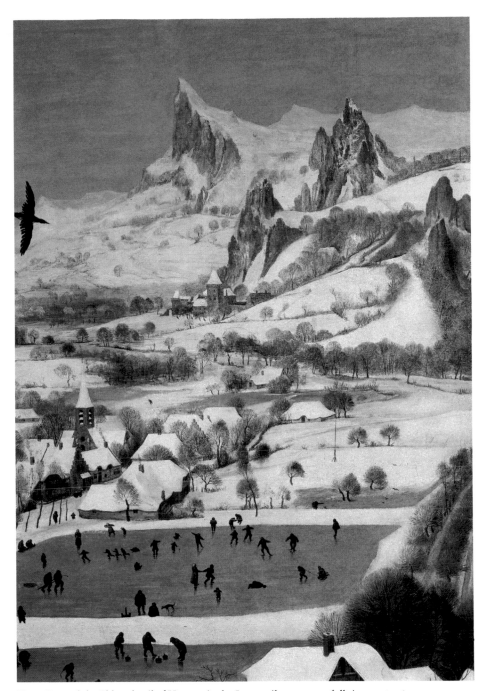

Pieter Bruegel the Elder: detail of Hunters in the Snow; oil on canvas; full size 117×162cm (46×64in); c1565. Kunsthistorisches Museum, Vienna

of his father's work for much of his long career; he often changed landscape settings or extracted groups of figures for variant compositions. He was called "Hell Bruegel" because he exploited the growing market for pictures of hell-fire and demons, the origins of which are found in his father's work. He was father of Pieter III, born in 1589, Master in Antwerp in 1608.

Jan, the younger son, was more talented than Pieter II. In his early twenties he traveled in Italy and became a member of the Guild of St Luke at Rome. In 1604 he is recorded at Prague. His ability to paint on a small scale led to his fame as a painter of cabinet pictures and he painted some of the

finest early flower pieces. He collaborated with a number of artists, including the young Rubens (for example, *Virgin with a Garland*; Prado, Madrid). His sons Ambrosius (1617–75) and Jan II (1601–78) were also artists, as was Jan II's son, Abraham (1631–90).

Further reading. Gerson, H. *Art and Architecture in Belgium: 1600–1800*, Harmondsworth (1960). Gibson, W. *Bruegel*, London (1977). Grossman, F. *Bruegel, the Paintings*, London (1973). Klein, H.A. *Graphic Works of Pieter Bruegel the Elder*, New York (1963). Munz, L. *Bruegel, the Drawings*, London (1961). Tolnay, C. de *Pierre Bruegel l'Ancien*, Brussels (1935).

Brunelleschi Filippo 1377–1446

The Florentine artist Filippo Brunelleschi was architect, engineer, and sculptor. He was the son of Ser Brunellesco Lippi, a Florentine notary who held important offices in the Republic and was sometimes entrusted with diplomatic missions. Filippo was enrolled as a master of the goldsmiths' guild in 1398; in the following year he was active in the shop of Lunardo di Matteo Ducci da Pistoia, for whom he made some silver figures for the altar of S. Jacopo in Pistoia Cathedral. The significance of a document mentioning a second matriculation by Brunelleschi in the goldsmiths' guild in 1404 has not been explained.

Brunelleschi first came to prominence as a result of the competition for the second bronze door of the Florence Baptistery, held in 1401, in which he participated alongside Ghiberti and five other sculptors. This contest has been described as the first art competition since Antiquity. In fact, it seems to have been common late medieval practice for a patron to invite several artists to submit designs before concluding a contract. Ghiberti and the anonymous biographer of Brunelleschi, believed to be Antonio di Tuccio Manetti, differ in their accounts of the result of this contest. While Ghiberti states that he won outright, the biographer claims that Brunelleschi and Ghiberti were invited to share the commission and that Brunelleschi subsequently withdrew.

Although Brunelleschi is known to have been involved in sculptural commissions c1409 and in 1415, he seems to have turned away from sculpture during the decade following the competition. Between 1404 and 1406 he served as a consultant on the fabric of Florence Cathedral, and it was probably around this time that he first visited Rome. It is not known precisely when Brunelleschi formulated the principles of "one-point" perspective which were subsequently employed by Masaccio and codified by Alberti, although his discovery could hardly have been made later than the second decade of the 15th century. There is little evidence that Brunelleschi was interested in painting; the two small perspectival views with which he is said to have demonstrated his ideas imply that his studies of this subject were primarily directed towards the requirements of architecture.

Little is known of Brunelleschi's work as an architect before 1417, when he was called upon to give his opinion on the dome of Florence Cathedral. Although the approximate design of the dome had been established as early as 1367, its actual execution remained a supremely difficult engineering problem. Originally working alongside Ghiberti, Brunelleschi soon acquired control over the supervision of the work. The completion of this enterprise spanned the rest of his life and it remains his most famous achievement. He overcame the main task of enclosing the enormous drum (which was already standing) by introducing a double-shell dome. This required a series of ingenious technical innovations to reduce weight and ensure maximum strength. The scaffolding and the weight-lifting devices needed to erect the massive superstructure of the dome posed serious difficulties in themselves. Brunelleschi surmounted every problem as it arose, with a brilliant display of engineering skill and meticulous attention to each detail of the construction.

Brunelleschi's earliest surviving public building is the Ospedale degli Innocenti, Florence, begun in 1419. Its long semicircular arcade reveals a clear debt to the Tuscan Romanesque, but the precision with which these medieval forms are applied, and the modular system of proportion with which the disposition of the whole design is governed, are entirely Classical. In 1421, Brunelleschi began the church of S. Lorenzo. Here he brought the traditional basilican plan up to date with a rigid application of modular theory, embracing the arcade bays, the span of the nave, and the equally-sized transepts, choir, and crossing, each of which stands in a precise proportional ratio to the others. The clarity of Brunelleschi's thought is well exemplified by the Old Sacristy of the church, adjoining the main building. A simple cube, rationally linked by pendentives to its dome above, it stands as virtually the first of a succession of centrally planned Renaissance structures.

With S. Spirito, begun in 1436 but completed after his death, Brunelleschi continued to develop his ideas upon the basilican church without being hampered, as he had been at S. Lorenzo, by an existing ground plan. The design was tightened up by continuing the aisle in an unbroken band around the transepts, choir, and west front, and by simplifying the ratio of arcade to clerestory from 5:3 to 1:1. Brunelleschi's original design incorporated a ring of semicircular chapel niches, visible from the outside, which established a formal congruity between the exterior wall and the interior configuration of the building.

Although Brunelleschi was commissioned to design the Pazzi Chapel in the cloister of S. Croce in 1429, the building seems to have progressed slowly and was not completed until many years after the architect's death. It consists of a domed central square, extended to an oblong by barrel-vaulted side bays, and further elaborated by a square, domed choir and a barrel-vaulted portico. This runs longitudinally across the facade of the building, firmly knitting the new structure into the cloister within which it stands. The exquisitely balanced proportions of the design are underscored by the subtle polychromy of the gray moldings set against the paler walls, and enlivened by the glazed majolica roundels on the walls and in the spandrels of the dome. It was partly because of this innovatory system of interior decoration that the Pazzi Chapel proved so influential upon subsequent generations of architects.

Unfortunately, Brunelleschi's design for S. Maria degli Angeli (1434–7) was never completed. Consisting of a domed octagonal lantern surrounded by a ring of eight chapels, it would have been the first true centrally planned building of the Renaissance—it marks a high point in Brunelleschi's development as an architect. In 1436 he designed a last centrally planned structure: the lantern of Florence Cathedral. An octagonal *tempietto*, braced against the ribs of the dome by flying buttresses, this design aptly demonstrates the structural purpose of the lantern and at the same time provides a superb conclusion to Brunelleschi's great composition.

In addition to these works, Brunelleschi's name has been associated with other important Florentine buildings, including the Palazzo della Parte Guelfa and even the Palazzo Pitti which was not begun until long after his death. Uniting his vast store of traditional engineering expertise with a new awareness of Classical models, and a personal genius for coherent and rational design, Brunelleschi transformed the outlook of the Florentine architectural world. More than any other individual, he established the forms and demonstrated the preoccupations of Italian Renaissance architecture.

Filippo Brunelleschi: the cupola and lantern of Florence Cathedral; built 1425–67

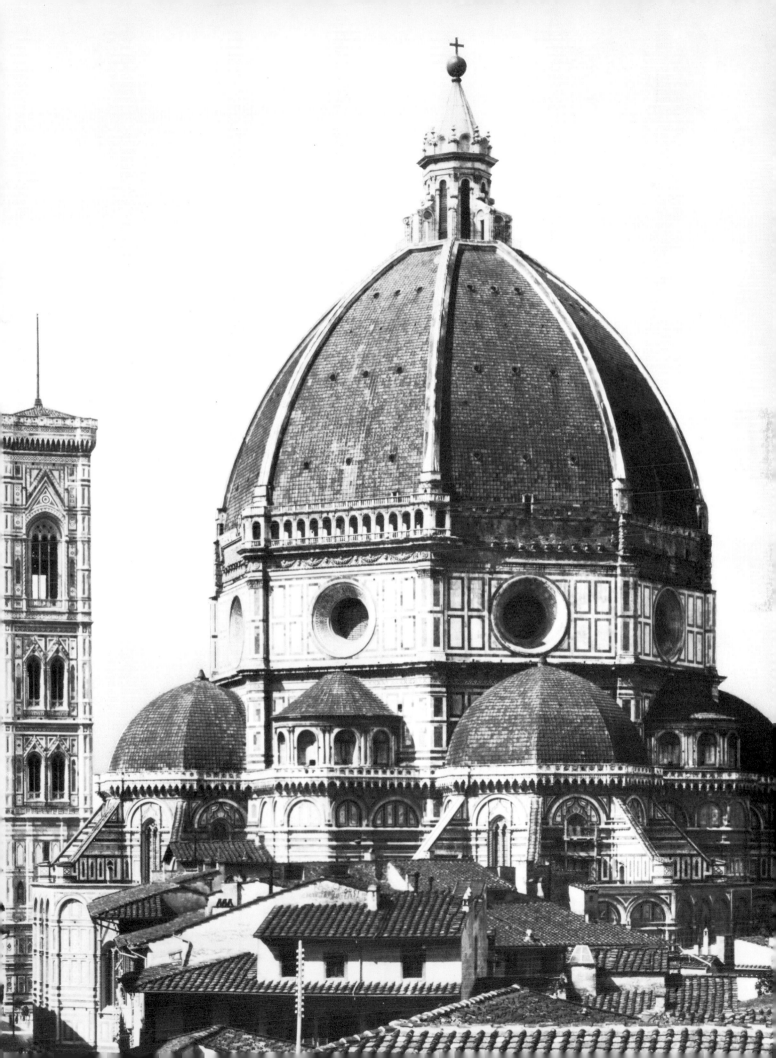

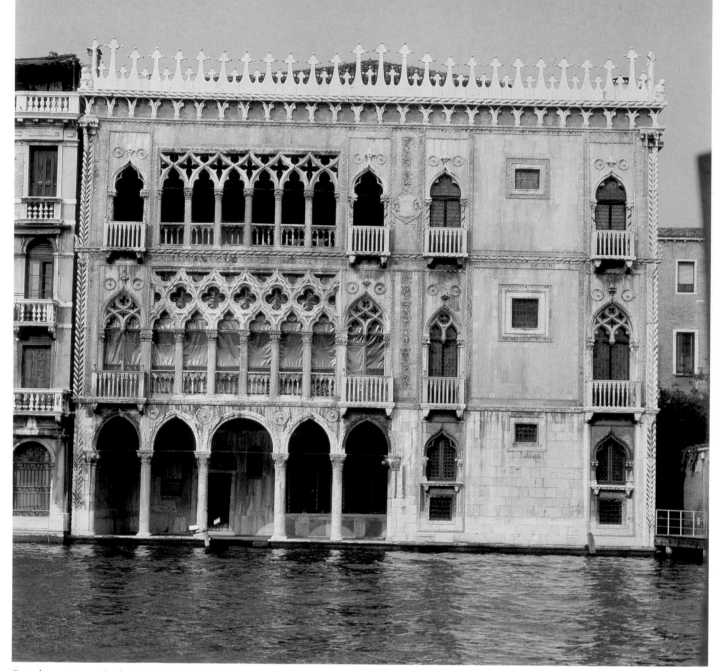

Bartolomeo Buon: the facade of the Ca' d'Oro, Venice; 1421–34

Further reading. Battisti, E. *Filippo Brunelleschi: The Complete Work*, London (1981). Heydenreich, L. and Lotz, W. *Architecture in Italy: 1400–1600*, Harmondsworth (1974). Klotz, H. *Die Frühwerke Brunelleschis und der Mittelalterliche Tradition*, Berlin (1970). Manetti, A. (trans. and ed. Saalman, H.) *The Life of Brunelleschi*, University Park, Pa., and London (1970). Prager, F.D. and Scaglia, G. *Brunelleschi, Studies of His Technology and Inventions*, Cambridge, Mass. (1970).

Bruyn Nicholaes de 1571–1656

The Flemish engraver Nicholaes de Bruyn was born in Antwerp, the son of the engraver Abraham de Bruyn. He entered the printmakers' guild of his home town in 1601. Around 1617 he moved to Rotterdam, where he died. Nicholaes completed over 200 engravings. A large proportion of these are reproductions of the designs of other artists, primarily near-contemporary figures such as Gills van Coninxloo, David Vinckboons, and Jacob Savery, but occasionally earlier artists including Lucas van Leyden and Albrecht Dürer. He also prepared original compositions, some of which he entrusted to other engravers, including Aswerus van Londerseel and Claes Jans Visscher. The majority of his works, both his copies and his own designs, are religious in subject matter, although he also undertook profane themes and ornamental compositions.

Bryaxis *fl.* 355–300 BC

Bryaxis was a Greek sculptor of the late Classical or early Hellenistic period. A signed early base of a votive tripod in the National Museum, Athens, indicates that he was probably an Athenian, although his name also occurs in Caria.

He collaborated with Scopas and Leochares in the Mausoleum of Halicarnassus and later worked mostly in eastern Greece. His fame rested mainly on two cult-statues: the *Apollo Pythius* at Daphne near Antioch in Syria, made of gilded wood with the nude parts in marble (known to us from coins); and the Hellenic-Egyptian god *Serapis* in Alexandria, an original, dark blue creation of rare metals and precious stones.

Brygos Painter *fl. c495–470 BC*

The Brygos Painter is the conventional name for a prolific Greek vase-painter in Athens who painted five of the finest cups signed by the potter Brygos. He painted mainly cups, on one of which he experimented with painting on a white ground (Staatliche Antikensammlungen, Munich; Inv. 2645). Onesimos was his teacher. His early work runs parallel to the later work of Onesimos, when that artist's figures were beginning to become rather delicate: the Brygos Painter gave them back their vigor. He was a master of movement, but was also capable of quiet grandeur; his faces are passionate, his subjects lively. He loved myth and abandoned carousals. A large school of artists who painted in a similar manner gathered around him. In his later works his style becomes weaker, his figures more attenuated, and his subjects repetitive.

Buncho Tani 1763–1840

The Japanese painter Tani Buncho was the first great master to be born and to work mainly in Edo (Tokyo). He was basically a *Bunjinga* (Chinese-style scholar-artist), but he could and did paint in every current style. He lived in the metropolis, where he moved in high circles and became a popular hero, but throughout his life he traveled widely in Japan, sketching from nature; so his landscapes are native in flavor in spite of their Chinese models. His most original landscape style is a fusion of chunky construction and bold outline filled with delicate atmospheric washes. As a virtuoso in pure ink he is in the first rank. He illustrated many books, and was a major influence on Japanese painting.

Buon Bartolomeo *fl. 1421–64*

Bartolomeo Buon was a Venetian stonemason and sculptor, and from c1440 until his death he was the principal sculptor in Venice. He undertook all types of work in stone and marble: stone decoration of brick buildings (windows, ornamental moldings, statues), elaborate doorways, and tombs. His was an elaborate late Gothic style with classical elements, but his incomplete facade for the Ca' del Duca Palace (c1460) is classical, entirely in stone, and innovatory for Venice. His most important documented statue, *Justice*, on the Porta della Carta, Doge's Palace (c1440) is in a style developed from that of

the works of Jacobello and Pierpaolo dalle Masegne (*fl.* 1383–1403) but the figure has more solidity, the draperies are ampler, and the face fleshier and more placid.

Buontalenti 1536–1608

The architect and stage designer Buontalenti (Bernardo dalle Guandole) worked mainly for the Medici court in and around Florence. He completed the Uffizi, begun by Vasari, and designed the Chapel of the Princes at S. Lorenzo. He also built a canal between Pisa and Leghorn, contrived some trick fountains at the Villa Pratolino, and designed other works requiring a high degree of technical skill. He showed a talent for decorative invention in architectural detail which links him closely to Mannerism. Examples include the Porta delle Suppliche (Uffizi, Florence), where the two halves of a broken pediment are reversed, and the altar steps for S. Trinità (now at S. Stefano), which cannot in fact be climbed. He was one of the major innovators of Baroque stage design.

Burchfield Charles 1893–1967

Born and raised in Ohio, the American landscape artist Charles Burchfield spent most of his adult life in Buffalo. Usually painting in watercolors, he was one of the first American Scene painters, his earliest works being based on memories of his childhood in Ohio. Created in response to fits of deep depression and anxiety, they show buildings and nature animated by strong and sometimes sinister forces. They are characterized by distortions, strong and often agitated rhythms, and childlike fantasy—in one of his best-known works, *Church Bells Ringing, Rainy Winter Night* (1917; Cleveland Museum, Ohio) a church spire has become a birdlike head, and the windows are faces. In the 1920s and 1930s he concentrated on depicting the drabness of small, Midwestern towns, the buildings derelict and ghostly, his style more restrained, though by the 1940s he had returned to the visionary landscapes of his early period.

Further reading. Baur, J. *Charles Burchfield, 1893–1967*, New York (1982).

Burgkmair Hans, the Elder 1473–1531

The German painter and draftsman Hans Burgkmair the Elder was born in Augsburg

where he was registered Master in 1498. He trained first under his father Thoman. On stylistic grounds it seems likely that he then studied in Martin Schongauer's workshop on the upper Rhine in the late 1480s.

Burgkmair's style, like that of his contemporary Albrecht Dürer, was decisively influenced by travel in Italy. About 1505 he was in Lombardy and Venice, and thereafter Italian Renaissance forms become assimilated into his work.

His portraits similarly show a grafting of Italian ideas on to the realistic traditions of Northern Europe. The *Portrait of Hans Schellenberger* (1505; Wallraf-Richartz-Museum, Cologne) has an elegance reminiscent of the highly self-conscious, gentlemanly self-portraits of Dürer. His woodcut portraits include a medallion study of *Pope Julius II* (1511). Other woodcuts show imaginative range and a command of ornamental design.

Burne-Jones Edward 1833–98

The English painter and designer Sir Edward Coley Burne-Jones was a leading figure in the second wave of the Pre-Raphaelite movement. Born in Birmingham, he was originally destined for a career in the Church. With this intention he went up to Exeter College, Oxford, in 1853, but soon became disillusioned by the apathetic atmosphere. However, he did meet William Morris, a kindred spirit who shared his enthusiasm for medieval legend and poetry and who later guided him toward the artistic path. Inspired by the writings of Ruskin, the Pre-Raphaelite periodical *The Germ*, a summer visit to northern France, and a meeting with D.G. Rossetti, Burne-Jones left the University in 1856 and went to London to become a painter.

He was admitted to Rossetti's studio as a pupil and remained under his tutelage for several years; together with Morris he helped Rossetti to paint the wall decorations of the Oxford Union Debating Chamber in 1857. Through Rossetti, Burne-Jones met various members of the Pre-Raphaelite circle, including Arthur Hughes, Thomas Woolner, and Ford Madox Brown. Morris, who had joined Burne-Jones in London in 1856, pursued his own artistic studies. In 1861 he founded the firm of Morris, Marshall, Faulkner and Company for which Burne-Jones made tapestry and stained glass designs, as well as cartoons for furniture decorations.

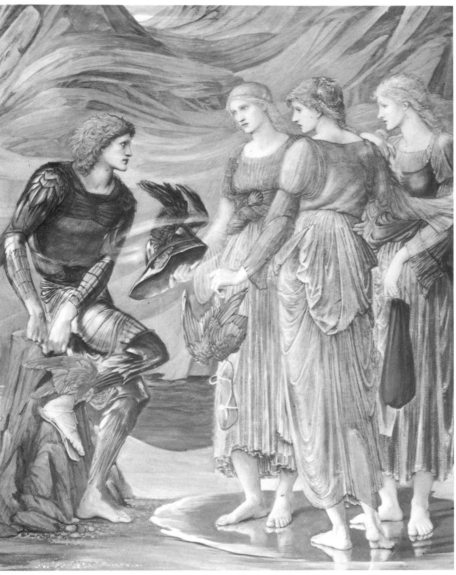

Edward Burne-Jones: The Arming of Perseus; gouache; 152×127cm (60×50in); 1877. Southampton Art Gallery

His best-known contributions in stained glass are those with large, single-figure compositions representing saints or virtues. Thus Morris and Burne-Jones gave practical expression to their shared desire to elevate the handicrafts to the level of Art.

Burne-Jones' first visit to Italy in 1859 revealed to him the glories of true "pre-Raphael" painting in the works of Orcagna, Signorelli, Mantegna, Botticelli, and Michelangelo. Three years later, in the company of Ruskin, he discovered the splendor of the Venetians. From this time on, his work moved away from the luxuriant, decorative treatment of Rossetti to the sparser forms and muted tones of the Italian primitives. His great love of literary themes remained with him, and he drew upon many such sources for his subject matter. A favorite subject, The Beguiling of Merlin (1874; Lady Lever Art Gallery, Port Sunlight) taken from Mallory's Morte d'Arthur, demonstrates his adherence to poetic imagery and displays many of the peculiar characteristics of his art. The clear muscular delineation of Merlin and Nimuë, (seen for example in Merlin and Nimuë in the Victoria and Albert Museum, London), the languid poses, the androgynous quality of the faces and figures, the muted yet rich coloring, the suspension of movement, the creation of an ethereal, otherworldly mood—all these elements distinguish the Burne-Jones style.

This style was not, however, recognized until the opening of the Grosvenor Gallery in 1877. With this event, Burne-Jones was finally hailed as England's most influential painter. The delay in public acclaim had been caused by a disturbed exhibition history. He had exhibited with the Old Watercolour Society in the 1860s, but resigned from the Society in 1870 following a dispute, and did not exhibit again in public until the first Grosvenor Gallery exhibition. He also refrained from exhibiting at the Royal Academy Summer Exhibition. Consequently his fame only became established in the late 1870s and 1880s. One of his most celebrated paintings, King Cophetua and the Beggar Maid (1880–4; Tate Gallery, London) was shown at the Grosvenor in 1884 and won a First Class medal at the Paris International Exhibition of 1889.

Burne-Jones was elected an Associate of the Royal Academy in 1885 and, as a concession to this unsought honor, he exhibited one painting, The Depths of the Sea (1885–6; private collection) at the annual Summer Exhibition of 1886. In 1893 he resigned from the Royal Academy without becoming a full Academician. He received a baronetcy in 1894.

Though his style changed during his career, his vision of painting as an amalgamation of the poetic and the aesthetic never wavered, as can be seen in his illustrations to William Morris' Kelmscott Press edition of The Works of Geoffrey Chaucer (printed 1896). Burne-Jones' conception of a picture as "a beautiful romantic dream of something that never was, never will be" resulted in the creation of a dreamworld haunted by wistful figures set within landscapes whose space was deliberately indeterminate.

Further reading. Spalding, F. Magnificent Dreams: Burne-Jones and the Late Victorians, London (1978).

Burra Edward 1905–76

The British painter Edward Burra was born in London. He studied at Chelsea Polytechnic (1921–3) and at the Royal College of Art (1923–4). His early work shows some affinity with that of George Grosz but Burra soon moved closer to Surrealism. He joined Paul Nash's short-lived group Unit One in 1933 (as did Ben Nicholson, Henry Moore, and Barbara Hepworth) and exhibited with the English Surrealists in 1936 and 1938. His mature

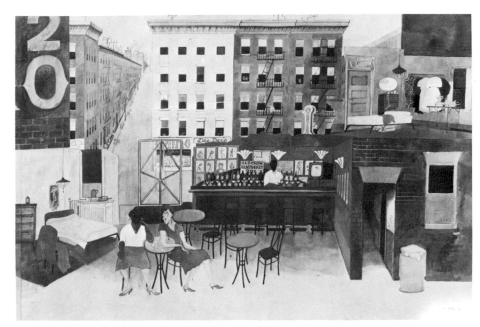

Edward Burra: Scene in Harlem (Simply Heavenly); watercolor; 72×112cm (28×44in); 1952. Lefevre Gallery, London

style, already developed by the mid 1930s and little changed since, is characterized by a strong visual rhythm, simplified forms, grotesque figures, and a mood that is invariably sinister and sometimes menacing. He always worked in watercolor and his later work shows a marked preference for landscape.

Burri Alberto 1915–1995

The Italian painter and collage artist Alberto Burri was born in Città di Castello. He took a medical degree in 1940 and practiced in the Italian Army. Captured in North Africa in 1943, he spent 18 months in a Prisoner of War camp in Hereford, Texas, where he began to paint in 1944. Returning to Rome in 1945 Burri gave up

Alberto Burri: Sacking and Red; sacking, glue, and plastic paint on canvas; 86×100cm (34×39in); 1954. Tate Gallery, London

his medical practice to become an artist; his first exhibition was held in 1947. His second important exhibition was the *Origine* group show in 1951 where he exhibited with Ballocco, Capogrossi, and Colla. Burri's earliest paintings were worked in thick opaque materials. These were followed by the collages in burlap, wood, iron, and plastic on hardboard for which he is now best known, for example *Sackcloth 1953* (1953; burlap, sewn, patched, and glued over canvas; Museum of Modern Art, New York).

Busch Wilhelm 1832–1908

The German illustrator and painter Wilhelm Busch studied at the Düsseldorf and Munich Academies (1851–2, 1854–5). He visited Antwerp in 1852, and the impact of Dutch and Flemish art turned his interest towards realism and comic genre painting. His contact with the bohemian circle of "Young-Munich" led to commissions for the humorous newspaper *Fliegende Blätter* (1858–71). Busch progressed from illustrating stories to providing his own verse-captions to picture-cycles. These *Bildergeschichten* are full of Schopenhauerian pessimism and *Schadenfreude* ("Max and Moritz", 1865), relying on a mixture of realism and the grotesque. Busch never exhibited his paintings, which seem to foreshadow Expressionism in the violence of their technique.

Bushnell John c1630–1701

The English sculptor John Bushnell trained under the London mason Thomas Burman. He gained firsthand knowledge of Baroque sculpture by working in Italy, France, and Flanders. He settled in Venice where he executed a large tomb with complex battle reliefs for the Mocenigo family in S. Lazzaro dei Mendicanti, Venice, in 1663–4. After returning to England, probably c1669, he received commissions for a number of royal portraits, as well as for tombs in Westminster Abbey. Bushnell's style is characterized by a Baroque bravura, and a knowledge of Bernini's sculpture; but his unstable temperament is reflected in the uneven quality of much of his work.

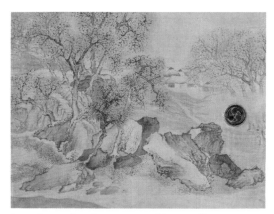

Yosa Buson: Landscape; 1771. Museum für Ostasiatische Kunst, Cologne

Buson Yosa 1716–83

The Japanese painter and poet Yosa Buson (born Taniguchi Buson) is considered, with Taiga (1723–76), one of the greatest masters of the *Bunjinga* (scholar-painters). Born near Osaka to a wealthy family, he moved to Tokyo as a young man; he became a *haiku* poet, with a reputation second only to that of the 17th-century master Basho. As a result he became adept at the abbreviated line-and-wash style of painting called *Haiga*, used to illustrate the poems. This humorous style is seen in his screens of parts of Basho's *Narrow Road to the Deep North* (Yamagata Art Gallery), where three-quarters of the paper is filled with text. Its racy vigor was handed on to his pupil in poetry and painting, Goshun, and thence to the *Shijo* School.

Buson left Tokyo in 1742, and until c1760 traveled and studied painting, especially the Chinese school of Nagasaki. A

late developer, he did not achieve a mature *Bunjinga* style until middle age; but by 1768 he was better known in his adopted town of Kyoto as a painter than as a poet. His best work of this period is the *Ten Conveniences and Ten Pleasures* album, done with Taiga, a small-scale masterpiece of the pure Chinese scholar spirit. Always learning, Buson was influenced later in life by the new naturalism of Okyo; in his last years he produced the soft, rhapsodic, leafy, usually springtime landscapes which are so in accord with Japanese sentiment. They include the famous *Cuckoo over Springtime Forest* (Hiraki Collection, Tokyo) and the screens *Bridle Path Through a Willow Grove* (Yabumoto Collection, Tokyo).

Bustelli Francesco 1723–63

The eminent porcelain modeler Francesco Antonio Bustelli (also known as Franz Anton) was born in Locarno. Nothing is known of his training or early activity before 1754, when he is documented at Neudeck in Bavaria as a modeler of figures. He remained there until 1761 when the porcelain factory was transferred to Nymphenburg, near Munich. In 1759 he had been appointed "Arcanista", indicating other forms of technical expertise. The elegant figures made by Bustelli during his nine years in Bavaria are closely related in style to the sculpture of Ignaz Günther; his sophisticated bust of *Count Sigismund Haimhausen* (1761) is one of the finest examples of Bavarian Rococo court portraiture.

Butler Reg 1913–81

The English sculptor Reg Cottrell Butler was born at Buntingford, Hertfordshire. He trained as an architect from 1933 to 1937, practicing until 1950 under the name of Cottrell Butler. He was Gregory Fellow at Leeds University 1950–3. In 1953 he was Grand Prizewinner in "The Unknown Political Prisoner" International Sculpture Competition, and was a visiting lecturer at the Slade School of Fine Art, London.

Reg Butler sculpted figures as a child. His early wood carvings and bronzes, influenced by Henry Moore, were succeeded in 1948 by open, linear forged iron figures and groups; from 1951 he also worked in cast iron. He introduced closed forms within a linear, skeletal structure. During

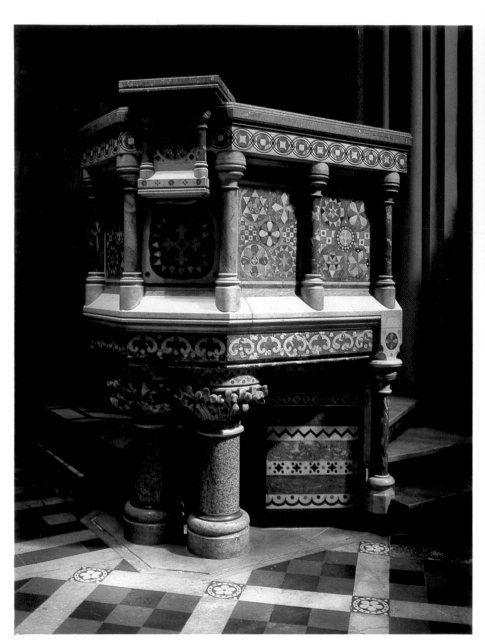

William Butterfield: the pulpit of All Saints church, Margaret Street, London; designed 1849

1953 he concentrated on single gesturing figures in bronze, supported by architectural constructions which become cages to suspend them in space. Between 1960 and 1963 he experimented with rectilinear maquettes for tower sculptures and from 1967 to 1972 he developed a series of larger-than-life female nudes in bronze, naturalistically painted with false eyes and hair, in exaggerated and provocative poses.

Butterfield William 1814–1900

The English architect William Butterfield was born in London. During his early training with a builder he developed an interest in the practical aspects of building. He combined this with a commitment to the revival of medieval architecture and ritual, as advocated by the magazine *The Ecclesiologist*, to which he contributed. Most of his large practice was devoted to church-building and restoration. His assertive use of colored brickwork and his bold pattern-making at All Saints, Margaret Street, London (1849–59), introduced into the Gothic Revival a new vigor and richness which was displayed on a fuller scale in his masterpiece, Keble College, Oxford (1867–75).

C

Caffiéri family
17th and 18th centuries

The distinguished Caffiéri family of sculptors and bronze founders were descended from Daniel Caffiéri (1603–39), a papal engineer who worked in Rome. His son Philippe (1634–1729) was summoned to France by Mazarin in 1660 and worked under Charles Lebrun. Philippe's elder son, François-Charles (1667–1729), like his descendants Charles-Philippe (1695–1755) and Charles-Marie (1736–*post* 1744), specialized in decorative marine sculpture. Philippe's other son, Jacques (1678–1755), was the outstanding bronze founder and chiseler at the French court, where he was followed by his eldest son Philippe (1714–74). His younger son, Jean-Jacques (1725–92), studied under J.B. Lemoyne and became an outstanding sculptor of portrait busts.

Calamis 5th century BC

The Greek sculptor Calamis may have come from Athens. He worked in bronze, in marble, and in ivory and gold. It is uncertain whether he belonged to the early Classical or the Classical period, or both. He was commissioned to make a statue of *Zeus Ammon* by Pindar in Thebes, and for an *Aphrodite* by Callias, brother-in-law of the Athenian general Cimon. (The signed base of this work was found on the Acropolis.) Calamis collaborated with Onatas in the bronze group of a chariot and horses erected at Olympia by Dinomenes, King of Syracuse (467–466 BC). He also made an *Apollo, Averter of Evil*, possibly dedicated by the Athenians after the plague of 430 BC.

Calder Alexander 1898–1976

The American sculptor Alexander Calder was born in Philadelphia; his father was a sculptor, his mother a painter. He was at first interested in engineering, and in 1919 graduated from the Stevens Institute of Technology as a mechanical engineer. It was not until 1922 that he became seriously interested in art; he attended the Art Students' League in New York from 1923 until 1926, when his first paintings were exhibited. That same year, after a visit to England, he went on to Paris. He stayed

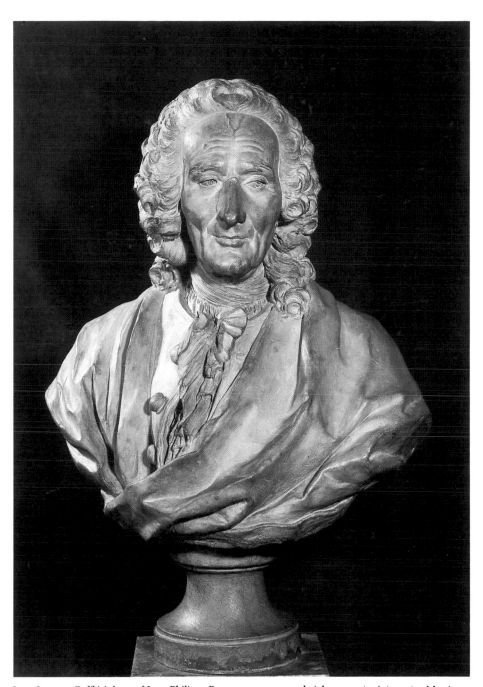

Jean-Jacques Caffiéri: bust of Jean-Philippe Rameau; terracotta; height 75cm (30in); 1760. Musée des Beaux-Arts, Dijon

there for a time, making a series of animated toys and also his first wire sculpture, inspired by the circus. For some years he continued to make wire sculpture, light in form and witty in tone, at times even reminiscent of drawings by Paul Klee (for example, *Romulus and Remus*, 1928; Solomon R. Guggenheim Museum, New York).

In 1930 Calder was attracted by the more austere work of Piet Mondrian and the Constructivists (notably Naum Gabo). He

also met Joan Miró and Jean Arp, who influenced his style. He began to produce very light, Abstract sculptures in wire and wood (Arp called them "stabiles", a word always associated with Calder's work). He also experimented with manual and motorized mobiles, which went through prescribed programs of movements (for example, *The White Frame*, 1934; Modern Museum, Stockholm).

From these experiments it was but a short step to the type of mobile Calder was to

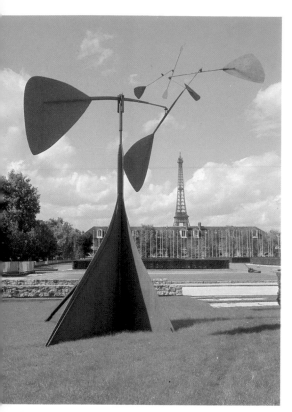

Alexander Calder: The Spiral; metal mobile; height 500cm (197in); 1958. Unesco Complex, Paris

make his own: the series of flat, often brightly painted disks and metal shapes, suspended either from a ceiling or from an arm linked to a base on the floor. These works were held in balance, yet needed only the slightest draft of air to set them moving in ever-changing patterns (examples, *Lobster Trap and Fish Tail*, 1939; Museum of Modern Art, New York—a suspended mobile; *The Spiral*, 1958; Unesco Complex, Paris—an outdoor standing mobile). During the 1950s and 1960s, Calder received many commissions for large-scale outdoor sculpture: the Unesco mobile is 30ft (10m) high, while *Man*, the stabile he created for Montreal's EXPO 67, is 94 ft (31 m) high. Among the most inventive of 20th-century sculptors, Calder also worked as a book-illustrator and painter. In 1971 he was awarded the Gold Medal for Sculpture by America's National Institute of Arts and Letters.

Further reading. Gimenez, C. *Calder: Gravity and Grace*, London (2004). Lipman, J. and Aspinwall, M. *Alexander Calder and His Magical Mobiles*, Manchester, VT (1982). Prather, M. *Alexander Calder 1898–1976*, New Haven (1998).

Callot Jacques 1592–1635

The French engraver Jacques Callot was born at Nancy in Lorraine where his father was King-at-Arms to Duke Charles III. After being apprenticed to a local goldsmith, Callot left for Rome c1610 where he learned the art of line engraving. Late in 1611 he moved to Florence where his greatest success was in recording the festivals staged by the Grand Duke Cosimo II. Such plates as the *Florentine Fete* (1619) depict hundreds of people skillfully controlled in a coherent pattern within the panorama. His ability to build up large numbers of small figures into a unified composition was probably influenced by engravings after the works of Bosch and Bruegel. He also showed an interest in the grotesque, producing small plates of *Gobbi* (hunchbacks) and beggars, or, as in *Pantaloons*, borrowing characters from the *Commedia dell'Arte*. Here, characteristically, he juxtaposes these bizarre figures with the affectedly elegant courtiers who promenade in the background.

In 1621 the Grand Duke died, and Callot lost his pension. He returned to Lorraine and became a leading figure among the late Mannerists working in Nancy. He continued to produce his series of *Fetes* and engraved the finest of his studies in the grotesque, *Gypsies* (1622). He also produced a number of religious etchings in which the witty artificiality of court Mannerism gives way to a poignant and more dramatic feeling. In 1625 he was called upon to depict *The Siege of Breda*, and in 1629 *The Capture of La Rochelle*. In Paris he produced some of his most notable topographical works.

Returning to Nancy, Callot produced in 1633 his last great series, the *Grandes Misères de la Guerre* (British Museum, London). Though partly influenced by the Thirty Years War (marked in 1633 by Richelieu's invasion of Lorraine) the scenes also draw on past experience, such as *The Siege of Breda*.

Calvaert Denys 1540–1619

Denys Calvaert (also called Dionisio Fiammingo) was a Flemish painter from Antwerp. He emigrated to Italy c1560–2 and there became an important member of the Bolognese school. In 1570 he went to Rome, where he helped Lorenzo Sabbatini with decorative work at the Vatican. He later founded a teaching academy in Bologna, which provided a model for the

more famous academy created by the Carracci c1585–6. Calvaert taught over 130 artists, notably the Bolognese painters Guido Reni and Domenichino.

Canaletto 1697–1768

Antonio Canale, nicknamed Canaletto, was born in Venice; he was the son of a scene painter and started his career in his father's workshop. About 1720 he turned to the painting of views and concentrated on this for the rest of his life, raising the genre to a new artistic level. His progenitors as *veduta* painters were Luca Antonio Carlevaris and the Dutch-born Jaspar van Wittel or Vanvitelli, but Canaletto's superiority to them was early recognized by his contemporaries.

His views of his native city were intended for export. Through the Irish impresario Owen MacSwiny and through Joseph Smith, a merchant resident in Venice who became British Consul in 1744, he acquired a large clientele in England. Smith's own collection of 54 paintings and over 140 drawings was sold to George III and many are still in the Royal Art Collection at Windsor.

In 1745, partly as a result of the War of the Austrian Succession, which made travel difficult for his patrons, Canaletto went to England. He lived mainly there until 1755, painting many views of the Thames and its bridges, of Whitehall, and

Denys Calvaert: The Presentation of Mary; oil on canvas; 93×78cm (37×31in). Pinacoteca Nazionale, Bologna

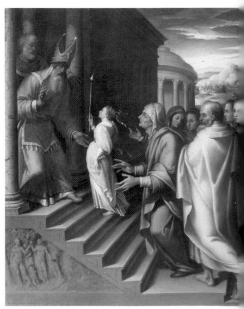

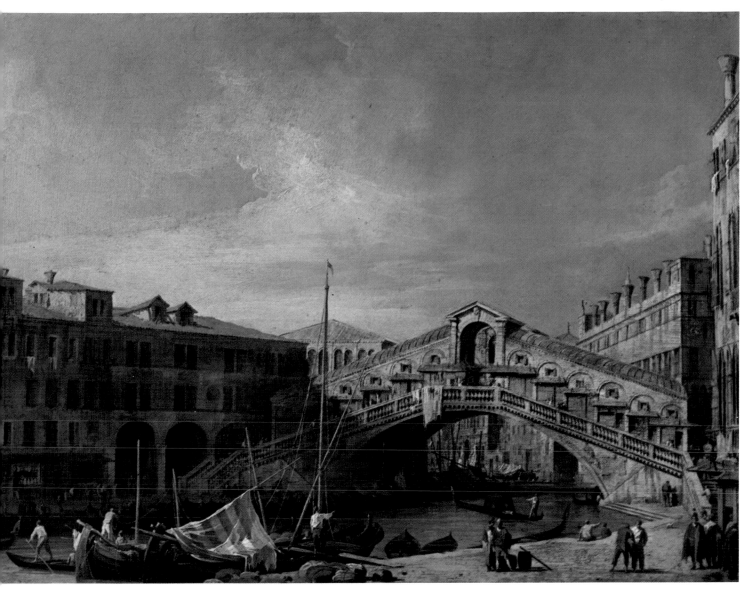

Canaletto: Venice, The Rialto Bridge from the South; oil on copper; 46×63cm (18×25in); c1729. Collection of the Earl of Leicester, Holkham Hall, Norfolk

of a number of country houses including Warwick Castle and Badminton.

In these, as in all his works, the topography is extraordinarily accurate. He made detailed pen and ink drawings, which are often annotated, and seems to have used a *camera obscura* in order to notate with detailed precision the minutiae of a scene before him. All his works employ linear perspective, which is used not only as an illusionistic device but as a means to aesthetic order. He often employs wide-angle or birds-eye views with several vanishing points; the perspective is handled so as to control the way the painting is seen, leading the eye on a structured voyage of exploration through its complex spaces.

His Venetian views are very varied, moving from the enclosed irregular spaces of the smaller Venetian *campi* to wide panoramas of the Grand Canal and the Bacino di San Marco. In the careful distribution of accents across the surface they show a sense of interval which is classical and deeply satisfying: but this is combined with a feeling for extended effects of air and atmosphere which is essentially Rococo and comparable with Tiepolo.

Canaletto's early works, such as the so-called *Stonemason's Yard* in the National Gallery, London, favor picturesque effects of surface and texture. Some of his greatest paintings of this period, for example, the *View of S. Cristoforo* (Royal Art Collection, Windsor) have open, Corotesque brushwork, evoking effects of light comparable to early Impressionism. Later, however, the need for elaborate detail and spatial precision led to a harder, more schematic notation, with many twirls and twiddles of the brush: in his very late work, the style became somewhat mannered and dry.

This mature style was well suited to engravings, and Visentini's several engraved series of Canaletto's Venetian views (1732; 1745) are important extensions of the painter's art and influence.

Further reading. Barker, C. *Canaletto*, London (1994). Brandi, C. *Canaletto*, Milan (1960). Bromberg, R. *Canaletto's Etchings*, London (1974). Constable, W.G. *Canaletto, Giovanni Antonio Canal*, Oxford (1976). Links, J.G. *Canaletto and his Patrons*, London (1977).

Cano Alonso 1601–67

The Spanish painter, sculptor, and architect Alonso Cano was born in Granada. He went early to Seville, and was apprenticed in 1616 to the painter Francisco Pacheco, becoming the fellow pupil of Diego Velázquez. Though painting was his major activity, Cano was early attracted to the polychromed wood sculpture that was popular in Seville; he may have received some training as a sculptor from Juan Martínez Montañés (1568–1648).

His large sculpture of the *Virgin and Child* in the retable in the church of Santa Maria at Lebrija (Seville; 1621–31), shows

striking originality in a Baroque idiom —the sweeping folds of the Virgin's draperies from head to feet give her an unprecedented air of majestic dignity. In the design of the architectural framework of that retable, Cano displayed even greater originality, abandoning the normal balanced proportions to make the lower story twice the height of the upper one and framing it in a giant order of Palladian inspiration.

Cano's early paintings in Seville were tenebrist, but he soon adopted a more colorful style. Among his works for religious orders, *St John the Evangelist's Vision of Jerusalem* (1635–7; Wallace Collection, London), for the nuns of Santa Paula, was an outstanding achievement. The painting displays a sculptural modeling and foreshortening prominent in a vigorous Baroque diagonal composition. The signed *St Agnes*, probably from the same period, was destroyed in Berlin in 1945. It made skillful use of shadows to add suppleness to a sculpturesque figure in a more static composition.

In Madrid (1638–52) Cano was mostly active as a painter and his work reflected renewed contact with Velázquez. He received royal commissions and frequently worked for religious bodies. Among many representations of the Virgin is *The Immaculate Conception* (c1650–2), in the Provincial Museum at Vitoria, in which the contrapposto attitude of the body gives a spiral movement to the wind-blown mantle. The beautifully modeled figure of Eve, a rare example of a female nude in this period, is notable in the *Christ in Limbo* (c1646–52; Los Angeles County Museum of Art, Los Angeles) though this composition is uneven in quality. In spite of increasing success, Cano returned to Granada embittered by false accusations that he had murdered his second wife.

Becoming a prebendary of Granada Cathedral, Cano again turned his attention to sculpture. Still in the cathedral are large busts of *Adam* and *Eve* (c1666–7), and a small *Immaculate Conception* (1656), originally decorating the lectern he designed. Notable among late paintings in Granada are seven enormous canvases of *The Life of the Virgin*, placed high in the cathedral sanctuary with simple compositions, most effective in the *Annunciation* and *Visitation* (1652–6). He also provided the design for the main facade of the cathedral, which was not completed until after his death.

Cano was the most versatile artist of his period in Spain. His reputation has suffered from the legends arising from his volatile temperament, together with the unevenness of his production and the disappearance of many important recorded works. But at its best his achievement as a painter and sculptor was of a high level, and he was a superb draftsman.

Canova Antonio 1757–1822

The Italian Neoclassical artist Canova became, internationally, the most famous sculptor of the 18th century. He began his career as a stonemason in northern Italy, but moved to Venice in 1768 and was apprenticed to a minor sculptor. In 1780 he arrived in Rome where almost immediately he discarded the skillful naturalistic style of his early work. He began to study Greco-Roman art and was influenced by the theories of Neoclassical collectors, archaeologists, and theorists, like Gavin Hamilton. In a short time Canova created the style that became the most expressive sculptural statement of the whole Neoclassical movement. His new inspiration depended on antique subject matter, but Canova also imbued his work with a personal concept of the ideal. His first major Neoclassical work, *Theseus and the Minotaur* (1781–3; Victoria and Albert Museum, London), is a figure that emulates the style of a Classical statue without being a slavish copy. Canova made constant use of the most diverse artistic precedents. His first important monument, *Pope Clement XIV* (1783–7; SS. Apostoli, Rome), was another personal adaptation from Bernini's Baroque tomb convention which Canova freely adapted into a Neoclassical idiom.

Canova was a prolific workman who ran a large studio in Rome. He usually finished the marble himself but he also employed a great many assistants. These worked on the marble and enlarged Canova's models (*bozzetti*) and preliminary designs with the aid of machinery. The sculptor could thus produce replicas of his work for an international market. Canova was always aware of the dangers of mechanical reproduction in sculpture and used numerous techniques for avoiding them. He made terracotta models, sometimes to scale, on which the details might be emphasized. When the assistants copied these models in marble they were less likely to lose surface animation and could preserve the dynamics of Canova's original image.

While Canova's style seems rooted in J.J. Winckelmann's Neoclassical creed (which demanded a smooth, calm sculpture with closed, compact outlines), the surfaces of Canova's figures are never monotonous like those of his contemporaries and imitators. This was perhaps due to the artist's early training. Canova's quest for truth to the Classical ideal was tempered by his insight into the possibilities of sculpture itself. His freestanding figures have an all-round viewpoint which maintains their antique derivation. Canova also systematically refined his work, bringing the details and textures to a highly polished state. This deliberate over-refinement often makes Canova's sculpture appear simultaneously frigid and sensual. It expresses the restraint and harmony that Winckelmann regarded as the essence of the best Greek sculpture; it also invests Canova's work with immense originality. Part of this originality came from the artist's fascination with different materials. Whether he worked in stone, marble, or clay Canova always displayed an understanding of the demands of each medium in relation to the shape he was trying to evolve. Many of his figures assume static, compact poses which allow little movement to disturb their integral form. Nevertheless, they are works of art that glory in physical beauty; they are never purely intellectual abstractions of a remote ideal. Canova himself cautioned admiring spectators never to forget the sculptor's struggle with the material: "I do not aim in my works at deceiving the beholder," he said. "We know that they are marble, mute, and immobile."

This overwhelming interest in techniques also influenced Canova's approach to the Antique. *Hebe* (c1808–14; Duke of Devonshire Collection, Chatsworth, Derbyshire), for example, was originally colored in order to make it correspond more closely to antique precedents, and Canova added a gilt ewer and cup. He was criticized for this scholarly departure from the Neoclassical rule of consistency and restraint in sculpture, but the figure became one of his most popular images.

The unorthodox nature of his Neoclassical sculpture made his work highly prized in the early 19th century. The sensuality of Canova's marble figures invited spectators to touch—or even kiss—the marble. When Canova saw the Elgin marbles during his visit to London at the end of 1815, he recognized the animation

and passion of genuine Classical carving. It was this sense of passion and movement that gave a Romantic character to Canova's work.

Canova's work spanned many regimes and nations. He worked for the Emperor Francis II of Austria, Catherine the Great of Russia, the Duke of Wellington, and Napoleon. He made many memorable portraits, the most bizarre of which was a nude statue of Napoleon in marble, 10 ft (3 m) high, which now stands in the Wellington Museum at Apsley House in London. An equally famous (or notorious) nude portrait was that of Napoleon's sister Pauline Borghese reclining as a *Venus Vincitrice* (1805–7; Museo e Galleria Borghese, Rome). Napoleon invited Canova to live and work in Paris but the sculptor declined; he remained in Rome, working for the Papal court.

In 1815 Canova became the Pope's representative in restoring to Italian collections works of art that had been looted by Napoleon during the Italian campaign. He traveled to Paris and London, where he was received as a major celebrity. The Pope made him Marchese d'Ischia in 1816, and Canova retired to his home village of Possagno near Treviso. Here he built a studio which now houses the most important collection of his works, particularly his models and his collection of antiquities. During the 19th century Canova's popu-

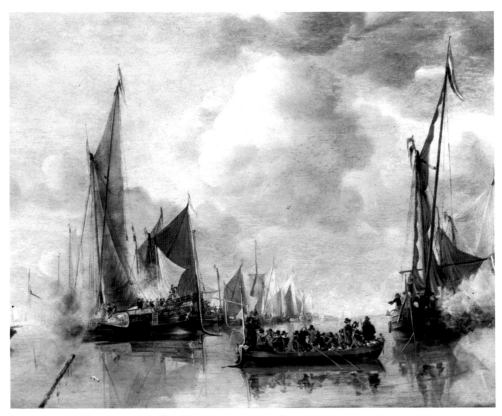

Jan van de Capelle: State Barge saluted by the Home Fleet; oil on panel; 64×93cm (25×37in); 1650. Rijksmuseum, Amsterdam

larity as a sculptor declined, but his style remained influential for serious historical sculpture, particularly in England. His work was celebrated by major poets such as Keats, Shelley, and Heinrich Heine.

Further reading. Honour, H. *Neoclassicism*, London (1968). Missirini, M. *Della Vita di Antonio Canova*, Milan (1824).

Antonio Canova: Pauline Borghese as Venus; marble; 87×185×65cm (34×73×26in); 1805–7. Museo e Galleria Borghese, Rome

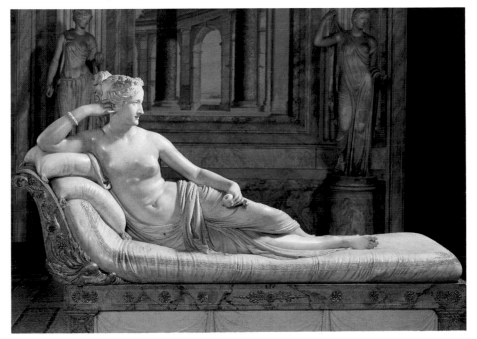

Capelle Jan van de 1626–79

Jan van de Capelle was a wealthy Amsterdam dyer and self-taught painter who became one of Holland's greatest marine artists. His pictures are less often seascapes than views of estuaries and harbors (for example, *The Calm*, 1651; Art Institute of Chicago). In these, Dutch merchant or naval ships lie quietly at anchor, the pattern of verticals created by their masts outlined against the large, fleecy clouds which fill three quarters or more of his canvases. The artist probably painted some of these views from his own pleasure yacht. His early works are silver-gray in tonality; later pictures have warmer colors, and convey a sense of moist but luminous atmosphere. Sunlight picks out detail at great distances in his translucent paintings; the effect is one of spaciousness and serenity. He also painted subtly composed and colored winter scenes, for example *Bridge Across a Frozen Canal* (1653; Royal Museum of Art, Mauritshuis, The Hague).

Capogrossi Giuseppe 1900–72

The Italian painter Guarna Giuseppe Capogrossi began his career in law but turned to painting between 1927 and 1933 while in Paris. Here his art gradually evolved from realism to abstraction under the influence of such artists as Joan Miró.

From 1933 he lived in Rome, and in 1949 he founded the "Origine" group with Burri, Colla, and Ballocco. Capogrossi's nonfigurative ideograms also appeared in 1949 and remained central to his work. These signs often take the form of hand-like graffiti ranged in opposing pairs over the whole canvas (for example, *Section 4*, 1953; oil on canvas; Museum of Modern Art, New York).

Caravaggio 1573–1609/10

Michelangelo Merisi, called Caravaggio, was born in Caravaggio near Bergamo, Lombardy. From 1584–8 he was apprenticed to Simone Peterzano, a Bergamesque late-Mannerist artist, and as a young man he absorbed the traditions of Savoldo, Moretto, and Lotto. Some time c1592–3 Caravaggio moved to Rome.

His temperament was violent and anarchic; throughout his life he was involved in brawls, continually skirmishing with the authorities, and sometimes in prison. His powerfully original art was also violent and showed no respect for authority. In Rome he quickly gained a reputation as an uncompromising realist who painted only what he saw. He worked straight on to the canvas without the use of preliminary drawings; he used strong, bright local colors, very different from the subtleties of Mannerist hues.

Caravaggio believed it required as much skill to paint a good picture of flowers as one of figures; it seems likely that he began his career as a still-life painter. His *Basket of Fruit* (Pinacoteca Ambrosiana, Milan) was probaby painted for Cardinal del Monte. From 1596 Caravaggio was attached to his household and painted for him and his circle a series of half-length figures of boys playing lutes, with carafes holding wine or flowers, or offering baskets of fruit. Among these works are *Self-Portrait as Young Bacchus (Bacchino Malato)* and the *Boy with a Basket of Fruit* (both Museo e Galleria Borghese, Rome), *A Musical Scene* (Metropolitan Museum, New York), and *Bacchus* (Uffizi, Florence). The figures are shown against plain but warm backgrounds. The paint is smooth, and the superbly accomplished still-life elements are painted in bright colors with precise, fresh details of surface and texture. There is, however, a hint of uncertainty in the placing of the figures in space. Though genre paintings, these are not realistic works. The boys have a lan-

guid elegance, and the clear beauty of their youth is mingled with their obvious knowledge of less innocent pleasures. The erotic appeal is made shamelessly explicit in *Victorious Love* (Staatliche Museen, Berlin), probably painted c1602.

From 1598 Caravaggio began to paint altarpieces. His most important commissions for the remainder of his stay in Rome were scenes from *The Life of St Matthew*, (Contarelli Chapel, S. Luigi dei Francesi) painted between 1599 and 1602, *The Conversion of St Paul* and *The Crucifixion of St Peter*, 1601 (Cerasi Chapel, S. Maria del Popolo), *The Entombment of Christ* (Vatican Museums, Rome) painted in 1602 for S. Maria in Vallicella, and the *Death of the Virgin* (Louvre, Paris) painted 1602–4 for S. Maria della Scala in Trastevere.

In these works Caravaggio created a deeply original religious style. They are distinguished by a startlingly direct dramatic appeal to the spectator, and a sense of profound compassion for the sufferings and complexities of humanity, both new in painting. The Contarelli Chapel paintings, in oil on canvas, consist of an altarpiece, *St Matthew and the Angel*, and two side paintings, *The Calling of Matthew* and *The Martyrdom of St Matthew*. These works mark a turning point in 17th-century art. Caravaggio's approach was realistic and he painted from humble models. A first version of the altarpiece, *St Matthew and the Angel* (formerly Kaiser-Friedrich Museum, Berlin; destroyed) was rejected by the clergy as improper. The saint was shown as a burly peasant whose dirty feet seemed to jut out of the painting towards the spectator. A graceful angel, erotically close to him, guided his hand. The final version was more conventional. *The Calling of St Matthew* shows a squalid setting and unheroic figures; the saint and his flashy gambling companions sit at a table in the courtyard of a Roman Palace. Their complex psychological reactions to the appearance of Christ are shown with a new and vivid narrative realism. To a public accustomed to Raphael's idealization, these were startling works.

Caravaggio abandoned the even lighting of his early work and began to place the figures in semi-darkness lit by a harsh beam of light. The lighting was contrived in the studio and is irrational: the dramatic and poetic contrasts of light and dark create a deeply spiritual atmosphere. In *The Calling of St Matthew* there is a

large dark area above the figures and the symbolic light falls from the right, accompanying the gesture of Christ, to penetrate the darkness of the unconverted. The composition is relatively simple; the figures are located in the foreground and the space behind closed.

The plebeian characters, stark settings and confined space occur in other works. In the *Death of the Virgin* Caravaggio shows the Virgin as a bloated corpse. The painting was rejected by the Carmelites as indecorous, yet it is a work of moving gravity.

Dramatic crises were heightened by the use of great gestures which seem to burst out of the picture-plane and fuse the world of the picture with the world of the spectator. In *The Conversion of St Paul* the saint lies at the foot of his horse; his dramatically foreshortened body and outflung arms are intended to draw the worshiper into the drama. Paul's eyes are closed and the conversion is within him; there is no excited recognition of supernatural powers.

At this period the figures themselves are solidly modeled and elaborately posed and the compositions clear and compact. *The Entombment of Christ* is Caravaggio's most severely constructed work; the figures have a grandiose, almost sculptural solidity. The corner of the stone slab on which the bearers of Christ's body are standing juts out towards us, and the whole composition seems to expand into our space. The emotions of the figures are expressed in expansive gestures.

In 1606 Caravaggio killed a man in a fight and had to flee Rome. In 1607 he was in Naples; his most important works there are *The Seven Works of Mercy* (church of the Pio Monte della Misericordia, Naples) of 1607 and *The Flagellation* (S. Domenico Maggiore, Naples), possibly 1610. The former is distinguished by its human warmth of feeling and astonishing freedom of composition, the latter by its somber brutality.

Caravaggio was in Malta in 1607–8. He was commissioned by the Grand Master of the Knights of Jerusalem to paint *The Execution of John the Baptist* for the cathedral of St John in Valletta. This huge canvas (12 by 17 ft; 4 by 5.6 m.) is remarkable for its austerely symmetrical

Caravaggio: The Entombment of Christ; oil on canvas; 300×203cm (118×80in); 1602–4. Vatican Museums, Rome

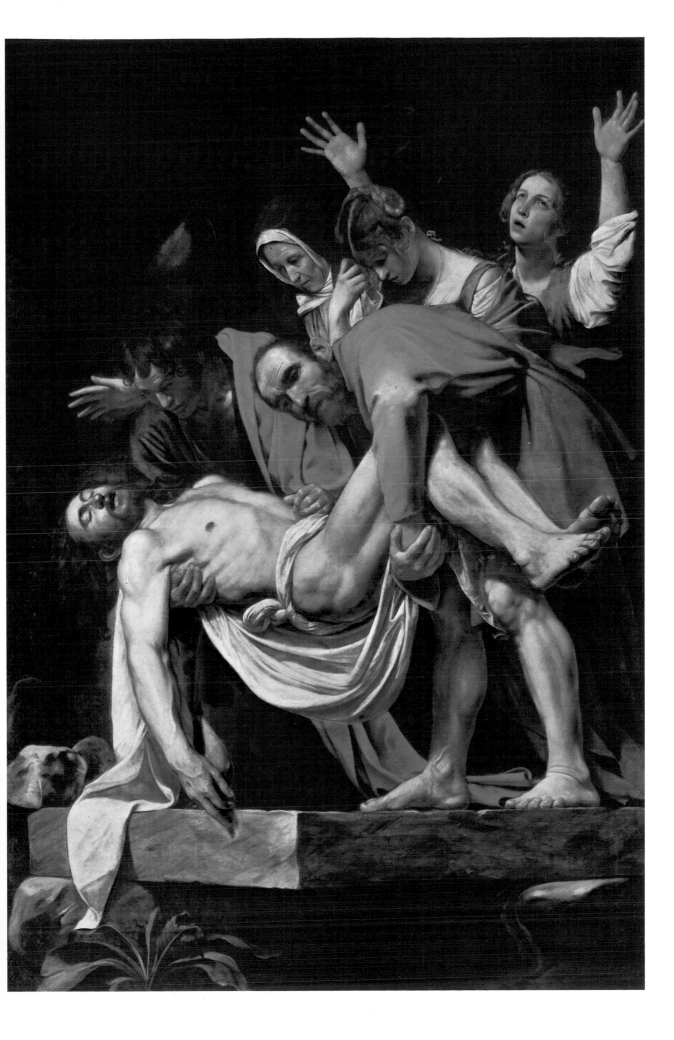

composition and for its unusual technical spontaneity. The executioner is about to lift the saint's head into a bowl held out by Salome, and the frozen stillness of the participants underlines the horror of the scene. In his detailed rendering of extreme violence Caravaggio typifies one important aspect of 17th-century emotional response.

After trouble with the authorities in Malta, Caravaggio fled to Sicily and then returned to naples; he died of a fever on his way to Rome in 1610. In Sicily Caravaggio had painted *The Burial of St Lucy* (Church of S. Lucia, Syracuse), *The Raising of Lazarus* (Museo Nazionale, Messina), and *The Nativity with St Francis and St Lawrence* (S. Lorenzo, Palermo). In these works both composition and gesture are even less traditional than before. The dark areas are often larger than in his earlier works and darkness seems to engulf the figures, who are themselves less solidly modeled. In *The Raising of Lazarus* emotions are rendered with a new expressionist urgency. In *The Burial of St Lucy* Caravaggio makes a painful contrast between the scale of the grave diggers—massive and unmoved in the foreground—and the small pathetic body of the saint stretched out beside the grave.

Although realism and lighting are the aspects of his style most often discussed, it should be stressed that Caravaggio did not paint scenes from everyday life but chose the traditional subjects of Italian figure-painters. Nor was his humble approach appreciated by the people or the lower clergy; he was patronized by cardinals and by the most cultivated members of the aristocracy.

Caravaggio did not have pupils nor did his imitators form a school or a homogenous group. Artists would adapt certain aspects of his style, or else, after undergoing a Caravaggesque phase, would turn to other styles. Nonetheless his influence spread rapidly and dramatically throughout Europe. In Rome it was most important between 1610 and 1620. His most significant Italian followers were Orazio Gentileschi, Orazio Borgiani, Carlo Saraceni, and Bartolomeo Manfredi. A group of Northern artists working in Rome, including the French Valentin de Boulogne, popularized the coarser versions of Caravaggio's early genre scenes throughout western Europe.

By 1620 the movement had finished in Rome, but Northern artists who had visited Rome had established a center in Utrecht. The most important of these were Dirck van Baburen, Gerrit van Honthorst (a specialist in candle-light scenes), and Hendrick Terbrugghen. Caravaggio's influence was most profound and lasting in the Spanish colony of Naples and in Spain itself; the Neapolitan Caracciolo and the Spaniard Jose de Ribera were both attracted by his chiaroscuro and by his violent subject matter. His influence also spread to north Italy, Sicily, and France. Many of the greatest artists of the period—Rubens, Rembrandt, Velazquez, Georges de la Tour, and Vermeer—were deeply affected by his art.

Further reading. Friedländer, W. *Caravaggio Studies*, Princeton (1955, reissued 1974). Hibbard, H. *Caravaggio*, London (1983). Kitson, M. *The Complete Painting of Caravaggio*, New York (1967). Mori, A. *Caravaggio and his Copyists*, New York (1976). Mori, A. *The Italian Followers of Caravaggio*, Cambridge, Mass. (1967). Nicolson, B. *The International Caravaggesque Movement*, Oxford (1979).

Carducho Vicente 1578–1638

The Spanish painter and theorist Vicente Carducho was born in Florence. In 1585 he went to Spain with his brother Bartolomé (1560–1608). He became Bartolomé's pupil and eventually succeeded him as King's Painter in 1609, becoming virtual dictator in artistic matters at Madrid.

Outstanding among his enormous production as a painter in a naturalistic style are the 56 large canvases for the Charterhouse of El Paular near Madrid (1626–31), now distributed among various collections in Spain.

His theories were expounded in his *Diálogos de la Pintura* (1633), which indirectly reveal envy of the success of the young Velázquez at Court.

Carlevaris Luca 1665–1731

Mathematician as well as artist, the Venetian view painter Luca Carlevaris is best remembered for his series of large reception pieces. *The Procession of the Earl of Manchester* (City of Birmingham Museums and Art Gallery) of 1707 is typical: it is composed like a school photograph with many small figures competing for

attention. This vast work was not painted from life but was built up from fluent oil sketches (now in the Victoria and Albert Museum, London) whose bravura appealed to Canaletto (1697–1768).

More influential in his own time was the series of 103 etchings (1703) which expanded the small number of stock Venetian views. These stimulated an interest in less familiar views of the city: a demand that was later met by Canaletto and Francesco Guardi.

Caro Anthony 1924–

The English sculptor Anthony Alfred Caro was born in London. He took his Master's degree in engineering at Cambridge University in 1944. He then studied at the Royal Academy Schools under Charles Wheeler, 1947–52. During 1951–3 he worked as a part-time assistant to Henry

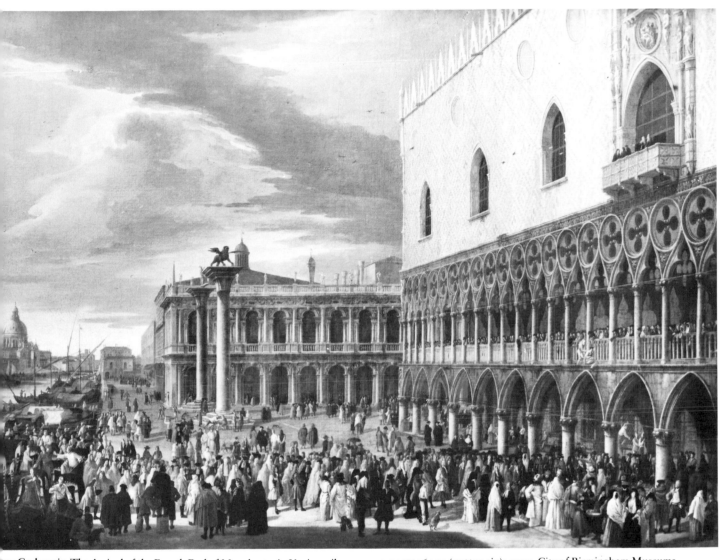

ca Carlevaris: The Arrival of the Fourth Earl of Manchester in Venice; oil on canvas; 132×264cm (52×104in); 1707. City of Birmingham Museums
d Art Gallery

Moore. He taught at St Martin's School of Art from 1953 to 1956, and again from 1968 to 1973. He spent the years 1963 to 1965 teaching at Bennington College, Vermont, U.S.A.

From 1954 to 1959 Caro modeled expressionist figures in clay, cast in bronze. After visiting the United States in 1959, influenced by the sculptor David Smith and the critic Clement Greenberg, he began making large, painted nonfigurative sculptures. These were welded and bolted from steel scrap, and placed directly on the ground. In 1962 he ceased painting his work, but from 1971 allowed them to rust and then varnished them. His working procedures are entirely distinctive. Since

Anthony Caro: Prospect II; painted steel; 260×215×31cm (102×85×12in); 1964. Museum Ludwig, Cologne

1966 he has made smaller pieces, especially for plinths, at the same time as full-scale works. Caro's work has had tremendous influence on other artists, both in Britain and the United States, where he had a retrospective exhibition at New York's Museum of Modern Art in 1975.

Further reading. Fried, M. "Caro's Abstractness", *Art Forum*, New York (April 1972). Whelan, R. *Anthony Caro*, Harmondsworth (1974).

Carpaccio Vittore 1472–1526

The Italian painter Carpaccio worked almost exclusively in Venice where he specialized in the production of huge panoramic paintings, depicting a large number of figures. In these he followed in the steps of Gentile (and Jacopo) Bellini, in

whose workshop he probably received his training; in 1507 he was named among Giovanni Bellini's assistants.

Carpaccio's first dated work is the canvas depicting *The Arrival of St Ursula in Cologne* (1490). This is one of a series of nine paintings dated 1490–5 portraying scenes from the saint's life, which originally hung in the Scuola di S. Orsola and are now in the Gallerie dell'Accademia, Venice. In common with Carpaccio's other narrative works, the action of these paintings takes place in settings that provide detailed evidence for contemporary architecture, fashion, and many other aspects of Venetian life. In the later paintings of the cycle, for instance *The Reception of the English Ambassadors*, his mastery of perspective, color, and the depiction of a large number of figures in space is far advanced: thereafter his style changes very little. *The Miracle of the True Cross* (c1495; Gallerie dell'Accademia, Venice) was commissioned by the Scuola di San Giovanni Evangelista as part of a series of canvases by different artists; it is particularly rich in authentic contemporary detail.

On a smaller scale are Carpaccio's paintings representing scenes from the lives of Saints George and Jerome; these are still preserved in the Scuola di San Giorgio degli Schiavoni, Venice, for which they were painted in the first decade of the 16th century. Carpaccio painted other cycles for the Scuola degli Albanesi and the Scuola di San Stefano; he also contributed paintings to the series of historical subjects in the Sala del Gran' Consiglio of the Ducal Palace (destroyed in the fire of 1577).

There are in addition a handful of religious and secular works, with several others recorded in drawings. Among Carpaccio's earliest works is the panel depicting *Christ and the Four Apostles* (Contini Bonaccossi Collection, Florence), showing elements derived from Antonello da Messina. His altarpieces generally have an exterior setting and do not usually employ the semi-illusory framework evolved by Antonello and by Giovanni Bellini. Carpaccio's historical importance lies almost entirely in his panoramic views; apart from his two sons, who were both painters of minor importance, he had no true artistic heirs.

Vittore Carpaccio: detail of The Disputation of St Stephen; oil on canvas; full size 147×172cm (58×68in); 1514. Pinacoteca di Brera, Milan

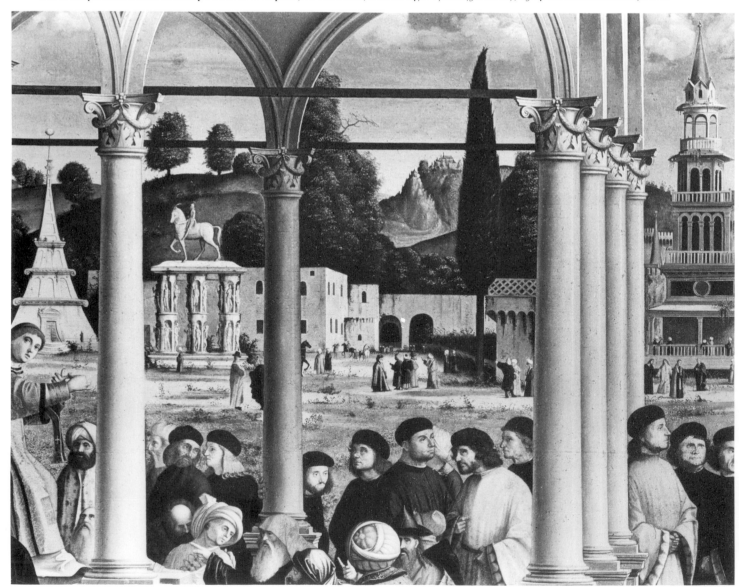

Carpeaux Jean-Baptiste 1827–75

Carpeaux was the major French sculptor of his day. His works have qualities of movement and rhythm that contrast with contemporary academic sculpture, and make him the precursor of Rodin. He also produced a number of oil paintings.

He studied at the École des Beaux-Arts under François Rude, won the Prix de Rome in 1854, and spent the years 1856–62 in Italy. He neglected his studies of the Antique to observe the daily life of the people, which furnished the basis for his *Fisherboy with a Seashell* (plaster; 1855–9; Louvre, Paris). In Rome he began *Ugolino* (bronze; 1861–3; Louvre, Paris), a dramatic work using a pyramidal composition of five figures in tortuous poses, influenced by Michelangelo.

On his return to France he was introduced into the circle of Princesse Mathilde, cousin of Napoleon III, and this led to commissions for a number of portrait busts of the ruling classes of the Second Empire. These combine the elegance of the work of Houdon (1741–1828) with a new frankness and liveliness: for example his bust of the Empress Eugénie (plaster; 1866; Musée du Petit Palais, Paris). He received a commission for the decoration of the Pavillon de Flore of the Louvre (stone; 1866), in which he used fuller forms based on Flemish painting. He sculpted a group for the front of the Paris Opéra, *The Dance* (stone; 1869; Louvre, Paris). This joyous, rhythmical work was considered immoral.

Carpeaux's last major monumental work was his fountain for the Paris Observatory (bronze; 1874); it includes four figures symbolizing the points of the compass, represented as ethnic types, and supporting the celestial sphere.

Carrà Carlo 1881–1966

The Italian painter Carlo Carrà was born in Piedmont. A self-taught artist, he worked first as a decorator. In 1910 he signed the *Manifesto of Futurist Painters*. He adopted the Cubist technique of breaking up a subject into facets in order to create repetitive rhythms that expressed Futurist dynamism. In 1914 he also used collage, incorporating printed letters implying noise—another Futurist fetish. He eventually became dissatisfied with the Futurist style, which lacked the solidity of form he admired in the work of Giotto (1266–1337). His paintings of 1916 depict

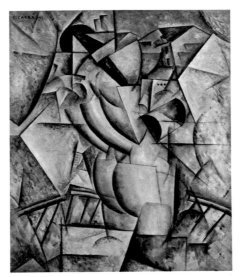

Carlo Carrà: Woman at a Window (Simultaneity); oil on canvas; 147×133cm (58×52in); 1912. Collection of Dr Riccardo Jucker, Milan

doll-like but fully rounded figures; these were to develop into the dummies in eerie deserted settings that characterize his metaphysical period (a response to the influence of de Chirico). This phase lasted from 1917 to 1921. Afterwards the fantastical element in Carrà's work became subdued in favor of muted classical treatment of landscape and the figure.

Carracci family
16th and 17th centuries

The Carracci—the brothers Agostino (1557–1602) and Annibale (1560–1609), and their cousin Lodovico (1555–1619)— were a family of Italian painters active in Bologna and Rome. It was above all Annibale, the most talented of the three, who, by reviving a classical and naturalistic style, broke away from the late Mannerist painting predominant in Italy from 1620. The Carracci worked closely together in Bologna in the 1580s; their studio, known as the Carracci Academy, in which life-drawing was regularly taught, attracted many younger artists to train there. In his Roman work, particularly in the ceiling of the Farnese Gallery (Palazzo Farnese, Rome) Annibale effectively restored the artistic language of Antiquity and of Raphael (1483–1520) and Michelangelo (1475–1564). This he combined with Venetian colorism to produce a style of painting rich in naturalistic form which was to remain influential throughout the 17th century.

Agostino, who trained with his cousin Lodovico, was principally an engraver. He made prints after the work of, among others, Barocci and Tintoretto (he met the latter in Venice in 1582). He was a gifted teacher, and among the first to systematize the teaching of life-drawing. Under his direction it was a step-by-step procedure: the student first learned to draw the different parts of the human anatomy, such as the eyes, the nose, and the mouth, before combining them together into a whole head. His anatomical drawings were engraved and the prints were widely used in later artist academies. Agostino was only periodically occupied as a painter; his work was inspired more by Annibale than by Lodovico. The paintings he executed in Bologna in the 1580s and 1590s before his visit to Rome include *Adoration of the Shepherds* (c1584; Madonna della Pioggia, Bologna), and *The Last Communion of St Jerome* (c1593; Pinacoteca Nazionale, Bologna). The composition of the latter work was developed by Domenichino in a famous painting of the same subject now in the Vatican Museums. In 1597 Agostino was in Rome where he helped Annibale with the decoration of the Farnese Gallery ceiling; his work there can be seen in the stories *Peleus and Thetis* and *Cephalus and Aurora*. After quarreling with Annibale he went to Parma where he worked for Duke Ranuccio Farnese in the Palazzo del Giardino. The frescoes he painted there are rather dry variations of Annibale's Roman work.

Annibale was born in Bologna where he trained under Lodovico. He soon gained experience of frescoe painting in decorating the Palazzi Fava and Magnani, in which all three Carracci collaborated. To begin with, his paintings showed elements of Mannerism; this can best be seen in the early *Crucifixion* (1583; S. Niccolò, Bologna). Soon there was a change: the results of a visit to Parma, where he studied the works of Correggio, became visible in his paintings. In 1585, still under the influence of Correggio, he painted *The Baptism of Christ* (S. Gregorio, Bologna) where his forms began to soften and became more naturalistic. By 1587, in *Assumption of the Virgin* (Gemäldegalerie Alte Meister, Dresden), his dependence on Correggio was even more complete. But after a stay in Venice his experience of Venetian painting, particularly of the work of Titian and Veronese, began to reveal itself, above all in another *Assumption of the Virgin*

(1592; Pinacoteca Nazionale, Bologna). The result was that he started using blocks of bright color together with the muted tones derived from Correggio: the combination is one of two essential ingredients of Annibale's later pre-Roman work. The other ingredient is a tendency towards classical solidity of form where figures are conceived monumentally. This became apparent even before his visit to Rome and before his close familiarity with the works of the High Renaissance masters and the Antique. The development is best seen in *The Almsgiving of St Roch* (Gemäldegalerie Alte Meister, Dresden), painted from *c*1590.

Annibale visited Rome in 1595; he stayed in the city, apart from making a few unimportant excursions, for the rest of his life. It was here that Annibale's art reached the high point of its development, and his classical and naturalistic style came to maturity. He had been called to the city by Cardinal Odoardo Farnese to paint the Camerino and the Gallery of the Palazzo Farnese. It was also intended that Annibale should decorate the Gran' Salone, in the same palace, with frescoes illustrating the deeds of Prince Alessandro Farnese. He was prevented from doing this by his early death. The decoration of the Camerino, a small room which was used as the Cardinal's study, was Annibale's first undertaking: it occupied him from 1595 to 1597. The stories of Hercules and Ulysses he painted there illustrate the triumph of virtue; their complicated allegorical theme was devised by the Cardinal's tutor and adviser, Fulvio Orsini. In the central painting, *The Choice of Hercules* (now Museo e Gallerie Nazionali di Capodimonte, Naples) Annibale showed himself capable of interpreting pictorially a subtle narrative theme.

The style employed by Annibale in the Camerino was successfully developed and extended to a larger scale in the ceiling of the Gallery, painted immediately afterwards (1557–1600). Here the frescoes illustrate love scenes of the gods taken from Ovid's *Metamorphoses*; the whole was conceived as an epithalamium, probably to celebrate the marriage of the Cardinal's brother, Duke Ranuccio Farnese. The program was frankly pagan in character, in contrast with the vast religious decorations of the preceding century, particularly Michelangelo's Sistine Chapel ceiling. Intended to show how love dominates action, the mood of the ceiling is light-

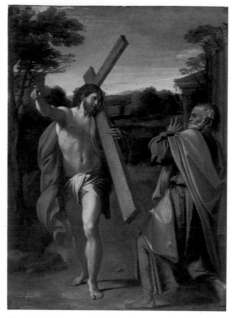

Annibale Carracci: Christ Appears to St Peter (Domine Quo Vadis?); oil on canvas; 77×56cm (30×22in); c1602. National Gallery, London

hearted and mischievous, the colors bright and joyous. In the structure of the ceiling Annibale used a design which—with its lateral divisions and its use of *ignudi* framing medallions—resembles that of Michelangelo's Sistine Chapel ceiling. This he combined with the type of simple frieze decoration employed earlier in the Palazzi Fava and Magnani. The scenes themselves are separate from the framework and are attached to it like transferred easel pictures (*quadri riportati*). Annibale borrowed this device from the ceiling frescoes of Raphael's Loggie in the Vatican, as well as from Tibaldi's ceiling decorations in the Palazzo Poggi, Bologna. The ceiling was not fully illusionistic; but the later Baroque ceilings it influenced, such as Pietro da Cortona's ceiling in the Palazzo Barberini, Rome, were to be so. Together with Michelangelo's Sistine Chapel ceiling, and Raphael's frescoes in the Vatican, Annibale's Farnese ceiling was rated as one of the masterpieces of Roman painting.

Towards the end of his life illness forced Annibale to be less active. But a number of history paintings from his later years were to influence artists like Domenichino and Poussin by their classical purity. They include *Christ Appears to St Peter (Domine Quo Vadis?)* (c1602; National Gallery, London) and the *Pietà* (c1602–7; Louvre, Paris). In both, Annibale restricted the number of figures within the composition and concentrated on the communicative force of gesture and facial expression.

Annibale was also a landscape-painter of great originality. His early experiments depended on Venetian landscapes but he later evolved a classical type in which the different scenic elements are logically arranged. *The Flight into Egypt* (Galleria Doria Pamphili, Rome) is a fine example of Annibale's late landscape-painting. Also, particularly at the beginning of his career, Annibale experimented with informal genre painting of which *The Butcher's Shop* (Christ Church Picture Gallery, Oxford) is an example.

Lodovico was the eldest of the Carracci. He was the dominant figure in the studio at the beginning of the 1580s and it was he who first indicated the path away from contemporary Mannerism. He spent his career almost entirely in Bologna, and for this reason his development was quite different from that of Agostino and Annibale, both of whom were to respond to the art of Rome. The paintings of Lodovico therefore show different preoccupations: far from exploring natural form in terms of classical structure, he aimed at transient effects achieved by means of light and shade. Anatomical accuracy was secondary to compositional unity. This can be seen in his painting, *The Holy Family with SS. Joseph and Francis* (1591; Pinacoteca Civica, Cento) where the figures, which are placed in darkened surroundings, are picked out by highlights. Their interrelationship in space is not clear, and the composition is held together by the gestures and glances of the figures. Lodovico's work, inspired by Tintoretto and Correggio, has more affinities with the developing Baroque style, (particularly the work of Lanfranco and Guercino), than with Annibale's classicism. After 1597, with Agostino's departure from Bologna, Lodovico was left in charge of the Carracci studio. As a result it was his work rather than Annibale's that inspired a new generation of younger Bolognese artists, among them Tiarini and Cavedone. But with the absence of his cousins, Lodovico's work became by degrees increasingly old-fashioned.

Further reading. Boschloo, A. *Annibale Carracci in Bologna*, The Hague (1974). Posner, D. *Annibale Carracci: A Study in the Reform of Italian Painting around 1590*, London (1971). Wittkower, R. *The Drawings of the Carracci*, London (1952).

Right: Lodovico Carracci: The Bargellini Madonna; oil on canvas; 282×188cm (111×74in); 1588. Pinacoteca Nazionale, Bologna

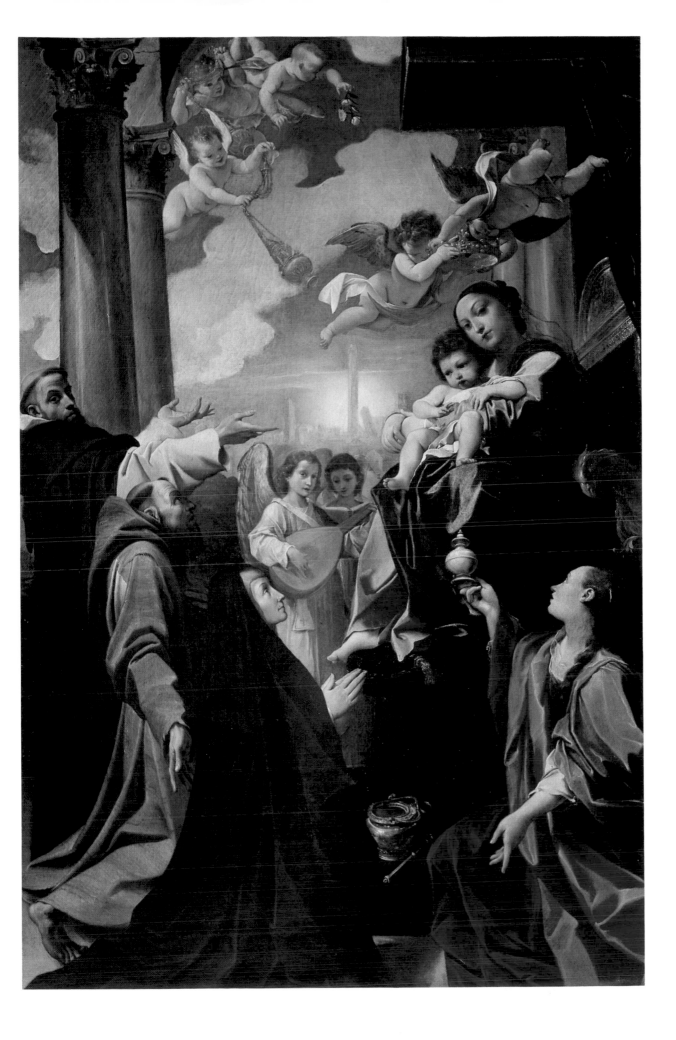

Carriera Rosalba 1675–1757

Lightness of palette and charm secured the Venetian painter Rosalba Carriera her immense success. She was honored and feted in many European capitals as well as in her native Venice. Although other pastelists were later to equal and to surpass her, she can lay claim to have been the inventor of Rococo portraiture. Rosalba started her career by decorating the ivory lids of snuff boxes. From this she turned to miniature painting—her pastel portraits always retained the feeling of enlarged miniatures. At her best, as in her self-portrait (Royal Art Collection, Windsor), she was capable of a penetrating psychological insight.

Carrière Eugène 1849–1906

Eugène Carrière was a French painter of portraits and religious pictures. The work he did during the last 20 years of his life made him popular with Symbolist artists and writers alike. Brought up in Strasbourg and trained as a lithographer, he came to Paris in 1869 to study under Alexandre Cabanel. Although his early work was naturalistic in style, both its subject matter and its low-toned palette point forward to the change in his style at the end of the 1880s. His work is characterized by absence of color and vagueness of form enveloped in mists; this transformed specific studies of his wife or of the

Eugène Carrière: Portrait of Verlaine; oil on canvas; 31×22.5cm (12×9in); 1891. Musée Tavet-Delacour, Pontoise

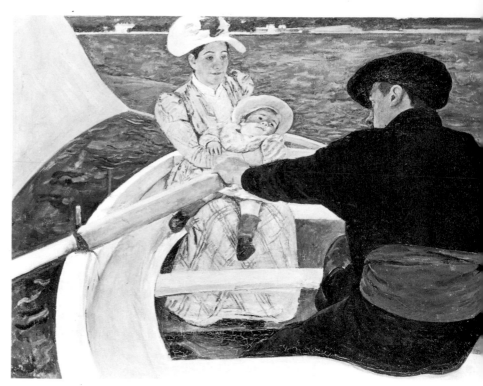

Mary Cassatt: The Boating Party; oil on canvas; 90×117cm (35×46in); 1893–4. National Gallery of Art, Washington, D.C.

sculptor Rodin into generalized statements about human states (for example *Maternité*, c1890–5; National Museum of Wales, Cardiff) and human activities, such as creativity. Carrière was a close friend of Verlaine, Daudet, Gauguin, Anatole France, and Rodin; it was the latter who arranged an honorary banquet for Carrière two years before the painter's death from throat cancer.

Carstens A.J. 1754–98

In 1776 the Danish history painter and portraitist Asmus Jakob Carstens studied at the Royal Academy, Copenhagen, under Nicolai Abildgaard. He made several visits to Italy, the first in 1783, and he lived in Rome from 1794 until his death. His idealized subject matter, executed in the Neoclassical manner, was derived from ancient and mythical sources. While living in Rome he was on close terms with Alberto Thorvaldsen, and others, and was an important influence on the Nazarene group of artists.

Cassatt Mary 1845–1926

Mary Cassatt was an American painter and printmaker. After a period of study in Italy, Spain, and Holland, she settled in

Paris in the mid 1870s and remained in France until her death. She was a close friend of Degas and exhibited with the Impressionists. Her work in oil and pastel is characterized by firm drawing and unusual compositions; her subject matter consists predominantly of figures (she painted virtually no landscapes or still life) culminating in a long series of *Maternités*. She produced a significant number of prints, especially a group of colored aquatints during the early 1890s which demonstrated her mature assimilation of Japanese prints, for example, *Woman Bathing*. She also encouraged American collectors, especially the Havemeyers, to buy a great many French Realist and Impressionist paintings.

Castiglione Giovanni 1616–70

Giovanni Benedetto Castiglione was born in Genoa where he studied under two local painters and also worked in van Dyck's Genoese studio. He was a many-sided and versatile artist, technically both original and supremely skillful. He invented the monotype, and probably the soft ground etching, and he created a highly original series of brush "drawings" in oil on paper. He was most famous for his processions of animals in landscapes which often illus-

trate the journeys of the patriarchs; these were influenced by Flemish artists working in Genoa and by works of the Bassano family.

During the early 1630s Castiglione was in Rome and briefly in Naples (1635). In Rome he was attracted by Poussin's early romantic style, and by the copying of fragments of Classical sculpture, an activity that absorbed artists associated with the learned antiquarian Cassiano dal Pozzo. By the end of the 1630s his etchings show a knowledge of Rembrandt unique in Italy at that date.

Back in Genoa, from 1640 to 1647 he produced large, religious paintings, including the Rubensian *St James Driving the Moors from Spain* (S. Giacomo della Marina). His subject matter widened and he began to paint and etch romantic, mysterious allegories; he was obsessed by the theme of the devouring power of time, and created an atmosphere of ruined splendor by the use of picturesque Classical motifs.

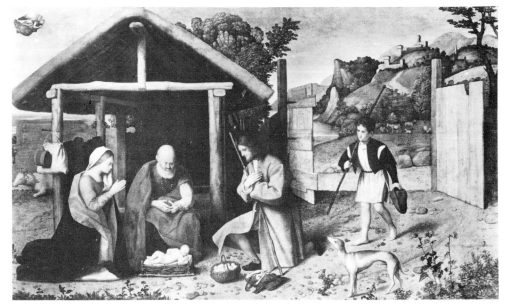

Vincenzo Catena: The Adoration of the Shepherds; oil on canvas; 122×207cm (48×81in); c1510. Private collection

From 1647 to 1651 he was again in Rome. In 1651 he entered the service of the Duke of Mantua; between 1659 and 1663 he was in Venice and Genoa. He died in Mantua. His late style has an ecstatic spirituality reminiscent of Bernini.

Catena Vincenzo c1470–1531

The early works of this Venetian painter are crude variants after Giovanni Bellini's paintings of the 1490s. He seems, however, to have quickly evolved his mature style. This reflects the values of Venetian humanism, can be seen in two minor masterpieces: *The Martyrdom of St*

Giovanni Castiglione: The Angel Appearing to the Shepherds; oil on canvas; 107×161cm (42×63in); c1640. City of Birmingham Art Gallery

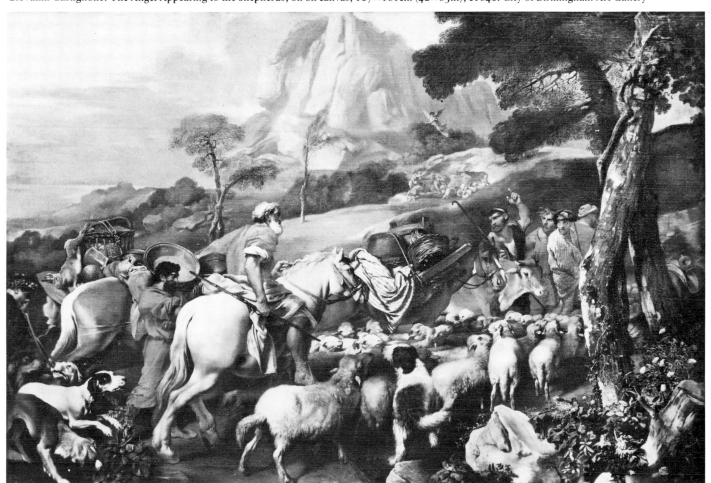

Christina (1520) in S. Maria Corpus Domini, Venice, and the *Warrior Adoring the Virgin and the Infant Christ* in the National Gallery, London. In these the influence of Giorgione is clear (he is described in an inscription of 1506 as a "colleague" of Giorgione), as is the influence of Giovanni Bellini's later work. In Catena's soft planes of warm, singing color and gently rounded forms, all the tension of Giorgione's art has been ironed out to create a mood of idyllic calm. A portrait of the humanist *Giangiorgio Trissino* (Louvre, Paris) further reveals his links with Venetian humanism.

Cavalcanti Emiliano di 1897–1976

The Brazilian painter Emiliano di Cavalcanti was born in Rio de Janeiro, where he abandoned his law studies to become an artist. He first exhibited caricatures in 1916, and in 1922 helped to organize the "Week of Modern Art" in Sao Paulo. From 1923 to 1925 he studied in Paris, where he met Picasso, Braque, and Matisse, and discovered the works of Cézanne, Gauguin, and Toulouse-Lautrec. He returned several times to Europe but never settled there. Although his work shows the influence of contemporary European painting, it is essentially figurative; his favorite subjects were landscape, still life, and local Brazilian motifs, especially mulatto girls. At the 2nd Sao Paulo Biennal (1953) he shared the prize for the "best national painter" and at the 7th Biennale was honored with a retrospective exhibition.

Cavallini Pietro c1250–1330

Pietro Cavallini was a Roman painter; his name is associated with those of Cimabue and Giotto in the movement towards greatly increased naturalism in painting which took place in the latter part of the 13th and the first part of the 14th centuries. It is significant that most of Cavallini's activity was in Rome, for during the last quarter of the 13th century a program of restoration and redecoration of Early Christian monuments was commissioned there by the Papal court.

One of the works that Pope Nicholas III (1277–80) was involved in was the restoration of a cycle of Early Christian frescoes in the huge basilica of S. Paolo Fuori le Mura: these were scenes from the *Lives of SS. Peter and Paul* dateable to 1277–9. On

Pietro Cavallini: detail of the Last Judgment fragment; fresco; c1293. S. Cecilia in Trastevere, Rome

the opposite, right, wall of the nave, Cavallini painted scenes from the Old Testament. All these frescoes were destroyed in a fire in 1823, but records of them survive in 17th-century manuscript copies. The scenes were divided in the Roman manner by twisted columns (a similar arrangement to that of *The Legend of St Francis* at Assisi). It is clear that in these scenes Cavallini was tackling the problem of creating a realistic sense of space by the use of architecture painted in perspective, and by the disposition of his figures. The surviving ciborium over the high altar of S. Paolo by Arnolfo di Cambio was completed in 1285, and this is the likely period of Cavallini's work in the church.

The influence of Gothic sculpture, and particularly of Arnolfo di Cambio, plays a considerable part in Cavallini's pioneering achievement; we find the two working at the same time in S. Cecilia in Trastevere. The church was frescoed by Cavallini and contains a ciborium by Arnolfo with the date 1293. The surviving fragment of Cavallini's *Last Judgment* displays rich, sculptural folds in the drapery, a new naturalism in the modeling of faces and hands, and the creation of a general sense of solid volume and weight in the figures. Although there are iconographical precedents for the form of this *Last Judgment*, it is transformed by Cavallini's revolutionary style.

It is perhaps more difficult to recognize a similar originality in his mosaics in S. Maria in Trastevere because he was using a

far less flexible medium. The mosaics are in the apse: there are six scenes from *The Life of the Virgin*, and a votive group. Even allowing for the difference in medium it seems clear that these lovely mosaics represent a slightly earlier stage than the S. Cecilia frescoes. Cavallini's latest work is to be found in S. Maria Donna Regina, Naples (being built 1307–c20) where the paintings appear to be the products of a large workshop. The frescoes include a few outstanding figures of commanding naturalism, such as that of *David*, which must be the last known works of the master himself.

Cellini Benvenuto 1500–71

The Italian goldsmith and sculptor Benvenuto Cellini trained in Florence. He worked in Rome from 1519 until 1540, with occasional visits to Florence and Venice. He traveled to France in 1537. Seals, medals, and cope-fastenings for noblemen and prelates were among his works: like most of his generation, he was influenced by Michelangelo and tended towards Mannerist elaboration of detail.

From 1540 to 1545 he was employed by King Francis I of France and extended his range into sculpture on a large scale, for example *The Nymph of Fontainebleau* (Louvre, Paris), a bronze lunette designed for the entrance of the palace. His most ambitious project, for 12 silver statues of gods and goddesses, never reached completion, though a *Jupiter* was ready by 1544. Cellini's masterpiece as a goldsmith was his Saltcellar (Kunsthistorisches Museum, Vienna) begun in Italy and finished for Francis I. It is the epitome of a Mannerist work of art: intricate in design, complex in theme, and technically brilliant. Its style betrays the influence of Primaticcio and Rosso, the Italians who worked at Fontainebleau.

Under suspicion of embezzlement, Cellini returned to Florence and persuaded Cosimo I de' Medici to commission a bronze statue of *Perseus and Medusa* for the Piazza della Signoria, to rival Donatello's earlier *Judith and Holofernes*. It is the most obviously Mannerist sculpture in Florence, with its decorative marble base including four large statuettes (unveiled in 1554). Meanwhile, Cellini produced a col-

Benvenuto Cellini: Ganymede on the Eagle; bronze; height 62cm (24in); 1545–7. Museo Nazionale, Florence

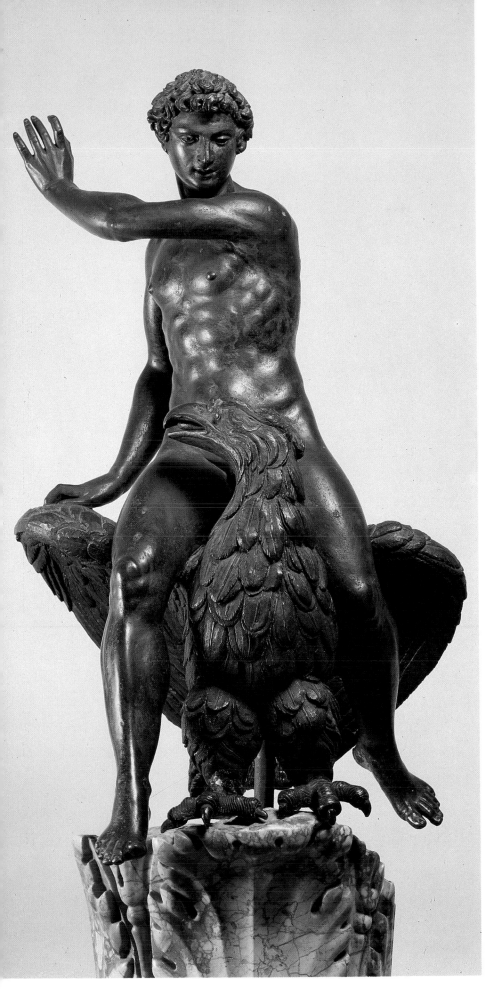

ossal bust in bronze of Cosimo, originally parcel-gilt and enameled (Museo Nazionale, Florence)—one of the most dynamic portraits of the century. To meet a challenge from Bandinelli he turned to marble carving: several statues are in the Museo Nazionale, Florence, but the best is his *Crucifix* (now in the Escorial, near Madrid). By 1560, Cellini's popularity was waning and he turned to writing, completing his *Autobiography* in 1562 and his *Treatises on Goldsmithing and Sculpture* in 1565. Because of these works, we are better informed about Cellini and his art than about almost any other Renaissance artist.

Cennini Cennino *c*1370–*c*1440

The Italian artist and writer Cennino d'Andrea Cennini was born in Colle di Val d'Elsa. He studied under Agnolo Gaddi and was presumably active in Florence. Although no surviving works by his hand have been identified, he is remembered because of his treatise, *Il Libro dell'Arte* ("The Book of Art").

Cennini's book was not printed until 1821, but several manuscript copies exist and it is generally supposed that it was written during the 1390s. It consists of over 100 short sections, the vast majority of which cover the different aspects of the painter's craft from drawing to making glue, from how to paint a face to the best manner of gilding. As a contemporary guide to the techniques used by Italian artists of the day, the historical importance of *Il Libro dell'Arte* is unequaled. It has often been unfavorably and unfairly compared with Alberti's *Della Pittura*. The former is a basic textbook written by a practicing craftsman, while the latter is a theoretical treatise composed by a humanist intellectual.

Cennini's observation that painting "justly deserves to be enthroned next to theory, and to be crowned with poetry" has a surprisingly modern ring. His attitude on such issues as fidelity to nature implies that Cennini should be placed among the more conservative painters of his generation. He considered himself an heir to the tradition of Giotto, which had been transmitted *via* Taddeo and Agnolo Gaddi. This outlook may indicate dissatisfaction with the general rejection of the precepts of Giotto, characteristic of Tuscan art of the second half of the Trecento.

Cephisodotus 4th century BC

The Athenian sculptor Cephisodotus was an elder relation of Praxiteles, and may have been his father. Praxiteles' son, also a sculptor, was allegedly named after Cephisodotus. His sister was the first wife of the Athenian general Phocion. He is best known to us from copies of his allegorical bronze group of *Peace holding the Infant Wealth*, erected in Athens shortly after the establishment of a public cult of Peace in 374 BC. (The best copy is in the Glyptothek, Munich.)

This work inspired a series of similar groups, including *Hermes holding the Infant Dionysos* at Olympia. It embodies the spirit of the beginning of late Classicism and heralds the art of Praxiteles. A new sensibility pervades the grouping of the woman and child, represented standing as never before in Classical art. The traditional High Classical drapery of *Peace* is balanced by her relaxed stance, the protruding hip which supports the infant, her smiling face with the soft features, the triangular forehead, and, above all, the new intimacy between the two figures. The representation of grandeur is tempered with softness and grace, and with sentimentality.

Cephisodotus is also recorded as having made a bronze *Athena* with a spear for the sanctuary of Zeus Savior in Piraeus, and to have collaborated in a group of Muses on Mount Helicon.

César 1921–1998

The French sculptor César (César Baldaccini) was born at Marseille and studied there under Cornu in 1935. From 1943 he studied with Gâumont and Saupique at the École des Beaux-Arts, Paris. The plaster and iron figures he made in 1947 represented an attempt to break away from his classical training. In 1950 he began to weld metal industrial waste into seated figures, and between 1954 and 1958 into fantastic creatures. His casts in bronze of 1957–8 show greater solidity than his earlier work. Until 1965 he continued to create figurative works. Meanwhile, in 1960, he produced his first "Compressions": cubic sculptures made from mechanically crushed car bodies. Their random juxtaposition of diverse elements creates rhythmic abstract surfaces. In the mid 1960s he experimented with plastics for casting, evolving in 1967 his "Expansions". These are bright monochromatic

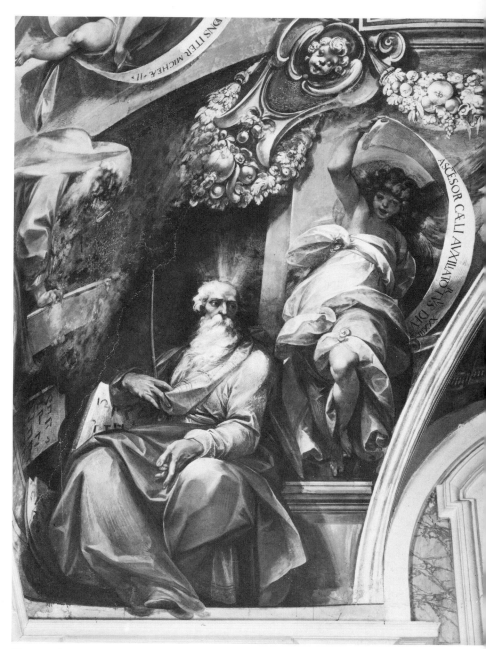

Giuseppe Cesari: Moses; detail of the frescoes in S. Prassede, Rome; c1593–5

forms in expanded polyurethane. He demonstrated his technique in public in many countries from 1967 to 1969. Later he made smaller expansions, cast in stainless steel. In 1967 César refused a prize at the Sao Paulo Bienal.

Cesari Giuseppe 1568–1640

Giuseppe Cesari, known as "Il Cavaliere d'Arpino", was the most favored of the decorative painters in Rome under Pope Clement VIII. His drawing was dexterous and artificial, his figures elegantly bloodless, and his color ingratiatingly Sienese.

Yet he disciplined his Mannerist inheritance at an early date through reference to the balanced compositions of High Renaissance classicism—so that a contemporary coupled his name with Domenichino's. He was the head of an efficient workshop. His principal frescoes are in S. Martino at Naples (1589), and at Rome in S. Prassede (c1593–5), the Palazzo dei Conservatori, and S. Giovanni in Laterano. He designed the mosaics in the cupola of St Peter's in 1603, but by this time his style had become dully anachronistic. Certain works by Fréminet, van Dyck, Reni, and G.B. Crespi reflect his influence.

Cézanne Paul 1839–1906

Born on 19 January 1839, at Aix-en-Provence, the son of a French banker and a former hat manufacturer, Paul Cézanne persevered throughout a career of failure and neglect to become recognized as one of the most profoundly original painters of the modern period.

His youthful letters to his boyhood friend Émile Zola reveal a schoolboy romantic, exuberantly scribbling verses and sketches without obvious talent for either. In 1858, when he was already thinking of becoming an artist, his father made him study law. He abandoned those studies in 1861 and went to Paris to join Zola and become an artist. He drew at the Académie Suisse and there met Camille Pissarro. But that September, apparently disillusioned, he returned to Aix, to work as a clerk in his father's bank. Months of scribbling in the ledgers convinced him and even his father of his vocation. In November 1862, he went back to Paris and painting.

From that time he was committed to art, though years of discouragement lay ahead. He had his friends. He knew the circle of the Café Guerbois, who, in addition to Zola and Pissarro, included Manet, Degas, Renoir, and Monet. Pissarro certainly respected his determination and his artistic promise. But Cézanne was not easy to know and like. He was uncouth in appearance, shy and sardonic. Though he admired Manet, who had praised his still lifes, he said to him at the Café Guerbois "I am not offering my hand to you, Monsieur Manet, I haven't washed for eight days."

His career failed to develop. He was not admitted to the École des Beaux-Arts and, from 1863, his works were regularly rejected by the Salon. He became notorious, even caricatured in the press, for his stubborn refusal to admit his own incompetence. Once, in 1882, his friend Antoine Guillemet used his privilege as a member of the Salon jury to exhibit a single canvas by his "pupil" Cézanne. The "pupil" was then 43, three years older than his "master". The picture went unnoticed.

For over a quarter of a century Cézanne depended on an allowance from his father. After 1869, when Hortense Fiquet became his mistress, part of that allowance went to keep her and their son in secrecy, while Cézanne lived in terror of discovery. The people of Aix regarded him and his works with derision. When they asked to see his paintings, he snarled at them "be damned to you!"

But his painting had its admirers. Dr Gachet, a friend of the Impressionists (and later of Van Gogh) and himself an amateur artist, bought several canvases. Cézanne's most important patron after 1875 was a customs officer, Victor Choquet, who not only had his portrait painted several times and acquired more than 35 works by Cézanne, but also became a good friend of the artist. At the first Impressionist exhibition of 1874, although his three canvases attracted ridicule from the critics, Count Doria bought his *Maison du Pendu* (1873–4; Louvre, Paris) for 300 francs.

Cézanne only exhibited once more with the Impressionists, at their third exhibition in 1877. But there he showed 16 works, which were given a place of honor, and hung together in the main room.

It would not have been surprising if Cézanne had become a recluse. Yet, despite his temperament and the considerable distance between Aix and Paris, for two decades there was hardly a year he did not travel north. There was a period of isolation between 1882 and 1888, when he made only one visit north (in 1885) to visit Zola at Medan, following a mysterious love affair. But even during this period, he met both Monet and Renoir on their visits to the south. It was his work as a portrayer of Provence, as much as his solitary temperament, that kept him in the south.

On 28 April 1886, he married Hortense Fiquet; six months later his father died, leaving him a considerable fortune. The most significant event of that year, however, was the end of his friendship with Zola. Since boyhood, his friendship with Zola had been assured. During the novelist's years of success he had provided Cézanne with money as well as encouragement. But in 1886, Zola sent Cézanne his new novel *L'Oeuvre*. In the central character, Claude Lantier—a talentless artist who eventually commits suicide—Cézanne saw a grotesquely misconceived caricature of himself. On 4 April 1886, he sent Zola an impersonal note thanking him, and never saw him or wrote to him again.

Although he had not exhibited in Paris for over ten years, by the time he was 50 Cézanne was becoming known. In 1890 he was invited to exhibit with Les Vingt, the avant-garde group in Brussels, and in 1895 Pissarro persuaded Vollard to organize a large exhibition of Cézanne's work at his gallery in the Rue Lafitte in Paris.

In his last years, after 1900, Cézanne became more solitary. His wife and son lived mostly in Paris while he, as his letters reveal, could think only of his work and of the failing health that interfered with it. Critics were becoming interested in his art and younger artists would make a pilgrimage to meet him; in 1904 the Salon d'Automne devoted a room to his works; Cézanne was unimpressed, for recognition had come too late. By then he was certain of his own worth. As he wrote in his last letter to his son: "compared to me all my compatriots are hogs". In October 1906 he was caught in a storm while out painting; after several hours in the rain he was brought home in a laundry cart, The next morning, after working on a portrait of his gardener Vallier in the garden, he came into the house desperately ill. He died on 22 October 1906.

Cézanne had virtually no public career. Even the annual rejections by the Salon were hardly more than an extension of his private anxieties. His serious attention was devoted solely to the development of his art.

His early works were crude, and at first he was often in despair over his lack of ability. He never developed skill in academic draftsmanship; his figures were curiously proportioned, their features clumsily drawn. He laid on the paint with an inept vigor, often using a palette knife. He chose subjects that were violent or erotic or both, including *The Temptations of St Anthony* (1869; Stiftung Sammlung E.G. Bührle, Zurich) *The Abduction* (1867; J.M. Keynes Collection) and *The Rape* (c1870, E. Roche Collection, Paris). Yet even these works were not merely uncontrolled youthful fantasies.

Cézanne studied profoundly the art of the past, visiting and copying in the Louvre when he was in Paris. He based his painting on the study of Poussin, Rubens, and, above all, the 16th-century Venetian masters. It was in their art that he found precedents for his erotic imagery. And it was in their art, particularly in that of Tintoretto, that he discovered the powerful pictorial rhythms his own work always possessed. He dismayed his academic contemporaries by ignoring superficial refinement and finish, and leaving bare the constructional skeleton on which his painting was built. His early works were vigorous caricatures of earlier pictorial forms.

Among the artists of his own century, he imitated Delacroix, Daumier, and Courbet. Some of his most powerful early works were studies, portraits, landscapes,

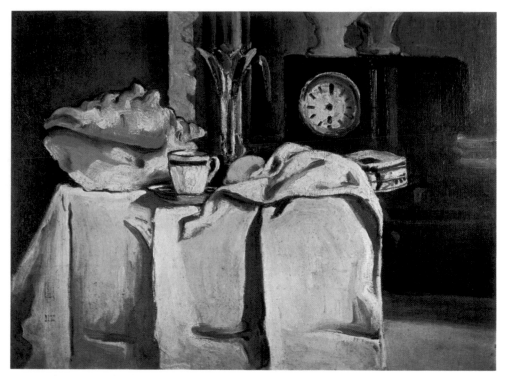

Paul Cézanne: The Black Marble Clock; oil on canvas; 55×74cm (22×29in); c1869–70. Collection of Stavros S. Niarchos, Paris

and still lifes influenced by Courbet. Like Courbet, Cézanne laid on his pigment with a palette knife, but with exaggerated breadth. It was this broad handling that gave studies of his *Uncle Dominique* (c1866; Museum of Modern Art, New York), his *Father Reading* (1866; Lecomte Collection, Paris) and two portraits of his friend *Valabrègue* (1870; private collection) a massive dignity. The masterpiece of these years is *The Black Clock* (1869–70; Stavros Niarchos Collection, Paris). Some of the forms, notably the cup, seem clumsily drawn, but the composition has an architectural solidity, and the vertical folds of the white napkin have the massive dignity that he later depicted on a grander scale in his painting of the quarry called Bibémus.

Cézanne had met Pissarro in 1861, and in 1866 had written to Zola that "all pictures painted inside, in the studio, will never be as good as the things done outside"; but it was not until 1872 that he visited Pissarro at Pontoise and worked alongside him. Under Pissarro's discreet guidance, Cézanne made the discoveries that were to be the foundation of his mature art. He learned to see forms as patterns of colored light and shade and to represent them as small patches of color. At first, he continued to compose in the manner of Courbet but

with a new luminosity. Later, he adopted a much smaller brush stroke. But he never became a true Impressionist: he was not interested in the transient effects of light, in qualities of weather or of the time of day or year. Rather, he transposed the crude, broad rhythms of his early compositions to the small scale of the Impressionist brush stroke, and created a complex mosaic of delicately balanced touches of color. Most important of all, he learned that this pictorial structure must be discovered through long contemplation of the motif. In this way, Cézanne at the age of 33 found himself beginning what he came to call his "researches".

The way in which Cézanne's vision differed from that of the Impressionists may be seen in the magnificent landscape he painted at Auvers, *La Maison du Pendu* (1873–4; Louvre, Paris). Though a country scene, it is not a true landscape, despite a glimpse of trees on the horizon. The greater area of the canvas is packed with solid surfaces: walls, thatched roofs, tree trunks, and slabs of earth, all painted in encrusted pigment. The picture is itself a feat of architecture, its surface like plastered masonry.

At the first Impressionist exhibition of 1874, Cézanne showed, together with *La Maison du Pendu*, a strange small canvas:

The New Olympia (1872–3; Louvre, Paris). Like many of his earlier canvases, it was an erotic subject, but with a fresh irony. As its title suggests, it is a parody of Manet's famous painting. It shows the black servant stripping away the sheet to expose the naked Olympia cowering before the passive gaze of a clothed male spectator—an ambiguous connoisseur who is included within the picture. It is also a satire of Cézanne's own early ambitions. The composition still recalls Delacroix and the Venetians, but the brilliant color is applied with a new flowing deftness of touch appropriate to this small, light, witty sketch.

The New Olympia was one of a number of small studies of voyeurist themes. In the most striking, *The Eternal Feminine* (private collection), an artist's model is unveiled to a fanfare before an audience of men, including a bishop. After 1875, Cézanne abandoned overtly sexual motifs and began instead a series of landscapes with bathers (male and female, but never both together) which he continued until the year before his death.

After his visit to Pissarro, the major part of Cézanne's work was painted from a motif: portrait, still life, and, above all, landscape. The countryside of his native Provence was decisive in the development of his mature vision. In 1876 he wrote to Pissarro: "The sun is so terrific here that it seems to me as if the objects were silhouetted not only in black and white, but in blue, red, brown, and violet ... this seems to me to be the opposite of modeling." The southern light and the evergreen foliage led Cézanne away from Impressionism to a slower contemplation of his subject. And the land itself, the scene of his childhood, had a significance far more important to him than the mere effects of light. Montagne Sainte-Victoire became the most important character he portrayed.

From 1875, Cézanne's art developed with rigorous logic. He worked slowly and with intense concentration, creating his pictorial forms out of an unprecedented scrutiny of his motifs. The subject matter, whether landscape, still life, portrait, or composition, was not an assembly of items but a harmonious relationship of forms. Each work was a search for a new resolution between the three-dimensional relationships perceived in nature and the two-dimensional relationships possible in painting, and between the colors of nature and the scale of the Impressionist palette.

He had learned the analysis of appearances from Pissarro. Now Cézanne sought to discover in nature equivalences to the synthetic pictorial patterns he had learned from the Venetians in his youth.

His later letters to such young admirers as Joachim Gasquet and Émile Bernard show that Cézanne was well aware of the paradoxical nature of his art. He believed that art grew out of the perception of nature, but also out of prolonged reflection which little by little modifies the artist's vision until "at last comprehension comes to us". He wrote to Émile Bernard on 26 May 1904: "One is neither too scrupulous nor too sincere nor too submissive to nature: but one is more or less master of one's model, and, above all, of the means of expression."

In the great works of his last years, it seems to matter very little whether—like the late landscapes of *Mount Sainte-Victoire*, the *Château Noir* (one example in the Sammlung Oskar Reinhart "Am Römerholz", Winterthur), or *Bibémus* (one example in the Museum Folkwang, Essen), or the still lifes with their amazing baroque rhythms—they are painted from the motif; or whether like the last heroic compositions of *Bathers*, they are invented or reconstructed from life-drawings of his youth. In all these works there is a symphonic resonance: a resolution of the perceived and the abstract, the sensuous and the intellectual, that transcends analysis. As Cézanne wrote in his last letter to his son (15 October 1906) "As with me sensations are at the root of all things, I am, I believe, impenetrable."

Further reading. Anderson, W. *Cézanne's Portrait Drawings*, Cambridge, Mass. (1970). Cachin, F. et al. *Cézanne*, Philadelphia (1996). Cézanne, P. (ed. Rewald, J.) *Letters*, Oxford (1977, reissued 1995). Chappuis, A. *The Drawings of Paul Cézanne*, London (1973). Dunlop, I. and Orienti, S. *The Complete Paintings of Cézanne*, London (1972). Reff, T. (ed. Rubin, W.) *Cézanne, the Late Works*, London (1978). Schapiro, M. *Cézanne*, New York (1965). Venturi, L. *Cézanne: Son Art, Son Oeuvre*, Paris (1936). Verdi, R. *Cézanne*, London (1992).

Chadwick Lynn 1914–2003

The English sculptor Lynn Chadwick was born in London, and trained as an architect. After serving as a pilot in the Second World War he started making sculptures; he concentrated on mobiles, influenced by Calder, and on constructions mainly in welded iron. In 1954 he developed his mature style: armatures of mild steel filled with composition, which from 1956 were

Paul Cézanne: Bathing Women; oil on canvas; 130×195cm (51×77in); c1900–5. National Gallery, London

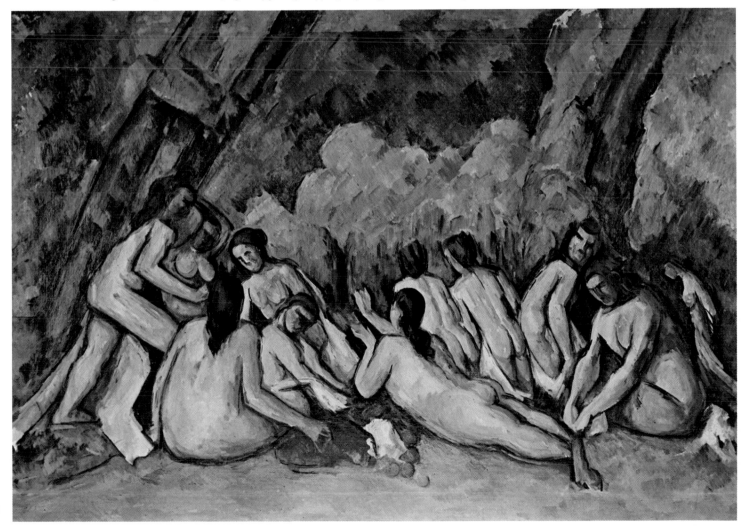

cast in bronze; these resembled birds, animals, and figures. In the mid 1960s he began to reduce his figures to pyramidal shapes, sometimes in laminated wood, but he later returned to winged and seated figures in which he combined realistic modeling and flat planes, with both polished and dull surfaces. Chadwick was awarded the International Sculpture Prize at the Venice Biennale in 1956.

Chagall Marc 1889–1985

The Russian painter Marc Chagall was born in Vitebsk, Belorussia, of a Jewish family. In 1907 he went to St Petersburg to study art, spending some time at the school of Leon Bakst who introduced him to advanced French art. He returned to Vitebsk in 1909, having already painted a number of scenes from Jewish life; these were done in a strident, primitive manner which reflected his period of apprenticeship to a sign-painter. In 1910 he traveled to Paris where he discovered Cubism, the methods of which he adapted to a highly personal fantasy rooted in the village life of his boyhood. *To Russia, to Asses, and to Others* (1911; Musée National d'Art Moderne, Paris) has a faceted treatment of the sky reminiscent of Picasso's 1908 landscapes; but when in Chagall's picture the milkmaid loses her head, this is not a Picasso-like pictorial fragmentation but a physical decapitation.

His greatest admirers were not other painters but the poets Blaise Cendrars, Max Jacob, and Guillaume Apollinaire. Because of its nostalgic subject matter, his work had a distinct literary appeal compared with most other avant-garde painting in Paris at the time. For Chagall, Cubism was not a rigid dogma; it was the gateway to an art that could ignore the law of gravity, naturalistic color, and the traditional treatment of space, to express a poetic vision. *I and the Village* (1911; Museum of Modern Art, New York) brings together diverse images within a single plane by means of arbitrary disparities of scale.

When war broke out in 1914 Chagall returned to Russia. After the Revolution he was appointed Commissar of Fine Arts in Vitebsk; he left the post after disagreements with Malevich about the conduct of art education. In 1919 he became designer for the State Jewish Theater in Moscow. He left Russia for Paris in 1923 and was commissioned by Vollard to make a series of etchings illustrating Gogol's *Dead Souls*. In the 1920s and 1930s his art became more lyrical, the aggressive sharp edges of his earlier work giving way to a flowing treatment. This development coincided with more sentimental subject matter. Lovers lie in a bouquet of flowers or float blissfully through the sky. While less ingenious in form than his earlier works, these paintings are more inventive in their imagery. Animals and musicians become musical instruments, and flying fishes play violins.

For all its element of escapist fantasy, Chagall's art was nonetheless affected by the Second World War which drove him to the U.S.A. in 1941. His palette acquired a sombre tone, and his flying figures became an expression of panic rather than ecstasy. He returned to France in 1947. After the War he continued to paint and also produced ceramics and stone sculptures. In the latter medium he produced a series based on Old Testament themes. His gift for intense decorative color led to several commissions for stained glass, notably those he made for the United Nations building, New York, in 1964. His airborne figures made him the natural choice to paint a new ceiling for the Paris Opéra, also installed in 1964.

Because of his penchant for visual metaphor, critics have related Chagall to the Surrealists. He never in fact had any formal contact with the group. The religious basis of many of his images, as well as the uncomplicated affirmative content of his art, with its romantic and tender vision of eroticism, is far from their subversive spirit.

Further reading. Carson, J. *Chagall*, New York (1965). *Chagall*, Zurich (1967). Chagall, M. *My Life*, London (1965). Erben, W. *Marc Chagall*, London (1966). Haftmann, W. *Marc Chagall*, New York (1972). Malraux, A. *The Ceramics and Sculptures of Chagall*, Monaco (1972). McMullen, R. *The World of Marc Chagall*, London (1968).

Marc Chagall: I and the Village; oil on canvas; 162×151cm (64×59in); 1911. Museum of Modern Art, New York

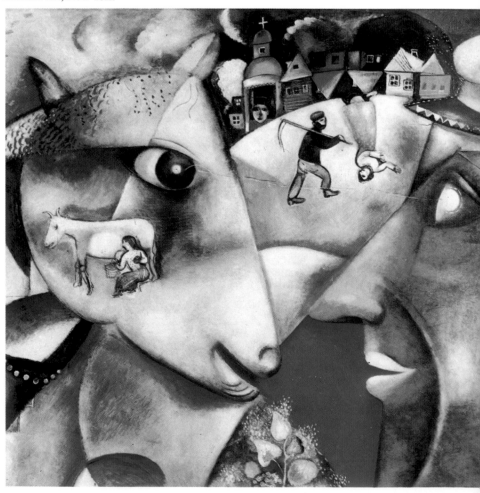

Chamberlain John 1927–

The American sculptor and painter John Chamberlain was born in Rochester, Indiana. He studied at the Art Institute of Chicago (1951–2), taught sculpture at Black Mountain College (1955–6), and then moved to New York. He began carving and modeling in 1951, turning to metal and welding the following year. Influenced by David Smith, his early sculpture was linear and open, constructed largely from iron piping. In 1957 he began to use scrap from wrecked cars, found at the home of the painter Larry Rivers. A year later he welded pieces of crushed and crumpled car bodies, retaining their original metallic colors.

The energetic volumes and surfaces of these works allied him to the Abstract Expressionists, especially to Willem de Kooning (1904–97). During the mid 1960s he made sculptures from simply tied urethane foam and painted paper; in 1970 he worked in mineral-coated plexiglass. Chamberlain made his first experimental film in 1967.

Chambers Sir William 1723–96

The architect Sir William Chambers was the first Treasurer of the Royal Academy. He was born in Sweden, educated in England, and had already visited India and China before entering the studio of the French academician J.F. Blondel in 1749. From France he traveled to Italy where he remained for five years, returning to England in 1755.

He developed an eclectic but conservative style, drawn almost exclusively from Renaissance sources, exemplified by his masterpiece, Somerset House, London (1776–96). His *Treatise on Civil Architecture* (1759) was very influential and provided an important counterweight to the innovations of his contemporary and arch-rival Robert Adam, with whom he temporarily shared the post of Architect of the King's Works.

Champaigne Philippe de 1602–74

Philippe de Champaigne trained in Brussels as a landscape painter and moved to Paris in 1621. He developed the classical qualities of economy and restraint admired in France, yet these remain tempered by an enduring debt to his Northern heritage. His works display a feeling for the beauty of domestic interiors, for the individuality of his sitters, and for realistic detail and effects of light in his landscapes.

Before 1643 he worked almost exclusively for Marie de Medici, Richelieu, and Louis XIII. He did many mural decorations, including frescoes in the dome of the Sorbonne, and undertook some important large commissions, among them *The Vow of Louis XIII* (1638; Musée des Beaux-Arts, Caen) and the *Échevins of the City of Paris* (1648; Louvre, Paris).

His style from c1629–30 is a modified version of the Baroque. His religious works are indebted to the glowing color and billowing draperies of Rubens, and his official portraits tone down the Baroque magnificence of van Dyck's Genoese portraits. A *Triple Portrait of the Head of Richlieu* (National Gallery, London) was meant as a working model for the sculptor Francesco Mochi.

About 1643 Champaigne became interested in the doctrines of the Jansenists of Port Royal, an austere Catholic sect. At the same time he began to move towards a more classical style. In *The Marriage of the Virgin* (1644; Wallace Collection, London) the composition is arranged as a frieze, the drapery has the sharp lines of antique sculpture, and the gesture and expression of each figure plays a distinct part. Champaigne was basing his art on Poussin, Raphael, and the Antique; like Poussin, he was deeply concerned with questions of historical and archaeological accuracy.

Between 1643 and 1661 de Champaigne began working for a wider public and it was then that he was most active as a portraitist; he painted sovereigns, merchants, lawyers, ministers, writers, and magistrates. His portraits are sober and restrained, the colors limited; his sitters rarely smile and the compositions are of the utmost simplicity. *Charles Coiffier* (private collection) rests his hands on a window sill, a portrait type perhaps developed from 15th-century Flemish precedents; the latent vitality of hands and features contrasts sharply with the stone-colored parapet and the severity of geometric shapes.

His most famous late work is the votive picture made after the miraculous recovery from paralysis of his daughter, a nun at Port-Royal (*Mère Agnès and Soeur Catherine de Ste-Suzanne Praying*, 1662;

Sir William Chambers: Chinese Pagoda; 1757–63. Kew Gardens, London

Chang Ta-ch'ien: Lotuses on Gold Screen; ink on gold silk; 168×369cm (66×145in); 1975. Private collection

Louvre, Paris). He avoids drama; in a very simple composition the prioress kneels beside the sick girl. There is the same feeling of stillness in his painting of the vision of *St Julienne* (Barber Institute of Fine Arts, Birmingham) where again the true subject is the communion of the soul with God. This quality of calm immobility links Champaigne more closely to Georges de la Tour (1593–1652) and Louis Lenain (c1593–1648) than to the visions and ecstasies of his Baroque contemporaries.

Chang Ta-ch'ien 1899–1983

The Chinese painter Chang Ta-ch'ien was born in Nei-chang, Ssu-ch'uan Province. After varied studies as a precocious youth, he moved to Shanghai to study the painting and calligraphy of the great Chinese masters. Chang became so adept at a variety of styles and techniques that he took up forgery; his copies confounded the connoisseurs of his time, and to this day they continue to create attribution problems.

Since Chang spent much of his youth copying ancient works, his own early art was a rather conservative reflection of Ming and Ch'ing literati styles. In 1940 Chang led a group of artists to the Mogao Caves in Tun-huang, Kan-su Province, to copy the Buddhist frescoes there. Exposure to this dazzling art brought about a turning point in Chang's own style, and he subsequently incorporated more decorative and colorful elements. A favorite theme became the lotus, which he depicted again and again during this period in works characterized by a stark, subtle elegance.

In the 1950s and '60s Chang traveled throughout the world, spending time in places as varied as Brazil, France, and California. Through his colorful personality and passion for Chinese traditions, he gained a reputation as an ambassador of Chinese art to the West.

Chang's style took on a radical new direction as a result of his exposure to Western art. He gained international renown for the nearly abstract renderings of landscapes he made late in his career, works in which he used a splashed-color technique that recalled the contemporaneous work of the American Abstract Expressionists.

Chao Meng-fu 1254–1322

Chao Meng-fu was a traditionally educated Confucian scholar and the pupil of the eminent figure painter Ch'ien Hsuan. From his teacher he had learned the styles of T'ang dynasty figure-painting, and the Northern Sung academic styles of landscape and bird-and-flower painting. Since he left Wu Hsing in 1286 to take up official posts in Peking, he has been traditionally referred to as "a traitor" for he had been a servant of the Mongol Yuan court. However, he was outstanding in his period as a painter and calligrapher and was much admired as an exponent of the classical styles; he was also revered as a great poet and scholar.

Unfortunately only fragments of his studies remain. These show he was a sincere, straightforward, and elegant draftsman with a strong instinct for the old masters. He seems to have deserved his imposing reputation as a scholar painter of taste and erudition and a stylist of the highest order.

Chao Meng-fu was a leader, with his teacher, of the movement that purposely turned its face towards the Old Masters and away from the sophisticated romanticism of the Hsia-Ma and Ch'an Schools. This was a period of reunification of China, though under foreign rule, and there was an acute awareness of former artistic standards. This led to a rejection of the Southern Sung courtly styles, and an attempt to reassess the old ideals. Chao Meng-fu as a traditional scholar official

Chao Meng-fu (attributed): detail of Horses Crossing a River; ink and color on paper; full size 17×87cm (7×34in); Freer Gallery of Art, Washington, D.C.

was ideal for the role; with his fellow official, Kao K'o-kung, who painted in the Mi Fei idiom, he overshadowed the very early Yuan period and was the epitome of the scholar-painter. The connotation of this term has varied through the ages. At that period it meant the well-educated man who painted for his own enjoyment and that of his friends, and who aimed at a directness of expression through the methods of the old masters, rejecting all technical "cleverness" but handling his brush with the skill of a well-trained calligrapher. To judge by the small sketch of the Ch'iao and Hua Mountains in the National Palace Museum, Taipei, Chao Meng-fu was the sort of painter who "wrote out" his ideas and his work seems close in spirit to that of Huang Kung-wang (1269–1354).

Chardin Jean-Baptiste 1699–1779

Jean-Baptiste-Siméon Chardin was a French painter of still-life and genre subjects. Born in Paris, the son of a carpenter, he entered the studio of P.-J. Cazes in 1718 and two years later worked as an assistant to N.N. Coypel. In 1728, he was received at the Académie with the still-life picture of a fish *The Skate* (*La Raise*; Louvre, Paris). This picture had caught the attention of some academicians at an exhibition, and it was at their suggestion that Chardin joined their ranks. The essential elements of his later still lifes are present in this painting, though the later works are less dramatic.

Simplicity, sobriety, and naturalness are the hallmarks of his still-life paintings, which vary little in style and content over 40 years. On a wooden or stone ledge will be arranged fruits, such as apples, grapes, peaches, and pears; a glass or bottle of wine or water; vegetables with copper or earthenware pots; a knife, a pipe, occasionally a piece of fine porcelain—the objects one would expect to find in any stable bourgeois household. Indeed, Chardin elevates that sober and unpretentious world to the status of an ideal.

This applies also to his figure-subjects, which he painted from the early 1730s to the mid 1750s. These show servants at work in austere, uncluttered kitchens—extensions of some of the still lifes, as it were; or they depict mothers and governesses instructing children in reading or in the domestic arts. Such paintings to some extent reflect progressive ideals of the period. They seem to recommend a return to what is natural and simple in life, as opposed to the glitter and formality of the court. They advocate education and a reasoned approach to the upbringing of children. Through such subject matter, Chardin expressed the bourgeois standards of his time. His technique was one of carefully modulated light and shade. He used muted earthy colors, with some powdery blues, grays, and pinks, an impastoed, deliberate brushwork, and a solid and powerful sense of structure and design.

Many of the great French private collectors of the age bought his work, as did foreigners such as the King of Sweden and the Empress of Russia. He also painted three overdoors for the Château de Choisy. Some academically minded critics thought his art low and vulgar, because he did not aspire to the great tradition of history painting—indeed, engravings of his art were popular with a wide general public. In his figure-pieces he retains something of the delicacy of Watteau, while never descending to the boorishness of certain Dutch 17th-century genre paintings. The latter were widely collected in 18th-century France, and influenced Chardin's interior scenes in a general way. He ceased inventing figure-subjects in the mid 1750s, probably capitulating before the rising star of the more sentimental art of J.-B. Greuze. He made a number of portraits in pastel during the 1770s.

Jean-Baptiste Chardin: The Attributes of Music; oil on canvas; 91×145cm (36×57in); 1765. Louvre, Paris

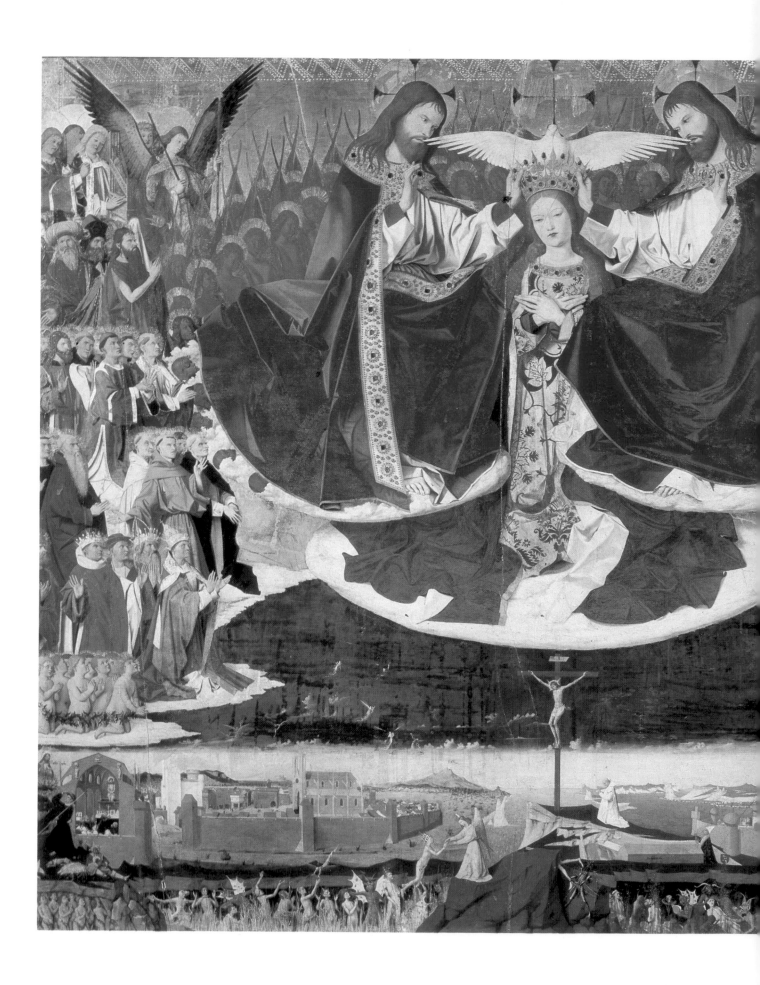

Charonton Enguerrand *c1410–61*

The French painter Enguerrand Charonton was born in Laon. In spite of his obscure northern origins, and the fact that only two paintings can be attributed to him with certainty, he is considered one of the masters of medieval painting in Provence. He worked in Aix, Arles, and Avignon for at least 22 years. His *Vièrge de la Miséricorde* and the great *Coronation of the Virgin* from the Hospice of Villeneuve-lès-Avignon present a decorative, highly tactile style suggestive of sculptural origins. His paintings also display the brilliance of light and harshness of line characteristic of the school of Avignon.

Chassériau Théodore *1819–56*

The French painter Théodore Chassériau was born in the Antilles. His work shows affinities with the supposedly antithetical styles of both Ingres and Delacroix. He painted portraits showing the influence of his teacher Ingres (for example, *The Two Sisters*, 1840; Louvre, Paris) but *c1845* he became disenchanted with pure "Ingrisme". He adopted the atmospheric color and chiaroscuro of Delacroix; while retaining Ingres' preoccupation with contour (for example, *The Tepidarium*, 1853; Louvre, Paris). His subject matter reflects the Romantics' interest in Shakespeare (*Desdemona*, 1849; Louvre, Paris) and in the East (*Moorish Dancers*, 1849; Louvre, Paris), which was reinforced by his visit to Algeria in 1846.

Chicago Judy *1939–*

The American multimedia artist Judy Chicago (pseudonym of Judy Cohen) studied art at Los Angeles and helped to establish the first feminist art courses in America, first at Fresno State College and the California Institute of Arts. She became the focus of feminist art debate with *The Dinner Party* (1974–79; a traveling exhibit), a triangular table with place settings for 39 women, real and mythical, who have contributed to Western cultural history, but have been "ignored, maligned, or obscured by that history". A collective work, it is executed in crafts traditionally associated with women, such as needlework and painted china. She continued her

Enguerrand Charonton: Coronation of the Virgin; panel; 183×220cm (72×87in); 1454. Hospice, Villeneuve-lès-Avignon

Théodore Chassériau: The Two Sisters; oil on canvas; 180×135cm (71×53in); 1843; Louvre, Paris

frank exploration of "women's achievement and struggle" in subsequent works. She also began exploring her own Jewish heritage, and in the mid 1980s, together with her husband, the photographer Donald Woodman, began *Holocaust Project*, a collection of paintings, photographs, tapestries and texts relating to the Holocaust and to the need for "what are sometimes called the 'feminine values' of compassion and nurturance".

Further reading. Lippard, L. et al. *Judy Chicago*, New York (2002).

Chikuden Tanomura *1777–1835*

Tanomura Chikuden was a Japanese painter of the *Bunjinga* (scholar-painters) School, born in Takeda in Kyushu. He became head of the Confucian school of his local lord, and head of his family, but decided to devote his life to painting. He traveled a great deal in Japan, but of all the *Bunjinga* he comes closest to the true Chinese spirit. He must have seen good original works imported through Nagasaki. He favored landscapes and bird-and-flower albums; these are painted with a dry, apparently hesitant brush which conceals great strength of purpose. His landscapes are often many-layered.

Chillida Eduardo 1924–2002

The Spanish Basque sculptor Eduardo Chillida was born in San Sebastian. He studied architecture at Madrid University from 1943 to 1947. He lived in Paris from 1948 to 1950, in Villenes 1950–1, returned to Hernani until 1957, and then moved back to San Sebastian.

His figure-carvings of 1948–9 led to Abstract sculptures in 1950 and to work in forged iron from 1951. Small in scale, and concerned with enclosed space within forms, these were jagged iron pieces owing something to Julio Gonzalez (1876–1942) and to local traditional techniques. They were followed in the mid 1950s by sculptures made from cut and twisted iron bars. He began wood carvings In 1959 and from 1964 also worked in alabaster. These media introduced a new emphasis on solidity and mass. As well as reliefs he has done many *papiers collés*, drawings, and graphics.

Ch'i Pai-shih 1851–1957

The Chinese painter Ch'i Pai-shih was born of humble parentage in Hsiang-tan, Hunan. He had a few years of schooling and then earned his keep on the family land as a woodcutter. He took up wood carving and learned to paint, doing mostly portraits and decoration for the villagers. He was helped by local writers, who introduced him to classical literature and poetry. During his twenties he gradually progressed to seal cutting, poetry, and painting, seeing for the first time works by Shih T'ao and Chu Ta. After a few years in which he traveled widely through his own country, Ch'i returned home and began seriously to write poetry and to paint.

He had by this time come under the influence of the painting of Wu Ch'ang-shih (1844–1927). Ch'i followed his master closely, especially in his flower painting; but the younger man used a wider range of subject matter and a different style of painting, which he would often combine with Wu's. Ch'i was a most acute observer of birds and flowers, but he seems to have had a special affection for insects and painted them with great sensitivity. From the age of 60 Ch'i Pai-shih lived in Peking; his paintings became popular and he himself became a cult figure. This very popularity perhaps led to a certain slackening of style and even a triteness which is never present in the painting of his master Wu Ch'ang-shih. There are many copies of

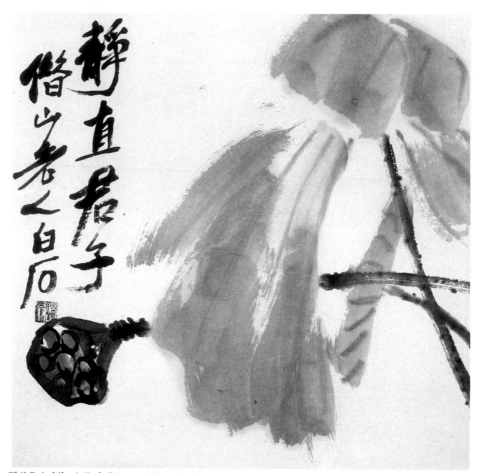

Ch'i Pai-shih: A Faded Lotus; ink and color on paper; 35×34cm (114×13½in); 1953. National Gallery, Prague

Ch'i's paintings which makes it difficult to identify with certainty the work of this forthright and, at his best, fine, poetic, and decorative painter.

Chirico Giorgio de 1888–1978

The Italian painter Giorgio de Chirico founded the Metaphysical School and had a vital influence on the development of Surrealist art. Born in Volo, Greece, he began studying art in Athens in 1900. In 1906 his parents moved to Munich, where de Chirico enrolled in the Academy of Fine Arts and came under the influence of late-19th-century German painters and philosophers, especially Böcklin and Nietzsche. Their joint example encouraged him to reject naturalism and to concentrate instead on poetic, imaginary, and visionary subjects. In 1909 the family moved to Milan where de Chirico painted mythological scenes closely based on Böcklin.

Traveling by way of Florence and Turin, where the arcaded buildings, statues, and desolate squares deeply affected him, he settled in Paris in 1911. His first characteristic works date from 1910–11. Subject to illness and depression, haunted by the writings of Nietzsche and by nostalgic recollections of Greece and Italy, a prey to hallucinations, de Chirico depicted a mysterious and troubling world which was for him as real as the banal world of everyday life.

In such works as *The Rose Tower* (1913; Peggy Guggenheim Collection, Venice), he created a sense of enigma in images of trance-like stillness and silence. The period of time is ambiguous, the space impossibly deep, and the perspective inconsistent, and objects are irrationally juxtaposed. The strangeness is heightened by the almost naive lucidity of his style. Sometimes spatially agoraphobic, sometimes claustrophobic, these paintings, with their looming statues and shadows, are full of tension and menace. They suggest, through an apparently unconscious symbolism of towers, arcades, and trains, feelings of panic and sexual frustration.

In 1915 de Chirico was drafted into the

army in Ferrara, but continued to paint. His work by now showed a debt to Cubism in the shallowness of the pictorial space, the use of collage-like effects, and its imagery of abstracted mathematical instruments. In January 1917 he was joined by Carlo Carrà and together they founded the Metaphysical School, whose tenets were a rationalization of the artistic aims de Chirico had held since 1910–11. Although short-lived, the association helped to draw attention to de Chirico's concept of poetic painting, which was to have a profound effect on such Surrealist painters as Dali, Ernst, Magritte, and Tanguy.

Daniel Chodowiecki: The Artist Having a Horse Shod; pen and ink; 11×19cm (4×7in); 1773

Giorgio de Chirico: The Child's Brain; oil on canvas; 1914. National Museum, Stockholm

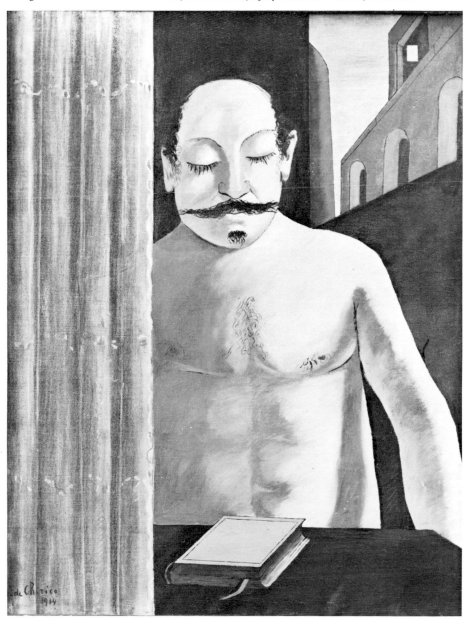

After 1917, when he painted masterpieces like *The Disquieting Muses*, (Gianni Mattioli Collection, Milan), de Chirico's work declined, although he created a series of remarkable still lifes and portraits in 1919. At the end of the war, he moved to Rome and turned his back on Metaphysical imagery; he became increasingly concerned with questions of pictorial technique and produced works imitative of the Old Masters. From this time onwards, when he did return to his early manner it was to make copies or pastiches. Nevertheless, the visionary intensity of his metaphysical work was recaptured briefly in his extraordinary novel *Hebdomeros* (1929).

Further reading. Brunio, C. *Catalogo Generale: Giorgio de Chirico* (3 vols.) Milan (1971). Chirico, G. de *De Chirico by De Chirico*, New York (1971). Gaffé, R. *Giorgio de Chirico, Le Voyant*, Brussels (1946). Rubin, W. (ed.) *De Chirico*, New York (1982). Sloane, J.C. "Giorgio de Chirico and Italy", *Art Quarterly*, Detroit (Spring 1958). Soby, J.T. *Giorgio de Chirico*, New York (1966).

Chodowiecki Daniel 1726–1801

Born in Danzig, the painter Daniel Nikolaus Chodowiecki went to Berlin in 1743 to work as a shop assistant. He soon turned to painting and established a reputation as a miniature painter. In 1757 he started engraving and painting in oils. The 12 paintings illustrating scenes from Lessing's *Minna von Barnhelm*, for the Berlin Calendar in 1768, proved to be a watershed in his career. In these he imbued the Rococo with a new realism. His later work, painted for the middle class of

Berlin, is remarkable for the directness and sensitivity of his response to unpretentious indoor scenes. These are comparable to the work of Chardin (1699–1779) in their approach.

Chokuan Soga *fl. 1596–1610*

The Japanese painter Soga Chokuan was the founder of the later Soga School. Little is known of his life, and his connections with the Muromachi Soga painters are obscure. He lived and worked in the prosperous part of Sakai, near Osaka, and his patrons were probably rich merchants and samurai. Chokuan specialized in ink monochrome painting of aggressive birds, especially hawks, often in a landscape dominated by foreground rocks, trees, and foliage. The brush work of his stabbing, horizontally jutting tree boughs recalls that of Yusho (1533–1615), but his composition is more dynamic and less elevated. Many hawk paintings are attributed to him; the authentic ones have a splendid, controlled ferocity.

Choshun Miyagawa 1683–1753

Miyagawa Choshun was a Japanese artist of the *Ukiyoe* School, born in Owari Province. He worked in Edo (Tokyo), but was never tempted into the woodblock medium. As the most sensitive colorist among *Ukiyoe* painters he probably found the print techniques of his day inadequate. He is said to have helped redecorate the Tokugawa mausoleum at Nikko; this would seem to indicate a rise in status of the *Ukiyoe* School, which had once been considered frivolous. Choshun's paintings nearly all depict women in softly sensuous, pleasurable situations, such as *Girl Enjoying Scent* (Tokyo National Museum), and more than any other artist he seems to give substance to the erotic dreams of the Edo world.

Christo 1935–

The Bulgarian sculptor Christo Javacheff, known simply as Christo, was born in Gabravo. He studied at the Fine Arts Academy, Sofia (1952–6), and moved to Paris in 1958. Since 1964 he has lived in New York. Christo's early association with the Paris Nouveaux Réalistes allied him with a movement critical of modern consumerism and waste. He is best known for his wrapped objects begun in 1958–9.

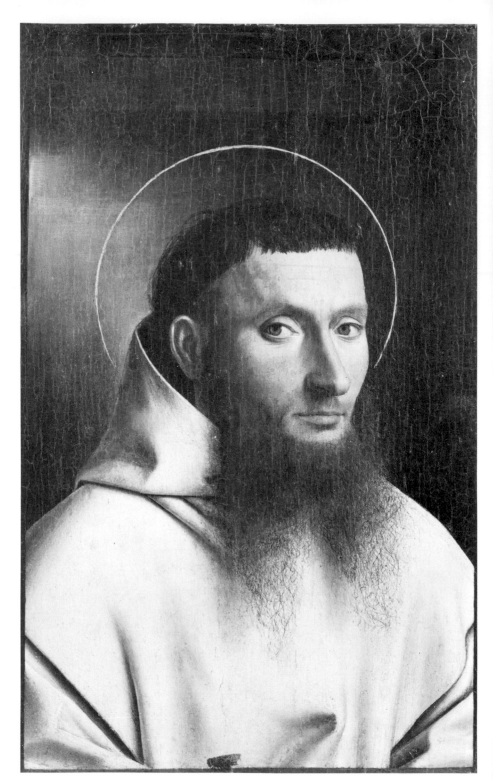

Petrus Christus: Portrait of a Carthusian; tempera and oil on wood; 29×20cm (11½×8in); 1446. Metropolitan Museum, New York

At first he wrapped bottles and cans and then famous monuments and buildings, adding a political dimension. In 1969 he wrapped part of the Australian coast. His major projects, achieved at great cost and through technological innovation, include *Valley Curtain* (1971–2; Rifle, Colorado), *Running Fence* (1976; California), and—in collaboration with his partner, Jeanne-Claude (1935–)—*The Gates* (Central Park, New York), planned for 25 years and unveiled in 2005.

Christus Petrus *fl. 1444–72/3*

Petrus Christus was the major painter in Bruges in the mid 15th century, and the principal follower of Jan van Eyck, who may have been his teacher. It has been suggested that Christus completed some of van Eyck's unfinished works and, less convincingly, that he introduced Eyckian techniques to Italian artists, notably Antonello da Messina (c1430–79). While

his work seems to have been popular in Italy, there is no evidence that he ever went there; he may have traveled to Germany, but he worked mainly in Bruges.

The chronology of his paintings is uncertain, despite an unusually large number of dated works from 1446–57. The earliest of these are two portraits, one of Edward Grymestone (Collection of the Earl of Verulam, St Albans), the other of a Carthusian (Metropolitan Museum, New York). The former is innovatory in placing the sitter in a domestic interior, as though the setting of the van Eyck's *Arnolfini Marriage* (National Gallery, London) had been combined with an Eyckian portrait bust. *The Exeter Madonna* (Staatliche Museen, Berlin) may belong to the same period: it is clearly indebted to Jan van Eyck's *The Madonna of Chancellor Rolin* (Louvre, Paris) for its architectural setting and competent perspective, though the figures are anatomically less convincing. The more complex *St Eligius* (1449; Metropolitan Museum, New York) combines half-length figures with a meticulously detailed interior (a goldsmith's shop; Eligius is the patron saint of metalworkers). The precise rendering of individual objects reveals Christus as a master of still life.

A pair of altar wings showing the *Annunciation*, *Nativity*, and *Last Judgment* (1452; Staatliche Museen, Berlin) combine motifs from the work of Jan van Eyck and Rogier van der Weyden. That Christus was influenced by the emotional intensity of van der Weyden is demonstrated by the large *Lamentation* (Musées Royaux des Beaux-Arts de Belgique, Brussels) a work variously dated to the very beginning and the end of Christus' career. But it is as a truthful recorder of the physical world that Christus is chiefly remarkable. He was a master of linear perspective and modeled surfaces, an underrated artist whose work represents, in pictorial terms, a development from the achievement of van Eyck.

Chu Jan *fl. 960–80*

A younger contemporary of Tung Yuan, the Chinese painter Chu Jan is known by his monastic name. Like Tung Yuan he came from Chiangnan and worked at first for the Southern T'ang court. However, when this State capitulated to the Sung rulers he retired to a monastery. Specializing in landscape painting, Chu Jan was a master of composition, building up impos-

Alberto Churriguera: the Ayuntamiento in the Plaza Mayor, Salamanca; 1728

ing "master mountain" landscapes in which he expressed the piles of rocks by his own distinctive "hemp fiber" *ts'un*. This is the earliest example of a brush stroke associated with a particular artist; although we must regard attributions of such a remote date with circumspection, it is possible to glimpse a most original painter at work. The smooth, repetitive curves and carefully accented dots create not only a sense of great volume and grandeur, but also a mild atmosphere characteristic of the southern area in which he worked. His landscapes are clearly related to those of the later 13th–14th-century group of southern painters of the Chiangnan district in the Yuan dynasty.

Churriguera family
17th and 18th centuries

The Churriguera family were Spanish architects. Arriving in Madrid in the 1670s, they brought from Barcelona an ornate style of Catalan Baroque decoration which they applied first to altarpieces and later to whole buildings.

José Benito de Churriguera (1665–1725), the leading member of the family, was the son of José Simón de Churriguera (José the Elder) a sculptor (*fl.* 1670–9). José Benito began with conventional designs like that of the main altarpiece of San Esteban, Salamanca (1693). This uses six large twisted columns in the lower story, with

the center pair continued above by pilasters in the upper story. (These serve to frame a great canvas by Claudio Coello.) José's architectural activity began in 1709 with the planning of the new town of Nuevo Baztán. The tall, narrow church and adjoining horizontal palace are in a severe style. In spite of their asymmetrical contrasting masses, they distantly recall Juan de Herrera's work at the Escorial. But José's achievement was neither extensive nor markedly original.

His brother Joaquín (1674–1724) was even less venturesome, reverting to an elaborately ornamented Plateresque style in the dome of Salamanca Cathedral (1714; later destroyed) and elsewhere in that city.

The youngest brother, Alberto (1676–c1747), constructed the Plaza Mayor, Salamanca (1728). The most successful town-planning scheme of the period, it was executed in a restrained Baroque style still reminiscent of Plateresque in its ornament.

The principal followers of the Churriguera family were Pedro de Ribera, Narciso Tomé, and Andrés García Quiñones who worked at Salamanca, Valladolid, and Toledo. It was the work of these later architects that gave the term "Churrigueresque" a note of opprobrium for its lavish, riotous ornament. This was sometimes inspired (as in the case of Ribera) by the French Rococo; but it lacked the elegance of that style. Tomé's *Transparente* (1721–32), a theatrical blending of painting, sculpture, and architecture in the ambulatory of Toledo Cathedral, is the most striking achievement of this extreme phase.

Chu Ta 1626–1705

The Chinese painter Chu Ta, who often signed himself by his monastic name Pa Ta Shan Jen, was a descendant of the Ming royal house; he retired to become a monk at the fall of the dynasty. He had a reputation for eccentricity which perhaps indicates some form of mental instability. He was subject to periods of depression and elation and drank wine to sustain himself. He eventually gave up speaking altogether, putting a notice "dumb" on his door. His painting is strong and entirely personal; he painted birds and flowers in the Ch'an School, using a deft skill in composition and a marvelously controlled ink tone. He did not use color. His birds and fish have a baleful, humorous quality,

and critics have perceived social comment in his animal painting.

The bird and flower paintings, scrolls or album leaves and fans, are done on paper; but when, more rarely, Chu Ta painted landscape he seems to have favored white satin as a base on which to paint in ink. The weave of the satin, encouraging a spiky spread of the ink, gives Chu Ta's wet ink style a brittle quality. His landscape composition is conventional, unlike the experimentalism of Tung Ch'i-ch'ang (1555–1636); the "bones" of the landscape are the subject, and little weight is given to considerations of atmosphere or light, or even to the natural world. These ascetic landscapes are a considerable contrast to those of his contemporary, Shih T'ao (1630–1707).

Cigoli 1559–1613

Lodovico Cardi da Cigoli, often known as "Il Cigoli", was a Florentine painter of the transition from late Mannerism to early Baroque. He was named after his birthplace near Empoli. He was also an architect and a poet, and a friend of Galileo. A close contemporary of the Carracci, Cigoli shared their desire to create a new pictorial language based on warm color and intense emotion. This was probably a reaction to the highly artificial and mannered style of his master, Alessandro Allori. Almost from the beginning, his works show the influences of Correggio, Barocci, and the Venetians. He also admired the work of Florentine painters such as Santi di Tito, who similarly rejected the more extreme forms of Mannerism in the interest of a greater simplicity and clarity.

Fundamental to Cigoli's artistic purpose was the effective expression of his religious subject matter, in accordance with the spirit of the Counter-Reformation. This may be seen in a mature work such as *The Martyrdom of St Stephen* of c1597 (Galleria Palatina di Palazzo Pitti, Florence), which in many ways anticipates the high Baroque of Pietro da Cortona, and even of Rubens. At the same time, Cigoli's formulation of the new style was much less radical than that of the Carracci; he remained to a much greater extent tied to Florentine traditions of incisive draftsmanship and hardness of color. Although his art had a pervasive influence on 17th-century painting in Florence, it had far less effect in Rome, where he settled after 1604.

Cimabue c1240–c1301

The Florentine painter Cimabue was also known as Cenni di Pepo (from Bencivieni di Pepo). He was long considered to have been Giotto's master. Whether or not this was true, Cimabue confronted many of the same artistic problems as Giotto. His work displays a similar, essentially Florentine, concern with a realistic sense of space and volume and the desire to create a human, dramatic interpretation of divine subjects.

The first mention we have of Cimabue records his presence in Rome in 1272, just a year before we hear of Pietro Cavallini there; this is significant in view of the importance of Rome for the development of painting at that time. Among Cimabue's surviving works only one is documented: the figure of *St John* in the apse mosaic in the Duomo at Pisa (1302). There is thus some controversy about attributions, but there is a small core of universally accepted works. Of these, the earliest seem to be his frescoes in the upper church of St Francis at Assisi. The frescoes cover the vaults of the crossing (*Four Evangelists*), the walls of the apse (*Life of the Virgin*), the left transept (*Apocalyptic Scenes* and *Crucifixion*) and the lower part of the right transept (*Lives of SS. Peter and Paul* and *Crucifixion*.) The *Evangelists* in the vault contain a possible heraldic clue to the date of the decoration, which seems to have been c1277–9. The frescoes are poorly preserved, but enough remains to show that the *Crucifixion* in the left transept, for example, is a work of enormous dramatic power. The same vastness of conception applies to the organization of the whole scheme, which combines the actual architectural space and the painted pictorial space into a satisfying unity. This approach is partly developed by succeeding painters in *The Legend of St Francis* in the nave of the same church, and more fully by Giotto in his Capella dell'Arena, Padua.

There is another fresco by Cimabue at Assisi, down in the lower church: the *Madonna and Child with Angels and St Francis*. This fresco, and a later Cimabue workshop *Madonna and Child* (Louvre, Paris) may both reflect the influence of Duccio's *Rucellai Madonna* (1285; Uffizi, Florence). Cimabue's major surviving altarpiece, however, the S. Trinità *Madonna* (Uffizi, Florence) is likely to date from shortly before 1285. Like the *Rucellai Madonna* it is one of the grandest of the series of huge gabled panel paintings of the Madonna and Child which culminates in

Giotto's *Ognissanti Madonna* (c1307; Uffizi, Florence). The throne is presented in convincing perspective, suggesting a central vanishing point. The accompanying angels are securely situated on its steps, and altogether the painting marks a major advance in the Florentine development of realistic space.

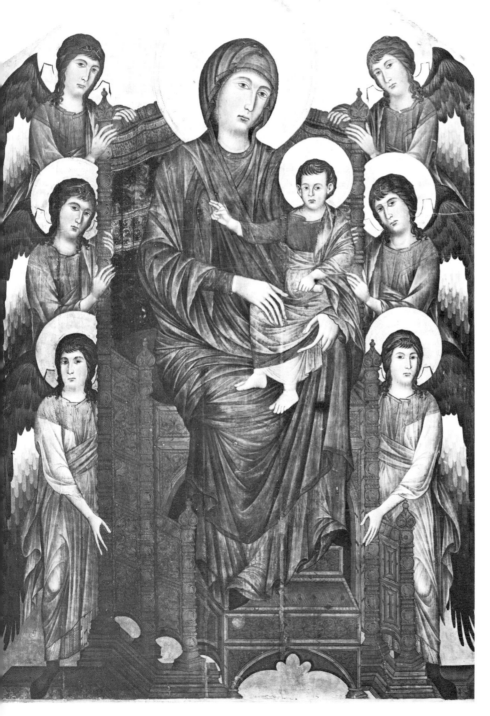

Cimabue (follower of?): Madonna and Child; panel; 424×276cm (167×109in); c1290–5. Louvre, Paris

Cimabue's grandeur can still be recognized even now in the tragically damaged S. Croce *Crucifixion* (S. Croce, Florence) which must date from the 1280s. The new softness of the painting of the flesh and of the diaphanous loincloth is present at the same time as the most extreme emotive use of the Gothic S-curve of Christ's body (an attitude strikingly developed in 13th-century Italy by the Tuscan painter Giunta Pisano, *fl.* 1229–55). It is difficult to understand the superb but very different *Crucifix* in S. Domenico, Arezzo, as a product of the same hand. As we know Cimabue worked as a mosaicist in Pisa in 1301–2, it is reasonable to suppose that he had a hand in the contemporary mosaics of the Baptistery in Florence; but they may merely show his influence.

Despite the fragmentary nature of his surviving work, it is still possible to recognize Cimabue as a major innovator.

Further reading. Battisti, E. *Cimabue*, Milan (1963). Bologna, F. *Cimabue*, Milan (1963). Salvini, R. *Cimabue*, Rome (1946). Sindona, E. *L'Opera Completa de Cimabue*, Milan (1975).

Cima da Conegliano

c1459–1517/18

Giovanni Battista Cima was an Italian painter known as Cima da Conegliano after his birthplace near Treviso. His first dated work is an altarpiece in Vicenza (painted for the church of S. Bartolomeo, now in the Museo Civico) of 1489 whose style, in common with all the artist's later works, suggests an early association with Giovanni Bellini (c1430–1516). From 1492 until 1516/18 he worked chiefly in Venice, before returning to Conegliano where he died. Cima's style developed little, and without the dates inscribed on many of his works it would be impossible to place them in any logical sequence. The altarpieces are in general derived from a Bellinesque type: for example the 1492 Conegliano altarpiece (Conegliano Cathedral) and the St Peter Martyr altarpiece, commissioned approximately 14 years later (Pinacoteca di Brera, Milan). He also painted many devotional panels showing the Madonna and Child seated in front of an open landscape. Two small roundels representing mythological subjects (Galleria Nazionale, Parma) are exceptions in an *oeuvre* chiefly concerned with religious subjects. (*See* overleaf.)

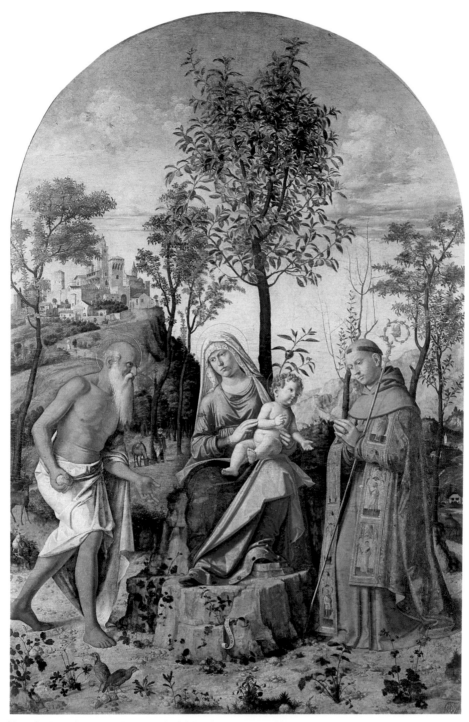

Cima da Conegliano: Madonna and Child with St Jerome and St Louis of Toulouse; canvas; 212×139cm (83×55in); c1495. Gallerie dell'Accademia, Venice

Ciurlionis 1875–1911

The Lithuanian painter Mikolojus Konstantinas Ciurlionis originally trained as a musician. He took up painting in 1904, working in a Symbolist manner reminiscent of Odilon Redon. He used a technique of tempera on paper to gain subtle translucent effects which accorded well with his cosmic subject matter. Claims have been made for him as the first Abstract painter, a misunderstanding arising out of his attempts to find visual equivalents for musical forms. *Fugue* (M.K. Ciurlionis State Art Museum, Kaunas) is basically a landscape in which the outlines of the hills and forest undulate in an analogy with musical counterpoint. Ciurlionis also painted in series, each painting representing one of the movements of a sonata.

Claude Lorrain 1600–82

Born Claude Gellée in the village of Chamagne in Lorraine, the French painter known as Claude Lorrain can be considered as the greatest landscapist of the 17th century. Apart from a short visit to Germany and France from 1625 to 1627, he spent his whole working life in Italy, and his art should be examined in the context of the Roman school of the period. His paintings of landscape relate to major concerns of 17th-century Italian art—the study of nature and the exploration of light. His achievements in these fields rank him with the greatest of his contemporaries. He restricted his investigation of those themes to landscape painting, unlike other pioneers such as Rubens, Rembrandt, and Poussin for whom this was only one aspect of their approach. Claude radically extended the concept of landscape, giving it historical significance without sacrificing his sensibility to effects of nature. In doing so, he further developed the classical tradition of landscape painting which had evolved in Italy since the Renaissance.

There are two sources for the life of Claude: biographies by Joachim von Sandrart and by Filippo Baldinucci. Sandrart (1606–88) was a contemporary of Claude during his early years in Italy. He was one of the many Northern artists who flocked to Rome in the early 17th century and with whom Claude was initially associated. Sandrart accompanied Claude on many of those expeditions in the countryside around Rome that remained his greatest inspiration. His biography is particularly valuable for its firsthand account of Claude's working method—especially of the studies from Nature which form the basis of Claude's landscape art. Baldinucci (1624–96), of a generation later than Claude's, obtained most of his information from the artist's nephew. His is a more professional type of biography, detailed and objective, but less circumstantial. Both tended to stress the supposed naivety of the painter, but the modern view more justly appreciates the intellectual content of his art and the seriousness of purpose of this careful and conscientious artist.

Two traditions exist about Claude's early training (he was the third of five sons). Sandrart claimed that he was originally apprenticed to a pastry cook; Baldinucci claimed that he began in the studio of his elder brother, a wood engraver in Strasbourg. However, his significant training

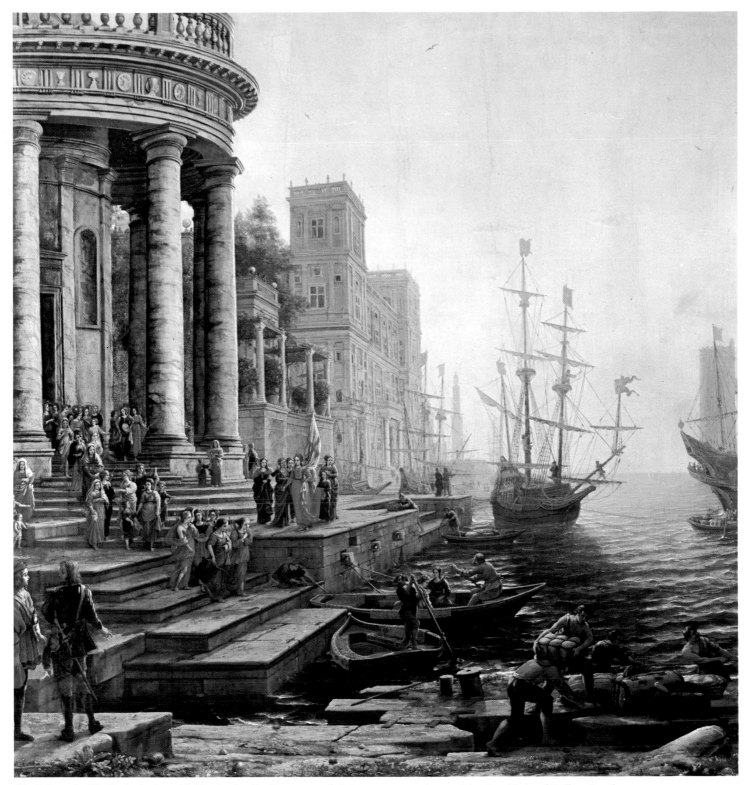

Claude Lorrain: The Embarkation of St Ursula; detail; oil on canvas; full size 113×149cm (44×59in); 1641. National Gallery, London

began in Italy where he had arrived by 1615. He may have worked for the German painter Gottfried Wals in Naples for the first two years. The first certain evidence is his apprenticeship to Agostino Tassi in Rome in 1618. He stayed with this artist until 1625. Tassi was a major influence on the formation of Claude's style. As a decorative landscapist working predominantly in fresco, his art was firmly based on the classical traditions of land-

scape. It used the elements of landscape, and coast scenes, with pastoral, Biblical, or mythological figures, architecture, and shipping. All these themes are to be found later in the work of Claude. After his return to Italy in 1627, Claude received commissions for frescoes in the palaces of certain high churchmen in Rome. However, he quickly abandoned this medium in favor of easel painting. His patrons remained drawn from aristocratic circles—

the Medici, Pope Urban VIII, Philip IV of Spain. In this he differed from his contemporary, Poussin, whose paintings were generally commissioned by the intellectual bourgeoisie.

In his first period, up to the 1640s, Claude produced many seascapes and landscapes which greatly developed the rather schematic compositions of the landscapes of Tassi and Bril. He succeeded in connecting the planes of his compositions

by subtle aerial gradations which achieved real unity of atmosphere. His landscapes are suffused with light—a result of his observations of nature, also evidenced in the many studies he made in the open air. He was the first to attempt to depict the sun on canvas and to explore its effects as accurately as possible.

In his second period, from the 1640s to his death, Claude's naturalism is increasingly affected by a classical humanist feeling. This derives from his study of the art of Domenichino (1581–1641) and of Annibale Carracci (1560–1609), especially as seen in the latter's contributions to frescoes in the Palazzo Aldobrandini, Rome (c1604). His artistic purpose became more ambitious with the inclusion of specific subjects drawn from Classical mythology or the Bible. His compositions were more posed and complicated than the earlier pastorals, and can be considered as fully historical: the form of the landscape depends directly on the significance of the subject matter, and the figures play an integral part in the composition. This mature style is brilliantly represented by pictures such as *Landscape with Dancers* (1669; Hermitage Museum, Leningrad) and *View of Carthage* (1676; Hamburger Kunsthalle, Hamburg) in which Claude has manipulated the figures and the scenery with great dramatic effect.

In search of a more severe, epic style, Claude turned for inspiration to Virgil's *Aeneid* which increasingly suited his mood towards the end of his life. The last paintings achieve a supreme blend of poetic feeling and decorative skill equal in sublimity to that of the Classical poet. There is no perceptible falling off in technical ability. The acceptance of the qualities of Mannerism now allow his very personal handling of his figures to be recognized as an essential ingredient of his art, and not as the failing they had for long been considered. This is quite evident in his last painting, *Ascanius Shooting the Stag of Silva* (Ashmolean Museum, Oxford), painted in his 82nd year.

Throughout his career, Claude kept a careful record of his compositions and his patrons in the so-called *Liber Veritatis*. This is a chronological series of copies in pen and ink of his major commissions: the 195 drawings serve as an indication of his style and its development.

Claude's vision of the Classical world was quite different in conception to that of Poussin, the artist who worked most

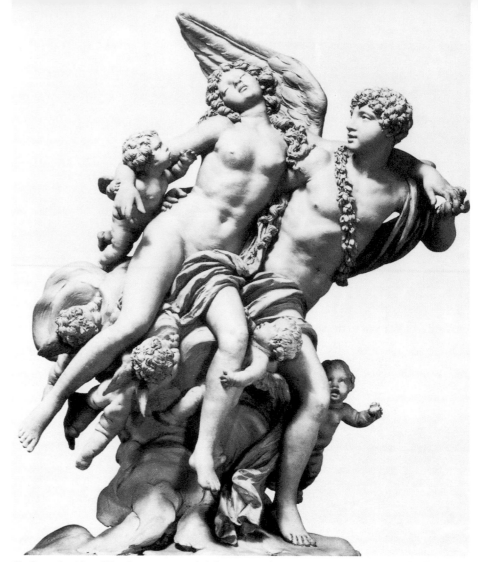

Clodion: Cupid and Psyche; terracotta; height 59cm (23in); c1798–1804. Victoria and Albert Museum, London

closely to him during his life. The latter's landscapes are intellectual constructs that depend directly on the imagination of the artist. The landscapes of Claude, while no less ideal, are rooted in his observation of the natural world. It was this quality that made his art of such consistent appeal to later generations, especially to those who fell under the spell of the Classical terrain of Italy. In 18th-century England this admiration was translated by the aristocracy and landed gentry into real terms in the Classical arrangement of their parks. It is Claude's ability to observe that makes his interpretation of nature of interest today, as much on the intellectual as on the sensuous level.

Further reading. Cecchi, D. *L'Opera Completa di Claude Lorrain*, Milan (1975). Friedländer, W. *Claude Lorrain*, Berlin (1921). Kitson, M. *Claude Lorrain: Liber Veritatis*, London (1978). Kitson, M. *The Art of Claude Lorrain*, London (1969). Mannocci, L. *The Etchings of Claude Lorrain*, New Haven (1988). Röthlisberger, M. *Claude Lorrain: the Drawings* (2 vols.), Berkeley (1968). Röthlisberger, M. *Claude Lorrain: the Paintings* (2 vols.), New Haven (1961, reprinted 1979).

Cleve Joos van c1490–1540/1

Originally from Cleves, the Flemish painter Joos van Cleve trained at Antwerp. His earliest works were in the style of late-15th-century painters such as Gerard David (c1460–1523). The ambitious *Death of the Virgin* (1515; Wallraf-Richartz-Museum, Cologne) shows an unexpected mastery of interior space. He may have traveled in Italy; his later works were infused with a soft Italianate chiaroscuro technique grafted on to the traditional Flemish format. An example is his *Virgin and Child* (c1520–30; Fitzwilliam Museum, Cambridge). Later in his career he became a successful court portraitist, since he avoided any penetrating analysis of character and achieved an immaculate smooth finish of skin and costume textures, as in the *Portrait of Henry VIII* (c1536; Hampton Court Palace, London).

Clodion 1738–1814

Born at Nancy, Claude Michel, known as Clodion, was the tenth child of Thomas Michel who was First Sculptor to the King of Prussia. On his mother's side Clodion was related to the Adam family of sculptors. Such connections were quite common among French master-craftsmen, with whom sculptors were numbered. In 1781 he married the daughter of the sculptor Augustin Pajou.

Clodion and three of his brothers came to Paris in 1755 and worked under their uncle, Lambert-Sigisbert Adam, moving on his death in 1759 to the studio of Jean-Baptiste Pigalle. Almost immediately, however, Clodion won the Academy Prize. Following the usual custom, he then left for a period of State-financed study at Rome, where he remained from 1762 to 1771. After 1767 he worked there privately for Catherine II of Russia who was a Francophile and an international patron of the arts.

By the time of his return to Paris he was producing many small-scale works, inspired by the more irreverent subjects of antique sculpture. He quickly established a workshop, assisted by his brother and a few craftsmen, in the Place Louis XV (now the Place de la Concorde). They created a succession of statuettes, groups, reliefs, and vases depicting nymphs, fauns, satyrs, and bacchantes in playful and bucolic settings. These were gay, charming figurines, delicately modeled, and evocative of childhood or rejuvenation.

The majority were executed in the supremely pliable medium of terracotta, the potential of which had been revealed by Robert Le Lorrain (1666–1743), and later extolled by the collector, Lalive de Jully. Clodion was the first sculptor to concentrate on terracotta; by doing so he freed himself from the lengthy struggles inevitably connected with work on and payment for large-scale monuments. Nevertheless he did receive some official commissions, and the most obvious proof of his abilities as a sculptor in marble on a large scale is his *Montesquieu* (final version 1783; Institut, Paris) commissioned by the Crown.

He was elected to the Académie Royale in 1773; but he failed to submit the statutory reception piece and was hence never a full Academician, though he became an Associate in 1793. So popular was his style that after 1783 he could afford not to exhibit at the Salon (where there was pressure to submit less frivolous pieces), and

Chuck Close: Alex; color woodcut on paper; 71×58cm (28×23in); 1991. Hirshhorn Museum and Sculpture Gardens, Washington, D.C.

none of his more brilliant terracotta groups was shown there.

Clodion's output before the Revolution was vast, and works were often duplicated in porcelain and bronze for incorporation into objects like candelabra and clocks. But since much is undated, it is often difficult to distinguish his own work from that of his many assistants.

During the Revolution, he retreated to Nancy. Afterwards he staged a Parisian comeback with his austere, sensational work for the Salon of 1800, *Déluge* (since destroyed) which was in tune with contemporary heroic preoccupations. He was subsequently given work on Napoleonic monuments, such as the Colonne Vendôme (or Column of the Grande Armée, Place Vendôme, Paris) of 1806–10, the Arc de Triomphe (1806), and the Carrousel monument.

Close Chuck 1940–

The American Photo-Realist painter Chuck Close was born in Monroe, Washington. After showing artistic promise as a child, he attended the University of Washington at Seattle (B.A., 1962), Yale University (M.F.A., 1964), and the Akademie der Bildenden Künste in Vienna (1964–5), where he studied on a Fulbright scholarship. As an art student, Close emulated the Abstract Expressionist style of contemporary artists such as Willem de Kooning.

By the late 1960s Close abandoned abstraction, turning instead toward meticulously realistic paintings based on photographs. He would impose a grid onto a photograph and then transfer a proportionate grid to a large canvas, a process that allowed him to make an exact replica. Close first experimented with photographs of female nudes, which he reproduced in

color. Wanting more restraints, he restricted his palette to black and white and limited his subject matter to close-up portraits from the neck up. The resulting works achieved a level of detail comparable to photographs, and he became identified as a Photo-Realist painter.

In the 1970s and '80s Close continued to create enormous portraits based on photographs, although he eventually expanded his palette to include color—for a time using only cyan, magenta, and yellow, the colors used in mechanical reproduction. He also introduced new techniques to fill in his grid such as Pointillism and fingerprints, which, while abstract when viewed up close, still combined into a figurative image from a distance. These monumental works were often self-portraits, portraits of family, and portraits of friends. Given their scale, these works show the tiniest details of a sitter's face, often highlighting imperfections; for all their closeness, however, the sitters are generally characterized by an enigmatic, detached quality.

In 1988 a spinal blood clot left Close a quadriplegic. Through therapy he gained some use of his arm and learned to paint again by using a brush taped to a hand splint. In his works since his illness, Close has continued to create figurative portraits and to use the grid as the underlying basis of his work. However, given his limited mobility, the component units of the grid have become tiny abstract paintings full of colorful, gestural brushstrokes; the resulting portraits create a powerful tension between realism and pure abstraction. Close, who is also a prolific printmaker, has been honored with several major exhibitions, including a 1998 retrospective at the Museum of Modern Art in New York.

Clouet family 16th century

The father and son Jean and François Clouet were French painters. Jean (1485/90–1541), possibly born in the Netherlands, is named in the accounts of Francis I for 1516. His first known residence was at Tours, and his wife was French.

After 1525 he moved to Paris and probably died there. All the surviving paintings that can be associated with his name are portraits. Only about eight of them have serious claims to authenticity. They are characterized by strong, luminous areas of smoothly applied color, restrained in chromatic range, yet sharpened by a vivid

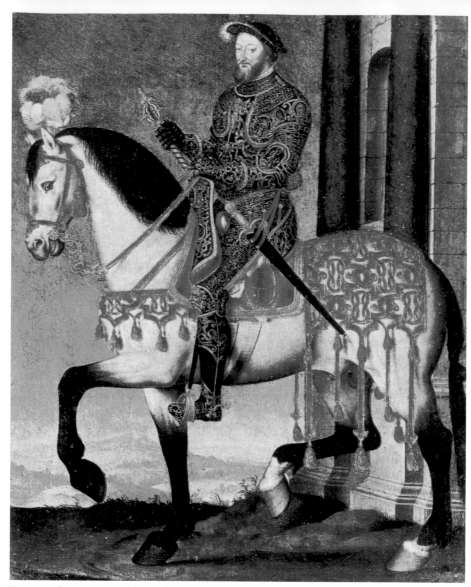

François Clouet: Portrait of Francis I of France; gouache on vellum mounted on wood; 27×22cm (11×9in); c1540. Louvre, Paris

sense of detail. All are small, and they include *A Man with a Book* (Royal Art Collection, Windsor) and *Guillaume Budé* (Metropolitan Museum, New York). He has generally been credited with the famous state portrait of Francis I (c1520; Louvre, Paris).

Clouet was almost certainly the author of portrait miniatures that anticipate the work of Hans Holbein the Younger and Nicholas Hilliard; he also anticipates Holbein as a portrait draftsman. About 120 drawings of the heads of royal and courtly persons, mostly done in black and red chalks, can be attributed to him (most are in the Musée Condé, Chantilly). Remarkable alike for their draftsmanship and their psychological acumen, they brought an essentially Florentine, even Leonardesque technical authority to the earlier forms of French portrait drawing.

François (c1510–72), the son of Jean Clouet, was perhaps born at Tours; he died in Paris. He succeeded his father as painter to the King, and was then de-

Jean Clouet: portrait of Antoine de la Barre, Archbishop of Tours; black and red chalk drawing; 28×20cm (11×8in); c1520-5. Musée Condé, Chantilly

scribed as having "already imitated him very well". This, and the fact that both painters were nicknamed Janet, has led to confusion.

François continued to make portrait drawings in the manner of his father (major collection in the Musée Condé, Chantilly, and Bibliothèque Nationale, Paris), although they sacrifice incisiveness to charm. He also painted portraits, for example *Pierre Quthe* (1562; Louvre, Paris), *A Lady in her Bath* (c1570; National Gallery of Art, Washington, D.C.); mythology (*Diana Bathing*, 1550s; Musée des Beaux-Arts et de la Ceramique, Rouen); and genre works. These make clear his knowledge of the school of Fontainebleau, and of painting at Antwerp. In all his works there are strong naturalistic tendencies.

Clovio Giulio 1498–1578

The miniature painter Giulio Clovio was of Croatian origin, but worked mainly in Rome. According to tradition, he learned his art from the Veronese Girolamo dai Libri (1474–1555) in the late 1520s, and his subsequent production in Rome included not only illuminated manuscripts, but also pictures on a minute scale. His most famous work is the Book of Hours decorated for Cardinal Alessandro Farnese (Pierpont Morgan Library, New York). This shows the overwhelming influence of Michelangelo in its figure types. However, in keeping with a typically Mannerist eclecticism, it draws freely on a wide range of sources that also includes Raphael, Dürer, and the 15th-century Netherlandish Grimani Breviary (Biblioteca Marciana, Venice).

Cochin family 18th century

The Cochins were Parisian engravers from an old family of printmakers originally based in Troyes. Charles Nicolas Cochin the Elder (1688–1754) produced engravings after Watteau, François Lemoyne, and other contemporary French painters.

Instead of painstakingly reproducing the work of other artists, Charles Nicolas Cochin the Younger (1715–90) executed freer compositions from his own drawings. His brilliant career was crowned by his appointment as keeper of the Cabinet du Roi. Even in his own day it was observed that Cochin's work was pretty and elegant rather than monumental. He was a master of the vignette, whose style was ideally suited to the fanciful taste of the court of Louis XV.

Coldstream Sir William 1908–87

Sir William Coldstream was one of the most distinguished of post-1945 British portrait-painters. Born in Northumberland and trained at the Slade School of Fine Art in London, he exhibited with the New English Art Club and the London Group. In 1934 he turned his attention to the cinema, taking a post with the film unit of the General Post Office. Coldstream started painting again in 1936 and in 1938 founded the Euston Road School with Claude Rogers and Victor Pasmore. In 1943 he was made an Official War Artist, and posted to Cairo; in 1949 he was appointed Slade Professor at University College, London. Coldstream's style is representational and subdued in mood. The earlier landscapes and portraits are often suffused with atmosphere. His later work is more cerebral and suggests the underlying influence of Cézanne.

Cole Thomas 1801–48

The American landscape painter Thomas Cole was the founder of the Hudson River School and an early member of the National Academy. Born in Lancashire, England, he was brought to America in 1820, where he worked as an apprentice engraver in Ohio. Cole was deeply influenced by the mezzotints of the English painter John Martin and traveled a good deal in Europe and England, but his major works are distinctly American in outlook. The best of them are grouped in series, such as *The Voyage of Life* (1894; Munson-Williams-Proctor Institute, Utica, N.Y.). These huge landscapes are approached in a poetical and philosophical spirit; in them Cole shows an appreciation of man's responsibilities in the face of the potential wealth and strength of the New World.

Colombe Jean 1430/5–1529

Jean Colombe was a French illuminator, the brother of the sculptor, Michel Colombe. His property transactions in Bourges are recorded in the 1460s. Jean's atelier became one of the most productive in the second half of the 15th century.

Probably during the 1470s he illuminated a massive Book of Hours for Louis Laval (Bibliothèque Nationale, Paris; MS. Lat. 920). Through the patronage of Charlotte of Savoy in the 1480s he received important commissions, including one for illustrations in the *Livre des Douze Périls d'Enfer* (Bibliothèque nationale, Paris; MS. Fr. 449) and the *Romuléon* (Bibliothèque Nationale, Paris; MS. Fr. 364), a book which contains the artist's anagram "Molbeco".

Colombe completed works that had been left unfinished earlier in the 15th century, including an Apocalypse now in the Escorial near Madrid, begun by Jean Bapteur and Perronet Lamy. He also finished parts of the *Très Riches Heures* (Musée Condé, Chantilly; MS. 65), begun by the Limburg brothers, for the Duke of Berry. He added ornate gilt framework and some rather powerful and diverse figures, and he preferred tricky perspective views to the delicate atmospheric rendering of his predecessors.

Colombe Michel 1430/5–1512

The French sculptor Michel Colombe was the brother of the miniaturist Jean Colombe. Not much is known of Michel's work before 1500 when he was almost 70 years old and working in Tours. There he is known to have designed works, including a medal in 1500, for the triumphal entry of Louis XI into Tours upon his return from Italy. Under the patronage of Anne of Brittany, Colombe's major work was a tomb for her parents, François II, Duke of Brittany, and his Duchess, Marguerite de Foix. Designed by Jean Perréal, the sarcophagus was executed by Michel with several Italian assistants, and was installed in 1507 in the Carmelite church in Nantes (now in Nantes Cathedral).

Colombe was one of the first 15th-century French sculptors to adopt Italianate ornament. He incorporated into the sarcophagus a round arcade with grotesques and pilasters in the antique manner; but his large corner-figures of the Virtues retained a Burgundian richness of material and naturalism of facial expression. About 1508–9, Colombe sculpted an altarpiece for the castle chapel at Gaillon; his relief of *St George and the Dragon*, now in the Louvre, Paris, shows evidence of Italian collaboration in its framework. The relief itself is the least Italianate of his works. A valiant St George pinions a giant scaly dragon. The diminutive princess is over-

whelmed by a mountainous space that shows none of the experimental features to be found in the works of Donatello or Uccello. The designer, Perréal, wanted Colombe to collaborate with him again on a ducal tomb in Brou, but that project was not realized.

Colonia Juan de c1415–81

The mason Juan de Colonia probably came from Cologne. Invited to Spain by the Bishop of Cartagena, he was one of several Northern architects to go there in the 15th century. From c1442–c58 he worked on Burgos Cathedral (begun c1220), particularly on the octagonal west spires which have openwork tracery in the German late Gothic manner. His magnificent *Cimborio* unfortunately collapsed, to be replaced by an equally elaborate 16th-century example designed by his grandson Francisco. Juan's other great work, begun in 1461, is the Miraflores Charterhouse Chapel near Burgos, which houses the monuments of King Juan II and Queen Isabella. A large church without aisles, it was completed by his son Simon.

Colvin Marta 1917–1995

The Chilean-born sculptor Marta Colvin studied sculpture under Julio Antonio Vasquez at the Santiago Academy. She visited Europe in 1948, working in wood and metal in the international sculptural idiom of the 1950s. In Paris she studied sculpture under Ossip Zadkine (1890–1967); her organic curvilinear sculpture—part abstract, part figurative—reflected an interest in the work of Laurens and Brancusi, whom she met. In the 1950s she lived in Paris and London and became acquainted with Henry Moore. Later she taught sculpture at the Santiago Academy, and in her carving was influenced by Pre-Columbian and primitive American sculpture.

Conrad von Einbeck fl. 1383–1416

Conrad von Einbeck was a German architect and sculptor. In 1383 he began the choir of St Moritz at Halle an der Saale, a design that shows the influence of the Parler workshops in Prague, particularly in its window tracery. Inside are several stone sculptures signed by Conrad, all of which combine emotional intensity with careful naturalism. The *Mourning Virgin*, for instance, expresses grief both in her face and

through her gestures; but, as though for additional emphasis, her eyes are shown rimmed with meticulously carved tears. The style is basically the so-called "Soft style" of the contemporary "Beautiful Madonnas", but without their courtliness. The bracket carved as a bust in the north aisle was inspired by the portrait busts in Prague Cathedral. Usually regarded as Conrad's self-portrait, it shows a youngish man with heavy features, deep-set eyes, and a brooding expression.

Conrad von Scheyern
early 13th century

Conrad von Scheyern was a German illuminator. Five manuscripts from Scheyern Abbey in Bavaria contain references to a man, "Cuonradus", who has often been regarded as their scribe and illuminator; in fact the works vary too much in script and decoration to be the work of one hand. A *Glossarium Salomonis* (Staatsbibliothek, Munich; Clm. 17403) dated 1241 is copied from a manuscript of 1158–65 from Prüfening near Regensburg; but the hard lines of the original are replaced by a gentler, rounded style with only a hint of the current "Jagged style" (*Zackenstil*) in the draperies. The splendid full-page illustrations to the *Liber Matutinalis* (Staatsbibliothek, Munich; Clm. 17401) made between 1206 and 1225 are nearer the Byzantine style of the late-12th-century *Hortus Deliciarum* which was formerly at Strasbourg.

Conrad von Soest fl. c1390–c1425

Conrad von Soest was an important German painter, working in Westphalia

during the first quarter of the 15th century. His artistic personality can be surmised from the magnificent high altar of the church of St Nicholas at Bad Wildungen which is signed and dated 1404. It is painted in the so-called "Soft style", closely related to the International Gothic, and indebted to Franco-Burgundian painting. The lyrical elegance of many of the figures is contrasted with an everyday realism in the details. Subsequently he painted the high altar of the church of the Virgin at Dortmund (c1420) of which substantial fragments survive.

Constable John 1776–1837

Constable is considered one of the two greatest masters of landscape painting in Britain, the other being J.M.W. Turner (1775–1851). Born on 11 June 1776 at East Bergholt, Suffolk, the son of a prosperous mill-owner, Constable was from an early age responsive to the natural beauties of his birthplace. "I associate my 'careless boyhood'", he wrote later, "with all that lies on the banks of the Stour. Those scenes made me a painter, and I am grateful."

He showed an early interest in painting and drawing, and was encouraged by John Dunthorne, a local plumber and glazier and amateur artist. He was also introduced to the famous patron and amateur painter Sir George Beaumont, and to the professional engraver J.T. Smith. After working for a time in his father's mill, he went to London and in 1799, with the encour-

John Constable: The Valley of the Stour; oil on paper laid on canvas; 50×60cm (20×24in); c1805. Victoria and Albert Museum, London

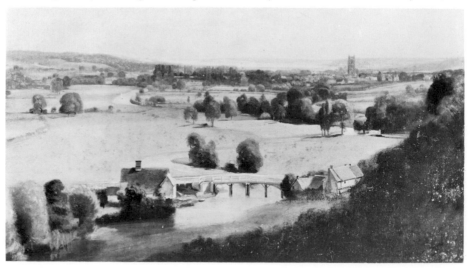

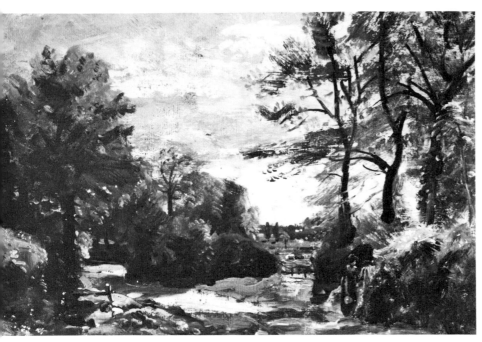

John Constable: A Country Lane; oil on paper; 20×30cm (8×12in); c1810. Tate Gallery, London

agement of the landscape painter Joseph Farington, he began training at the Royal Academy Schools. Through Beaumont, Smith, and Farington, he became familiar with the European landscape tradition, particularly the works of Claude Lorrain (1600–82) and the Dutch painters of the 17th century. But Constable was already dedicated to depicting the countryside around his native Stour Valley in his own more direct and informal way. As early as 1802, the year he exhibited his first landscape at the Academy exhibition, he wrote to Dunthorne: "For these past two years I have been running after pictures and seeking the truth at second hand … I shall make some laborious studies from nature … There is room enough for a natural painter." Although he was to paint several portraits—sometimes with success when he was intimately concerned with the sitter, as is shown by the portrait of his fiancée Maria Bicknell (1816; Tate Gallery, London)—his main concern for the whole of his career was with the painting of the English landscape.

Constable's early development as an artist was slow; drawings made during sketching tours of the Peak District in 1801 and of the Lake District in 1806 show the diverse influences of Beaumont, Gainsborough, the Cozens, and Girtin. But he found that picturesque sights and mountain scenery did not greatly appeal to him, and he did not undertake such tours again. He wanted to depict nature directly and accurately, as is shown by the notes he made on drawings recording the time of day, the climatic conditions, and so on; but some of his paintings, such as Dedham

Vale (1802; Victoria and Albert Museum, London), are composed in the formal manner of Claude, an artist Constable always admired.

From about this time he began to explore more intensely the pictorial possibilities of the countryside around his Suffolk home, making small oil sketches in the open air and experimenting with brighter, more varied colors to convey the effects of light and atmosphere. He also made small pencil studies, notably those in the sketchbooks of 1813 and 1814 (Victoria and Albert Museum, London). With immediacy and brilliance, he recorded his observations, not only of details of foliage, of agricultural equipment, of men at work and at rest, but also of any scene that might be used later as the basis for a composition. These outdoor sketches in oil and pencil were intended as preparatory work for the highly finished oils he painted in his studio and exhibited annually at the Royal Academy. On one apparently unique occasion, however, when he was working on Boatbuilding near Flatford Mill (1815; Victoria and Albert Museum, London), Constable painted wholly in the open air.

In 1816, after a long and difficult courtship, Constable married Maria Bicknell, and by 1820 had settled in Hampstead, London. It was in 1819, the year he was elected an Associate of the Royal Academy, that he revealed the full results of his studies and the extent of his talent in his painting of The White Horse (Frick Collection, New York). This was the first in a series of six large canvases (approximately 4 by 6 ft, 1.3 by 2 m) depicting everyday

life and work on the River Stour. Like his earlier painting Flatford Mill on the Stour (1817; Tate Gallery, London) these works were intended to raise the status of his landscape painting at the Academy. The most famous of the series is The Hay Wain (1821; National Gallery, London) which was exhibited at the Royal Academy as simply Landscape: Noon. This picture not only exemplifies the verdant, sunny qualities of the English countryside in summer, but also creates a quiet mood of utter contentment. Man is seen here as completely at one with his environment: an image that perfectly illustrates one aspect of the Romantic attitude towards the relationship between man and nature.

For The Hay Wain, and for some other larger works, Constable made a full-size preliminary sketch in oils. This practice doubtless inspired the greater freedom of handling evident in his exhibited works of the 1820s, for example his use of the palette knife as well as the brush to apply paint, and his extensive use of touches of white to give a glittering surface texture. By 1825, when he painted the last in the great series, The Leaping Horse (Royal Academy of Arts, London), he was undecided whether to send the finished oil to the Academy exhibition, or the preparatory sketch (1825; Victoria and Albert Museum, London). The two works were almost identical in their degree of finish and their loose, rapid brush strokes.

There is always evident in Constable's mature works an impressive confidence in the beauties of nature itself; he once claimed that his "limited and abstract art is to be found under every hedge and in every lane." He wrote to his friend John Fisher in 1821: "old rotten planks, slimy posts, and brickwork, I love such things … as long as I do paint, I shall never cease to paint such places." It is one indication of his originality that he expressed this view when the formality of the classical and picturesque styles of landscape painting was still universally expected and admired.

Although Constable traveled very little in England, places outside Suffolk became familiar and important to him as subjects for painting during these years. There was Salisbury, which he first visited in 1811. There he met John Fisher who was to be a life-long friend and whose uncle, the Bishop of Salisbury, commissioned the famous view of the Cathedral (1823; Victoria and Albert Museum, London). There was Brighton, where he first took his

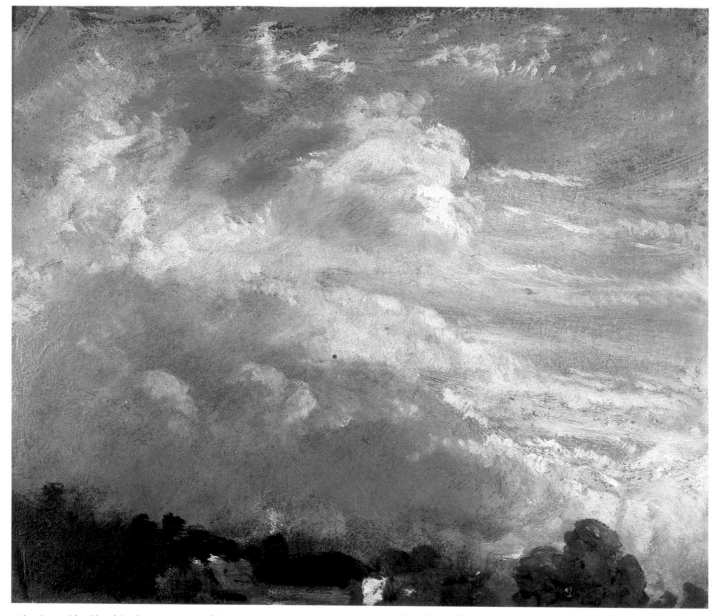

John Constable: Cloud Study—Horizon and Trees; 25×29cm (10×11in); 1821. Royal Academy of Arts, London

family in 1824 because of his wife's poor health, and where he painted some remarkably fresh and vivid beach scenes. The periods he spent at his home in Hampstead encouraged his interests in climatic change, particularly in the formation of clouds.

Despite his belated election to full membership of the Royal Academy in 1829, his later years were unhappy. In 1828 Maria died, leaving him with seven children, and his friend Fisher died four years later. Constable never fully recovered from these bereavements. His sporadic black moods seem to be expressed in the stormy atmosphere and restless brushwork of his paintings during these years, for example *Hadleigh Castle* (1829; Paul Mellon Center for British Art, New Haven) and the dramatic preparatory oil sketch for that picture (c1829; The Tate Gallery, London). Also c1829 Constable began work on designs to

be engraved in mezzotint by David Lucas and published as a series entitled *English Landscape Scenery*, a project presumably undertaken in emulation of Claude and Turner, and intended as a summary of the artist's ideas and achievements. Some of Constable's opinions on landscape were expressed in the accompanying text, and were expanded and extended in lectures he gave in Hampstead in 1833 and 1835. He died on 30 March 1837.

In the 1830s Constable achieved more expressiveness in his work; he aimed less at the careful naturalistic depiction of a scene and more at an immediate record of the light and atmosphere of the moment and their fleeting effect on the sky, foliage, and water. This expressiveness is seen at its most intense in the later outdoor sketches in watercolors, a medium he used more frequently in these years, and in the elaborate finished oils such as *The Valley Farm*

(1835; Tate Gallery, London), the last great Suffolk picture. The most turbulently Romantic of all the later works is perhaps the remarkable watercolor *Stonehenge* (1835; Victoria and Albert Museum, London), in which the mystery of the subject is enhanced by the disturbing presence of the double rainbow and the dramatically ominous sky.

The naturalism of Constable's work was recognized in his own day; Henry Fuseli remarked to Callcott in 1823 that Constable "makes me call for my greatcoat and umbrella". He achieved this naturalism largely by close observation, at times of a scientific intensity. He not only consulted scientific treatises, concerning meteorology for example, but also believed, as he stated in a lecture given in 1836, that his profession was "*scientific* as well as *poetic*". He was particularly interested in the effects of light and shadow, with which he attemp-

ted to suggest the transient qualities of the scene before him, to depict what he called the "chiaroscuro of nature". The advice he received from the President of the Royal Academy, Benjamin West, in 1802, that "light and shadow never stand still" was described by Constable as the best lecture on chiaroscuro he had ever heard.

Constable's place in early-19th-century Romantic art is assured partly by this interest in the transience of nature, but mainly by his belief that "painting is with me but another word for feeling". For Constable, a landscape could express a poetic mood, as in *The Cornfield* (1826; National Gallery, London), which gives a visual interpretation of the lines from James Thomson's poem *Summer* which accompanied the picture when it was exhibited at the British Institution in 1827:

> ... A fresher gale
> Begins to wave the woods and stir the
> streams
> Sweeping with shadowy gusts the fields of
> corn.

The boy drinking from the stream in the foreground of the picture also calls to mind certain passages from Wordsworth's *The Prelude*. Constable also possessed a grand, cosmic vision, different from that of Turner but no less intense. Both artists were able to convey their own feelings for the basic forces of nature, for the powerful vibrancy of the living landscape.

Constable's achievement, like Turner's, was so original and individual that he had few followers among English artists; his closest imitator was Frederick William Watts (1800–62). However, his paintings were much copied and forged. Although he never traveled abroad, his work was known in France; several works were exhibited and sold in Paris, notably *The Hay Wain* which won a Gold Medal at the 1824 Salon. Delacroix, among others, especially admired Constable's work, calling him "one of the glories of England" and adopting to some extent his loose, broken handling of paint. Constable's principal influence in France was more far-reaching; his work was admired by the Barbizon group of landscape painters, whose consequent interest in naturalism and outdoor painting was to provide a suitable background for the Impressionists later in the century.

There are works by Constable in London at the National and Tate Galleries, and at the Royal Academy of Arts; he is also represented in galleries elsewhere in Britain and abroad. The main collection of sketches in oils, watercolors, and pencil is at the Victoria and Albert Museum, London, mainly because of the bequest in 1888 by the artist's daughter Isabel.

Further reading. Beckett, R. B. (ed.) *John Constable's Correspondence*, vol. 1, Woodbridge (1976); vols. 2–6, Ipswich (1962–9). Leslie, C.R. (ed.) *Memoirs of the Life of John Constable*, Oxford (1951). Reynolds, G. *Catalogue of the Constable Collection in the Victoria and Albert Museum*, London (1973). Reynolds, G. *Constable, the Natural Painter*, London (1965).

Cooper Samuel 1609–72

The work of the English miniaturist Samuel Cooper marked a break with the tradition of Nicholas Hilliard and Isaac Oliver, and introduced the Baroque into English miniature painting. Cooper was first apprenticed to his uncle John Hoskins, but was working on his own by 1642. He soon learned to absorb the influence of van Dyck, and echoes of Lely's compositions are also discernible in his work. His most characteristic effect is a soft pearly-grayish tone. Cooper's work was highly prized during his lifetime, and his services were much in demand both by Cromwell and by Charles II after the Restoration.

Samuel Cooper: Portrait of an Unknown Man; watercolor on vellum; 7.3 × 5.7cm ($2\frac{7}{8}$ × $2\frac{1}{4}$in); 1645. Collection of H.M. Queen Elizabeth II

Copley John 1738–1815

The American painter John Singleton Copley had two separate careers: one as America's first great portrait-painter and one, from 1774, as a history painter and precursor of Romantic painting in London.

Copley was born in Boston. Although he was the stepson of Peter Pelham, a London-trained engraver of mezzotints, he was largely self-taught; yet he produced a personal portrait style far superior to any he had ever seen. In *Henry Pelham (Boy with a Squirrel)* of 1765 (Boston Museum of Fine Arts) Copley painted with an objective clarity, acuteness of characterization, and sheer professionalism unknown previously in the American colonies. From the 1760s he produced a magnificent record of his native New England clientele such as *Mrs John Winthrop* (1773; Metropolitan Museum, New York) and of heroes of the revolutionary period such as *Paul Revere* (1765–70; Boston Museum of Fine Arts).

However, Copley felt cut off from artistic developments in Europe; the political situation made his economic survival as a portraitist in America doubtful, and as the son-in-law of a prominent tea-merchant his family position was precarious. All these factors conspired to make him leave permanently for England in 1774. In London the influence of Sir Joshua Reynolds and Benjamin West made Copley's portrait style lose its vivacity and his interest changed to large-scale history paintings. His best historical works were of modern subjects, and, like those of West, in contemporary dress.

In *Brook Watson and the Shark* (1778; Boston Museum of Fine Arts) Copley's interest was in man's exposure to natural hazard rather than in historical significance; his success was greater here with an essentially Romantic theme than in set pieces such as *The Collapse of the Earl of Chatham in the House of Lords* (1779–80; Tate Gallery, London). Despite outstanding success with the latter and with *The Death of Major Pierson* (1783; Tate Gallery, London) Copley's later life was darkened by an ever-growing melancholy, exacerbated by his permanent exile.

Coppo di Marcovaldo c1225–74

Coppo di Marcovaldo was a Florentine painter who worked between 1250 and 1270. In 1261 he signed the *Madonna del*

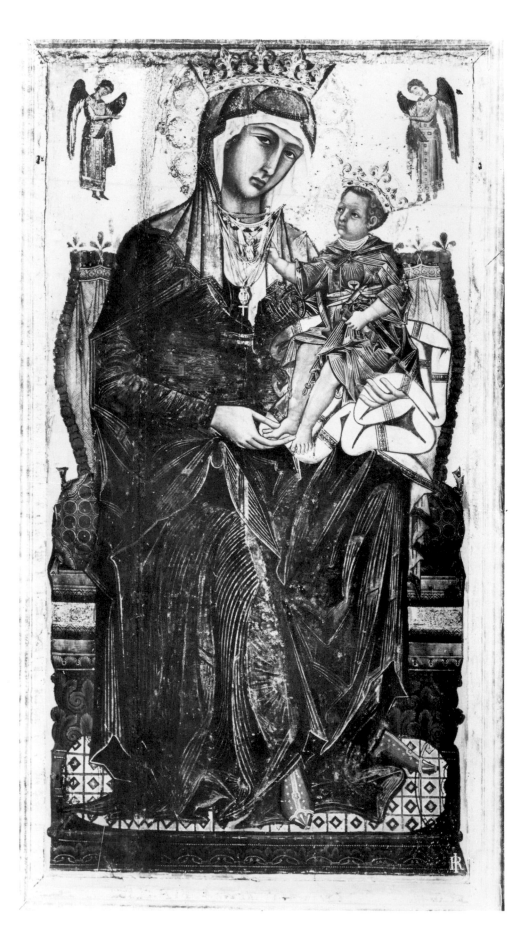

Bordone (S. Maria dei Servi, Siena), a work monumental both in design and size (7 ft 3 in by 4 ft; 2.2 by 1.3 m). A similar work, in the same rich yet somber coloring, is the *Madonna and Child* in Orvieto (S. Maria dei Servi). Within a framework of Byzantine style, Coppo's work displays a new sense of physical and moral weight. He tries, both by means of the still linear "creases" which serve for folds of drapery, and by setting the body and legs of the Virgin at an angle to the picture-plane, to indicate that they occupy a position in space. Other works attributed to him are disputed; his known work in fresco— Pistoia Cathedral, *c*1265—is now lost.

Cornelius Peter 1783–1867

Peter Cornelius was a German draftsman and painter. Despite a thoroughly classical training (Düsseldorf Academy, 1795–1800), Cornelius shared his generation's enthusiasm for the Middle Ages. His illustrations to Goethe's *Faust* (1808–16) and to the *Niebelungenlied* (1812–17) show the influence of Dürer's line drawings and a search for specifically German subject matter.

In 1811 he went to Rome to study early Italian painting and became a member of the group of artists known as the Nazarenes. Cornelius' contribution to the frescoes they painted in a room of the house of the Prussian Consul in Rome (the *Story of Joseph* in the Casa Bartholdi, now in the Nationalgalerie, East Berlin; 1815–16) bears the fruit of these studies; the human warmth they express shows the influence of Johann Friedrich Overbeck (1789–1869). The designs Cornelius painted for the ceiling of the Dante room in the Casino Massimo, Rome, show his ability to summarize symbolically a subject's spiritual content. His stay in Rome and his work on the frescoes helped to revive German art and in 1819 he eagerly accepted the offer to decorate the Glyptothek in Munich.

In keeping with his Nazarene principles, he treated the Classical myths required by the commission as symbolically foreshadowing Christian ideas. The result was intellectual and cold. The frescoes are more mannerist than his Roman works,

Coppo di Marcovaldo: Madonna del Bordone; panel; 220×130cm (87×52in); 1261. S. Maria dei Servi, Siena

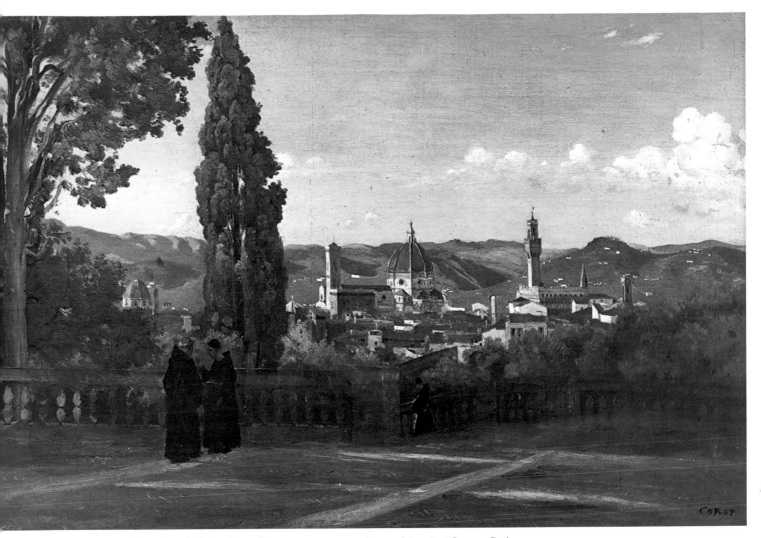

Corot: View of Florence from the Boboli Gardens; oil on canvas; 51×74cm (20×29in); c1836. Louvre, Paris

color is neglected for the sake of line, and there is frequent overcrowding; but Cornelius has successfully integrated his pictures into their architectural setting.

The driving force behind Cornelius' subsequent work was the belief that underlying Christianity there were basic truths all sects should embrace. Unfortunately his intellectual treatment of Christian iconography and his lack of sensuous appeal (for example, his frescoes in the Ludwigskirche, Munich; 1830–40) prevented him from making the spiritual impact he sought.

Cornell Joseph 1903–72

Joseph Cornell was an untaught, highly original American artist. His works consist of collections of objects and fragments in small-scale box-like constructions such as *Box with a Perched Bird* (1945), *Dovecote* (c1950), both at Xavier Fourcade Inc., New York. His juxtaposition of unlikely objects in poetic disarray owes much to Dada, and especially to Kurt Schwitters. But whereas Schwitters constructed out of *Merz* (his coinage for rubbish or garbage),

Cornell builds up a gem-like quality. A man of great breadth of knowledge, he learned about Surrealism—particularly the work of Max Ernst—from the Julian Levy Gallery in the 1930s. During the 1940s he was close to the European Surrealists in exile in New York. He wrote several books and also made films.

Corot 1796–1875

The French landscape and figure-painter Jean-Baptiste-Camille Corot played an important part in the development of plein-air painting. He began working within the framework of the classical French Italianate landscape tradition as seen in the work of Claude (1600–82) and Poussin (1615–75), but revitalized the style by the freshness of his observation. Though he was never to forsake his classical principles completely, he made important technical advances. He particularly emphasized the quality of the sketch as an artistic production equal to, or even greater in value than the finished studio composition.

Born in Paris in 1796 into a prosperous commercial family, he was educated at

Rouen and then worked as an assistant in a draper's shop. Only in 1822, at the age of 26, was he able to persuade his parents to let him turn to painting full time. He studied with the painters Achille Michallon (1796–1822) and Jean-Victor Bertin (1775–1842), and at the Académie Suisse, and made the first of three trips to Italy in 1825. His first Salon painting was shown in 1827, and though he was only slowly accepted as a talented artist, his work was never as controversial as that of Rousseau. He visited England and Holland, and spent an itinerant life painting in many parts of the French provinces.

Corot began painting out of doors in 1822 on the advice of his first teacher, Michallon. His trip to Italy from 1825 to 1828 confirmed his dedication to the classical principles of landscape, which he was to adapt but never forsake. Here, through painting on the site, he developed his technique of treating distance in terms of tonal values rather than drawing. As he was working primarily on plein-air studies during his first Italian trip, there are many sketches but few finished works from this period. One of the most famous studio

compositions is *Le Pont de Narni* (National Gallery of Canada, Ottawa), which he sent to the Salon of 1827. When this is compared with sketches of the same site, it becomes clear that he made several alterations to the landscape in the studio painting, changing the disposition of the ground and trees for compositional reasons. This classical practice became less and less frequent in Corot's landscape work over the years.

The artist made two trips to Italy in 1834 and 1843. The intense sunlight, which tended to bleach color, led him to develop his characteristic technique of mixing white with all his colors: this gives an effect of opacity, and unites the painting through chromatic harmony. In 1834 he painted a view of Volterra (Louvre, Paris) which he sent to the Salon of that year: this was the first Salon entry he had painted in front of the motif.

In France, Corot painted on numerous sites, one of his favorite subjects being views of his parents' home at Ville d'Avray, near Paris. He preferred to paint calm rather than turbulent scenes, and rarely depicted violent effects of weather, or objects in motion. In the late 1840s he developed a more misty style, with feathery treatment of trees; this is characteristic of his later landscapes, such as *The Church of Marissel, near Beauvais* (1866; Louvre, Paris). He also painted several "topographical" landscapes, which give clear records of the views depicted, for example *The Cathedral of Chartres* (c1830; Louvre, Paris).

Corot's historical landscapes, which place figures of religious or Classical history in backgrounds of scenery, were painted for exhibition at the Salons. They were assembled from various sketches done in the open air, and are now perhaps the least admired of his works, as their distance from original inspiration results in a lack of spontaneity. One of his best paintings of this type is *Homer among the Shepherds* (1845; Musée de St-Lô).

The lyrical or fantastic landscapes Corot painted later in his career (c1850 onwards) use an atmospheric, Claudesque style, and show the influence of the Rococo and the French 18th century. The forms are softened and the colors reduced to a very narrow range, carefully graded and silvery in hue. Peopled with nymphs and bathers, set at dawn or dusk in a misty atmosphere, these charming works were much admired by Corot's contemporaries (for example,

Souvenir de Mortefontaine, 1864; Louvre, Paris).

From the start of his career Corot painted portraits of his family and close friends. They depict the prosperous commercial bourgeoisie from which he sprang (for example, *Portrait of Claire Sennegon*, 1837; Louvre, Paris). He occasionally included a figure-subject in his Salon entries, for example in 1859 in *La Toilette* (private collection). Most of his figure-subjects are late works, however. Mainly pictures of women, either against neutral backgrounds or in Corot's studio, they are posed and motionless, silent and melancholy (for example, *Woman with a Pearl*, 1869; Louvre, Paris; *Lady in Blue*, 1874; Louvre, Paris).

Corot was in touch with the artists of the Barbizon School, and was particularly close to Daubigny; they often painted together in the Forest of Fontainebleau and elsewhere. Open-hearted in character, he showed great generosity to his friends, notably to Daumier, and to Millet's widow. He had great personal prestige among younger artists, and by 1850 had a number of disciples, including Antoine Chintreuil and François-Louis Français. During the mid 1860s he was in occasional contact with the young Impressionists.

Though admired by many critics, and named by Baudelaire in 1845 as the head of the modern French landscape school, he never enjoyed official patronage to any great extent and was forced to rely on the considerable enthusiasm of private collectors. By the 1860s they were collecting his sketches as well as finished works.

A single-minded artist with few interests outside his work, Corot was a "pure" painter and had little concern with depicting his own period. While his subject matter remained very conventional—particularly in his liking for the Italian scenes renounced by many avant-garde artists—he made innovations in plein-air painting and in techniques, which prepared the way for the Impressionists.

Further reading. Arts Council *Corot*, London (1965). Herbert, R. *Barbizon Revisited*, Boston (1962). Roberts, K. *Corot*, London (1965).

Correggio c1490–1534

Correggio, whose real name was Antonio Allegri, was a north Italian painter, and a master of illusion and sentiment, whose

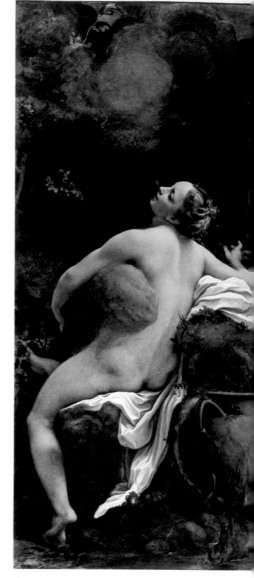

Correggio: Jupiter and Io; oil on canvas; 163×74cm (64×29in); 1531. Kunsthistorisches Museum, Vienna

dome decorations and altarpieces exercised a profound influence upon Baroque and Rococo art.

His reputation has never regained the peak of esteem it deservedly achieved during the 17th and 18th centuries. No contemporary artist rivaled his ability to set huge spaces in motion with form and color, or equaled the fluid design, soft forms, and engaging emotion of his easel paintings.

His father acted as guarantor in the contract for his first recorded commission in 1514, *The Madonna of St Francis* (Gemäldegalerie Alte Meister, Dresden) which he painted for the church of S. Francesco in Correggio, his home town. A local law required such a guarantor for an artist under the age of 25. The altarpiece, finished in 1515, containing echoes of the work of Lorenzo Costa (c1460–1535) and and perhaps also of Leonardo and

Raphael, but the main influence is that of Mantegna's *Madonna della Vittoria* of *c*1494–6 in Mantua (now Louvre, Paris). Correggio had almost certainly visited the city and may have been responsible for the *Four Evangelists* in Mantegna's funerary chapel, and for two fresco roundels (S. Andrea, Mantua).

The influence of Albrecht Dürer's prints is apparent in two of his earliest paintings, *The Mystic Marriage of St Catherine* (*c*1513; Detroit Institute of Arts) and *Christ Taking Leave of His Mother* (*c*1512; National Gallery, London).

The Albinea Madonna (now lost) and the *Four Saints* (Metropolitan Museum, New York), both works probably begun in 1517, give little indication that Correggio was to develop into anything more than a provincial painter. The relatively sudden sophistication and amplitude of his figure style after 1518 may result from at least one visit to Rome and direct experience of the works of Michelangelo and Raphael.

His first fully mature paintings are the Raphaelesque *Diana* and cherubs in the Camera di San Paolo in the Benedictine convent at Parma. The suite of rooms of Gioanna da Piacenza, the Abbess, possessed little of the enclosed atmosphere of an ordinary convent, but served as a center for humanist intellectual activity. Correggio's vault decorations accordingly contain learned images illustrating Classical themes and based substantially upon Roman coins. Above these images, painted to look like sculpture, playful cherubs are visible through holes in a painted trellis of fruit and vegetation.

His success with this vault may have led to his being asked to paint the dome, apse, and friezes of S. Giovanni Evangelista, Parma. Payments made between 1520 and 1525 record the steady progress and completion of the frescoes. His entirely original conception transforms the whole dome into the vision of St John the Evangelist on Mount Patmos, who crouches in awe on the section of cornice nearest the nave. Above him, Michelangelesque Apostles are seated in a ring, while the upper region dissolves into a radiant vision of sky teeming with nebulous angels. The foreshortened figure of Christ miraculously floats in an indefinable space above the spectator. His apse decoration for the same church, the *Coronation of the Virgin*, survives only in fragments (Galleria Nazionale, Parma, and National Gallery, London).

In 1526 he received the first payment for the even grander project for the huge dome of Parma Cathedral (commissioned 1522). Work was to continue until 1530. The dome arises from an octagonal base, punctuated by round windows between which stand excited Apostles. To enhance the illusion, Correggio has carried some sections of the plaster upon which the draperies are painted across the edges of the window frames. In the dome itself, the Virgin ascends towards a luminous heaven through a vast, floating, celestial funnel composed of biblical characters and flying angels. She is greeted by a heavenly messenger (the adolescent Christ?) flying free on the opposite side. The spectator's viewpoint is placed off-center towards the nave, so that the inner surface of the divine cylinder is more visible on the Virgin's side.

During the painting of the domes, he also completed a series of major altarpieces, whose overlapping chronology is difficult to disentangle. *The Madonna of St Sebastian* (Gemäldegalerie Alte Meister, Dresden) finished *c*1526 and the *Madonna of St Jerome* (Galleria Nazionale, Parma) possibly commissioned in 1523 but painted later, show the development of fluid, flickering compositions based upon complex patterns of light and color, often with daring asymmetry.

In the justly famous *Nativity* (*La Notte*; Gemäldegalerie Alte Meister, Dresden) commissioned in 1522 and finished *c*1528–30, asymmetry is combined with a brilliant exposition of divine light radiating from the child. Correggio increasingly highlights sentiment, expressing sweetness and reverent delight. In what may be one of his later works, *The Martyrdom of Saints Placidus, Flavia, Eutichius, and Victorinus* (*c*1528–30, but often dated earlier; Galleria Nazionale, Parma, formerly in the Del Bono Chapel, S. Giovanni Evangelista) the saints welcome their deaths with a swooning ecstasy which is repeated in countless Baroque altarpieces.

Also during the 1520s he was patronized by Isabella d'Este Federico Gonzaga, producing a series of mythologies and allegories for the ducal palaces in Mantua. These began with *The Education of Cupid Anteros* (*c*1524; National Gallery, London), reminiscent of Leonardo's *Leda*, continued with the disconcertingly seductive *Virtues* (*c*1529; Louvre, Paris), and reached great heights of sensual appeal in the luscious *Io* (*c*1530; Kunsthistorisches Museum, Vienna). The scale of his artistic activity appears to have diminished greatly in the last four years of his life.

After his death, Correggio was followed in Parma by a school of imitators and by the young Parmigianino; but his major impact was to be felt in the late 16th and early 17th centuries, when Federico Barrocci, the Carracci, and Lanfranco translated his style into the language of Baroque art.

Further reading. Ekserdjian, D. *Correggio*, New Haven (1998). Gould, C. *The Paintings of Correggio*, London (1976). Panofsky, E. *The Iconography of Correggio's Camera di San Paolo*, London (1961). Ricci, C. *Correggio*, London (1930).

Cossa Francesco del *c*1435–*c*77

The Italian painter Francesco del Cossa came from Ferrara. He was first recorded in 1456; his earliest authenticated works, some frescoes in the Palazzo Schifanoia, Ferrara, date from 1469–70. They illustrate the months and include much astrological subject matter. The remainder of his working life he spent at Bologna painting religious pictures, notably the dismembered Griffoni Chapel triptych (*c*1473; center panel in the National Gallery, London) and an altarpiece dated 1474 (Pinacoteca Nazionale, Bologna). Cossa's style draws its grace and clarity from Florentine draftsmanship, its hardness and tautness from the works of Mantegna and Cosmé Tura. Its characteristics include contrived rocky landscapes and, in the Ferrara frescoes, engaging details of human activities.

Costa Lorenzo *c*1460–1535

Lorenzo Costa, known as Costa the Elder, was a Ferrarese painter who worked in Bologna and Mantua. He was in Bologna by 1483 where he undertook several commissions for the ruling Bentivoglio family, notably frescoes in their chapel in S. Giacomo Maggiore (1488–90). Costa's partnership there with Francesco Francia ended when he succeeded Mantegna as court painter at Mantua in 1506. His Mantuan works included two allegories for Isabella d'Este's Studiolo (both in the Louvre, Paris). He was superseded by Giulio Romano *c*1524. Costa's earlier paintings show the influence of Cosmé

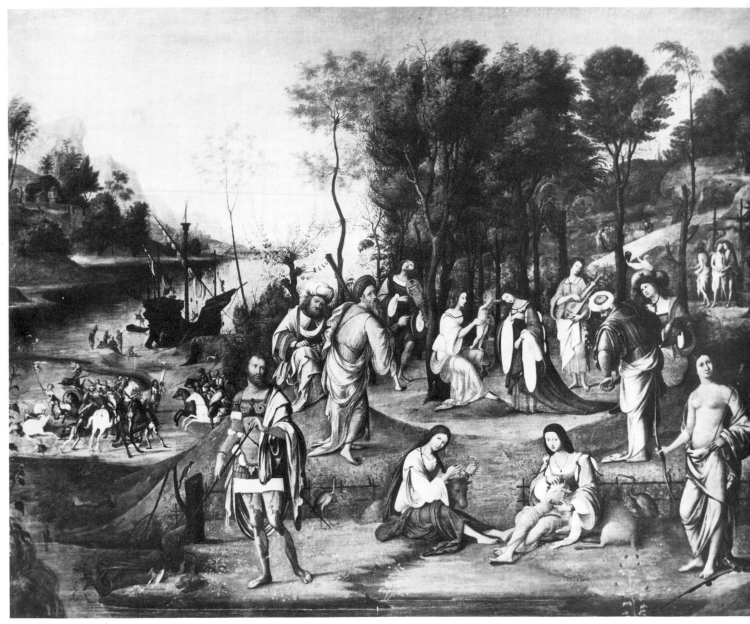

Lorenzo Costa: Isabella d'Este Crowned by Love; oil on canvas; 158×193cm (62×76in); c1504–6. Louvre, Paris

Tura (c1430–95) and particularly Ercole de' Roberti (1456?–96). His later style was softened by the elegance of Francia's works, which introduced Costa to Umbrian styles.

Cotman John Sell 1782–1842

The landscape artist John Sell Cotman was one of the most important figures in the development of English watercolor painting. Born in Norwich, he moved to London in 1798, though by 1806 he was back in his home town, where he was to become one of the leaders of the Norwich School, a group of landscape painters who painted the English countryside in a style strongly influenced by 17th-century Dutch painting. His own style, however, was highly original: flat, crisply defined areas of clear color created landscapes structured by abstract shapes and patterns. Among his finest works are those he made on his trips to Yorkshire between 1803 and 1805, such as *Greta Bridge* (1805; British Museum).

Cotte Robert de 1656–1735

Robert de Cotte was a French architect of the early Rococo period. His early years were spent assisting his brother-in-law J. Hardouin Mansart, whom he succeeded as *Premier Architecte* to Louis XIV in 1709, in which capacity he completed Mansart's unfinished chapel at Versailles. His independent work consists mainly of town houses in Paris and the provinces. The gallery of his Hotel de la Vrillière, Paris (1719), is a gem of Rococo decoration. The Palais Rohan, Strasbourg, is one of his principal works outside Paris. Cotte is important for the role he played in disseminating French architectural ideas abroad during the early 18th century.

Gustave Courbet: Portrait of P.J. Proudhon; oil on canvas; 147×198cm (58×78in); 1853. Musée du Petit Palais, Paris.

Robert de Cotte: Schloss Schleissheim in Schleissheim, Munich

Courbet Gustave 1819–77

The French painter Gustave Courbet, born at Ornans (Doubs) on 10 June 1819, was a self-confessed Realist, painting only what he could see and hostile to every kind of idealist art. After the Revolution of 1848, he was identified as an artist of the Left; later generations have seen him as one of the originators of the modern movement.

Intended for the law by his father, a rich farmer of peasant stock, Courbet left home for Paris in 1840. For a decade he struggled to establish himself as an artist. He was virtually self-taught, drawing at the Atelier Suisse and studying composition and technique at the Louvre. His early works were mediocre, aping the worst excesses of contemporary Romanticism. They were also narcissistic: he was his own model for such works as *Self-portrait with a Black Dog* (1844; Musée du Petit Palais, Paris), *The Sculptor* (1845; private collection), and the famous *Man with a Leather*

Belt (?1845; Louvre, Paris). But gradually he discovered the true sources for his art: works by the Italian painters Caravaggio (1573–1609/10), and Guercino (1591–1666), by the Spaniard Zurbaran (1598–1664), and, after a visit to Holland in 1847, by Hals (*c*1580–1666) and Rembrandt (1606–1669).

It was in 1847 that Courbet painted his only commissioned altarpiece, *St Nicholas Resurrecting the Children*, for the church of the local parish of Saules. But success in Paris eluded him. To four successive Salons after 1844 he submitted a total of 18 works, but only three were accepted. The 1848 Revolution and the brief Second Republic eventually established Courbet as a Revolutionary artist, but this did not happen immediately. It is true he designed a crude masthead for his friend Baudelaire's revolutionary paper *Le Salut Public* in 1848. But otherwise he simply took advantage of the jury-less Salon that year to show ten of his early works. These attracted little attention, but he returned to Ornans to paint the canvas that in 1849 did establish his reputation.

Even this work, *After Dinner at Ornans* (Musée des Beaux-Arts, Lille), was not strikingly revolutionary in either an aesthetic or a political sense. It was described in Courbet's own subtitle: "It was in November, we were at our friend Cuénot's house, Marlet had just returned from the hunt, and we had persuaded Promayet to play his violin for my father". But this autobiographical incident, a trivial pastoral occasion, was painted on a heroic scale (over 6 by 8 ft; 2 by 2.6 m) with a mastery that demanded comparison with Caravaggio or Rembrandt. It was bought by the State and presented to Lille's museum. More important, it won Courbet a second-class medal and the right to exhibit what he chose at future Salons.

Again returning to Ornans, Courbet began the three works that made him notorious when they were exhibited in the Salon of 1850–1. The most scandalous was the enormous *A Burial at Ornans* (1849; Louvre, Paris), 10 ft high and 7 yds long (3.3 by 7 m). Flattered by Courbet's second-class medal, more than 45 citizens of Ornans, including the artist's relatives and friends, posed for this frieze of life-sized mourners. But when the painting was seen in Paris alongside the degraded proletariat in *The Stonebreakers* (1849; formerly in Dresden; destroyed in 1945) and *The Peasants of Flagey Returning from the Fair* (1850; Musée des Beaux-Arts, Besançon) the public believed that Courbet was satirizing contemporary social values, and the bourgeois *Burial* was thought a caricature. Courbet, supported by his friend the Socialist Pierre-Joseph Proudhon, acknowledged his own socialist political ideals. But aesthetically his ideal was Realism. He thought the word Realism was a misnomer, but in 1861 he defined his art as independent of teachers or traditions, concerned only to represent "*real and existing things* ... Imagination in art consists in knowing how to find the most complete expression of an existing thing". In practice, Courbet painted the surfaces of things vividly and vigorously with his unique palette-knife technique. This gives *The Stonebreakers* a poignant immediacy, without revealing the subjects' faces or using heroic poses, as Millet would have done.

After the *coup d'état* of 1851 and the coming of the Second Empire, Courbet's paintings became less obviously political. *Young Ladies of the Village Giving Alms* (1851; Metropolitan Museum, New York) shows his sisters giving alms to a cowgirl, an inoffensive enough image of charity. The broad, naked buttocks of *The Bather* (1853; Musée Fabre, Montpellier) offended by their realistic vulgarity: the Emperor likened the model to a draft horse. The painting was, however, bought by a rich eccentric, Alfred Bruyas, who became Courbet's patron and friend.

In turning away from political commitment, Courbet's art became increasingly egotistical. Of the many works he painted for Bruyas, the most revealing is *The Meeting* (1854; Musée Fabre, Montpellier) in which the artist arrogantly confronts his patron and manservant who deferentially doff their hats to him.

In the autumn of 1854, to prove that he was "not dead yet, or realism either" Courbet undertook a second immense painting, 12 ft high by 20 ft long (4 by 6.6 m), *The Artist's Studio: a real allegory defining a seven year period of my life* (Louvre, Paris). Painted at Ornans, it shows his Paris studio, with Courbet himself at work on a landscape, but he is surrounded by 27 other figures, including a life model. On the right are his friends, including Baudelaire, Bruyas, Proudhon, and Champfleury. On the left are "the others, the world of trivialities: the common people ... those who thrive on death". This immense fantasy, painted in little over two months, seems far from socialist in spirit.

Courbet had expected that both *A Burial at Ornans* and *The Artist's Studio* would be accepted for the Paris International Exhibition of 1855. When they were rejected, he angrily opened his own pavilion. This was a novel enterprise, later emulated by Manet, but it attracted little attention.

Courbet's *The Return from the Conference* depicts drunken clergy and was refused even for the Salon des Refusés of 1863: it was bought and destroyed by a strict Catholic. Apart from this painting and *Young Ladies on the Banks of the Seine* (1857; Musée du Petit Palais, Paris), Courbet produced few works in later years with overt social messages. He painted what he liked and what he was commissioned to paint: splendid landscapes of his native Franche-Comté, hunting scenes, deer in woodland, and female nudes, sensual and even deliberately indecent. In 1861, he opened a studio for a few months, but then declared he was not and could not be a teacher. In the Commune of 1871 he was made President of the Art Commission and was implicated in the destruction to the Vendôme Column. This was his last political act. When the Commune fell in May 1871, Courbet was arrested and imprisoned.

While in prison he painted a number of exquisite still lifes. Released in 1872, he fled to Switzerland where he spent the rest of his life. In those years of exile, he drank heavily and employed assistants to paint salable Swiss landscapes in his broad palette-knife style. He died at Le Tour de Peilz, near Vevey, on 31 December 1877.

Further reading. Arts Council of Great Britain *Gustave Courbet 1819–1877*, London (1978). Boas, G. *Courbet and the Naturalistic Movement*, Baltimore (1938). Clark, T.J. "A Bourgeois Dance of Death", *The Burlington Magazine*, London (April/May 1969). Clark, T.J. *Image of the People: Gustave Courbet and the 1848 Revolution*, London (1973, reprinted 1999). Fernier, R. *La Vie et L'Oeuvre de Gustave Courbet*, Lausanne (1978). Fried, M. *Courbet's Realism*, Chicago (1990, reissued 1992). Leger, C. *Courbet et Son Temps*, Paris (1948). Mack, G. *Gustave Courbet*, New York (1951, reissued 1990). Nicolson, B. *Courbet: The Studio of the Painter*, London (1973). Riat, G. *Gustave Courbet, Peintre*, Paris (1906). Rubin, J. *Courbet*, New York (1997).

Courtois brothers 17th century

The French painter Jacques Courtois (1621–75) was born at St-Hippolyte, Doubs. After a period serving in the Spanish army in Milan he had arrived in Rome by 1640 and spent the rest of his life there. He worked in the manner of Salvator Rosa (1615–73) and Michelangelo Cerquozzi (1602–60), and is best known as a painter of battles; these are full of verve, light, and smoke, thanks to his loose, glittering technique. His works are extremely popular with collectors. His name is sometimes italianized to "Il Borgognone".

Guillaume Courtois (1628–79), his younger brother, was also born at St-Hippolyte. A pupil of Pietro da Cortona, he was primarily a religious painter, working in Rome. He was known in Italy as "Guglielmo Cortese". Among his many works are the high altar of S. Andrea al Quirinale, Rome (c1670) and *The Battle of Joshua* (1657; Palazzo del Quirinale, Rome). He also engraved religious subjects.

Coustou family
17th and 18th centuries

Nicolas Coustou (1658–1733) and his brother Guillaume (1677–1746) were French sculptors. They were born at Lyons, sons of the wood sculptor François Coustou and his wife Claudine who was the sister of the sculptor Antoine Coysevox. They thus began their careers as nephews of the leading court sculptor of the day. Louis XIV said of Nicolas that he was "born a great sculptor". The brothers were pupils first of their father, and later of their uncle in Paris. Both in turn won first prize for sculpture at the Academy, Nicolas in 1682 and Guillaume in 1697, and each made the journey to Rome, where they were influenced by Baroque sculpture. After his return to Paris in 1687 Nicolas pursued an active career as a court sculptor, working (later in conjunction with his brother) at the Royal Châteaux of Versailles, the Trianon, and Marly.

Nicolas was perhaps the finer artist of the two although less versatile and imaginative than his brother. Guillaume is the more

Above: Guillaume Coustou: one of the Chevaux de Marly; marble; erected in 1745. Place de la Concorde, Paris

Below: Nicolas Coustou: Pietà; marble; 230×280cm (91×110in); 1712–28. Notre Dame de Paris

celebrated. His great marbles of horse tamers, the *Chevaux de Marly*, erected at Marly in 1745 and now in the Place de la Concorde, Paris, are the most famous French sculptures of their time.

Guillaume had a son, Guillaume II Coustou (1716–77). A less distinguished artist than his father, he nevertheless enjoyed a long, prosperous career as a court sculptor, his style gradually moving away from the Baroque. His highly original monument to the Dauphin at Sens (1766–77) is one of the earliest great Neoclassical sculptures.

Cox David 1783–1859

David Cox was an English watercolorist whose anecdotal genre subjects enjoyed considerable popularity in the 19th century. He studied under John Varley and first exhibited at the Royal Academy in 1805. After living in London from 1829 to 1841 he retired to Harborne near Birmingham, and made annual sketching tours to the Welsh mountains. His watercolors are painted in a broad, free style, and after 1836 he began to paint on a coarse Scottish paper which was commercially marketed as "Cox Paper". Cox published several works on landscape painting of which *Treatise on Landscape Painting and Effect in Water-colour* (1841) is the best known.

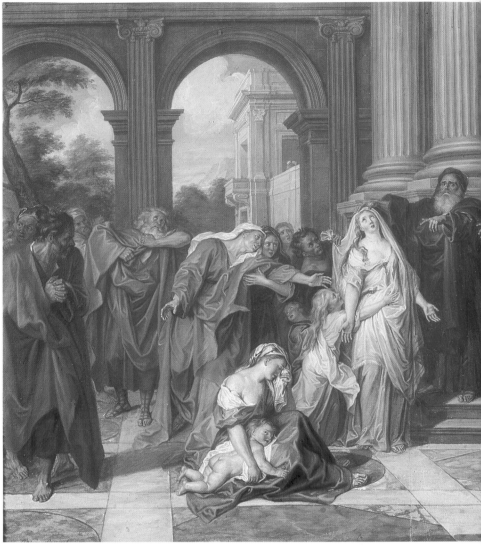

David Cox: The Brocas, Eton; watercolor; 21×33cm (8×13in); c1812. British Museum, London

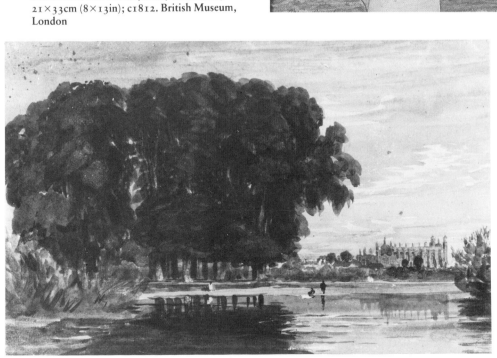

Coypel family
17th and 18th centuries

The Coypels were a family of French painters. Noël (1628–1707) worked in the general manner of Poussin; he was a leading light of the French Academy of Painting and Sculpture from 1663, and became a Professor in 1664. He went to Italy as Director of the French Academy in Rome in 1672, returning two years later. His main work was the decoration of the Invalides (Paris, 1700–7).

Antoine Coypel (1661–1722) was the son of Noël, and went with his father to Rome. He became Director of the Academy of Painting and Sculpture in 1714. His chief work was the ceiling of the chapel at Versailles (1708), which was an important assertion of the continuing values of the Roman Baroque in court circles.

Noël Nicolas (1690–1734) was half-

Antoine Coypel: Chaste Susanna being Denounced; 48×70cm (19×28in); c1700. Musée des Beaux-Arts, Angers

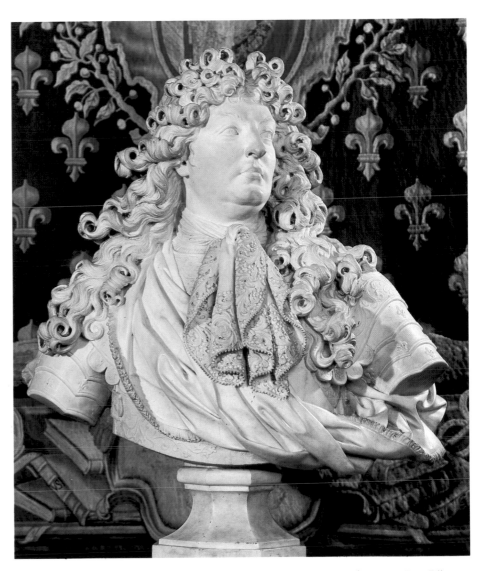

Antoine Coysevox: Louis XIV; marble; 89×80cm (35×31in); 1686. Musée des Beaux-Arts, Dijon

brother to Antoine. His career was less successful than that of his son Charles-Antoine (1694–1752), who was made *Premier Peintre du Roi* (1743) and Director of the Academy (1747). He is significant for his part in the formation of an *École des Élèves Protégés*, who were fed on a wholesome diet of Classical learning and historical texts. The institution became the foundation stone of a strong French school of Neoclassicism.

Coysevox Antoine 1640–1720

The French sculptor Antoine Coysevox was born at Lyons. In 1657 he went to Paris, where he studied under Louis Lerambert and at the Académie. In 1666 he gained the title of *Sculpteur du Roi*.

Between 1667 and 1671 he worked at Saverne in Alsace for Cardinal Egon, Bishop of Strasbourg. After a brief return to Lyons, where he seems to have thought of establishing himself, he settled in Paris from 1667, and embarked on a busy career as a Royal Sculptor, producing works for Versailles, the Trianon, Marly, Saint-Cloud, and the Invalides. A brilliant portraitist, he made busts of most of the leading public figures of the time, and was the first French sculptor to portray fellow artists and friends, establishing a tradition that was to remain a special feature of French sculpture. Working in both bronze and marble, he produced several major sepulchral monuments, sometimes in collaboration with other Royal Sculptors.

Coysevox epitomizes the restrained Baro-

que style favored by Louis XIV, and was the dominant figure in French sculpture in the latter part of the reign. He exercised a powerful influence on the development of French sculpture in the first half of the 18th century. The foremost sculptors of the succeeding generation, Nicolas and Guillaume I Coustou, were his nephews and pupils. Coysevox's output was very large, but many of his important works have not survived; several of those that have have been moved from their original locations. His best-known statues, *Mercury* and *Fame*, originally carved in 1702 for Marly, have since 1719 stood at the entrance to the Jardins des Tuileries in Paris. There is an extensive and varied collection of his work in the Louvre, Paris.

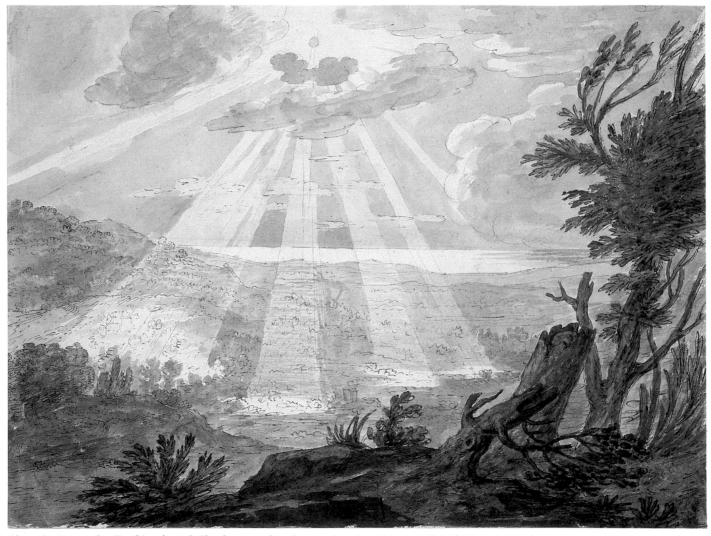

Alexander Cozens: **Sun Breaking through Clouds**; pen and wash; 21×28cm (8×11in); 1746. British Museum, London

John Robert Cozens: **The Oak**; etching tinted with Indian ink; 24×32cm (9×12½in); 1789. British Museum, London

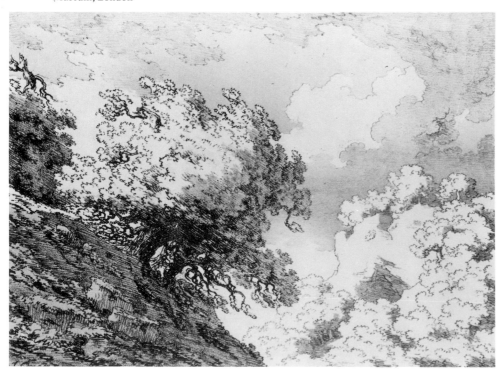

Cozens family 18th century

The English landscape painter and drawing master Alexander Cozens (c1717–86) was born in St Petersburg, but by 1742 he had settled in London. His dated sketchbooks (British Museum, London) confirm that he visited Rome in 1746. In England he painted and exhibited landscapes in oil, but he is best known for his monochrome landscape drawings and his teachings on art. His landscape compositions are almost always imaginary and reflect his deep respect for the classical tradition of Claude (1600–82). In 1771 he published an artist's manual on 32 varieties of trees. In his last publication, *A New Method of Assisting the Invention in Drawing Original Compositions of Landscape* (1785), he advocated his method of composing landscapes by applying ink to a sheet of paper at random, and then working the abstract markings into a finished representation. His emphasis on invention was not new; but his wash technique, which allowed extreme simplification of forms and a

patterned massing of areas of light and shade, departed radically from the methods then in use.

John Robert Cozens (1752–97) was the only son of Alexander, from whom he received his early training as a landscape painter. In 1776 he exhibited a historical landscape in oils at the Royal Academy and then departed for Italy, via Switzerland. He was accompanied by Richard Payne Knight who was later to become an important theorist of the Picturesque. Cozens returned to England in 1779 but within three years set off again for Rome, on this occasion as draftsman to William Beckford. From 1783 Cozens lived in London and produced, on commission, a steady stream of watercolors based on sketches culled from his two Italian trips. In 1792 he suffered a nervous breakdown from which he never fully recovered.

Cozens' works are almost exclusively watercolor paintings of Italian and Swiss scenes, in which he reveals a heightened sensitivity to the most poetic and contemplative states of nature. His range of colors was limited, but he used them to create the most varied atmospheric effects. His technical innovations with watercolor and his moving response to nature were formative influences on Turner and Girtin, both of whom acknowledged their debt to his achievement.

Cranach Lucas, the Elder
1472–1553

Lucas Cranach the Elder was one of the most influential and prolific German artists of the 16th century. He was born at Kronach in northern Franconia, and received his early training in the workshop of his father, Hans Maler, who taught him the art of engraving. It was a journey along the Danube to Vienna that inspired the first and perhaps the most inventive phase of his career. On either the outward or the return journey he may have passed through Nuremburg and gained knowledge of Albrecht Dürer's woodcut style and technique. His own *St George* woodcut of 1507 is possibly the first true chiaroscuro print in Germany.

The influence of the Danube school of painting, with its distinctive landscape style and dramatic contrasts of color and lighting, is seen in Cranach's paintings, such as the *Crucifixion* of 1503 (Alte Pinakothek, Munich). This work is also highly original for its ingenious composi-

tion. The cross is placed at an angle to the picture-plane, so that the spectator's vision of the crucified Christ and his relationship to the other mourning figures are given a new psychological impact. In the same year Cranach painted what are probably his most successful and sympathetic portraits, those of the historian Johannes Cuspinian and of his wife Anna (both in the Sammlung Oskar Reinhart "Am Römerholz", Winterthur).

By 1505 Cranach had been appointed court painter to Frederick the Wise, Elector of Saxony, at Wittenberg. There he set up a large workshop to carry out variations and copies of his major compositions, where his sons, Hans (*ob.* 1537) and Lucas the Younger (1515–86) were trained. The characteristic features of a recognizable workshop style became quickly established and underwent little development after *c*1520.

Lucas Cranach the Elder: The Ill-matched Couple; originally wood panel, now canvas; 79×57cm (31×22in); c1532. Musée des Beaux-Arts, Besançon

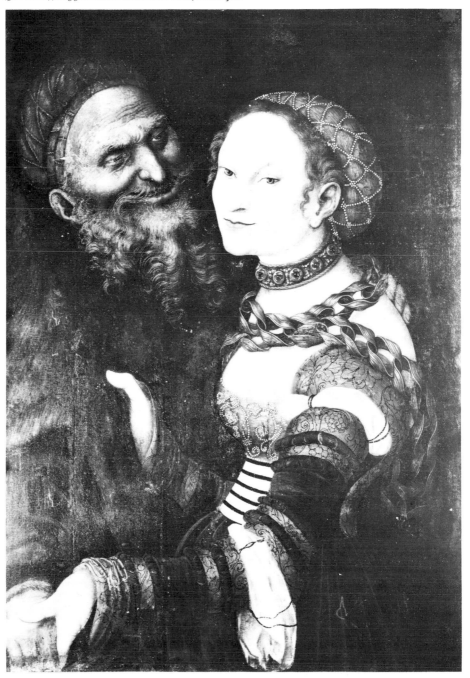

The portraits of Duke Henry the Pious and his wife (1514; Gemäldegalerie Alte Meister, Dresden) are early examples of his most familiar style. The figures are flattened and their contours outlined against a dark background. The tall format makes them dominate the picture-field and removes the need for any spatial setting. The elaborate surface patterning of their costumes is accentuated at the expense of anatomical accuracy. The *Three Graces* (1535; William Rockhill Nelson Gallery, Kansas City) shows this style transferred to a mythological subject. The delicate nude forms are traditionally northern in character, sinuous and rhythmical in contour with bluish, pearl-like flesh tones. Hair and drapery (in other nude subjects jewelry as well) lend an erotic quality to these works.

Many of Cranach's later works are difficult to distinguish from the best of the workshop's productions. Originals such as the *Nymph of the Fountain* (1518; Museum der Bildenden Künste, Leipzig), *Adam and Eve*, and *The Ill-matched Couple* are repeated in many copies (one example of the latter is in the Musée des Beaux-Arts, Besançon).

Apart from his reputation as a court artist, Cranach holds an important place as a portrait painter of the German Reformation. His friendship with Martin Luther was very close and several portraits by Cranach of the Reformer and his wife survive. Cranach's last years were shaped by the wars resulting from the religious conflicts of his time. In 1550 he followed his patron, the exiled Elector John Frederick I, first to Augsburg and then to Weimar, where the artist died in 1553.

Further reading. Dornik-Eger, H. *Die Druckgraphik Lucas Cranachs und Seiner Zeit*, Vienna (1972). Friedländer, M.H. and Rosenberg, J. (eds.) *The Paintings of Lucas Cranach*, London (1978). Ruhmer, E. *Cranach*, London (1963). Schade, W. *Die Malerfamilie Cranach*, Dresden (1974).

Cresilas *fl.* 450–425 BC

Cresilas was a Greek sculptor from Crete; he was influenced by Pheidias in Athens where he probably collaborated on the Parthenon marbles. In his day he was famous for his noble portrait of Pericles; this stood on the Acropolis, and seems to have been an ideal characterization of a

Cresilas: Pericles; marble; height 50cm (20in); Roman copy derived from original of mid 5th century BC. Vatican Museums, Rome

general and statesman, perhaps portrayed in heroic nudity. Only copies of the head survive, as in the herm in the British Museum, London, and a Roman copy in the Vatican Museums, Rome. His bronze *Amazon* from Ephesus (Roman copy in the Capitoline Museum, Rome) is probably represented in copies showing her wounded under the right armpit, her right hand resting on her head, her left elbow on a pillar. The pathetic gesture, drooping head, and archaistic drapery were combined in an elegant style. The new, bold device of the supporting pillar was exploited later by Praxiteles (*fl. c*370–330 BC).

Crespi Daniele *c*1590–1630

Daniele Crespi was an Italian painter who worked in Milan. With Guglielmo Moncalvo he painted the dome of S. Vittore al Corpo in 1619. He later enrolled in Cerano's painting class in the Ambrosiana, Milan. His masterpiece is *The Fast of S. Carlo Borromeo* (S. Maria della Passione, Milan). In his last years he painted frescoes in the nave of the Certosa di Garegnano and in the choir of the Certosa di Pavia (both Carthusian monasteries). He died of the plague. His paintings are realistic, with strong effects of light and color developing later into cool silvery tonality.

Crespi Giuseppe Maria
1665–1747

Giuseppe Maria Crespi was an Italian painter, also known as "Lo Spagnuolo". He was born in Bologna. A specialist in genre painting, he portrayed the idiosyncrasies of man's everyday behavior with both sympathy and irony. He drew inspiration from the work of Bolognese painters as diverse as Lodovico Carracci (1555–1619), Domenico Maria Canuti (1620–1684), Guercino (1591–1666), and Lorenzo Pasinelli (1629–1700), as well as from the Umbrian painter Federico Barocci (1526–1612). From all these influences he developed an entirely individual style. In 1708 he was working in Florence where he was employed by the Grand Duke. On his return to Bologna soon afterwards he painted the famous cycle of *The Seven Sacraments* (Gemäldegalerie Alte Meister, Dresden).

Critius 5th century BC

Critius was a sculptor of the early Classical period; he worked with Nesiotes in Athens, specializing in bronze. Their greatest creation was *The Tyrannicides Harmodius and Aristogeiton*, heroes of the Athenian democracy; the statue was set up in Athens in 477 BC. Copies in Naples (Museo Archeologico Nazionale) and elsewhere present them in the act of killing Hipparchus, brother of the tyrant Hippias. The marble *Boy* attributed to Critius (Acropolis Museum, Athens) is one of the finest examples of the early Classical style in which Archaic frontality is abandoned and the weight rests on one leg.

Crivelli family
15th and 16th centuries

The Crivelli were a family of Italian painters, of Venetian origin. The first reference to Carlo Crivelli (1430/5–*c*1495) occurs in 1457 when he was sentenced to imprisonment in Venice for adultery. He seems to have left Venice soon after this date and in 1465 is recorded as living in Zara, Dalmatia. Thereafter he appears to have settled in the Marches of central Italy. His surviving works consist entirely of religious paintings, which retain the same highly

Daniele Crespi: The Last Supper; oil on canvas; 210×230cm (83×91in); c1624–5. Pinacoteca di Brera, Milan

decorated, hard edged, and rather provincial character throughout his life. Richly patterned fabrics and gold, embossed with elaborate patterns, form an essential part of his art.

We know nothing of Carlo Crivelli's early training, but his style, as seen for instance in the Demidoff Altar of 1476 (National Gallery, London), appears to derive from the Vivarini school: the elaborate frames surrounding his paintings would also confirm such a connection. Other paintings, such as the *Annunciation* of 1486 (National Gallery, London) contain reminiscences of works by Mantegna and Antonello. The Brera *Coronation of the Virgin* of 1493 (Pinacoteca di Brera, Milan) includes female types and ecstatic sentiment closer to works by Botticelli than to those of any other painter of this date. Carlo Crivelli's paintings are full of natural phenomena, especially fruit and vegetables, depicted with a very high degree of accuracy; these objects are often used as part of the elaborate structure of symbolism employed in his works.

Vittorio Crivelli (*fl.* 1481–1501/2) was probably Carlo's younger brother and is first recorded in 1481 when he signed and dated the now dismembered Vinci polyptych (Philadelphia Museum of Art). He worked in a style close to Carlo's, and like him found his chief patrons among the religious houses of the Italian Marches.

Crome John 1768–1821

The English landscape painter John Crome spent most of his life in Norwich. He trained as a coach painter until 1790. His ambition to become a landscape painter was encouraged by Thomas Harvey of Catton who made available a large collection of Dutch and English pictures for Crome to study. He rapidly assimilated the achievements of Hobbema (1638–1709), Jan Wynants (*c*1625–84), Richard Wilson (1714–82), and Thomas Gainsborough (1727–88). By the early 1800s he had developed his own version of the picturesque landscape, infused with sensitively observed details, always based on his rustic East Anglian terrain. In 1803 he helped to found the Norwich Society of Artists, a group of gifted painters to whom he was

Carlo Crivelli: St George and the Dragon; tempera on canvas; 90×46cm (35×18in); c1476. Isabella Stewart Gardner Museum, Boston

John Crome: Houses and Wherries on the Wensum; pencil and watercolor on paper; 30×40cm (12×16in); c1809–10. Whitworth Art Gallery, Manchester

the senior adviser. He exhibited landscape paintings annually with the Society from their first exhibition in 1805 to his death.

George Cruikshank: Monstrosities of 1825 and 1826; etching; 22×36cm (8½×14in); 1826. British Museum, London

Cruikshank George 1792–1878

The painter, illustrator, and cartoonist George Cruikshank was born in Bloomsbury, London; coming from a family of cartoonists and engravers, he learned the trade from his father Isaac (c1756–c1811) who had been a book illustrator and caricaturist of some popularity. When the caricaturist James Gillray died in 1815, Cruikshank took over his last plates. He was associated with Dickens, for whom he illustrated *Sketches by Boz* (1836) and *Oliver Twist* (1838). He worked with equal success for Harrison Ainsworth on his magazines (*Bentley's Miscellany*, *Ainsworth's Magazine*, etc) on *Jack Sheppard* (1839) and *The Tower of London* (1840), as well as illustrating numerous other books and pamphlets. From 1847 he was actively involved in the Temperance Movement, for which he produced a great deal of propaganda.

Cuvilliés Jean-François de 1695–1768

The French architect and decorator Jean-François de Cuvilliés was of Flemish origin. Tiny in stature, he was appointed as court dwarf by Max Emanuel of Bavaria in 1708 while Max Emanuel was living in exile in France. In 1715 Cuvilliés returned

Jean-François de Cuvilliés: detail of the main saloon of the Amalienburg hunting lodge, Schloss Nymphenburg; 1734–9

to Munich with the Elector. After five years' work as a draftsman for the Generalbaudirektor in Munich, Cuvilliés was sent to Paris for further training under François Blondel the Younger. In 1726, after Max Emanuel's death, the Elector Karl Albrecht appointed him Hofbaumeister, thus supplanting Joseph Effner. From 1728, Cuvilliés was also in the service of Karl Albrecht's brother, Clemens August, the Archbishop Elector of Cologne.

Apart from work on the Schloss Brühl near Bonn, Cuvilliés was responsible between 1729 and 1740 for the elegant hunting lodge Falkenlust, which is in the park there. In 1729 there was a disastrous fire in the Munich Residenz which destroyed most of the rooms newly completed by Effner. Cuvilliés redecorated the Reiche Zimmer (1730–7), with elaborate naturalistic *rocaille* work executed by the *stuccatore* J.B. Zimmermann and the woodcarvers J. Dietrich and W. Mirofsky. This introduced the fully developed Rococo into Germany for the first time.

The decoration of Falkenlust is in the same style, which reaches its climax in the interiors of the Amalienburg in the park of Schloss Nymphenburg (1734–9).

In the facades of his palaces in Munich (now mostly destroyed or damaged) Cuvilliés blended French discipline with the Bavarian love of surface decoration. The masterpiece of his later years is the interior of the Residenz Theater in Munich (1751–3) in which classical columns are replaced by naturalistic palm trees.

Cuyp Aelbert 1620–91

The Dutch landscape painter Aelbert Cuyp (or Cuijp) was born and died in Dordrecht. He was the son of the painter Jacob Gerritsz. Cuyp, and early works such as his *Landscape with Cattle* (1639; Musée des Beaux-Arts, Besancon) may reflect his father's style. For a time he painted landscapes in the tonal manner of Jan van Goyen (1596–1656); but by the early 1640s Cuyp's style began to reflect the influence of those artists, such as Jan Both (*c*1618?–52), whose vision of landscape had been formed by travel in Italy.

Cuyp is best known for his river scenes and seascapes in which the moist atmosphere bathed in soft golden light lends an Arcadian quality to his work. The mood of his pictures is generally calm and silent and there is a degree of generalization in his rendering of specific localities; the *View of Nijmegen* (Indianapolis Museum of Art) is an example of this. Sometimes he takes a close and very low viewpoint as in the *Herdsman and Five Cows by a River* (National Gallery, London). Cuyp seems to have avoided narrative pictures wherever possible; his scenes of action are his least successful works. (An example is *Christ Entering Jerusalem*; Glasgow Art Gallery and Museum.)

The Maas at Dordrecht (Kenwood, The Iveagh Bequest, London) is one of several representations of the mouth of the river in his native town. Though there is no documentary evidence that he ever left Dordrecht, paintings and drawings suggest that he traveled to Utrecht and along the Rhine. Through his marriage in 1658 he belonged to the wealthy merchant class of Dordrecht, and he later purchased a country estate. The chronology of his work is difficult to establish since he dated so few of his pictures; but it does appear that his financial security enabled him to give up painting in the last years of his life.

Cuyp had little influence on painters outside Dordrecht, but he became a favorite of collectors, especially in England, where some of his finest works remain.

Aelbert Cuyp: River Landscape (detail); oil on canvas; full size 123×241cm (48×95in); c1655–60. Private collection

D

Dadd Richard 1819–87

Richard Dadd was an English faery painter and illustrator. Born in Chatham, Kent, Dadd began drawing at the age of 14 and entered the Royal Academy Schools in 1837. His promising career was interrupted by a sudden mental breakdown during a trip to the Holy Land (1842–3). Dadd returned to London and murdered his father. Committed as insane in 1844, Dadd spent the rest of his life in care. In London's Bethlem Hospital he painted his meticulously worked oils *Oberon and Titania* (1854–8; private collection) and *The Faery Feller's Master Stroke* (1855–1864; Tate Gallery, London). In 1864 he was moved to Broadmoor; he continued to paint well on into the 1880s.

Richard Dadd: The Faery Feller's Master Stroke; oil on canvas; 54×39cm (21×15in); 1855–64. Tate Gallery, London

Bernardo Daddi: The Meeting of St Joachim and St Anne at the Golden Gate; tempera on panel; c1340. Uffizi, Florence

Daddi Bernardo c1280–1348

The Florentine painter Bernardo Daddi worked in the manner of Giotto between c1312 and 1345. In 1328 he signed a triptych (now in the Uffizi, Florence) of *The Madonna with SS. Matthew and Nicolas.* Other important works are his frescoes in the Pulci Beraldi Chapel in S. Croce, Florence (1324). His acquaintance with the manner of the Lorenzetti meant that those frescoes, while recognizably Giottesque in their massive bodies and characteristic drapery and shadings, contain elements of Sienese style as well—a higher color tone and much richer detail. These make his work less austere and more decorative than anything by Giotto himself. They seem to point to a certain dilution of the Giotto manner in the years after the painter's death.

Daedalus 7th century BC

Daedalus was originally a Greek mythological figure personifying the qualities of craftsman and engineer implicit in his name (Daedalic means "skillful"). His legendary career was set in the Bronze Age and he was credited with a number of inventions and engineering works such as the Cretan Labyrinth and the wax wings that flew him from Crete to Sicily. Another

Daedalus, who may or may not have been a historical figure, lived in the early Archaic period (7th century BC) and was said to have introduced monumental sculpture in Greece. The first generations of Archaic sculptors claimed him as their teacher.

"Daedalic" is a conventional term for a Greek artistic style of the 7th century BC. It is characterized by the flat, angular appearance of the human form, notably the head, which has wig-like hair fashioned in horizontal layers, a triangular face, pointed nose, and large eyes. It was formed under Near Eastern influence and is commonly found on the Aegean islands, Crete, and in the Peloponnese, on mold-made clay figurines, small bronzes, ivories, gold jewelry, and statuettes of limestone or wood.

The first large marble sculptures in Greece were also conceived in this style, the technique of stone carving having been borrowed from Egypt. They are draped women of a columnar appearance, free-standing or in relief, used for architectural decoration or votive offerings. The modeling is shallow. The shoulders and back of each figure are covered by a shawl, the waist accentuated by a large girdle of metallic form; drapery patterns are picked out in color, and are sometimes also incised. The statue dedicated by Nikandre to Artemis on Delos is one of the earliest and finest (National Museum, Athens). The Daedalic conventions for the head were used in the early male standing nudes (*Kouroi*) *c*600 BC, some of which also retained the large belt.

Dahl Michael 1656–1743

The Swedish-born painter Michael Dahl rivaled Sir Godfrey Kneller in maintaining a flourishing portrait practice in England. After studying in Stockholm he came to England in 1682 and was patronized by Prince George of Denmark and Queen Anne. However, unlike Kneller, Dahl was content with commissions from less illustrious subjects, and his observation and understanding were reserved for sitters such as merchants and naval officers (a series of portraits is in the National Maritime Museum, London). Dahl's technique was light and feathery; his portraits have an unmistakable resemblance to the European Rococo style, which may be due to his knowledge of contemporary French painting.

Dali Salvador 1904–89

The Spanish painter and writer Salvador Dali was at one time a member of the Surrealist movement. Born in Figueras, he studied at the Madrid School of Fine Art. His paintings of the mid 1920s show the influence of Carrà and de Chirico and of Surrealism. In Spain in 1928, he and his contemporary Luis Bunuel made the film *An Andalusian Dog*, which was received rapturously in Paris by the Surrealists. From this point onwards, Dali divided his time between Spain and France.

In such works as *Illumined Pleasures* (1929; Museum of Modern Art, New York), Dali employed a meticulously smooth, *trompe-l'oeil* style; he evolved a system of shading that resulted in a hallucinatory luminosity and dramatically receding perspectives. This contributed to the resurgence of illusionism in Surrealist painting in the late 1920s. In these paintings Dali's exposure of his neurotic sexual fantasies and fears (often by means of Freudian symbols) asserted the Surrealists' belief that art should be unflinchingly self-revelatory.

During the years 1929 and 1930, Dali developed his "paranoiac-critical method", which he used in both his paintings and his art criticism. It involved the ability to perceive unexpected analogies between forms and objects: thus Mae West's face is also a furnished room (*Mae West*, *c*1936; Art Institute of Chicago).

In 1930 Dali and Bunuel made the classic Surrealist film, *The Golden Age*. During this decade Dali was a leader in the Surrealist cult of the object. But his self-promotional stunts and his flirtation with Fascism eventually led to his exclusion from the movement. After the Second World War he worked in a style imitative of Vermeer and J.-L.-E. Meissonnier; his paintings express his erotic and religious fantasies, and his obsession with the Catalonian landscape, his wife Gala, and himself.

Salvador Dali: Autumnal Cannibalism; oil on canvas; 65×65cm (26×26in); 1936. Tate Gallery, London

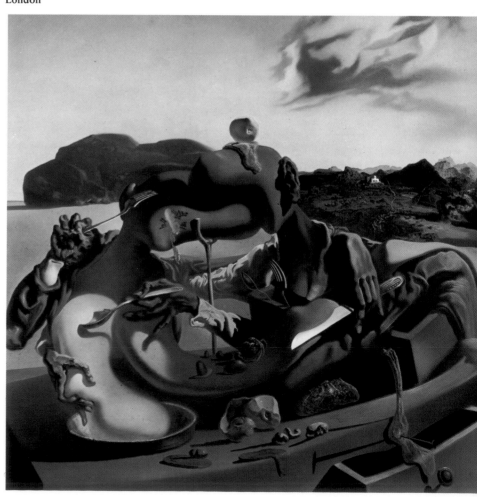

Further reading. Dali, S. *Dali by Dali*, New York (1970). Dali, S. *Diary of a Genius*, London (1974). Gerard, M. (ed.) *Dali*, New York (1968). Morse, A.R. *Dali, a Guide to his Works in Public Museums*, Cleveland (1974). Tapie, M. *Dali*, Paris (1957).

Daliwes Jaques *fl.* early 15th century

The superb draftsman who signed his name Jaques Daliwes on the first of a series of drawings on 12 boxwood panels now in Berlin (Öffentliche Wissenschaftliche Bibliothek; Lib. pict. A. 74) is otherwise unknown. He was clearly a major artist, probably Franco-Flemish in origin but aware of Italian trends. A profile female portrait in The National Gallery of Art, Washington D.C., formerly attributed to Pisanello, closely resembles one of the Daliwes Berlin drawings and may be by the same hand. The panels include religious and animal subjects as well as heads; they are iconographically adventurous, and were probably intended as a model-book.

Dalmau Luís *fl.* 1428–61

The Spanish artist Luís (or Lluís) Dalmau was born in Valencia. By 1428 he was official painter to the city and to Alfonso V of Aragon. From 1431 to 1436 he studied with Jan van Eyck in Bruges; his surviving work, the Altarpiece of the Councillors, suggests a synthesis of Flemish experience with the International Gothic of Catalonia. The five Councillors of Barcelona are disposed with the Virgin, St Andrew, and St Eulalia, and angels, in a manner reminiscent of van Eyck's altarpiece at St-Bavon. In this work, landscape, buildings, and the treatment of detail and dimension all testify to Flemish origins. Dalmau's style had some influence in Castille and León, as well as throughout Catalonia.

Dalou Aime-Jules 1838–1902

The French sculptor Aime-Jules Dalou was born in Paris. He fled to London after the Paris Commune in 1871. In the following decade he worked in England on terracotta sculptures, naturalistically depicting scenes of family life; this class of subject, which appealed greatly to the Victorian love of domesticity, had previously been confined to painting. His ambition was to become a monumental sculptor, and on his return to Paris in 1880 he had already secured the

Aime-Jules Dalou: The Triumph of the Republic; bronze; completed in 1899. Place de la Nation, Paris

commission for *The Triumph of the Republic* (completed 1899, Place de la Nation, Paris), the largest of the many monuments sponsored under the Third Republic. He worked in secret on a *Monument to Labour* (sketches in Musée de l'École Supérieure des Beaux-Arts, Paris) intended as a socialist complement to the *Triumph*. This was never completed, but a large number of his small realist figures of workers survive.

Danti Vincenzo 1530–76

The Italian goldsmith and sculptor Vincenzo Danti was born in Perugia, where he matriculated as a goldsmith in 1548. His earliest sculpture is a monumental bronze figure of *Pope Julius III Enthroned*, erected outside Perugia Cathedral (1553–1556). From 1557 until 1573 Danti worked as a sculptor at the court of Cosimo I, Grand Duke of Florence. His masterpiece there was a bronze group on the Baptistery, depicting *The Beheading of St John the Baptist* (1571). In this and all his other works, the figures are gracefully elongated and set in balletic poses characteristic of sculpture in the age of Mannerism. For the Medici he cast a bronze statuette of *Venus Anadyomene* for the

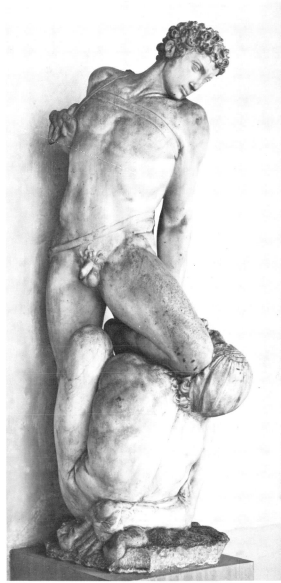

Vincenzo Danti: Honor Triumphant over Falsehood; marble; c1561. Museo Nazionale, Florence

Studiolo in the Palazzo Vecchio, Florence (c1573) and a large narrative relief of *Moses and the Brazen Serpent* (now Museo Nazionale, Florence) for the altarfrontal of the Medici private chapel. Danti also carved in marble during the 1560s (for example, *Honor Triumphant over Falsehood* and *Duke Cosimo I*; both Museo Nazionale, Florence). In 1567 he published a treatise on proportion. He retired after 1573 to Perugia, where he was honored as an Academician. Danti's sculpture has a delicacy of detail and an elegance of line reminiscent of many another goldsmith turned sculptor, for example Ghiberti and Cellini.

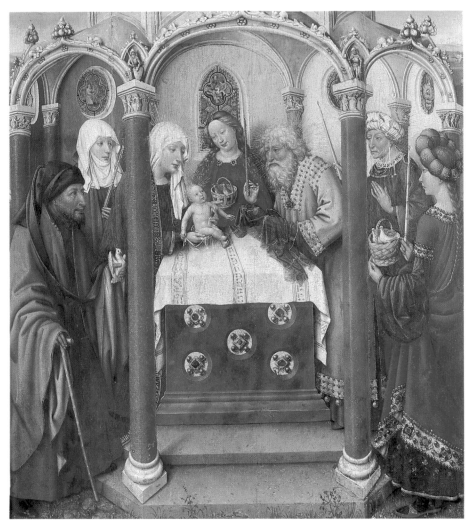

Jacques Daret: The Circumcision, a panel from the St Vaast Altarpiece; oil on panel; c1434. Musée du Petit Palais, Paris

Daret Jacques c1404–70

Jacques Daret was a Flemish painter from Tournai. During the years 1427–32 he was apprenticed to Robert Campin, an artist who is identified by some scholars with the Master of Flémalle. Rogier van der Weyden was one of Daret's fellow students. In 1434 Daret was commissioned to paint an altarpiece for St Vaast, Arras. Four panels are regarded as belonging to his work; they are divided between the Staatliche Museen, Berlin, Paris (Musée du Petit Palais), and New York (Pierpont Morgan Library). These are his only documented extant paintings, though an *Annunciation* (Musée d'Art Ancien, Brussels) copied from the Master of Flémalle's *Mérode Altarpiece* has been attributed to him. He also produced designs for tapestries, festivals (including the wedding of Charles the Bold, 1468), and he also probably illuminated manuscripts.

The St Vaast panels, with their steep perspectives and ornamental naturalistic details, recall the conventions used in Tournai and Arras tapestries. Both documentary evidence and the surviving works suggest that Daret's talent was primarily that of a decorative artist.

Daswanth c1550–84

The Mughal painter Daswanth's remarkable talent and tragic life made him a legendary figure in his own time. The son of a palanquin bearer, his compulsive interest in drawing even on walls attracted the attention of the Mughal Emperor Akbar (1556–1605). Akbar arranged for the young man to study art under Abd al-Samad. Daswanth soon reached the height of his profession and was widely regarded as the greatest painter of his time. A melancholic figure who suffered from fits of depression, he took his own life at an early age. Despite his artistic reputation he remains a shadowy figure. The only surviving picture done entirely by his hand is in the *Tuti-nama* (Cleveland Museum of Art). Other works of his were the product of artistic collaboration. However, some 30 turbulent works in the *Razm-nama* (Maharaja Sawai Man Singh II Museum, Jaipur) bear the unmistakable imprint of his passionate, expressionist style.

Daubigny Charles-François
1817–78

Charles-François Daubigny was a French landscape painter and engraver. He studied under his father, a minor landscapist, and went to Italy in 1836. He concentrated on graphic work early in his career, turning to systematic plein-air painting in the 1850s. His *Villerville-sur-Mer* (1864–72; Hendrik Willem Mesdag Museum, The Hague) was painted completely from the motif, breaking the traditional practice of finishing works in the studio. His favorite subjects were tranquil water scenes painted from his studio boat on the major French rivers (for example, *Women Washing Along the Oise*, 1859; Louvre, Paris). Like the Impressionists, of whom he was a major precursor, he was criticized for rendering only an "impression" of nature.

Daucher family
15th and 16th centuries

The sculptors Adolf Daucher (1460–1523/4) and his son Hans (c1485–1538) worked at Augsburg. The altarpiece of the Fugger Chapel there (finished by 1518) is usually attributed to Hans, but it may reveal a collaboration between father and son. The stone figure-group of *Christ supported by the Virgin, St John, and an Angel* on top of the altar is one of the first freestanding groups in Northern altarpiece design. The scenes of the Passion below it show Hans' talent for relief sculpture. This was also evident in later work he carried out for the Hapsburg family, such as *The Meeting of Charles V and his brother Ferdinand* (post 1518; Pierpont Morgan Library, New York).

Daulat 16th century

A Muslim artist at the Mughal Court, Daulat was one of the ablest illustrators in the reign of the Emperor Akbar (1556–1605). He achieved prominence in Jahangir's reign (1605–27) but continued even in the Shah Jahan period (1628–58). Jahangir held a high opinion of him and ordered a portrait of the artist to be painted for inclusion in the *Khamsa* (Dyson Perrins Collection). Daulat in his turn did thumbnail sketches of five contemporary painters in the *Gulshan* Album (Gulistan Palace Library, Teheran). His works are in the *Akbar-nama* (Victoria and Albert Museum, London), *Babur-nama* (Indian Museum, Delhi), *Iyar-i-Danish*,

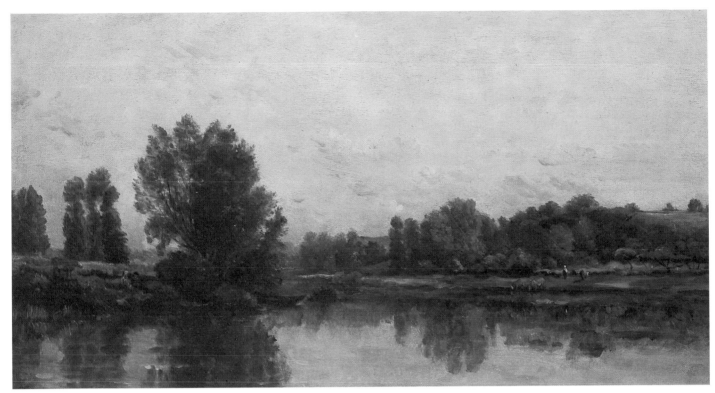

Charles-François Daubigny: Sunset on the Banks of the Oise; oil on canvas; 39×67cm (15×26in); 1865. Louvre, Paris

Shah Jahan-nama (Royal Art Collection, Windsor), and in the Rothschild Collection, Paris.

Daumier Honoré 1808–79

Honoré Daumier was an important French lithographer and painter. His lithographs are valuable documents for the political and social history of his period, and his paintings, largely unappreciated during his lifetime, are now held in high esteem.

He studied briefly in an academic studio before learning lithography. The Revolutions of 1830 and 1848 gave him the opportunity to express his republican sentiments in his caricatures. At other times, censorship confined him to social satire (he was even imprisoned in 1833 for criticizing the government). In the mid 1840s he became increasingly interested in painting, while still producing lithographs for his livelihood. Contemporaries knew him mainly as a graphic artist: in his lifetime he showed only six paintings in official exhibitions.

During the 1830s Daumier's political cartoons—published in the newspapers *La Caricature* and *Le Charivari*—included *Gargantua* (1831), an earthy caricature of Louis-Philippe's corrupt government, and the famous *Rue Transnonain 14 April*

1834 (1834), in which he abandons the satirical manner to show the pathetic aftermath of a military slaughter of civilians.

In 1836 Daumier began a series on the invented character Robert Macaire, personifying the chicanery of commercial society. He produced several great series of

lithographs in the 1840s, for example *Ancient History* (1842), a lampoon of Neoclassicism. His targets were often pomposity and pretentiousness, as in the series *Men of Justice* (1845–8): here the flowing robes and black–white contrast of the legal costume allowed impressive pic-

Honoré Daumier: The First-Class Carriage; crayon and watercolor on paper; 21×30cm (8×12in); c1858–60. Walters Art Gallery, Baltimore

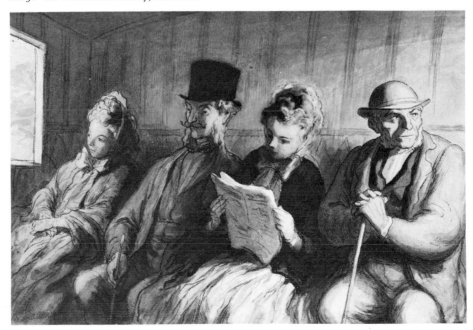

torial effects. He invented the character of Ratapoil, of which he also made a sculpture in bronze (1850; Louvre, Paris) to satirize the unscrupulous brigands of Napoleon III.

Daumier entered the competition for an allegorical figure of the Republic in 1848: he was placed eleventh, but never completed the painting, the sketch for which is now in the Louvre, Paris. Works he did at this period owe some debt to Rubens, for example, *The Miller, his Son, and the Ass* (c1848–9; Burrell Collection, Glasgow). A number of Daumier's paintings were inspired by contemporary events, for example *The Uprising* (c1848; The Phillips Collection, Washington, D.C.). Others are everyday scenes, such as *Third Class Carriage* (1863–5; National Gallery of Canada, Ottawa). The sculptural nature of his drawing is seen in *The Washerwoman* (1863–4; Louvre, Paris).

Daumier often depicted clowns and acrobats (for example, *Saltimbanque*, c1855–60; Louvre, Paris) and theater scenes (for example, *Crispin and Scapin*, 1858–60; Louvre, Paris). *Don Quixote and Sancho Panza* (c1870; Courtauld Institute Galleries, London) is one of a group of paintings on this subject, showing the loose handling and calligraphic brushwork of his late years. His paintings were not given the degree of finish expected by his contemporaries, but they have an evocative quality resulting from this sketchiness which gives them a particular appeal today. Daumier uses a tentative and broken line, so that the contours are made indefinite by the surrounding light, in an Impressionistic manner.

Further reading. Escholier, R. *Daumier et Son Monde*, Paris (1965). Kist, J.R. *Daumier, Eyewitness of an Epoch*, London (1976). Larkin, O.W. *Daumier, Man of his Time*, London (1967). Maison, K.E. *Honoré Daumier, Catalogue Raisonné of the Paintings, Watercolours, and Drawings* (2 vols.), London (1968). Passeron, R. *Daumier*, Oxford (1981).

David Gerard c1460–1523

The Flemish painter Gerard David was born in Oudewater, near Gouda. He may have trained under his father, Jan, or possibly under Geertgen tot Sint Jans. In 1484 he entered the Bruges painters' guild, of which he became Dean in 1501. He married Cornelia Cnoop, herself a miniaturist and the daughter of the Dean of the goldsmiths' guild, in 1496. David was admitted to the Antwerp guild in 1515, but by 1519 he was back in Bruges where he subsequently died.

After the death of Memling (1494), David's position as the leading artist in Bruges was unassailable. Although very few of his works are identifiable by documentation, a large group of paintings has been associated with his name. A high percentage of these were clearly produced by his workshop, but enough autograph pictures survive to reconstruct his artistic development in some detail. David's early style as illustrated by *Christ Nailed to the Cross* (c1480–5; National Gallery, London) reveals a brutal realism that relates to the work of Hugo van der Goes (c1436–82) and, more generally, to the Dutch tradition. By the time of the *Justice of Cambyses* (State Museum, Bruges) diptych of 1498, the tense drama of his earlier manner had been substantially toned down—although the flaying alive of the unjust judge Sisames in the left-hand panel is depicted with an excruciating objectivity. Owing to this work's double function as a narrative theme and a disguised group portrait, the two compositions are inevitably crowded and somewhat lacking in visual coherence.

The slightly later altar shutter of *Canon Bernardinus de Salviatis and Three Saints* (c1501; National Gallery, London) is a great deal more monumental in conception. The weighty poise of the four main figures implies a perceptive study of the work of Jan van Eyck (c1390–1441). This impression deepens as David's style progresses. His *Mystic Marriage of St Catherine* (c1505; National Gallery, London) is a centralized composition of five massive figures, tightly focused upon the simply articulated form of the Virgin and Child. By comparison, the Rouen *Virgin and Child with Saints* (Musée des Beaux-Arts) of 1509 is no less symmetrical, but much less static. A high point in David's art is reached with the approximately contemporary Bruges triptych of *The Baptism of Christ* (State Museum). In this painting, exquisite variety of detail and sensitivity of handling is combined with a striking monumentality of design, in a fashion closely reminiscent of the founding generation of Early Netherlandish painting.

A distinct duality is apparent in David's late productions. The many variants of his *Virgin and Child with a Milk Bowl* (examples in the Musée Royaux des Beaux-Arts de Belgique, Brussels; Galleria di Palazzo Bianco, Genoa) are pervaded by a gentle domesticity. On the other hand, a painting such as the Genoa *Crucifixion* (Galleria di Palazzo Bianco) indicates that he could also produce dramatic compositions of stark simplicity. While David was undoubtedly the last great master of the 15th-century Netherlandish style, it would be wrong to classify him as an old-fashioned artist. His students, particularly Ambrosius Benson and Adriaen Isenbrandt, prolonged his style of painting until almost the middle of the 16th century. David's return to the origins of the tradition within which he worked was fundamentally creative, as it allowed a rediscovery of the monumental values that had eluded many of his contemporaries. A later generation of artists, including Quentin Massys (1465/6–1530) and Jan Gossaert (c1478–1532), began by following his precepts before discovering a new formal vocabulary in Italian art.

David Jacques-Louis 1748-1825

The early career of the French painter Jacques-Louis David (often known as Louis David) followed a well established pattern. Born in Paris, he trained initially in the studio of a successful painter, finishing his education at the French Academy in Rome. On his return to France, he emerged as a leading exponent of Neoclassicism. He held official positions during both the Revolutionary period and the Empire, and was particularly active in the former. Throughout his life he was also much in demand as a portrait-painter. Exiled at the Restoration of 1815 for his continued support of Napoleon, he passed the remaining ten years of his life in Brussels, painting some outstanding works.

The France in which David grew up was ripe for both political and artistic revolution. The Rococo style of the previous generation—best exemplified by the decorative, sentimental, and sometimes overtly erotic work of François Boucher (1703–70) and Fragonard (1732–1806)—was fading. A reaction was taking place in the paintings of such artists as David's teacher Joseph-Marie Vien, who favored a return to the more classical tendencies of French art, particularly those portrayed in the 17th century by Poussin. In addition, theorists such as J.J. Winckelmann were becoming fashionable by stressing the

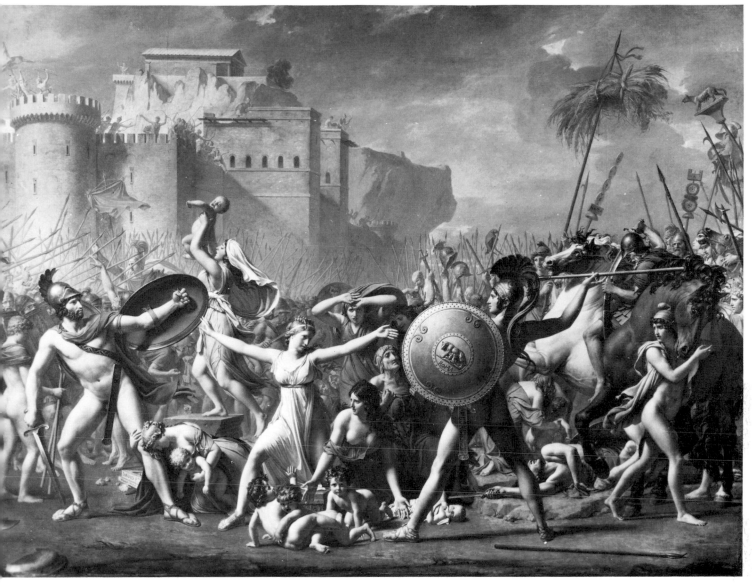

Jacques-Louis David: The Intervention of the Sabine Women; oil on canvas; 386×520cm (152×205in); 1799. Louvre, Paris

beauty, and above all the correctness, of antique Greek and Roman art. At the same time, archaeologists were bringing to light antiquities which profoundly affected artists' conceptions of bygone days.

David progressed slowly towards the style that was to make him the most influential French painter of his time. His *Antiochus and Stratonice* (1774; Musée de l'École Supérieure des Beaux-Arts, Paris), won him the Prix de Rome, entitling him to spend four years in Italy at the French government's expense. The picture does not break radically with the taste of the day. The classicizing style that was to dominate French art under David's leadership is evident in its subject matter, but the Rococo is still strongly suggested in the crowded composition and consciously pretty colors. David's five years in Rome, from 1775 to 1780, which he spent studying ancient monuments and sculptures as well as works of the Renaissance and the Baroque, convinced him of the need to adopt a more rigorously classical approach.

Back in France, David finally drew together all the elements associated with Neoclassicism in his *Oath of the Horatii* (1785; Louvre, Paris), called by one contemporary critic "the most beautiful painting of the century". The background is as sparse and rigid as a Greek theater; the figures of the warriors, as unbending in their bearing as in their intent, are placed in parallel rather than receding planes. The painting echoes perfectly the "noble simplicity and calm grandeur" so favored by Winckelmann. This work has often been cited as heralding the Revolution. Although this seems far-fetched, David himself quickly became involved when hostilities began in 1789. He voted for the death of the King in 1793, as a member of the National Assembly, and allied himself with the extreme faction headed by Maximilien Robespierre. His support of the group led to his imprisonment in 1795, but fortunately he was not long incarcerated. All his work of this period demonstrates his involvement, be it his organization of festivals celebrating Revolutionary events, or such a drawing as the *Oath of the Tennis Court* (1791; William Hayes Fogg Museum of Art, Cambridge, Mass.). Echoing in its gestures the *Oath of the Horatii*, the work breaks new ground in showing a large number of identifiable figures engaged in an important contemporary event.

Another side of David's work is shown by his portraits—often intimate, even when executed on a large scale as in *Lavoisier and his Wife* (1791; Metropolitan Museum, New York). The superb *Death of Marat* (1793; Musées Royaux des Beaux-Arts de Belgique, Brussels) is much more than the mere representation of a man known and admired by David: it is conceived almost in the manner of an icon, glorifying the Revolutionary who has been assassinated in his bath for his beliefs. Portraiture remained an important element in David's art throughout his life, and it

assumes a new importance in his relations with Napoleon Bonaparte, who, David declared, was "his hero". Napoleon knew nothing about art, but, recognizing David's fame, he wished to have him at his service in order to fullfil his aim of propagating his image throughout Europe. David's first Napoleonic commission was *Bonaparte Crossing the Saint Bernard Pass* (1800; Versailles), very different in conception from the somber *Death of Marat*. This latter, painted in quiet shades of green and brown, has none of the splendor in the portrait of the ambitious and victorious Consul and General. Under the Napoleonic regime, when David became *Premier Peintre* to the Emperor, he did not entirely neglect his first love, classical painting. However, as can be seen from *Leonidas at Thermopylae* (Louvre, Paris), worked and reworked from 1800 to 1814, this style could not compete with the brilliance of contemporary reality. Depicting as it does a group of warriors condemned in advance to defeat, the work was totally out of key with the times. As Napoleon himself told David, "You are wasting your time painting losers".

The two vast works David executed to commemorate Napoleon's coronation, *The Coronation of Josephine* or *Le Sacre* (1808; Louvre, Paris), and the *Distribution of the Eagles* (1810; Versailles), are much more successful. Here David draws his inspiration from the Flemish school, especially Rubens, rather than from the Antique; he even visited Belgium to study Flemish works *in situ* before embarking on his own paintings. Both of these immense canvases caused David considerable trouble, as he had to fit his conception to the vacillating demands of the self-conscious Emperor, over-anxious to ensure a flattering likeness to himself and his retinue. Despite the difficulties, however, these works are unrivaled in showing, if not the truth of life under Napoleon, then the glory he wished to evoke.

At the Restoration David was in an untenable position. True to Napoleon, he refused to sign an oath of loyalty to the new monarch, Louis XVIII, and was forced into exile, living in Brussels until his death. There he continued to paint, and kept in touch with his former pupils: many of them, for example Gros, Gérard, and Ingres, had now become famous. David's own art had suffered, however. He was still convinced that the Antique was the only serious subject for a painter, but was unable to forget the influence of contemporary events; the work of his last years lacks the tautness and vitality that had made him preeminent.

Further reading. Brookner, A. *Jacques-Louis David*, London (1980). Friedländer, W. *David to Delacroix*, Cambridge, Mass. (1966). Hautecoeur, L. *Louis David*, Paris (1954). Herbert, R.L. *David's "Brutus"*, London (1972). Rosenblum, R. *Transformations in late 18th Century Art*, Princeton (1970).

Davie Alan 1920–

The Scottish painter, jeweler, and jazz musician Alan Davie was born in Grangemouth. He studied at Edinburgh College of Art in 1937, was Gregory Fellow at Leeds University from 1956 to 1959, and taught at the Central School of Art and Design, London, from 1954 to 1957 and again in 1960.

Davie's paintings are never entirely Abstract. Those dating from the late 1940s depend upon an imaginative vocabulary of

Stuart Davis: Lucky Strike; oil on canvas; 84×46cm (33×18in); 1921. Museum of Modern Art, New York

symbols relating to primitive magic, mysticism, and Zen. A strong autobiographical and unconscious content, often erotic, runs through his work. The painter's thick, gestural brushstrokes in somber, earthy colors and bright, jewel-like flashes became more controlled in the late 1950s. He began to develop detail-encrusted images, using lighter colors and smoother paint. His earlier spontaneity was gradually replaced by a reworking of themes. In the late 1960s the figuration in his paintings became less ambiguous and he introduced interior settings for his imagery.

Davis Stuart 1894–1964

Stuart Davis was one of the most consistent, adventurous, and relatively unrecognized of American modern painters. He was a radical illustrator before the First World War, and by the 1920s was creating Abstract paintings composed of shapes and mass-produced objects, such as *Lucky Strike* (1921; Museum of Modern Art, New York). A visit to Paris from 1928 to 1929 did not have a profound effect on his style, but did much to enhance his self-confidence. Davis painted murals such as *Swing Landscape* (1938; Indiana University) in the 1930s. His enthusiasm for jazz syncopation and for the internal visual development of his work provided a more genuine structure than slavish adaptation of contemporary European models.

Degas 1834–1917

Hilaire-Germain-Edgar de Gas (who signed his works "degas" or "Degas" after 1870) was the great draftsman of his age. He rivaled the virtuosity of his hero Ingres, and developed boldly original pictorial forms in his scenes of contemporary life.

Degas was born on 19 July 1834, in Paris. Both his parents were descendants of French *emigrés*—his father came from Naples and his mother from New Orleans. But despite several journeys to Italy during his youth, and a visit to an uncle in New Orleans in 1873, Degas remained essentially a Parisian. All his major themes were taken from Parisian life. He did paint one masterpiece in the United States, *The Cotton Exchange at New Orleans* (1873; Musée des Beaux-Arts, Pau). But he felt uneasy there, saying: "one makes an art out of what one knows well."

Degas' father was a banker, director of the Paris branch of the family business;

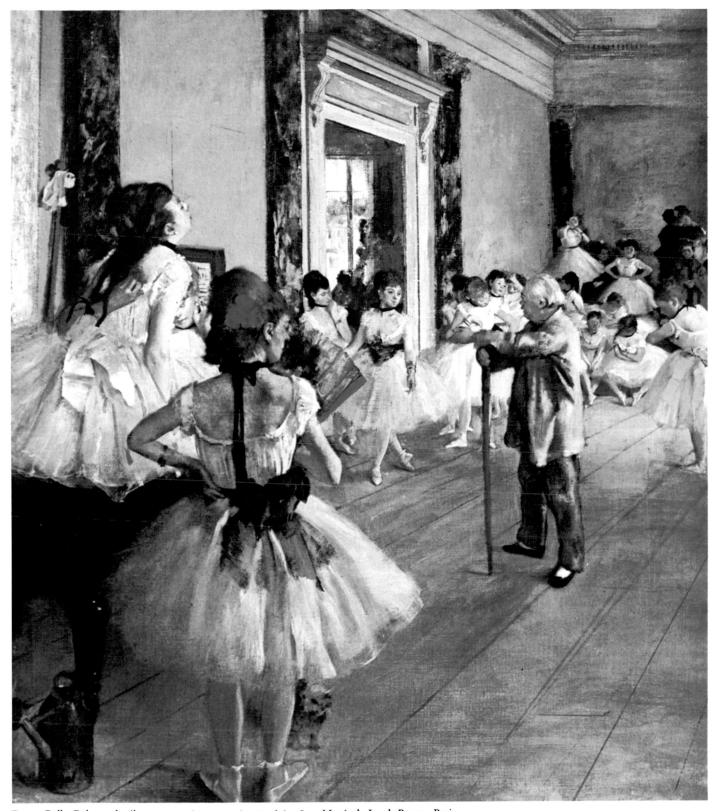

Degas: Ballet Rehearsal; oil on canvas; 85×75cm (33×30in); 1875. Musée du Jeu de Paume, Paris.

when Edgar preferred painting to the law, he received an income that made him independent of academic recognition and patronage. It was only after 1875—when he sacrificed most of his inheritance to save his brother Achille from bankruptcy—that he had to earn his living as a professional artist.

His financial independence reinforced his solitary and aristocratic temperament. He never submitted works to the Salon after 1870. Although he was a close friend of Manet, and a founder member of the *Société Anonyme des Artistes, Peintures, Sculpteurs, Graveurs*, later known as the Impressionists, he was never himself a true Impressionist. His fascination with indoor figure-groups places him apart from the

Impressionists, though his increasingly brilliant palette and interest in the fleeting makes him akin to them.

Degas' art was rooted in tradition. When he was 21 he entered the École des Beaux-Arts; there he was taken under the wing of Louis Lamothe, who had been a pupil of Ingres. At the Beaux-Arts, and on his first visit to Italy, Degas studied and copied the

works of Old Masters. As he said: "No art was ever less spontaneous than mine. What I do is the result of reflection and the study of the great masters." He also believed that "the study of nature is of no significance, for painting is a conventional art."

Although he met Manet in 1862, Degas was slow to treat contemporary subjects. His early compositions were taken from history, and included such works as *Semiramis Founding a City* (Louvre, Paris), *Young Spartans Exercising* (National Gallery, London), and *Jephthah's Daughter* (c1861–4; Smith College Museum of Art, Northampton, Mass.). Each of these works was constructed from careful preliminary studies in the academic tradition. The only history painting he exhibited at that time was *Scenes of War in the Middle Ages* (1865; Louvre, Paris) at the Salon of 1865. Degas' disquieting image of mounted archers discharging their shafts at naked women was admired by Puvis de Chavannes, but was generally unnoticed.

The one modern subject he exhibited at the Salon also went unregarded. This was the *Fallen Jockey* (1866; private collection) which, although prepared from careful drawings in the traditional way, was a large, unconventional composition. Apart from a few, usually small, racecourse subjects, Degas approached modern subject matter obliquely during the 1860s. Beginning with an enormous canvas, *The Bellilli Family* (1858; Louvre, Paris) showing his aunt's family in Florence, he painted a brilliant series of portraits that showed his sitters in elaborate interiors, and so combined subtle and polished characterizations with original, even bizarre, compositions. One of the earliest is *Woman with Chrysanthemums* (1865; Metropolitan Museum, New York). *Mme Camus* (1870; National Gallery, Washington, D.C.) is silhouetted against a golden wall that dominates the composition, creating an abstract arabesque that suggests Japanese woodcuts.

But by that time, Degas was beginning to look out for modern subjects: he listed potential motifs in notebooks. Among the earliest of these studies was *The Orchestra of the Paris Opera* (1868–9; Louvre, Paris). This was developed from portrait studies—including one of the composer Chabrier. The heads of the players were related in a complex wedge of forms, while the ostensible spectacle (the dancers) was reduced to a fringe of legs and tulle along the top of the canvas.

The dancers were given their due importance in the series of ballet dancers at rehearsal, painted in the 1870s, such as the *Dancing Class at the Ballet School of the Opera* (1872; Louvre, Paris). These are the most remarkable works of Degas' career, yet none is large; several in fact are remarkably small (for example, *The Foyer*, 1872, Metropolitan Museum, New York, is 71/2; by 101/2 in, 19 by 27 cm) and are all muted in color. In many ways they are traditional, with precursors among the works of Watteau (1684–1721) and Hogarth (1697–1764), yet at the same time they are completely original. In ballet rehearsals, Degas found a curious blend of charm and tedium, grace and ungainliness, with figures grouped not dramatically, but accidentally, according to ritual and repetition. In the bleak rehearsal rooms, with large mirrors and long windows, he discovered uncanny perspectives: a world that mixed dream and drab reality.

Ever since the Franco-Prussian war of 1870 Degas had suffered from failing eyesight, and in the 1880s he abandoned the small scale of his first ballet scenes. Instead, he began experimenting in a range of media, pastel in particular. His motifs included racecourses, theaters, laundresses, milliners, and cafés and cabarets. But the two themes he made his own were the ballet and a woman at her toilette. On these subjects he made pastels of almost abstract brilliance, showing powerfully the influence of Japanese art. His series of a woman taking a bath has images at once intimate and anonymous, close-up, yet abstract and detached. In this way they differ completely from the many monotypes he made of brothel scenes: these are filled with a bawdy wit and a light line that is a brilliant complement to the economy of Japanese draftsmanship.

During his lifetime, Degas exhibited only a single piece of sculpture, a wax of *The Little Dancer of 14 Years* dressed in specially made muslin tutu, linen bodice, and satin shoes, which he showed at the sixth Impressionist exhibition of 1881. (Bronzes can be seen at the Tate Gallery, London, and elsewhere.) But after his death, 74 smaller pieces, mainly in wax, were found in his studio, including dancers, bathers, and horses. Modeled broadly yet precisely, they established Degas as one of the great sculptors of the 19th century.

Despite a prickly temperament, Degas supported younger artists he admired. At his death, his collection included works by Cézanne, Gauguin, Pissarro, Sisley, Morisot, and Van Gogh. Although attracted to women, Degas appears to have been both timid and proud; he never married. In his last years he went almost completely blind, and in 1912, when he had to leave the studio he had used for many years, he stacked up his canvases and never worked again. He was often to be seen stalking through the Paris streets until his death in 1917 at the age of 83.

Further reading. Kendall, R. (ed.) *Degas by Himself: Drawings, Prints, Paintings, Writings*, London (1987). Lemoisne, P. *Degas et son œuvre* (4 vols.), New York and London (1947–8, reprinted 1984). Millard, C.W. *The Sculpture of Edgar Degas*, Princeton (1976). Reff, T. *Degas: the Artist's Mind*, New York (1976). Reff, T. "The Pictures within Degas' Pictures", *Metropolitan Museum Journal*, New York (1968). Rivière, G. *Degas, Bourgeois de Paris*, Paris (1935).

Delacroix Eugène 1798–1863

The greatest French painter of the first half of the 19th century, Eugène Delacroix is generally considered to have been the leader of the Romantic school—opposed to the Neoclassicism of Ingres. Delacroix's emotive use of color, relative subordination of line, and dramatic composition contrast with Ingres' insistence on draftsmanship and carefully balanced static composition.

The public and many critics saw Delacroix as an indiscriminate iconoclast: he was elected to the Institut only in 1857, at his seventh attempt, and suffered much adverse criticism. In personality, however, he was very different from the turbulent young Romantics who gathered round Victor Hugo. His aloof and aristocratic nature emerges from his *Self-portrait* (1835–7; Louvre, Paris).

He was born in 1798 into a family of the *haute bourgeoisie* (although evidence suggests that he may have been the natural son of Talleyrand), and received a thorough classical education. In 1816 he entered the studio of Pierre-Narcisse Guérin, a distinguished Neoclassicist; there he met Géricault, who influenced him profoundly. He visited England in 1825 and Morocco in 1832. After his return he received a number of important decorative commissions through friendship in official circles. In 1855 he was made a Commander of the

Legion of Honor, and also had 35 works shown in the *Exposition Universelle*. He died in 1863: Baudelaire, his greatest and most discerning champion, wrote an obituary *L'Oeuvre de Delacroix*.

Géricault's *The Raft of the Medusa* (1819; Louvre, Paris) was the inspiration of Delacroix's *Dante and Virgil Crossing the Styx* (1822; Louvre, Paris), his first Salon painting, which was generally admired. His color here is still close to Géricault's, showing a predominantly earthy palette and marked chiaroscuro; but the painting also shows the expressive use of color that he was to develop later in his career.

A decisive innovation in Delacroix's style took place under the influence of Constable, whose paintings he saw in Paris in 1823. In the Salon of 1824, Delacroix exhibited the *Massacre at Chios* (Louvre, Paris). He is thought to have retouched the painting using Constable's procedure of adding flecks of paint of various colors to the foreground to animate the surface, and to bind the composition together through chromatic harmony.

The *Massacre at Chios* and *Greece Expiring on the Ruins of Missolonghi* (1827; Musée des Beaux-Arts de Bordeaux) illustrate subjects inspired by the Greek War of Independence, interest in which was stimulated by Byron. *The Death of Sardanapalus* (1827; Louvre, Paris) depicts a subject drawn from Byron, and, like *Massacre at Chios*, typifies Romantic interest in exoticism and suffering. The composition of *Sardanapalus* is highly animated, showing baroque, diagonal lines of force; vibrant reds and golds are used to underline the violent nature of the scene.

In the four years that followed his visit to England, Delacroix's major works used subjects from English literature: *The Murder of the Bishop of Liège* (1829; Louvre, Paris) was based on Sir Walter Scott, and *The Execution of the Doge Marino Faliero* (1827; Wallace Collection, London) on Byron. The treatment of the latter relies heavily on the influence of Bonington (1801–28), while the *Portrait*

Eugène Delacroix: Lion Hunt; oil on canvas; 76×98cm (30×39in); 1861. Art Institute of Chicago

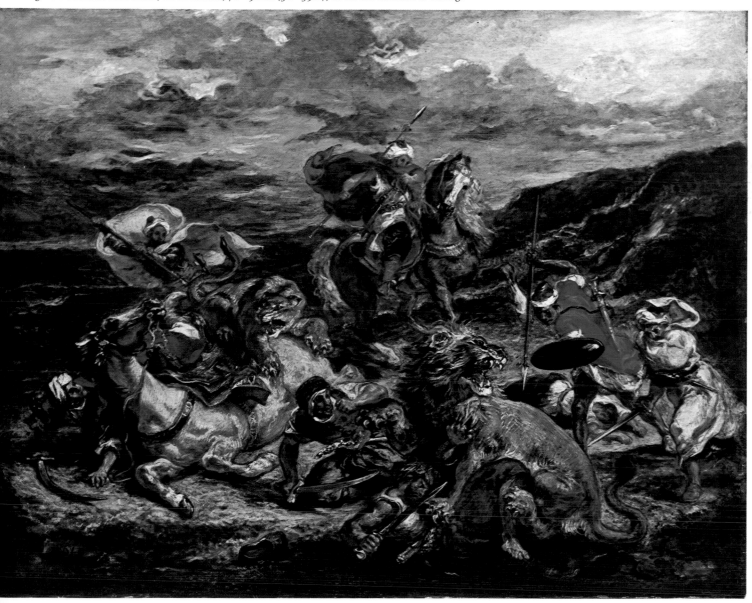

of *Baron Schwitter* (1827; National Gallery, London) shows the influence of Sir Thomas Lawrence (1769–1830), whom Delacroix met on his trip to London. The Revolution of 1830 inspired Delacroix to paint *Liberty Leading the People* (1831; Louvre, Paris), which combines idealism with vivid, realistic description.

On his visit to Morocco in 1832 Delacroix found that the Arabs, in their bearing, dress, and way of life, represented a living link with the ancient world. Their natural dignity contrasted with the cold formality of Neoclassical depictions of the Greeks and Romans. For his Moroccan sketches he reverted to the English watercolor techniques of his friends Bonington and Thales Fielding, in an attempt to render the freshness of his impressions. The intensity of the north African light sharpened his observation of the interaction of light and color in nature. He applied these discoveries in *Women of Algiers* (1834; Louvre, Paris), modifying the local colors according to the intensity of the light falling on them, and using contrasts of complementary colors. A series of paintings grew out of this journey, including *Jewish Wedding in Morocco* (1841; Louvre, Paris), and *The Sultan of Morocco Surrounded by his Court* (1845; Musée des Augustins, Toulouse).

Delacroix's major decorative commissions in Paris under Louis Philippe were the Salon du Roi (1833–7) and the Library (1838–47) of the Palais Bourbon, the Library of the Luxembourg Palace (1841–6), a *Pietà* at St Denis du Saint Sacrement (1843), a ceiling in the Galerie d'Apollon of the Louvre (1849–51), the Salon de la Paix of the Hôtel de Ville (1851–3; destroyed), and the Chapelle des Anges in St-Sulpice (*c*1856–61). The works are conceived in the tradition of Baroque mural painting, but within this framework Delacroix made considerable advances in his use of color. He was preoccupied with luminosity; he decreased the quantity of black in his work, and began using white underpainting, a technique later adopted by the Impressionists.

Delacroix's color theories were derived from two sources: close observation of nature and scientific theories of the interactions of color, such as those of Eugène Chevreul. In Delacroix's *Entry of the Crusaders into Constantinople* (1841; Louvre, Paris), there is a systematic use of contrasts of complementary colors, which can be seen in the standards carried by the Crusaders. In contrast to Ingres, who concealed his brush strokes, Delacroix made his quite obvious. In his mature work, for example *The Justice of Trajan* (1840; Musée des Beaux-Arts de Bordeaux), he developed this technique, using a broken style of brush work to animate the surface of the painting.

Throughout his career, Delacroix produced a number of colorful, lively easel paintings. These include many animal paintings (for example, *Lion Hunt*, 1855; Musée des Beaux-Arts de Bordeaux), scenes of Arab life (for example, *Fanatics of Tangier*, 1831; Jerome Hill Collection; New York), and subjects from medieval history and from literature (for example, *Hamlet and the Gravedigger*, 1839; Louvre, Paris). He painted many successful portraits, for example those of *Chopin* (1836; Louvre, Paris), *Paganini* (1831; The Phillips Collection, Washington, D.C.), and *Jenny Leguillou* (1840; Louvre, Paris).

Delacroix was deeply concerned with the theory of art: he began, but never completed, a dictionary of the fine arts. His journal, kept from 1822 to 1824 and again from 1847 to 1863, is a particularly valuable source of information about his personal and professional life, and about his aesthetic theories.

Further reading. Baudelaire, C. (trans. Mayne, J.) *The Painter of Modern Life and Other Essays*, London (1964). Baudelaire, C. (trans. Mayne, J.) *Art in Paris 1845–1862*, London (1965). Delacroix, E. (ed. Wellington, H., trans. Horton, L.) *The Journal of Eugène Delacroix*, Oxford (1980). Huyghe, R. (trans. Griffin, J.) *Delacroix*, London (1963).

Delaunay Robert 1885–1941

The French painter Robert Delaunay was apprenticed to a stage designer in 1902. He took up a painting career in 1904, but his work always continued to show his concern for the qualities of design.

He rapidly moved away from traditional practices. By 1905 he was painting in large patches of bright color in the manner of the Fauves. In 1908, under the influence of Cubism, his color was temporarily subdued, but he soon reintroduced it in a fractured, prismatic form.

A major work, *La Ville de Paris* (1912; Musée d'Art Moderne de la Ville de Paris) demonstrates the then-popular idea of "simultaneity", as elaborated by the French philosopher Henri Louis Bergson. Both Delaunay and the Italian Futurists

Robert Delaunay: Rhythm 579; oil on canvas; 113×145cm (44×57in); 1934. Private collection

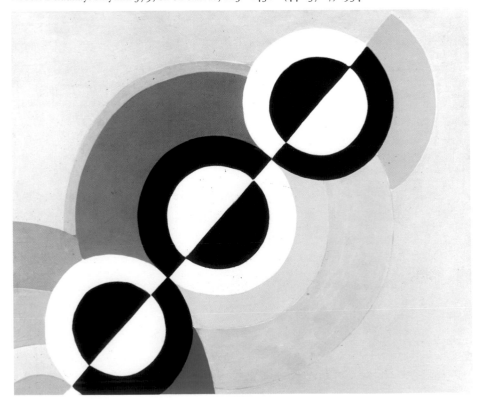

explored this idea, which contends that the world impresses itself upon the consciousness as fleeting, intuitively understood sensations. In *La Ville de Paris*, Delaunay was not concerned to depict how Paris looked, but how it felt from minute to minute; he indicated the speed and pressure of life in a big city with overlapping and fragmented forms including an iron bridge and the Eiffel Tower. "Simultaneity" was seen as a particularly appropriate description of modern life, and Delaunay painted a series of views of contemporary Paris which conveyed a sense of urgency and movement, as in *The Cardiff Team* (1912–13; Van Abbe Museum, Eindhoven).

After 1912 this dynamism changes to more regular rhythmic form: rectangular shapes in the *Fenêtres* series, and circular shapes in the *Disks*. Some of these paintings could be considered Abstract, but they contain an insistent strain of cosmic symbolism. Brilliant light and color are enhanced by "simultaneous contrast", an effect of spatio-temporal juxtapositions—attempted by Michel Eugène Chevreul, Toulouse-Lautrec, and Seurat in the 19th century—in which color is a primary element. Delaunay and the Duchamp brothers combined Fauve color with Cubist forms in penetrating simultaneous views of the same object either at the same time or at successive moments. In 1912, Apollinaire gave a lecture at an exhibition of Delaunay's work in Berlin; he labeled the artist's style "Orphism". It had a great effect on the German *Blaue Reiter* group—Franz Marc, Auguste Macke, and Wassily Kandinsky—as well as on Paul Klee, Fernand Léger, and Marc Chagall.

In 1910 Delaunay married the Russian artist Sonia Terk; she used Orphism as the basis of a style of decoration. Delaunay spent the years 1914 to 1921 in Spain and Portugal. After his return to Paris, his work became stiff and lacking in spontaneity. He painted large mural decorations such as the *Ville de Paris* (1925; Exhibition of Decorative Arts, Paris), and a gigantic *Rhythm* in the Hall of Air for the 1937 Paris International Exhibition.

Further reading. Cohen, A. (ed.) *The New Art of Color: the Writings of Robert and Sonia Delaunay*, New York (1978). Dorival, B. *Robert Delaunay et le Cubisme*, Saint-Étienne (1973). Pernes, R. *Robert et Sonia Delaunay à Portugal*, Lisbon (1972). Schmidt, G. *Robert Delaunay*, Paris (1957).

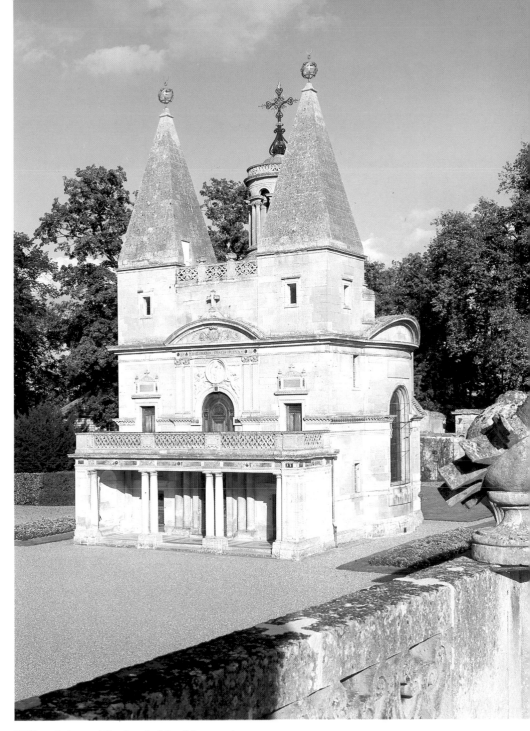

Philibert Delorme: The chapel of the château at Anet; 1549–52

Delorme Philibert c1510–70

The French architect Philibert Delorme (or De L'Orme) came from Lyons. He lived in Rome from c1533 to 1536, but returned to Lyons to begin his career as an architect. On the accession of Henri II in 1547 he was appointed superintendent of buildings. In this capacity and in that year, he took over the newly begun château at Anet; on commission from Diane de Poitiers, he built the side-wings between 1549 and 1551, the chapel between 1549 and 1552, and the entrance pavilion in 1552. The rather old-fashioned courtyard plan was not impressive, but Delorme's centralized chapel anticipated that of Palladio at Maser. The ingenious mixture of medieval and classical in the entrance pavilion was a vital step forward in French architecture. His later work at Chenonceaux and the Tuileries show a refinement of these bold innovations. As a canon of Notre Dame of Paris he oversaw work on the cathedral. In 1567, he published his popular *Le Premier Tome de l'Architecture*, which included French versions of the Classical orders; the book helped to establish the respectability of his own works, and of French architecture in general.

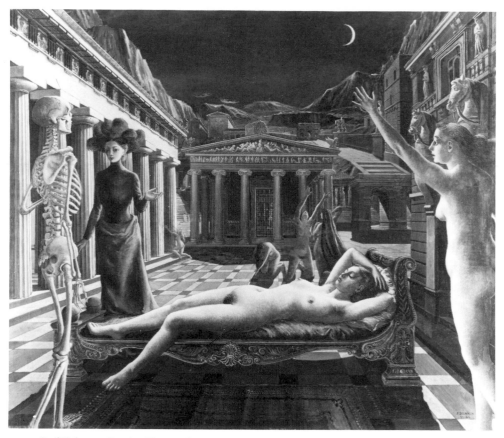

Paul Delvaux: Sleeping Venus; oil on canvas; 173×199cm (68×78in); 1944. Tate Gallery, London

Delvaux Paul 1897–1994

The Belgian painter Paul Delvaux was associated with the Surrealists, although he was never actually a member of the movement. After studying architecture in Brussels he took up painting, at first working in a style derived from the Impressionists. In 1936 he came under the transforming influence of Chirico and Magritte, and after that his work altered little. His characteristic paintings are illusionistic in style and dream-like in imagery: naked or partially clothed women, sometimes observed by respectably dressed men, move silently and expressionlessly within improbable architectural settings. These superficially tranquil scenes are invested with an atmosphere of muffled sexual tension.

Further reading. Butor, M. and Clair, J. *Paul Delvaux: Catalogue Raisonné*, Brussels (1974). Terrasse, A. *Paul Delvaux*, Paris (1972).

Demuth Charles 1883–1935

The American painter Charles Henry Demuth was born at Lancaster in Pennsyl-vania. Lame from childhood, he was always frail. He studied at the Pennsylvania Academy of Fine Arts (1905–10), and made two visits to Europe (1907–8; 1912–14), where he met Gertrude Stein and her circle. He had an opportunity to see the art of Cézanne and the Fauves which influenced his style. His preferred medium was watercolor. He was eclectic, borrowing from both Cubism and Expressionism; his finest watercolors combine a simplified sense of space with a delicate command of color.

Demuth was fond of circus themes, and still life; but he also became an illustrator, for example for the two Henry James' stories, *The Turn of the Screw* (1918–19) and *The Beast in the Jungle* (1919–20). Alongside his more naturalistic work he also developed a Cubist-based style that he applied to urban subject matter such as streets and factories. His most famous work, the oil painting of 1928 known as *I Saw the Figure Five in Gold* (Metropolitan Museum, New York) belongs to this more abstract idiom.

Further reading. Haskell, B. *Charles Demuth*, New York (1987).

Denis Maurice 1870–1943

The French artist and art theorist Maurice Denis was a founder member of the group of painters known as the Nabis. He was the most prominent spokesman of the generation that followed in the footsteps of Gauguin, Émile Bernard, and Cézanne.

Born at Granville, he spent almost all his life at St Germain-en-Laye outside Paris. After attending the Lycée Condorcet, where he met the future artists Vuillard and K.-X. Roussel, Denis joined the Académie Julian in 1888. It was here that he met Paul Sérusier, Pierre Bonnard, and Paul Ranson and in the autumn of 1888 saw the result of Sérusier's lesson in Pictorial Symbolism, *The Talisman* (1888; Collection of J.E. Denis, St Germain-en-Laye). This painting acted as a catalyst for the young art students. Denis and his friends formed themselves into a revolutionary group and christened themselves the "Nabis", or "prophets". They dedicated themselves to the rejection of three things: the photographic representation of Nature in painting, the use of trivial anecdotal subject matter, and belief in the superiority of the easel painting. Furthermore, they believed in the unity of the arts and the serious and revelatory mission of the arts in proclaiming the existence of the idea.

Denis, with the help of Sérusier, published this program of artistic reform in two articles entitled "Définition du Néo-Traditionnisme" in the periodical *Art et Critique* (August, 1890). This was the first of a series of theoretical writings on art, the most important being his *Théories* published in 1912. The pictorial equivalent to this program can be seen in Denis' *Taches de Soleil sur la Terrasse* (1890; Collection of D. Denis, St Germain-en-Laye). Influenced by Gauguin, Bernard, Puvis de Chavannes, and Japanese prints, the work's title alone helps the spectator to discern the line of trees receding on the right-hand side of the panel with their red shadows cast across the orange path.

Gauguin's departure to Tahiti in 1891 caused a vacuum in the Nabis' artistic leadership which, as Denis later recalled, they filled by turning to literature. In response to this change, Denis produced between 1891 and 1898 a number of "synthesist" stage, costume, and program designs for the Symbolist *Théâtre de l'Oeuvre* founded by his friend, the actor and impressario Lugné-Poë. He also turned his attention to book illustration,

During the decade of the 1890s, Denis visited Italy three times. Confronted with the Classical traditions of Ancient Rome and the Renaissance, he gradually modified his two-dimensional, non-naturalistic Nabis style and adopted the more vigorously classical vocabulary seen in his painting *Jeux Aquatiques* (1908; private collection).

Denis' output covered both easel painting and decorative cycles. For subject matter he relied heavily upon representations of his family as participators or actors in scenes from the Bible (for example *Sinite Paevulos*, 1900; private collection). Denis was a deeply committed Roman Catholic. He believed that his gift as an artist should be placed at the service of the Church. He undertook a number of large decorative cycles for churches (for instance *La Glorification de la Croix*, 1898–9; Collège de la Sainte-Croix, Le Vésinet) and in response to the parlous state of contemporary church art he founded the Atelier d'Art Sacré in 1918, together with the artist Georges Desvallières. This Atelier undertook the complete decoration of church interiors, including frescoes, altarpieces, and stained glass windows—such as are found in Perret's church, Notre-Dame de Raincey, Paris (1922–3).

Further reading. Brilliant, M. *Maurice Denis*, Paris (1930). Denis, M. *Du Symbolisme au Classicisme: Théories*, Paris (1964). Denis, M. *Journal: 1884–1943*, Paris (1959). *Exposition Maurice Denis*, Albi (1963).

Denny Robyn 1930–

The British painter Robyn Denny was born in Abinger, Surrey, in 1930. He studied at St Martin's School of Art (1951–3) and at the Royal College of Art (1953–7). In 1966 he represented Britain at the Venice Biennale and in 1973 became the youngest living artist ever to have a retrospective exhibition at the Tate Gallery, London. His large-scale paintings of the late 1950s were influenced by Abstract Expressionism and he was included in the "Situation" exhibition (1960). But at the same time he was developing a hard edged rectilinear style. This led to symmetrical compositions in which a centralized "image", comprising bands and later blocks of color, was disposed against a color ground. In the late 1970s the paintings became asymmetrical with fewer colors.

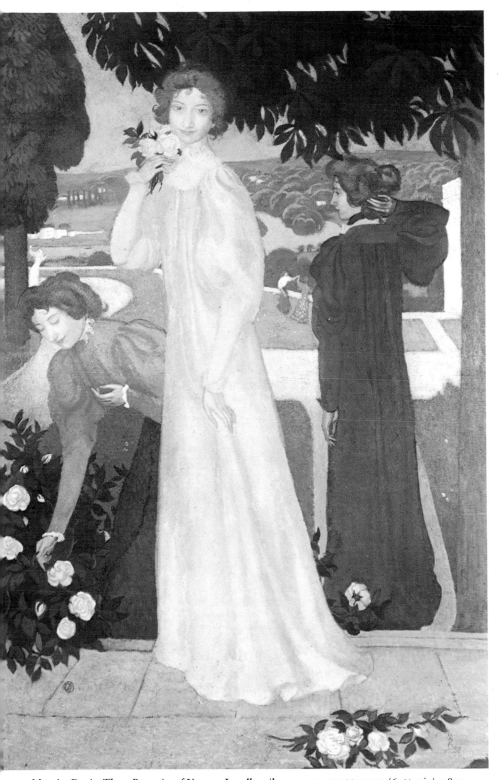

Maurice Denis: Three Portraits of Yvonne Lerolle; oil on canvas; 170×110cm (67×43in); 1897. Private collection

producing work just as radical as his painting and stage designs. He believed that an illustration "must find that form of decoration without servitude to the text", and he sought in the designs such as those executed for André Gide's *Voyage d'Urien* (1893; Librairie de l'Art Indépendant, Paris) to create "an embroidery of arabesque on the page, an accompaniment of expressive lines".

Derain André 1880–1954

The French painter André Derain was born at Chatou. He rapidly gained prominence in Paris after studying at the Académie Carrière (1898–9) and the Académie Julian (1904), and was given a contract by the art dealer Ambrose Vollard in 1905. He was one of the boldest of the Fauve group, which included Matisse, Vlaminck, Braque, and Marquet.

Derain's series of landscapes from 1905 to 1907 are vigorously painted with dabs of intense color, rapidly applied and held together by spontaneous and powerful compositions which combine to give dramatic expression to the picture space (for example, *Westminster Bridge*, 1906; private collection).

He was soon open to new possibilities and was the first of the Fauve group to consider seriously using ethnographic art as a source, although Vlaminck is credited with starting the vogue for collecting it. Later, Derain's impressionable nature brought him under the influence of Picasso, Braque, and Cézanne, whose posthumous exhibition in 1907 led him to a reappraisal of his treatment of structure and space (for example, *Old Bridge at Cagnes*, 1910; National Gallery of Art, Washington D.C.).

After 1912 his paintings exhibited a fusion of Cubist and Neoclassical styles. After his first one-man show in 1918 at the Galerie Paul Guillaume in Paris, neoclassicism predominated, entailing a corresponding loss of verve. Derain received First Prize in the Carnegie International in Pittsburgh in 1928 for *La Chasse*.

He was also active as an illustrator and made drawings for Apollinaire's *L'Enchanteur Pourrissant* of 1909, as well as illustrating the works of many other writers.

Further reading. Diehl, G. (trans. Hamilton) *Derain*, New York (1964). Sutton, D. *André Derain*, London (1959).

André Derain: The Artist and his Family in the Artist's Studio; oil on canvas; 116×89cm (46×35in); 1920–1. Pierre Matisse Gallery, New York

Deschamps Jean 13th century

Jean Deschamps was a 13th-century French architect. In 1248 he began work on Clermont-Ferrand Cathedral. Like its exact contemporary at Cologne, it is a monumental example of northern French Gothic imported into a region that had no earlier experience of the style. Certain features of the design, notably the deep side-chapels surrounding the choir and the restricted size of the clerestory windows, suggest a deliberate rejection of the "glass cage" effect favored in the North. The increased emphasis on plane surfaces and spatial effects was to become characteristic of southern French and Catalan Gothic in the following century. In 1286 Deschamps was appointed architect to Narbonne Cathedral, but its design is quite different in style to Clermont-Ferrand and had probably already been settled when work started in 1272. He may have been the father of Pierre Deschamps, an architect of the same area of France who died in the early 14th century.

Desiderio da Settignano c1428–64

The Italian sculptor Desiderio was born in the quarry-town of Settignano near Florence. Like the Rossellino brothers, Desiderio came of a family of stonemasons from whom he learned his craft. He matriculated into the Sculptors' Guild of Florence in 1453 and was associated in that year with Antonio Rossellino. Desiderio was a brilliant carver both of marble and of the gray sandstone known as *pietra serena*. His style shows the strong

Jean Deschamps: Narbonne Cathedral

influence of Donatello, particularly in his reliefs, but lacks Donatello's drama and emotional intensity. Only two works from his brief career can be approximately dated: the monument to Chancellor Carlo Marsuppini (ob. 1453) at S. Croce, Florence, and the Altar of the Sacrament in S. Lorenzo, Florence, in 1461. A number of reliefs showing the Virgin and Child, as well as busts of boys and young women, may be reliably attributed to him.

Desportes Alexandre-François
1661–1743

The French painter Alexandre-François Desportes moved to Paris from Champagne at the age of 12. He studied under a pupil of the Flemish painter Frans Snyders, learning to specialize in still life and hunting scenes. After a brief period in Poland as Court Painter to King John Sobieski, Desportes returned to Paris and was appointed painter to the Royal Hunt. He decorated a number of palaces including Anet and Chantilly, and designed a series of eight large hunting scenes for Gobelins

Alexandre-François Desportes: A Tiger Walking; chalks. Louvre, Paris

tapestry factory. The Flemish style of both Chardin (1699–1779) and Oudry (1686–1755) is due more to the influence of Desportes than to Flemish painting itself.

Devis family 18th century

The British brothers Arthur and Anthony Devis specialized in painting conversation pieces and portraits. Their clientele was drawn mainly from the merchant classes whom they depicted as living in a secure world of middle-class values. The elder brother Arthur (1711–87) is supposed to have studied under the landscape painter Peter Tillemans (1684–1734); his work was regarded as cliché-ridden, even during his own lifetime. His brother Anthony (1729–1816) worked in London as a painter of conversation pieces from 1742. His work presents a meticulous inventory of a family's estate and possessions, with formally posed figures which have a certain naive charm.

Dexamenos 5th century BC

Dexamenos was a Greek gem-engraver, native of the island of Chios, who worked in the third quarter of the 5th century BC. He is the foremost exponent of the Classical style in gem-engraving, working on scarab-shaped gems of chalcedony, about ¾ in (2 cm) long. His style is characterized by originality of subject matter and extreme precision of technique, including the hand-cutting of fine linear detail where usually wheel-cut work was considered adequate. Four signed gems survive. One in the Museum of Fine Arts, Boston, from Attica, shows a bearded male head which has been regarded by many scholars as one of the earliest examples of a portrait in Greek art. It is likely, however, to be a

Arthur Devis: The Rookes-Leeds Family; oil on canvas; 91×124cm (36×49in); c1763. Private collection

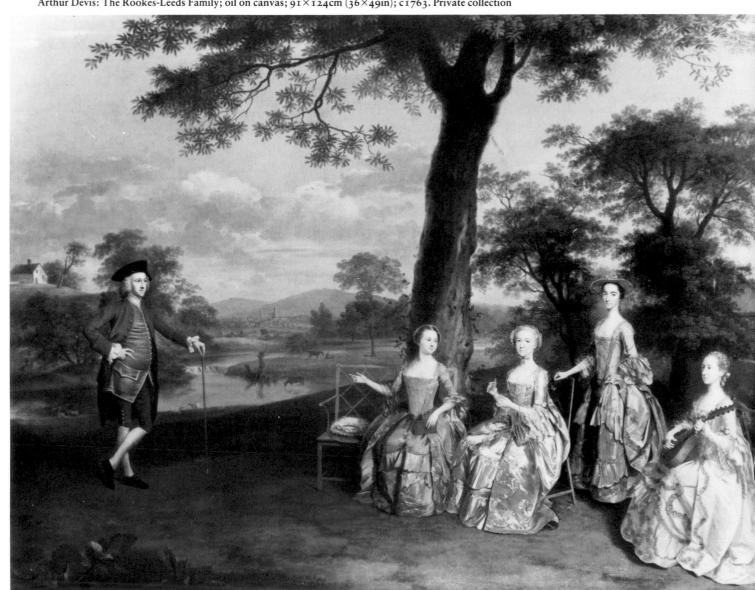

characterization of a male type such as is seen elsewhere in Greek art, contrasting with the idealizing features of Athenian art. On two other stones (British Museum, London, with a boxer; Staatliche Museen, Berlin, with a beardless head) that can be attributed to Dexamenos, the same features and wild hair appear.

A gem in the Fitzwilliam Museum, Cambridge, shows a seated woman and her maid, the maid holding a mirror and a wreath. Two gems in the Hermitage Museum, Leningrad, found on Greek sites in south Russia, have studies of herons—one flying, the other preening itself, with a locust beside it. These are prime animal studies in an art that lent itself especially to this genre at this period. A few other stones can be attributed to Dexamenos, including one with a riderless horse in the Museum of Fine Arts, Boston, and another in the Hermitage Museum, Leningrad, with a still-life study of a wine jar of the type made on his native island of Chios. The quality of his work is unrivaled in this period and it is likely that he also worked in other materials but his name is not mentioned by any ancient author.

Dharamdas c1556–c1605·

Dharamdas was an artist of Hindu origin, an excellent painter of animals and historical scenes, who worked during the period of the Mughal Emperor Akbar (1556–1605). His early work can be seen in the *Darab-nama* in the British Library, London. He also contributed to the *Akbarnama* in the Chester Beatty Library in Dublin, the scenes *Akbar Receiving Congratulations on Murad's Birth*, *Shahbaz Khan Taking the Fort of Dunara*, and *Shahbaz Khan Marching against Kumbhalmer*. Other works he helped to illustrate include the *Timur-nama*, *Iyar-i-Danish*, *Babur-nama*, and the *Khamsa* (British Library, London) and the *Jami-al-Tawarikh* of Rashid al-Din (Gulistan Palace Library, Teheran).

Diaghilev 1872–1929

The Russian impresario Sergei Pavlovich Diaghilev was born in the city of Perm. He went to St Petersburg in 1890 to study law. In 1898 he published the first issue of *The World of Art*, in collaboration with a group of artists including Alexandre Benois and Leon Bakst; it ran until 1904. Reacting against the literary tendencies of

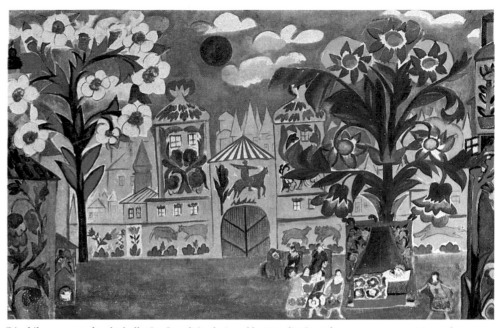

Diaghilev: scenery for the ballet Le Coq d'Or designed by Natalia Gontcharova; 1913–14. Musée de l'Opéra, Paris

contemporary Russian painting these young men promulgated an "art for art's sake" doctrine. Through this journal and through exhibitions, Diaghilev introduced foreign painting—including works by the French Post-Impressionists and the Nabis—to the Russian art-world. In 1906 he presented an exhibit of Russian painting at the Paris Salon d'Automne; he followed this with concerts of Russian music in 1907 and a production of Mussorgsky's opera *Boris Godunov* in 1908.

These activities introduced to Paris existing aspects of Russian culture. His creation of the *Ballets Russes*, which first appeared in Paris in 1909, was genuinely innovatory: it rejected classical tradition in order to treat music, dance, and design as equal components in an artistic entity. He employed painters for costumes and settings, to escape from the time-honored conventions of specialist designers—a practice that gave scope for the sumptuous exoticism of Bakst, and the 18th-century revivalism of Benois. Natalia Goncharova's designs for *Le Coq d'Or* (1914) introduced her version of Cubism to Paris.

After the outbreak of war, Diaghilev's company left these headquarters and became Paris-based. He continued to employ outstanding painters, often assiduously courting the avant-garde. *Parade* (1917) used noise music by Erik Satie and unwieldy costumes by Picasso reminiscent of his Cubist works. *La Chatte* (1927) had Constructivist settings by Antoine Pevsner and Naum Gabo. It is largely due to Diaghilev that designing for opera and ballet is today considered a worthy activity for a serious artist. Diaghilev's influence on 20th-century ballet cannot be exaggerated.

Diaz de la Pena 1808–76

Virgilio-Narcisse Diaz de la Pena was a French painter of landscapes and genre subjects. He had a brief academic training, and in his early works combined a rococo manner derived from the 18th century with the vivid color of Delacroix. These light-hearted and charming paintings depict nymphs, gypsies, and bathers (for example, *Descent of the Bohemians*; Museum of Fine Arts, Boston). Under the influence of Rousseau, he painted an increasing number of pure landscapes during the 1840s. These works, often painted at Barbizon, used dappled colors on a darker background; they were heavily glazed to give a lustrous, shimmering finish, as in the *Forest Interior* (c1867; Washington University Gallery of Art, Steinberg Hall, St Louis, Mo.).

Dibbets Jan 1941–

The Dutch artist Jan Dibbets was born in Weert, the Netherlands. He attended art school in Tilburg (1959–63) and studied at St Martin's School of Art, London, in 1967. There he abandoned Abstract painting and turned to still photography (later adding film and video). His *Perspective Corrections* (1968–9) rely on the monocular viewpoint of the static camera for their effect. His later works, *Panoramas* and *Dutch Mountains*, for example, comprise sequences of images recorded by the camera as it turns on its axis according to predetermined procedures. The mounted photographs give paradoxical, abstract, poetic, and anti-Euclidean images of the world. His 24-minute television film of

T.V. as a Fireplace was transmitted on Westdeutsches Fernsehen on 31 December 1969. Dibbets represented the Netherlands at the 1972 Venice Biennale. He lives and works in Amsterdam.

Diebenkorn Richard 1922–93

Richard Diebenkorn was one of a group of American West Coast artists based on the San Francisco Bay area who abandoned abstraction and reverted to figurative art. Diebenkorn, Elmer Bischoff (1916–) and David Park (1911–60) all taught at the California School of the Arts, San Francisco, and developed figurative styles that showed some debt to their earlier Abstract Expressionism. Diebenkorn began his figurative work in 1955, using broad areas of color in carefully structured wedge shapes. He achieved a sense of thoughtful quiet and isolation in his figure studies, as in *Man and Woman in Large Room* (1957; Joseph Hirshhorn Museum, Washington, D.C.), and a pleasing sense of cool space in his landscapes.

Dientzenhofer family
17th and 18th centuries

The Dientzenhofers were a remarkably talented family of architects whose activities extended over almost a century in central Germany and Bohemia. Georg Dientzenhofer (1614–89) assisted Abraham Leutner on the abbey church of Waldassen (from 1681) and at the end of his career designed Kappel nearby (1685–1689). His son Christoph (1655–1722) was almost certainly responsible for a series of major churches in Bohemia employing Guarinesque vault designs, including Obořiště (*c*1699–1712), Smiřice (*c*1700–13), sv. Mikulaš, Malà Strana, in Prague (1703–11) and St Margaret's (1719–21) attached to the Benedictine monastery of Brevnov (Breunau).

Another of Georg's sons, Johann Leonhard (1660–1707), was most important as a designer of monasteries (Ebrach, 1687–98; St Michael at Bamberg, 1696–1702; and Schöntal, 1700–17). A third son, Johann (1663–1726), studied in Rome, as is revealed by his cathedral at Fulda (1704–12). Johann's brilliant de-

signs for the abbey church of Banz (1710–1718) reflect the vaulting patterns employed by his brother Christoph in nearby Bohemia; his secular masterpiece is Schloss Pommersfelden (1711–18). A fourth brother, Wolfgang (1648–1706) was also active as an architect.

The major figure of the third generation was Christoph's son Kilian Ignaz (1689–1751). He was the principal church architect active in Bohemia during the second quarter of the 18th century, and was responsible for the dome and tower of St Niklas, Mala Strana (1737–52).

Above: Georg Dientzenhofer: the pilgrimage church at Kappel; 1685–9

Below: Johann Dientzenhofer: Schloss Pommersfelden; 1711–18

Left: Johann Leonhard Dientzenhofer: detail of the interior of the abbey church at Ebrach; designed 1687–98, built in the early 18th century

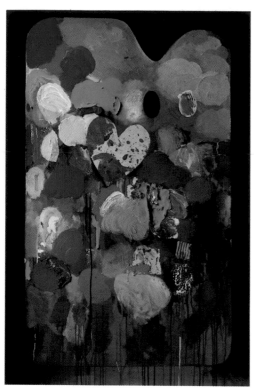

Jim Dine: Pleasure Palette; paper and canvas; 152×102cm (60×40in); 1969. Museum Ludwig, Cologne

Dine Jim 1935–

Jim Dine is, with Robert Rauschenberg and Jasper Johns, one of the American Pop artists closest in technique to Abstract Expressionism. His approach is the juxtaposition of fluent Abstract brush work with man-made objects: ties, tuxedos, toothbrushes, tumblers, washbasins, shower baths, and a wealth of modern products are all physically incorporated into his works. The tradition is one culled from Dada and the works of Marcel Duchamp. It was developed in New York in the late 1950s and 1960s by Allan Kaprow in his Happenings at the Reuben Gallery. In 1960 Dine created an Environment exhibition called *The House* in conjunction with Claes Oldenburg's *The Street*. Dine has remained one of the most versatile of the American Pop painters.

Dionysios of Fourna
18th century AD

Dionysios of Fourna was a Greek painter and author. As a Byzantine monk who spent much of his life on Mount Athos, he wrote the *Exposition of the Art of Painting*, the only surviving manual of Byzan-

tine iconography. This work, first made known to the West in a French translation in 1845, consists of technical and iconographic instructions. It is based on a series of earlier texts dating from about the 16th century and also upon the author's personal observations. It deals in particular with the works of the painters Panselinos and Theophanes of Crete. Some of the iconographic instructions are based on Western models, such as that of the *Apocalypse* which was derived from Dürer's etchings. Several icons and wall paintings by Dionysios are preserved at Fourna and Mount Athos. They are mediocre imitations of earlier models.

Dioskourides late 1st century BC

The Greek gem-engraver Dioskourides worked principally in Italy and especially for the family of Caesar. He is mentioned by Pliny as making a famous gem portrait of Augustus Caesar which the Emperor used as his seal. Three of his sons are also mentioned as distinguished engravers—Eutyches, Herophilos, and Hyllos—all

known from extant signed stones. Of their father's work about a dozen signed pieces are preserved, but his name was often forged on the skillful classicizing stones of the 18th and 19th centuries AD or was added to less distinguished ancient gems. His portraits may have included a study of Julius Caesar, known to us today only from later copies.

Original signed works by Dioskourides include a carnelian intaglio in the Duke of Devonshire's Collection (Chatsworth, Derbyshire) showing Diomedes escaping from Troy, an amethyst with the head of Demosthenes (private collection), studies of Hermes, a bust of Io (in the Uffizi, Florence), the figure of *Alexander the Great posing as Achilles* (Museo e Gallerie Nazionali di Capodimonte, Naples), and a cameo with *Herakles Capturing Cerberus* (Antikenabteilung, Berlin).

He was the foremost Greek engraver serving the Roman nobility and the new Imperial family, in common with other Greek artists who had been brought by the Romans. Their style, like their names and signatures, is wholly Greek, and the sub-

Otto Dix: The Artist's Parents; oil on canvas; 101×115cm (40×45in); 1921. Öffentliche Kunstsammlung, Kunstmuseum Basel

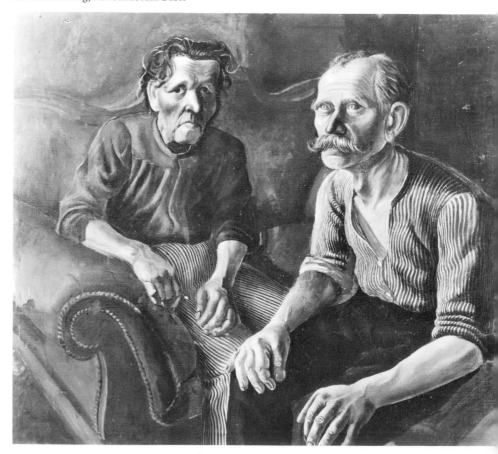

jects they cut are also Greek except where portraiture was required. The work of Dioskourides in particular characterizes the classicizing style of the early Empire, apparent in many sculptural and decorative works of the day.

Dix Otto 1891–1969

The German painter Otto Dix was born in Untermhausen in Thuringia. He studied at the Dresden and Düsseldorf Academies. He was professor at the Kunstakademie Dresden from 1927 to 1933, when he was dismissed by the National Socialists. In 1937 he was included in the Nazi "Degenerate Art" exhibition. After the Second World War he lived in seclusion until his death in 1969. Although he painted until he died, Dix's most important work dates from the 1920s. He illustrated postwar German society, both through figure-subjects—cripples, prostitutes, and war profiteers—and through pitilessly realistic portraits which border on caricature. He was included in the 1925 "Neue Sachlichkeit" exhibition in Mannheim.

Further reading. Dube, W.-D. *The Expressionists*, London (1972). Löffler, F. *Otto Dix: Life and Work*, New York (1982).

Dobson William 1610–46

William Dobson was probably the most accomplished native portrait-painter working in England before the advent of William Hogarth (1697–1764). His short career was mainly confined to the period after 1642, during the time the English royal court was in Oxford, when he painted a number of portraits of King Charles I and his officers. His portraits have a distinctly blunt and realistic feel about them, quite unlike the dash and glamor found in the work of van Dyck, by whom Dobson appears to have remained uninfluenced. A love of accessories and detail, rich coloring, and unusual three-quarter compositions are typical of his original style.

Doesburg Theo van 1883–1931

Theo van Doesburg, whose real name was Christian Emil Marie Küpper, was a Dutch polemicist, painter, and architect. His early paintings were Fauvist and Expressionist in style. He first painted in an Abstract manner under the influence of Kandinsky,

whose *Concerning the Spiritual in Art* he read during his war service. By 1917, aware of the painting of Bart Anthony van der Leck and Mondrian, his work became simplified and geometric.

In August of that year Doesburg founded *De Stijl*, the magazine of the Dutch contribution to the modern movement. He collaborated on interiors with two architect members of the group, Jan Wils and J.J.P. Oud. In the early 1920s Doesburg undertook lecture tours, notably in Germany; with some success he attacked the teaching methods of the Bauhaus at Weimar, particularly its emphasis on individual expression. In the same period Doesburg worked as a Dadaist, writing

Theo van Doesburg: Composition VI; 1917. Private collection

Dada poetry, editing the Dada magazine *Mecano*, and both organizing and performing in Dada "Evenings" in 1923 on a tour of Holland, with Schwitters.

Increasingly concerned with architecture, Doesburg joined two new members of *De Stijl*, van Eestern and Rietveld, in exhibiting architectural projects at the Galerie de l'Effort Moderne, Paris, in 1923. In the following year he moved away from the strict horizontal-vertical aesthetic of *De Stijl*, feeling that it limited expression. He introduced the diagonal, calling the new style "counter-composition".

In 1926 Doesburg published the *Elementarist Manifesto*. Elementarism opposed the balanced relationship of Neo-Plasticism with non-balanced counter-composition based on the diagonal and on color-dissonance. A commission with Jean Arp for the design of the Aubette restaurant in Strasbourg, 1927 (completed 1928), gave him the opportunity to put his Elementarist ideas into practice. His last important work was the design for his own house at Meudon, outside Paris. He became editor of *Art Concret* in Paris in 1929, and was involved in the formation of a broadly based group of Abstract artists.

Further reading. Doig, A. *Theo van Doesburg*, Cambridge (1986).

Dolci Carlo 1616–86

The Italian painter Carlo Dolci spent almost his entire career in his native Florence, where he was taught by Jacopo Vignali. Of a profoundly religious temperament, he specialized in the painting of sacred subjects. These devotional works, for example *The Martyrdom of St Andrew* (1646; Galleria Palatina di Palazzo Pitti, Florence), were small in size and intended for private chapels and apartments; their execution was deliberately laborious and highly wrought. From this approach to painting, Dolci earned himself the reputation of being a slow worker. Displaying a great sensitivity to color and light, his paintings also express a sentimental poignancy. (*See* overleaf.)

Domenichino 1581–1641

Domenico Zampieri, called Domenichino, was born in Bologna and later entered the Carraccis' Academy. In 1602 he went to Rome, where he helped Annibale Carracci decorate the Gallery ceiling of the Palazzo

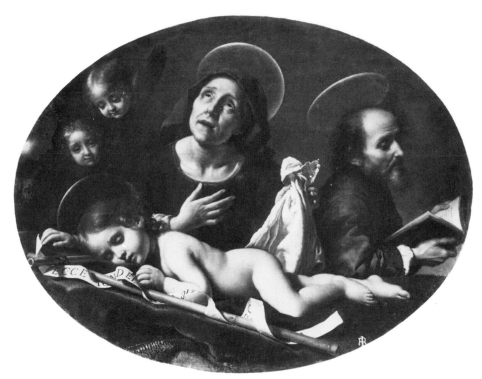

Carlo Dolci: The Young St John Asleep; oil on canvas; 45×58cm (18×23in); 1670. Galleria Palatina di Palazzo Pitti, Florence

Farnese. He lived in Rome from 1602 to 1617 and again from 1621 to 1631. By 1617 he had become the leading artist in Rome, admired as the defender of classical *disegno*, and a friend of the influential

Domenichino: Portrait of Monsignor Agucchi; oil on canvas; 61×46cm (24×18in); c1621–3. York City Art Gallery

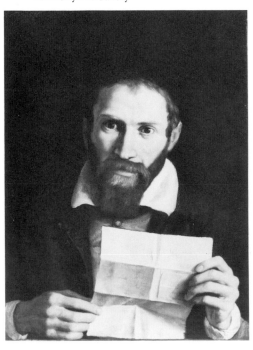

theorist Monsignor Agucchi.

Domenichino owed his severe style and use of careful preparatory drawings to Annibale's teaching. His most important works were a series of fresco decorations in Rome. *The Scourging of St Andrew* (1608; S. Gregorio Magno) and the *Scenes from the Life of S. Cecilia* (1611–14; S. Luigi dei Francesi, Rome) show the development of an austere classicism influenced by Raphael (1483–1520) and the Antique. Space is lucidly defined, and carefully balanced groups of elaborately studied figures are arranged parallel to the picture-plane.

Between 1616 and 1618 Domenichino executed ten scenes from the legend of Apollo for the Villa Aldobrandini at Frascati (eight are now in the National Gallery, London). His frescoes in the tribune of S. Andrea della Valle, Rome (1624–8) are freer and more Baroque in style. In 1631 he began work in Naples on frescoes in the chapel of S. Gennaro in the cathedral; these were left uncompleted at his death.

Domenichino also painted in oil: altarpieces, a few portraits, and landscapes. His famous *The Last Communion of St Jerome* (1614; Vatican Museums) is distinguished by its warmth and clarity. His grandiose ideal landscapes lead on to the mature style of Claude.

Domenico Veneziano *fl.* 1438–61

Domenico Veneziano (Domenico di Bartolomeo di Venezia) was an Italian painter of the Florentine school, although his name denotes a Venetian origin. Very few paintings survive that are definitely by his hand, but from the scattered contemporary records concerning his life we obtain some idea of his undoubted importance in the history of art. The first record of Domenico is in a letter dated Perugia, April 1438, in which he offers his services to Cosimo de' Medici and demonstrates his intimate knowledge of the artistic life of Florence, where he had presumably lived for some time.

In 1439 he began work on an important but now lost series of frescoes of the life of the Virgin in the choir of the church of S. Egidio, Florence, where he is documented until 1445. At that time Piero della Francesca "sta con lui", implying that Piero was Domenico's pupil and assistant.

His principal surviving work is the signed St Lucy Altarpiece from the church of S. Lucia dei Magnoli, Florence (Uffizi, Florence; predella panels in the Staatliche Museen, Berlin, Fitzwilliam Museum, Cambridge, and National Gallery of Art, Washington, D.C.). The Virgin is shown seated within a loggia, with the Christ child on her knee, and Saints Francis, John the Baptist, Zenobius, and Lucy standing at either side. The figures occupy a single unified space, in a *sacra conversazione*, rather than being divided into separate compartments by the frame, as would previously have been the case. The development of the *sacra conversazione* was an important step in the evolution of Renaissance art, and the St Lucy Altarpiece was among the first of the type to be painted. Each figure in this painting is lit by a single light source, and depicted in soft but richly varied colors. The painted architecture, which provides the main stresses in the picture, is composed of pink, green, and blue, as well as white and black marble. Domenico's interest in and mastery of perspective, which was inherited by his pupil Piero della Francesca, is seen in the complicated recession of the colored geometric floor design in the foreground.

The St Lucy Altarpiece is probably from the 1440s; the only other signed work by the artist, the much damaged *Carnesecchi Tabernacle* (National Gallery, London) is certainly earlier. The pose of the Madonna, her facial type, and her throne, with its

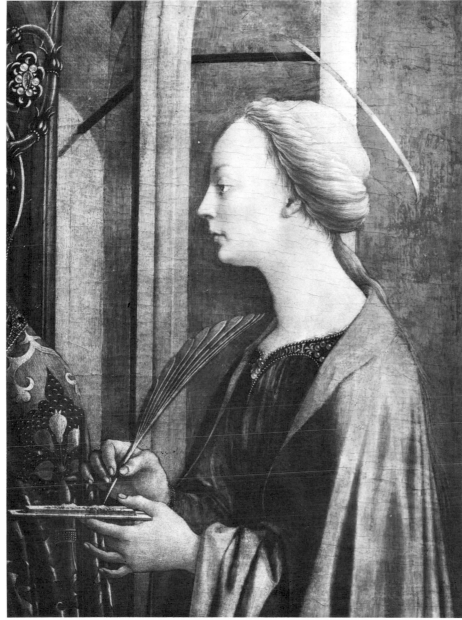

Domenico Veneziano: St Lucy, detail of the St Lucy Altarpiece; panel; full size 209×216cm (82×85in); c1445. Uffizi, Florence

steeply receding perspective, are reminiscent of the work of Gentile da Fabriano or even Jacopo Bellini; this would accord well with Domenico's apparently Venetian origins.

Further reading. Wohl, H. *The Paintings of Domenico Veneziano: a Study in Florentine Art of the Early Renaissance*, Oxford (1980).

Donatello c1386–1466

The Florentine artist Donato di Niccolò di Betto Bardi was known as Donatello. He is generally considered the most important sculptor of the Florentine Quattrocento and, indeed, one of the most influential of all Renaissance artists. There is no definite record of his activity before 1403, when he is recorded by name as an assistant to the sculptor Lorenzo Ghiberti. He would have learned bronzeworking in that busy workshop, then making the first set of doors for the Florence Baptistery. Vasari believed that Donatello visited Rome with Brunelleschi (the sculptor, goldsmith, and, later, architect) in 1402/4, but modern opinion tends to date the visit to c1410. Before that year there was no sign of the influence of Classical Antiquity in his basically Gothic style—witness the *Little Prophets* for the Porta della Mandorla of Florence Cathedral (1406–8).

The first work that pointed the direction in which his style would develop was the *St Mark* (1411) for a niche on the facade of Orsanmichele, a guildhall, which might be called the battleground or showcase of Florentine sculptural pretensions during the Quattrocento. Other niches were to be filled with statues by Ghiberti, by Donatello himself, by Nanni di Banco, Verrocchio, and others. The *St Mark* stands weightily on its cushion base, one leg as straight as a column, the other trailing in true contrapposto. Equally important, the slight twist of the body, together with the powerful expression on the face and the tension in the hands, spelled a strong psychological presence; Vasari tells of Donatello cursing one of his statues for not actually speaking.

An expression of vigorous physical and mental life is evident in all Donatello's work, and is shown with greater delicacy in the half-assured, half-reticent figure of *St George* (c1416), also intended for a niche on Orsanmichele (now Museo Nazionale, Florence; replaced in Orsanmichele by a copy). The pedestal of this statue contains the famous relief of *St George and the Princess* (c1420). It is celebrated as one of the first examples of the use of linear perspective to construct a convincing representation of space and, indeed, atmosphere on a basically two-dimensional surface. We may imagine that the relief was studied with great interest by painters. Occasionally, there is a similarity between the sculptor and the painter—as in Donatello's *Christ giving the Keys to St Peter* (Victoria and Albert Museum, London) and Masaccio's *Tribute Money* in the Brancacci Chapel of S. Maria del Carmine, Florence, both works dating from c1427.

Around the time of the *St George*, Donatello began a series of *Prophets* for the Campanile of Florence Cathedral (1415 onwards), of which the last and most startling was *Habbakuk* (sometimes called *Lo Zuccone*) of 1427–36. If the *St George* was classical in its stasis and graceful monumentality, this work broke the bounds of the classical style, and created almost a new category of nervous, single-minded passion which was later to attract painters like Andrea del Castagno and the Pollaiuolo brothers.

In certain works Donatello uses antique elements in a totally new way, and thereby turns classicism on its head. This is the case in the Cavalcanti Altar (c1435; S. Croce, Florence) where the vocabulary of Classical architecture is abused and maltreated for decorative ends. It appears even more menacingly in the riotous and uncontrollable *putti* of the Cantoria for Florence Cathedral (1433–9; now Museo dell'Opera del Duomo). This work is in strong

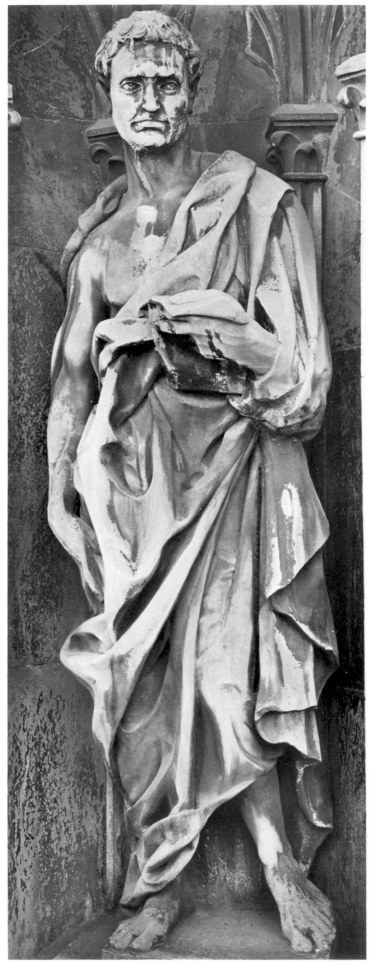

contrast with Luca della Robbia's majestically calm choir gallery which faced it across the nave. Often an evocation of Antiquity vies with a potent expressionism, as in the bas-relief of *The Dance of Salome*, made in Florence *c*1425 for the font of the Baptistery of S. Giovanni in Siena. Here, the massiveness of the antique arches is the setting for a scene of unmitigated horror.

Donatello's relationship to Classical Antiquity is therefore more complicated than the clarity and serenity of a Luca della Robbia or a Masaccio. He sees it as a source for interesting motifs (and indeed uses Etruscan and Gothic motifs on occasion), not as a vision of restraint, logic, and order. Donatello's art can have a demonic quality akin to that in some of Michelangelo's work: in both cases, lesser artists have tended to copy the motifs without attaining the inner vision that makes such subjects live.

Such considerations do not, of course, diminish the important influence of Antiquity on his art. This is clear from a study of the bronze *David* (*c*1433; Museo Nazionale, Florence) which reflects Donatello's visit to Rome in 1432–3 and possibly conversations there with Leon Battista Alberti. He may well have seen there something in the manner of Praxiteles—but the serenity of the work is disturbed by the playful inclusion of a long feather on Goliath's helmet, which tickles the top of the young hero's leg.

The anti-Classical nature of some of his art is confirmed by his reported argument with his friend Brunelleschi about the two doors, the Door of the Apostles and the Door of the Martyrs, which Donatello made in 1440–3 for the Old Sacristy of S. Lorenzo, Florence. Brunelleschi, who had designed the plain, serene architecture of the Sacristy, did not like the doors, which show fiercely arguing pairs of figures. He probably liked the eight terracotta roundels set within his architecture even less, for four of them thrust upon the spectator Donatello's continuing interest in the intricacies and emotional potential of violent perspective.

Possibly as a result of the quarrel, Donatello went to Padua in 1443 and made a bronze crucifix for the Basilica of St Anthony. This led to the most splendid,

Donatello: Jeremiah; marble; height approximately 200cm (79in); 1423–6. Museo dell'Opera del Duomo, Florence

varied and influential of all his commissions, the high altar for the same church (c1446–50). The altar consisted of a group of seven bronze statues of the Virgin and Child and saints, four bas-reliefs of scenes of the *Miracles of St Anthony*, four reliefs of symbols of the Evangelists, one relief of a *Pietà*, 12 reliefs of singing angels, and a stone panel of *The Entombment of Christ*. The altar was dismembered in 1579/82, and the original arrangement of the various elements is now disputed. The statues stood on the altar table, sheltered by a canopy (the design of which is perhaps reflected in Mantegna's S. Zeno altarpiece), and reliefs were no doubt arranged around the skirt of the altar. Yet some of the reliefs might have decorated the architectural canopy, and some of the saints might have faced to the rear of this large pilgrimage church.

Donatello's other great Paduan work is the equestrian statue of *Gattamelata*, the condottiere (1446–53; Piazza del Santo, Padua). The warrior is represented as an antique hero, perhaps following the example of the celebrated Regisole of Pavia, now lost. However, the armor is only pseudo-Roman. The powerful impact of the group derives from the uprightness of the soldier, and the geometry that governs every detail and seems to be a metaphor for the inflexible strength of will that Donatello here exalts. The condottiere looks straight to the front, controlling both horse and invisible army by willpower, not force. This statue was to be the model for the final version of Leonardo's equestrian monument to Francesco Sforza, a piece that was, unfortunately, never cast. Both have clear links with that most famous of all antique equestrian groups, the Marcus Aurelius, now on the Capitol in Rome.

A comparison between the heroic *Gattamelata* and the Santo Altar demonstrates the great range of style and emotion of which Donatello was capable. The central focus of the Altar is the group of the Virgin and Child, surrounded by a *sacra conversazione* of saints (which may have prompted Giovanni Bellini's predilection for the form). Compared with the rigidly central, hieratic, rather Byzantine Virgin, the saints are supple, naturalistic, noble, and serene. The four plaques of *The Miracles of St Anthony* proclaim the grandeur of Roman architecture; but the figure-style, by contrast, is nervous and frenetic. The stone relief of *The Deposition* intensifies this manner, with its violent gestures and crammed, despairing bodies; it continues that cult of ugliness begun as early as 1425 in *The Dance of Salome* in Siena. The slow nobility of Classical art, breathing serenely in naturalistic space, has been discarded in favor of deliberate confusion and contortion, which together present an emotional intensity unequaled until Michelangelo.

The change from the relatively serene work of Donatello's youth can be appreciated by contrasting the *St George* with the *Mary Magdalen* (polychrome wood; 1453–5; Baptistery, Florence), which he made before his final return to Florence in 1455. This depicts spiritual yearning and repentance by bodily degradation. Even more apposite is the group of *Judith and Holofernes* (1455/60; Piazza della Signoria, Florence), which has similar heroic intentions. This was originally commissioned to decorate a fountain, but was placed on its present site in 1495 on the expulsion of the Medici, when it became a symbol of the right for freedom against tyranny. It must, indeed, have been in the forefront of Michelangelo's mind when he conceived the nature of his gigantic *David*.

The *Judith and Holofernes* is unusual in Donatello's work because it is made to be viewed from the rear and sides as well as from the front. All his other works have painterly characteristics. This group is unthinkable in two dimensions, for its full horror and deliberate awkwardness are revealed only by walking around it. The implacable and pensive Judith, standing with one foot on the twisted arm of the victim, the other pressed to his crotch, waits to strike a second blow to sever the gory head from the limp and distorted body, the legs of which flop over the sides of the triangular pedestal. Judith's extravagant drapery is Gothic in its emotional intricacy—and probably inspired Benvenuto Cellini to produce something similar in his *Perseus*, which faces Donatello's group from its position at the front of the Loggia dei Lanzi.

When Donatello died, work was well in hand on two pulpits for S. Lorenzo, Florence; certain panels were completed by assistants. The north pulpit is decorated with five bronze reliefs of *The Agony in the Garden, Christ before Caiaphas and Christ before Pilate, The Crucifixion, The Descent from the Cross*, and *The Deposition*. The south pulpit has six reliefs: *The Three Women at the Tomb, The Descent into Limbo, The Resurrection, The Ascension, Pentecost*, and *The Martyrdom of St Lawrence*. The pulpits display the tragic breadth of vision that sometimes visits artists in extreme old age: certain mature works by Michelangelo, Titian, and Rembrandt make a similarly strange, almost terrifying impact. In *The Descent from the Cross* the confusion of gesticulating bodies—against the cowled stillness of the Virgin supporting her Son—lends a tragic significance that transcends the immediate Christian reference. Raphael and Michelangelo were much in his debt.

Further reading. Janson, H.W. *The Sculpture of Donatello*, Princeton (1962). Janson, H.W. "Donatello and the Antique" in *Donatello e il Suo Tempo*, Florence (1968).

Donner Georg 1693–1741

Born near Vienna, and trained under Giovanni Giuliani at Heiligenkreuz, the Austrian sculptor Georg Raphael Donner worked briefly in Salzburg as a medalist (1726) and contributed to the staircase of Schloss Mirabell (1726–7). His figure of *Paris* (signed and dated 1726) with its relaxed pose and mellifluous outline points the way to his mature style.

Summoned to Bratislava in 1729 by the Prince-Bishop Emmerich Count Esterhazy, Donner was responsible for his funerary chapel in Bratislava Cathedral (consecrated 1732) and for the high altar (consecrated 1735). The latter consisted of *St Martin and the Beggar* within a semicircular colonnade, of which only the lead central group with two angels and the *Passion* reliefs survive. The rationalism of the 18th century is reflected in the figure of St Martin who is represented not in armor but in the dress of a Hungarian hussar.

Donner's selection of lead, with its softness and silky sheen, is an essential element in the composition and emphasizes his detachment from Baroque dynamism. Nevertheless, his personal move towards classicism was based on Mannerist principles rather than any anticipation of Neoclassicism. We can discern the influence of Giovanni Bologna (c1524–1608) in the elongation and the twisted poses of the lead figures representing the *Rivers Ybbs, Traun, March*, and *Enns*. Arranged around the central figure of *Providence*, these are the dramatic components of Donner's famous fountain for the Mehlmarkt in Vienna (1737–9; now in Österreichische Galerie, Vienna). The lead

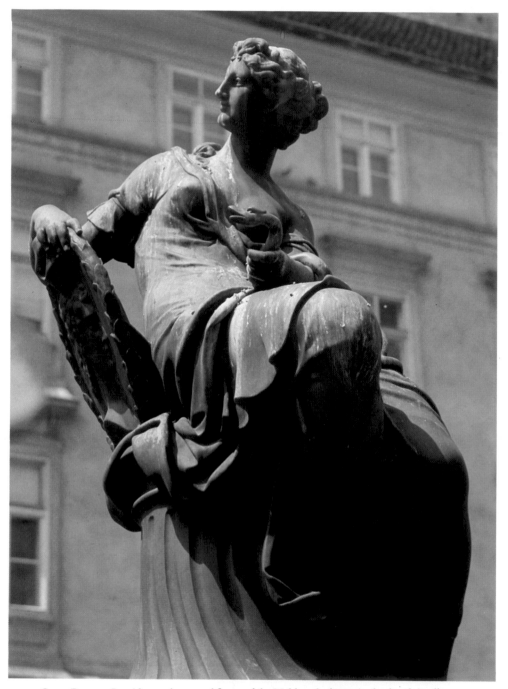

Georg Donner: Providence, the central figure of the Mehlmarkt fountain; lead and tin alloy; 1737–9. Österreichische Galerie, Vienna

Dou Gerrit 1613–75

The Dutch genre painter Gerrit Dou, the son of a Leiden glass-maker, was Rembrandt's first pupil. The religious subjects of his early years were influenced by his teacher, and he also attempted to master the chiaroscuro effects of Rembrandt's paintings. But he never exploited contrasts of light and dark for expressive purposes; although he frequently used Rembrandt's studio props—even the same models—his work lacks the latter's sense of drama and mystery. Increasingly Dou concentrated on small domestic scenes whose detailed realism (often achieved with the aid of a magnifying glass) and enamel-like finish brought him wealth and an international reputation.

Dove Arthur 1880–1946

The American painter Arthur Garfield Dove was among the very first pioneers of Abstract art. On leaving Cornell University he moved to New York and began working as an illustrator for magazines such as *Scribners*, a job that supported him until the 1930s. He lived in Europe from 1907 to 1909, where he absorbed the influences of Cézanne and the Fauves, and on his return to the United States began experimenting with Abstraction, exhibiting at Alfred Stieglitz' 291 Gallery in New York. In 1913 he exhibited at the Armory Show. Dove developed his Abstract works, which he called "extractions", by refining and simplifying objects and scenes until color and rhythmic forms took on a life of their own. Yet despite his emphasis on non-naturalistic qualities—he saw painting in terms of music—he was concerned to remain close to nature, and the origins of his Abstract forms in landscapes and plants can often be glimpsed. *Nature Symbolized No. 2* (1914; Art Institute of Chicago) is among his best-known works. In the 1920s he experimented with collage, often with great inventiveness and wit, as in his *Portrait of Alfred Stieglitz* (1925; Museum of Modern Art, New York), in which he used springs and camera lenses (among other things) to depict the photographer.

Further reading. Balken, D. *Arthur Dove: a Retrospective*, Boston, Mass. (1997).

Right: Gerrit Dou: Interior with a Young Violinist; panel; 31×24cm (12×9in); 1637. National Gallery of Scotland, Edinburgh

Pietà for Gurk Cathedral in south Austria was completed in the year of Donner's death, and his Mannerist classicism was to dominate Viennese taste for almost half a century.

Dossi Dosso c1490–1542

The Italian artist Dosso Dossi was for nearly 30 years court painter to the Este at Ferrara. Beginning in 1514, his duties entailed designing stage sets and wedding decorations, and even varnishing carriages, besides painting mythologies, portraits, and altarpieces. His earlier works were an extension of Giorgione's pastoral fantasies, with figures set in beautiful, impressionistic landscapes. In the 1520s, while retaining the rich Venetian colors, he adopted a more monumental Roman figure-style. An example can be seen in the altarpiece in Modena Cathedral (1522).

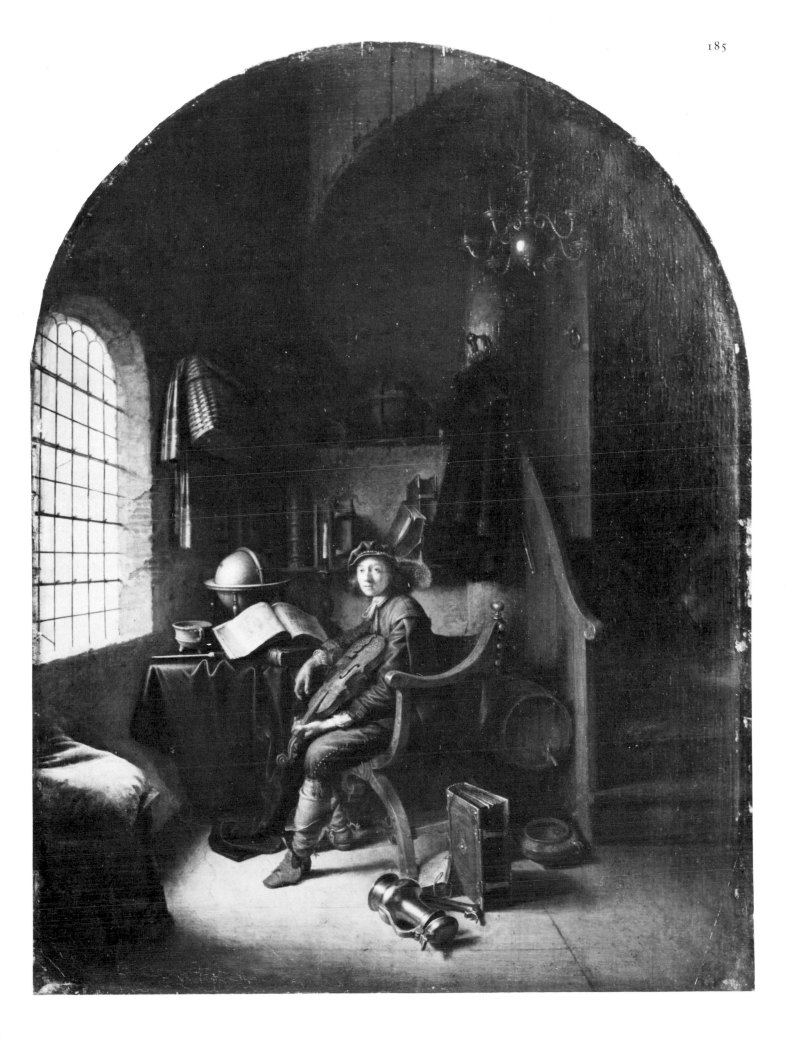

Jean Dubuffet: Setting Snares; oil on canvas; 130×196cm (52×78in); 1963. Detroit Institute of Arts

Dubuffet Jean 1901–85

The French painter and sculptor Jean Dubuffet was born in Le Havre of middle-class parents. Although he began training as a painter in 1916, he felt that art was irrelevant to common experience; he did not work as a full-time artist until 1942. He looked for an alternative inspiration in the art of the insane. This he discovered in 1923 in H. Prinzhorn's *The Artistry of the Mentally Ill*, which claimed that such art was able to express drives usually repressed by civilization.

Dubuffet took the themes of his earliest exhibited paintings from the familiar life of the city and the countryside. These were first shown in Paris just after the liberation in 1944. He abandoned spatial illusionism for a childlike hieratic style with garish colors. In a situation where the future of painting was presumed to lie either in realism or in lyrical abstraction, Dubuffet created a scandal. Particularly controversial were the *Hautes Pâtés* ("thick impastos"), exhibited in 1946. His imagery was as startling as his style: the canvases were dominated by ungainly bodies drawn like crude graffiti. This idea was taken to extremes in the series of *Dames* of 1950–1, in which heads and limbs are mere adjuncts to uneven, flat, rectangular torsos like table-tops on which anything might be scrawled.

During the 1950s Dubuffet developed these preoccupations, devoting a series of paintings to evoking the surface of the earth in terms of collage or thick oil-paint. He also used crumpled silver paper, vinyl plastics, and polyester resins from 1959. After 1962, he confined himself to red, white, black, and blue pigment in a further attempt to resist aesthetic blandishments. His life's work was rooted in an attempt to rehabilitate values that fall outside aesthetic preconceptions.

Further reading. Damisch, H. (ed.) *Jean Dubuffet: Prospectus et Tous Écrits Suivants*, Paris (1967). Gagnon, F. *Jean Dubuffet aux Sources de la Figuration Humaine*, Montreal (1972). Loreau, M. *Jean Dubuffet: Stratégies de la Creation*, Paris (1973).

Duccio Agostino di 1418–81

Agostino di Duccio was an Italian sculptor, a native of Florence. His first dated work is an *antependium* in Modena Cathedral carved in high relief with scenes from the life of S. Gemignano (1442). The provincial style of this work suggests that he received his artistic training outside Florence.

Duccio's most important work is the carved decoration within the Tempio Malatestiano at Rimini (from 1447), where an inscription records him as the sculptor responsible for the transformation of Gothic church to Renaissance "temple". There is, however, some doubt about the exact part Duccio played in the introduction of the neo-Attic low relief style of carving so characteristic of this building: the reliefs in the Chapel of the Sibyls and the Arca degli Antenati are documented as his works, and much of the rest of the sculpture was probably his too.

From 1457 to 1462 Duccio was active in Perugia where he executed the sculptured facade of the Oratory of S. Bernardino (dated 1461), much of which is derived directly from Rimini. Thereafter he divided his time between Perugia, Bologna, and Florence where he was commissioned in 1463 to carve a *Gigante* (giant) for the Duomo. Work on another colossal figure begun the following year was abandoned after two months; the block remained with the cathedral authorities until Michelangelo used it to carve his celebrated figure of David. But Duccio is known chiefly for his work in low relief, and many reliefs of the Madonna and Child.

Duccio di Buoninsegna
*c*1255–1319

The Italian painter Duccio di Buoninsegna worked chiefly in Siena, whose first great artist he was. Records of Duccio's name occur in 1278 and 1279, when he was paid for decorating bookcovers for the Siena town government. His first major commission came from the Confraternity of the Virgin Mary in Florence in 1285: this was for a painting of the Madonna and Child for the church of S. Maria Novella, and is today generally identified with the so-called *Rucellai Madonna* (Uffizi, Florence), in spite of Vasari's attribution of the picture to Cimabue. Duccio is again recorded in Siena in the 1290s, and in 1295 he helped Giovanni Pisano with the preliminaries for the erection of the Fonte d'Ovile, Siena.

Seven years later, he was responsible for painting a *Maestà* (Madonna and Child enthroned in Glory, with Saints and Angels) for the Chapel of the Council of Nine in Siena town hall. That work is now lost but most of another and greater *Maestà*, commissioned in 1308 for Siena

Agostino di Duccio: Philosophy, a relief carving in the Tempio Malatestiano, Rimini

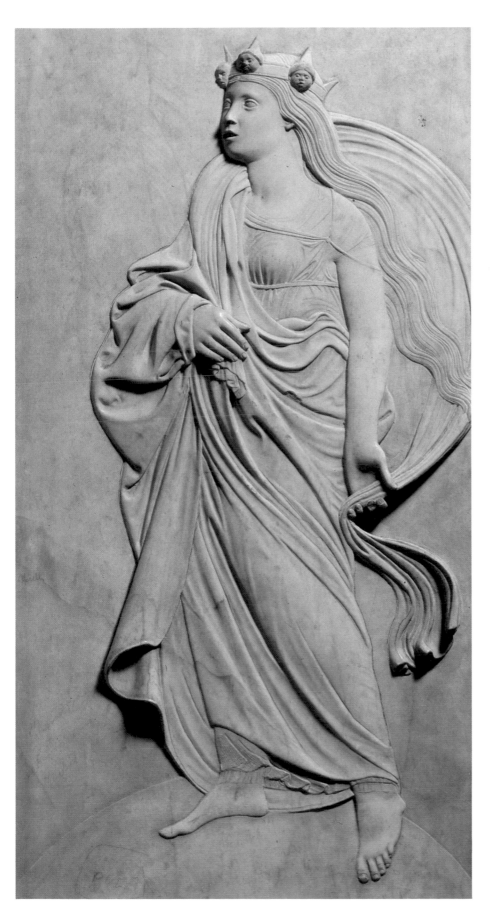

Cathedral, has survived. As the only fully documented surviving work by Duccio this must act as the key to an understanding of his style, and to the attribution of other works to his hand. The painting, which Duccio contracted to execute unaided by assistants, was probably not completed until 1311, when it was carried in solemn procession from Duccio's workshop to the Cathedral, there to take its place on the high altar.

Duccio's art, although clearly based in the Byzantine style then current in Italy, gradually enriches this tradition with a new life and humanity. The early *Rucellai Madonna* conforms to the shape and type of altarpiece of Cimabue's S. Trinità *Madonna* (which probably precedes it by a few years) to the extent of copying the frame, with roundels connected by ornamental strips. Duccio's Virgin is shown holding the Christ-child with his right arm raised in blessing, enthroned in the centre of an upright panel pointed at the top. The vast scale of the image of the Virgin is emphasized by the small scale of the three angels crouched at either side of her elaborate throne. In these figures the painter's skill is seen in the clear but delicate coloring of the drapery of each angel, complemented by the coloring of the angels on the opposite side of the throne.

Some of the panel paintings of smaller dimensions can on stylistic grounds be placed between the *Rucellai Madonna* and the *Maestà*. One of these is the *Madonna with Three Franciscan Monks* (Pinacoteca Nazionale, Siena); here the flowing "Gothic" line, already apparent in the Virgin's hemline of the Florentine painting, can be seen again. The rich golden ground behind and around the Virgin is partly obscured by a richly decorated cloth of honor, as it is in a later panel, now in the National Gallery, London. In both these panels, the Virgin and Child are seated between angels much smaller in scale; but the subsidiary figures now have a less ethereal nature and begin to stand more firmly on the ground.

That is certainly the case in the great Siena Cathedral *Maestà* of 1308–11. This work, now dismantled, was originally made up of two parts, each demanding a different talent from the artist. The front, facing the congregation, showed the Virgin and Child enthroned in the center of an oblong panel; angels and saints were ranged in three rows, two standing and one kneeling, at either side of the throne.

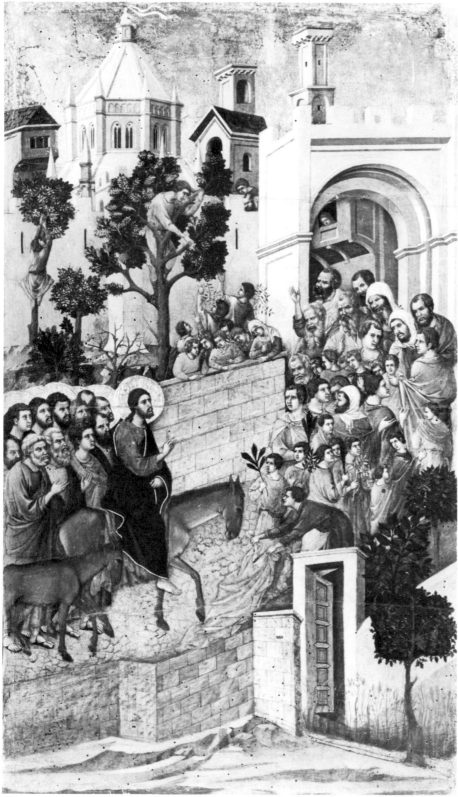

Crucifixion scene occupied the large upper central area (26 panels in all). The greater part of this vast altarpiece survives in the cathedral museum (Museo dell'Opera del Duomo) at Siena. However, the panels from the predella are scattered through public and private collections in Europe and America (examples in the National Gallery, London; Frick and Rockefeller Collections, New York; National Gallery of Art, Washington, D.C.).

In the small panels of the *Maestà*, Duccio reveals himself as a master of pictorial narrative. In many cases he follows a pattern of storytelling inherited from Byzantine artists. But he enriches the traditional iconography with many new incidents intended to provoke greater contemplation in the devout beholder. The individual figures have a sensitivity of characterization which reinforces Duccio's importance in the prehistory of Italian Renaissance art, and clearly distinguishes him from his Florentine contemporary Cimabue. He places these figures within a convincing spatial setting which is used, for narrative purposes, in a brilliantly inventive manner. For instance, Christ appears before Annas in the upper floor of a building, on the ground floor of which St Peter's denial is shown, with a staircase linking the two floors.

It is probably Duccio's skill as colorist that is made clearest in the *Maestà*. The figure of Christ, clad in a glowing red and blue robe which becomes striated with gold after the Crucifixion, can be traced passing from panel to panel. The jewel-like quality of color seen in Duccio's work was to remain of fundamental importance to the painters of the Sienese school throughout the next 200 years.

Further reading. Brandi, C. *Duccio*, Florence (1951). Carli, E. *Duccio di Buoninsegna*, Milan (1951). Cattaneo, G. *L'Opera Completa di Duccio*, Milan (1972). Weigelt, C.H. *Duccio di Buoninsegna*, Leipzig (1911). White, J. *Duccio: Tuscan Art and the Mediaeval Workshop*, London (1979).

Duccio di Buoninsegna: The Entry into Jerusalem, a panel from the Maestà; size of panel 102×54cm (40×21in); 1308–11. Museo dell'Opera del Duomo, Siena

Above the main figures, in separate compartments of the no-longer-extant original frame, were half-length figures of saints. Crowning it all, in separate gabled panels, were six scenes narrating the life of the Virgin, with her Death and Assumption in the center.

The reverse side of the *Maestà* was occupied by panels depicting the life of Christ. The ten predella panels narrated his early life and ministry, and the crowning gabled panels his appearances following the Resurrection. The story of Christ's Passion adorned the main area, shown in two bands, each two panels deep, progressing from bottom left to top right; while the

Ducerceau family
16th and 17th centuries

The Ducerceau were a family of French architects and architectural theorists. The elder Ducerceau (Jacques I, *c*1515–*c*84) was probably connected with two buildings, both now destroyed: Charleval, a vast rural palace begun in 1568 for Charles IX,

and Verneuil of 1570. He is mainly known for his many architectural and ornamental engravings. He illustrated the principal French châteaux in two volumes (1576; 1579).

In 1559, Jacques I wrote *Livre d'Architecture* and in 1561 a second *Livre d'Architecture*. Both books were rag-bags of ideas with little emphasis on the practical, and they may well have hindered rather than helped his career. His sons, Baptiste, (c1555–c90) and the more famous Jacques II (1556–1614) continued the architectural rather than the literary traditions of their father. Jacques II built the Petite Galerie des Tuileries in Paris, c1608, and at the Louvre the Pavilion de Flore, c1607; this followed his earlier work on the western part of the Grande Galerie of the Louvre, with its impressive use of the giant order. The architecture of the Ducerceau family strengthened and extended the naturalization of Serlio's Italian manner.

Duchamp Marcel 1887–1968

The French artist Marcel Duchamp was a leading exponent of Dada principles and was later associated with the Surrealists. He was born in Blainville, Normandy, the son of a notary. His two elder brothers, Gaston (1875-1963), known as Jacques Villon and Raymond Duchamp-Villon (1876–1918), were also artists. Duchamp began painting in 1902, and two years later joined his brothers in Paris, where he studied for a year at the Académie Julian. From 1905 to 1910 he worked

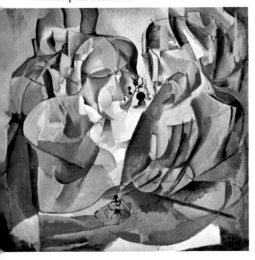

Marcel Duchamp: Portrait of Chess-Players; oil on canvas; 102×102cm (40×40in); 1911. Philadelphia Museum of Art

sporadically as a cartoonist for popular periodicals, and he also began to frequent his brothers' avant-garde poet and painter friends.

Duchamp's paintings of 1910–11 reflect the influence of Cézanne and of Fauvism, but they also have Symbolist overtones in their imagery of female nudes and lovers. An awareness of Cubism is shown in his works of 1911–12. Influenced by Futurism and Étienne-Jules Marey's Chrono-photography, Duchamp also began to depict movment by means of successive images of the body in motion. *Dulcinea* (1911; Philadelphia Museum of Art) and his most important painting up to that time, *Nude Descending a Staircase* (no. 2; 1912; Philadelphia Museum of Art), both employed this method. In neither work, however, was there any sign of the Futurists' optimistic attitude to modern life. Rejected from the Indépendants exhibition in Paris, *Nude Descending a Staircase* had a *succès de scandale* when it was shown in the Armory Show in New York in 1913.

In 1912, Duchamp was in close association with Apollinaire and Picabia; with them he evolved a critical attitude to the nature and purpose of art that prefigures the studied iconoclasm of Dada. On a visit to Munich that summer, he painted *The Passage from the Virgin to the Bride* (Museum of Modern Art, New York) and *Bride* (Philadelphia Museum of Art), in which sexual intercourse and the loss of virginity are symbolized cryptically in semiorganic, semimechanical terms. Duchamp had by now moved far from Cubism, which he had come to regard as too "retinal". As he repeatedly stated, his aim was to reintroduce the cerebral into painting at the expense of pure visual beauty.

Nineteen-thirteen was a crucial year in Duchamp's development. Apparently as a "diversion" he created his first so-called "Ready-made" (*The Bicycle Wheel*; original lost; replica, Museum of Modern Art, New York), which consisted of a bicycle wheel upended on a stool. Implicit in this gesture is a Dadaist contempt for the traditional notions of what constitutes a work of art, and the suggestion that the essential factor in the creation of art is not skill but choice. *The Chocolate Grinder* (no. 1; 1913; Philadelphia Museum of Art) was almost the last of Duchamp's oil paintings: in it he employed all the resources of academic illusionism in the portrayal of a simple implement, thus

directing his irony against both academic and avant-garde artists. At the same time, he developed a quasi-scientific system, "canned chance", to incorporate random effects into his work. Thus, in *Three Standard Stoppages* (1913–14; Museum of Modern Art, New York), the design was established by dropping three one-meter lengths of string from a height of one meter on to the floor.

Duchamp settled in New York in 1915. He spent most of the rest of his life there, becoming an American citizen in 1955. With Man Ray, Picabia, and others, he founded the New York Dada group. Periodically, he manufactured Ready-mades. One of the most notorious of these was *Fountain* (1917; original lost; replica, private collection), which was an upended urinal. Another was *L.H.O.O.Q.* (1919; private collection)—a reproduction of the *Mona Lisa* defaced by a mustache, beard, and inscription, which he made while staying in Paris.

Duchamp's most important work, *The Bride Stripped Bare by her Bachelors, Even*, or *Large Glass*, was begun in 1915 and abandoned unfinished in 1923 (Philadelphia Museum of Art). Notes and studies for it dated back to 1912. In this complex work, executed in mixed media on glass, the Bride's domain occupies the top half, and the organic vocabulary of the 1912 paintings is employed; the Bachelors, in the lower half, represented by nine "malic moulds", are controlled by an elaborate pseudo-mechanical apparatus dominated by the Chocolate Grinder. Despite the strenuous efforts of the Bachelors, aided by the Oculist Witnesses (represented by optical charts), and despite the Bride's encouraging messages (the cloud-like forms at the top), sexual union is never achieved. Through the metaphor of impotent machines and the medium of glass, Duchamp makes an ironic and pessimistic comment on human sexuality. For the Surrealists, who immediately recognized Duchamp's importance, the *Large Glass* was a key work, comparable to the great occult creations of the Middle Ages.

In the 1920s, Duchamp became increasingly interested in optics and cinematic techniques. He experimented with the visual effects created by rotating disks, and in 1926 made a short film, *Anemic Cinema*, with Man Ray. In the 1930s he spent less time on artistic activities as he became increasingly involved in chess-playing at an international level. He con-

centrated on the publication in 1934 of *The Green Box*, a complete facsimile of his notes and drawings for the *Large Glass*; he also designed installations for Surrealist exhibitions. The legend that he had given up art to play chess began to circulate, and had a considerable influence on avantgarde artists in the 1950s and 1960s.

In fact, however, Duchamp had been engaged secretly for some 20 years, from 1946, on making the illusionistic tableau-assemblage, *Given: 1. the waterfall, 2. the illuminating gas* (Philadelphia Museum of Art). In essence, this extraordinary construction is a further extension of the erotic theme of the *Large Glass*. Revealed only after his death in 1968, the work had been preceded by a number of erotic objects during the 1950s.

The influence of Duchamp's ideas and of his work has been vital: his Ready-mades were a major stimulus to Surrealist object-making and to Pop art. His belief that living is the true art form, and his emphasis on the cerebral content of art, have deeply affected such avant-garde developments as Conceptual art.

Further reading. Cabanne, P. *Dialogues with Marcel Duchamp*, New York (1971). Golding, J. *Duchamp: The Bride Stripped bare by her Bachelors, Even*, London (1972). Harnoncourt, A. d' and McShine, K. *Marcel Duchamp*, Munich (1989). Lebel, R. *Marcel Duchamp*, London and New York (1959, reprinted 1967). Paz, O. (trans. Phillips, R. and Gardner, D.) *Marcel Duchamp: Appearance Stripped Bare*, New York (1979). Sanouillet, M. and Peterson, E. *The Essential Writings of Marcel Duchamp*, London (1975). Schwarz, A. *The Complete Works of Marcel Duchamp*, New York (1969). Tomkins, C. *Duchamp: A Biography*, New York (1996).

Duchamp-Villon Raymond
1876–1918

The French Cubist sculptor Raymond Duchamp-Villon was the brother of Marcel Duchamp and Jacques Villon. Born in Rouen, he settled in Paris 1901, having first taken up sculpture during a convalescence from 1899 to 1900. His early terracottas had an Art Nouveau stylization, and a dynamic sense of the spiral remained vital to his art.

Under the influence of Cubism he used increasingly angular forms. An example is

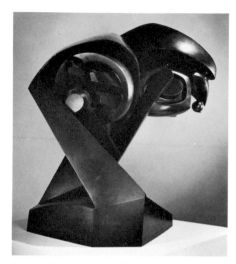

Raymond Duchamp-Villon: The Larger Horse; bronze; height 150cm (59in); 1914. Museum of Fine Arts, Houston

his *Baudelaire* (1911; Museum of Modern Art, New York). In other works he made reliefs analogous to Cubist painting in their compressed space and formal dislocation.

His bronze *Horse* (1914; Museum of Modern Art, New York) is one of the most famous and revered of Cubist sculptures. Close in spirit to Léger and to Futurism, it is a dynamic machine-age image, blending ideas of animal energy with mechanistic forms and using the play of light on turning surfaces.

The increasing abstraction of his last bronze, *Professor Gosset* (1917–18; Albright-Knox Art Gallery, Buffalo), has prompted much speculation about how his art might have developed. His career at the center of the Cubist movement was curtailed by his early death from typhoid, contracted during service at the Front in the First World War.

Dudok Willem 1884–1974

The Dutch architect Willem Marinus Dudok was born in Amsterdam. An admirer of the work of H.P. Berlage (1856–1934), he quickly evolved his own distinctive style. He was in contact with the *De Stijl* movement but was not a member. Most of his important works were public buildings for the town of Hilversum, where he was made municipal architect in 1915.

Dudok's work is largely in exposed brick, asymmetrically composed, often with a tower and long horizontal strips of window. The interlocking of massive rectangular blocks is effective. His best building, the Hilversum Town Hall (1924–30), was admired in England where his work as a whole—less radical than that of his friend J.J.P. Oud (1890–1963)—was seen as representing the softer stream of modernism.

Dufy Raoul 1877–1953

The French painter Raoul Dufy was born at Le Havre. After studying at the École des Beaux-Arts in Le Havre (1900) he developed a brightly colored style influenced by Van Gogh and the Impressionists. Much impressed by the work of Matisse, he joined the Fauves in 1905. From printed fabric made in 1910 he evolved his familiar decorative style of luminous washes and calligraphic notations evoking scenes of elegant life. He executed one of the largest murals ever painted on the theme of Scientific Progress for the Palace of Electricity at the 1937 Paris World Fair.

Further reading. Perez-Tibi, D. *Dufy*, New York (1989).

Dujardin Karel 1622–78

The Dutch painter and etcher Karel Dujardin painted genre scenes, life-size portraits, and occasional religious pictures, but is best known for his landscapes. These are usually, like those of his teacher, Berchem, in the Italianate tradition deriving from Claude. Unlike most Italianizing painters from the north, Dujardin combined clear, warm light effects and such classical pastoral motifs as shepherds and grazing animals with a Dutch setting and a particularizing approach to natural forms. Dujardin's bucolic landscapes found a ready market in his native Amsterdam.

Duquesnoy François 1597–1643

The Flemish sculptor François Duquesnoy acquired his fame in Rome, where he became generally known as "Il Fiammingo". Born in Brussels, he was trained by his father, the sculptor Jérôme Duquesnoy the Elder. No works survive from this period and his later works do not display any marked Flemish characteristics.

He reached Rome in 1618 with a pension from Archduke Albert, for whom he had previously executed some minor works. The Archduke died in 1621, and Duques-

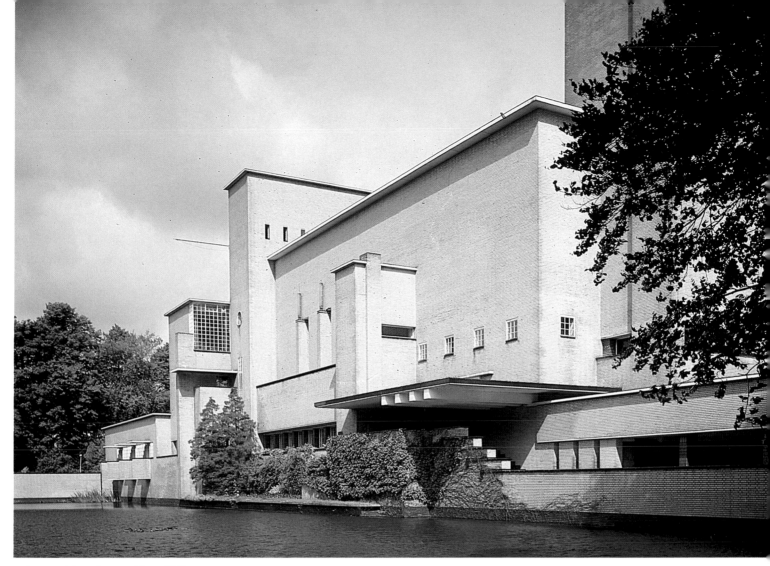

Willem Dudok: Hilversum Town Hall; 1924–30

Raoul Dufy: Races at Goodwood; watercolor; 50×66cm (20×26in); 1930. Private collection

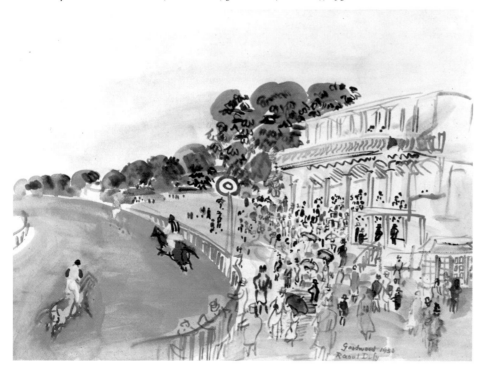

noy earned his living by producing small sculptures in ivory and metal, and by restoring antiques. He was fortunate in securing powerful patrons. He received commissions from Cardinal Francesco Barberini, for whom he carved the busts of *Bernardo Guglielmi* and *John Barclay* (1627); from Cardinal Connestabile Filippo Colonna, for whom he modeled an inkwell; and from Marchese Giustiniani, for whom he designed a frontispiece and created small bronze statuettes of *Mercury* and *Apollo*.

Duquesnoy made only two over-life-size marble statues. One of these, the *St Andrew* (1633–9; in the crossing of St Peter's, Rome) was based on a model prepared by Bernini. The other, *S. Susanna* (1630–3; S. Maria di Loreto, Rome), was one of the most influential statues carved in modern times. The graceful, curving form of *S. Susanna* combined a warm classicism with gentle sentiment. It achieved that perfect statement of the ideal for which its slow-working creator was

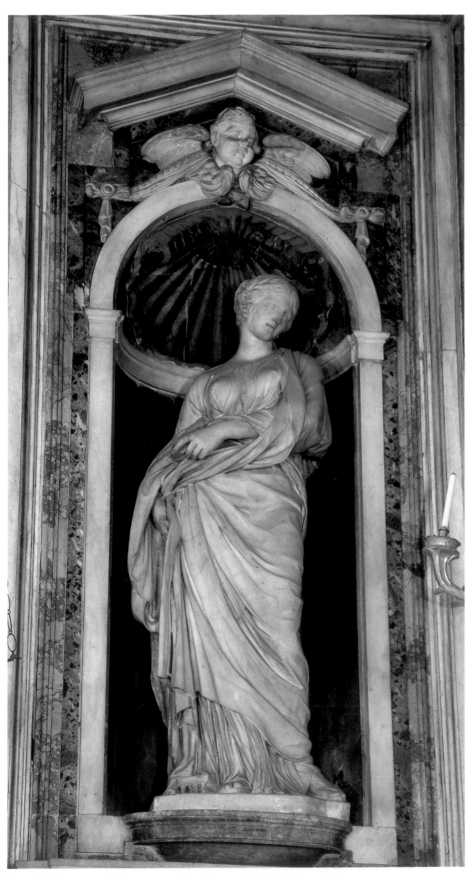

François Duquesnoy: S. Susanna; marble; 1630–33. S. Maria di Loreto, Rome.

constantly striving, and its style impressed itself upon a host of later imitators.

Apart from the busts already mentioned, Duquesnoy carved a portrait of Cardinal Maurice of Savoy. He created a fascinating study of the dwarf who accompanied the Duc de Créqui on his embassy to Rome (1633–4), and modeled a bust of the wife of his friend Nicolas Poussin.

His most popular and influential contribution to art was his treatment of *putti* (babies), which in his hands attained a new veracity and charm. Some are to be seen in the three surviving small tombs of Adrien Vryburch (1629) and Ferdinand van den Eynde (1633–40) in S. Maria dell'Anima, and of Jacob de Hase (*post* 1634) in S. Maria in Campo Santo, Rome, and others are in reliefs such as the *Bacchanal of Putti* and *Amor Sacro and Amor Profano* in the Galleria Doria Pamphili, Rome. There are further examples in his *Musician Angels* on the Filomarino Altar in SS. Apostoli in Naples (1640–2), and there are also numerous small models, such as that of the Colonna inkwell.

Despite his small output, much of it in such "minor" genres, Duquesnoy achieved a perfection that places him among the great sculptors of the Roman Baroque. Such was his fame in his own day that he was summoned to work for the King of France; it was at Leghorn, on the journey to Paris, that he died.

Durand-Ruel Paul 1831–1922

Paul Durand-Ruel was the leading French dealer in the works of the French Impressionists. He inherited his father's Paris gallery in 1865, and initially concentrated on the work of the Barbizon School and their contemporaries, as well as some earlier French painters and Old Masters. He met Monet and Pissarro in London during the Franco-Prussian War of 1870–1, and bought much from the Impressionists and from Manet between 1871 and 1873, though he continued to buy the work of Academic artists such as Adolphe William Bouguereau. Financial difficulties prevented him from investing further in the work of the Impressionists until the 1880s, but from then onwards he was the principal agent of their increasing success, in the United States, in France, and elsewhere in Europe.